CHALLENGING HISTORY IN THE MUSEUM

Challenging History in the Museum
International Perspectives

Edited by

JENNY KIDD
Cardiff University, UK

SAM CAIRNS
Cultural Learning Alliance, UK

ALEX DRAGO
Historic Royal Palaces, UK

AMY RYALL
University of Sheffield, UK

MIRANDA STEARN
Orleans House Gallery, UK

ASHGATE

Published by
Ashgate Publishing Limited
Wey Court East
Union Road
Farnham
Surrey, GU9 7PT
England

Ashgate Publishing Company
110 Cherry Street
Suite 3-1
Burlington, VT 05401-3818
USA

www.ashgate.com

British Library Cataloguing in Publication Data
A catalogue record for this book is available from the British Library.

The Library of Congress has cataloged the printed edition as follows:
Kidd, Jenny.
 Challenging history in the museum : international perspectives / edited by Jenny Kidd, Sam Cairns, Alex Drago, Amy Ryall and Miranda Stearn.
 pages cm
 Includes bibliographical references and index.
 ISBN 978-1-4094-6724-3 (hardback) -- ISBN 978-1-4094-6725-0 (ebook) -- ISBN 978-1-4094-6726-7 (epub) 1. Historical museums--Exhibitions--Moral and ethical aspects--Case studies. 2. Historical museums--Educational aspects--Case studies. 3. Historical museums--Social aspects--Case studies. I. Kidd, Jenny, editor of compilation. II. Title.

 D2.5.K53 2014
 907.5--dc23

 2013032311

ISBN 9781409467243 (hbk)
ISBN 9781409467250 (ebk – PDF)
ISBN 9781409467267 (ebk – ePUB)

MIX
Paper from
responsible sources
FSC® C013985

Printed in the United Kingdom by Henry Ling Limited, at the Dorset Press, Dorchester, DT1 1HD

Contents

List of Figures

List of Contributors

Mikel Errazkin Agirrezabala has a degree in social and cultural anthropology and has been working since 2004 on the recovery of the historical memory of the Civil War in Spain with Aranzadi Society of Sciences, where he has published several studies and books. He currently lectures in the Faculty of Humanities and Education of Mondragon University.

Verena Alberti coordinates the Documentation Sector from the Center for Research and Documentation in Contemporary History of Brazil (CPDOC) at Fundação Getulio Vargas and teaches history at Escola Alemã Corcovado, Rio de Janeiro. She has a history degree from Universidade Federal Fluminense, a master's in social anthropology from the Social Anthropology Graduate Program at Museu Nacional, Universidade Federal do Rio de Janeiro, a doctorate in literary theory from the University of Siegen, Germany and has undertaken post-doctoral work in history education from the Institute of Education, University of London.

Åshild Andrea Brekke is a social anthropologist currently working as a senior adviser for Arts Council Norway. Her main fields of responsibility are community participation, social inclusion, access and learning, museum and cultural heritage education. She has previously worked for the Norwegian Museum, Library and Archive Authority, as well as for Save the Children Norway and the UN Refugee Agency (UNHCR), on issues such as community participation and child protection in emergencies.

Judith Bryan, a novelist and playwright, is a senior lecturer in creative writing at the University of Roehampton, where she convenes the MA in Creative and Professional Writing course. Her research interests include eighteenth- and nineteenth-century black British writers. She is a member of the Tricycle Theatre's Bloomberg playwrights' group.

Samantha Cairns started her career in museum education and then expanded into libraries, archives and the arts. Sam has worked for the UK Museums, Libraries and Archives Council, Imperial War Museums at the Churchill War Rooms and at the Wellcome Trust and Victoria and Albert Museum. She currently co-manages the Cultural Learning Alliance and is a trustee of the UK Group for Education in Museums.

Alex Drago is the Explorer Manager for 11-19 years at Historic Royal Palaces, having previously worked as Education Manager at the Tower of London. He is also a co-founder of the 'Challenging History' network. Prior to this he ran an arts-education company that delivered literacy through photography projects for children and young people. Possessing master's degrees in both cultural studies and photography, Alex's approach to both heritage learning and photography is characterised by a constant questioning of our relationship with history, to deconstruct and reframe assumed narratives in order to reveal new perspectives on our shared past. <www.alexdrago.co.uk>.

David Fleming believes that museums should be democratic institutions that are concerned with and valued by the whole of society. One of the ways they can achieve this is to accept the fact that, rather than being neutral and dispassionate, museums should be places that celebrate their emotional impact.

David Gunn is the founding director of Incidental, an organisation operating on the intersections of sound art, new media and participatory practice to explore notions of identity, archive and site. In the past seven years, David has led a variety of projects in the UK, Europe, Asia and the USA, with a diverse output including websites, live performances, installations, software design and site-specific interventions. <www.theincidental.com>.

Ceri Jones joined the Research Centre for Museums and Galleries (RCMG) at the School of Museum Studies, University of Leicester in September 2002. As a researcher, Ceri has worked in collaboration with colleagues on a number of research projects exploring the social role and impact of museums and cultural organisations.

Jenny Kidd is lecturer in the School of Journalism, Media and Cultural Studies at Cardiff University. She is one of the founding members of the 'Challenging History' network. Jenny publishes across the fields of heritage, culture and media, and is co-editor of *Performing Heritage* (with Anthony Jackson, 2011). Further writings about the themes in this collection can be found in *Museum and Society*, the *International Journal of Heritage Studies* and *The Curator* and online at the 'Challenging History' network resource <www.challenginghistorynetwork. wordpress.com>.

Bernadette Lynch is an academic, writer and museum professional with 25 years' experience in museum senior management in the UK and Canada. Lynch has a reputation for ethical and innovative museum theory and practice. Formerly deputy director of the Manchester Museum, she works freelance and is committed to participation, dialogue and debate in museums.

Jolene Mairs Dyer is a documentary filmmaker and Lecturer in Media Production at the University of Ulster researching the role of audio-visual storytelling in post-conflict Northern Ireland.

Rosa Martínez Rodríguez has a degree in political science and a post-graduate degree in history. She currently works as educational manager at the Aranzadi Society of Sciences, where she has been working on heritage and memory issues and has coordinated the 'Sharing European Memories at School' project. She is an external expert for the 'Lifelong Learning' programme of the European Commission.

Bryony Onciul is a lecturer in history at the University of Exeter, where she leads the 'Public History' programme. Her research interests include community engagement, indigenising and decolonising museology, (post)colonial narratives, and the power and politics of representation. She formerly taught at the International Centre for Cultural and Heritage Studies, Newcastle University.

Alix H.J. Powers-Jones is, by profession, an observer of the material record and, by passion, a dipper into narrative. After years as an environmental archaeologist, she merged these twin foci by becoming director of the Highlanders' Museum, Fort George before a move to National Trust Scotland, Hugh Miller's Birthplace Cottage and Museum, Cromarty.

Bjørn Tore Rosendahl graduated in 1998 with an MPhil in history from the University of Oslo. He has been working at Stiftelsen Arkivet in Kristiansand, Norway since 2005, first as education manager and from 2012 as a historian. He has previously taught history and trained history teachers at the University of Agder.

Ingvild Ruhaven graduated in 2002 with an MPhil in history on 'The Great History Debate' in England between 1988 and 1991. She has been working as education manager at Stiftelsen Arkivet in Kristiansand, Norway, since 2011. She has previously been a teacher and a lecturer and teacher trainer at the University of Agder.

Amy Ryall is the external engagement projects officer for the Faculty of Arts and Humanities at the University of Sheffield: a role that supports academic staff to use their research in innovative ways to partner external organisations and reach wide audiences. She has a background in history teaching and in museum and heritage learning, most recently with Imperial War Museums. Amy's interest in issues surrounding veterans and eyewitnesses developed with her involvement in the Imperial War Museums' 'Their Past Your Future' project, which ran from 2004 to 2010 and aimed to support young people to learn about war and conflict using the experiences of those who were involved.

Amanda Shamoon began her career as a primary school teacher, before switching to the museum sector and the role of schools officer at Museum of London Docklands. She moved to Historic Royal Palaces (Tower of London) in 2009 to take up the role of education officer, devising and delivering education sessions to groups from KS2 through to A Level, before transitioning to the role of Learning Producer in 2013.

Miranda Stearn is a doctoral student at the Courtauld Institute of Art. Her research focuses on museum-commissioned artist interventions, looking at how and why museums bring in artists as interpreters of their collections. She is currently arts and heritage development coordinator for London Borough of Richmond upon Thames and has worked in public sector arts and heritage since 2005.

Juliet Steyn has published widely on art and cultural criticism focusing on art, the politics of memory and identity, the language of display in museums and galleries, notably in the anthology *Other than Identity: The Subject, Politics and Art* (1997) and her book *The Jew: Assumptions of Identity* (1999). A collection, *Breaching Borders: Art, Migrants and Waste* (with N. Stamselberg), will be published in 2014.

Claire Sutherland is a lecturer in politics at Durham University. Recent publications include *Nationalism in the Twenty-first Century* (2012) and *Soldered States: Nation-Building in Germany and Vietnam* (2010).

Judith Vandervelde, senior educator at the Jewish Museum, specialises in Holocaust education and Judaism. After graduating with a degree in ancient and modern history from Worcester College, Oxford and a PGCE (history) from the Open University, she worked as a secondary school teacher. She acts as a specialist adviser to educational organisations and schools.

Victoria Ward founded Sparknow in 1997, 'a collaborative enterprise designing spaces for knowledge', after a career in the City which started the day Sadat was shot in Egypt, 6 October 1981. Sparknow works with clients through a fusion of narrative, analysis and orchestrating different kinds of spaces and sequences, to emerge the potential for different futures from the hidden resources of the present. <www.sparknow.net>.

Introduction
Challenging History in the Museum

Jenny Kidd

Museums have always challenged visitors, tasking them with acknowledging and understanding artefacts, ideas and values that were previously unknown to them, perhaps in ways that are unfamiliar or unexpected. There is nothing contentious about that. But they have challenged them in other ways also; requiring them to perform identities they may be uncomfortable with (even that of 'the visitor'), to locate themselves and their communities within (or perhaps in opposition to) politically charged and ideologically loaded displays and to accept the authoritative and legitimised version of the events of their lives, and often the lives of their ancestors, as played out in the public spaces of these institutions. Evidently the latter kinds of challenge are more complex: difficult to anticipate and to set the parameters for, unwieldy, and ethically loaded. We are only beginning to understand their ramifications in relation to the global museums sector.

This book arises from such challenges. It seeks to explore the justifiable and tangible anguish from both museums and their users[1] about how best to navigate this difficult and contested terrain: one that is, for both parties, political, territorial and intensely personal.

Certain heritages or histories can of course be perceived as challenging by virtue of their subject matter alone, the agendas they reveal, the political debates they feed into and stem from, the emotions that they engage and the lack of any sense of 'resolution' to be found in their exploration or perhaps exploitation. Such heritages often make exclusion, domination, conflict, territorial struggle, genocide, imprisonment and survival visible, and as such they ask uncomfortable questions about our humanity and inhumanity, legacy, apology, ownership, voice, repatriation, classification, memorialisation, memory and forgetting. These are indeed histories that challenge, and we might note that they are ubiquitous.

We might also note that foregrounded in heritage 'work' of this nature is a tendency to do things differently, to challenge the conventional narrative of 'history' itself. Approaches to difficult histories often involve interpretation from different perspectives, revealing hidden, sidelined and forgotten artefacts of culture (and

1 I use the word 'users' with intent here to encourage us to think about how we understand the various constituencies of the museum – on-site, online, visitor, audience, user, participant, collaborator. The discourse and the ground we work on are shifting beneath our feet.

even of our social life and behaviours), and expose the process of history 'making' as inherently biased and at its worst, bigoted. In this context, histories are asked to intersect with human rights, social justice and conflict resolution agendas and asked to 'do' something quite contrary and in a way that is exoteric.[2] Here, it is the history itself that is being challenged: a fact that has been explored and articulated in literature from across the academy.[3]

But lest we forget, the visitor also challenges the museum, and, increasingly so, has an eloquent, considered, powerful and (crucially) visible voice with which to call it to account. We see that increasingly visitors might challenge the very institutions that 'give' them history. This is good news for those of us who are interested in democratising cultural institutions and creating and empowering citizens, but continues to be a profound and provocative realisation for many museum professionals and heritage scholars. However, let us not get carried away here. We remain a long way from any inclusivist and open ideal and from any common understanding of why and on what grounds such a thing should be desirable.[4]

There are then at least three ways in which we might understand 'challenging history', and it will be seen that these insights, in various permutations and combinations, inform the discussions in this book.

We use this term 'challenging history' then to honour a number of differing agendas. It is a term that the collaborating editors of this book have been using since 2009, yet it continues to be precarious. It is a useful shorthand term, but perhaps misleads colleagues into thinking that we see ourselves as competent, or even able, to capture (or perhaps contain?) the challenge of history within a succinct and tidy definition. We have always maintained that that is impracticable and undesirable, potentially divesting individuals and institutions of engagement in a serious and ongoing conversation about what might be serious and ongoing concerns within their own contexts.

As such, there exists no accepted, or even common, terminology in use here. A literature search reveals different ways of categorising such work: the themes are 'challenging', 'difficult', 'emotive', 'sensitive', 'contested', 'disturbing' and even 'unsavoury'; they are 'histories', 'issues', 'heritages' and 'legacies'. Fiona

2 Such as through the International Coalition of Sites of Conscience initiative or as part of the Federation of International Human Rights Museums (see Orange and Carter 2012).

3 In education (Cole and Barsalou 2006; Historical Association 2007; Weinland and Bennett 1984), history (Morris-Suzuki 2005; Walkowitz and Knauer 2009; Winter 2006), memory studies (Bal, Crewe and Spitzer 1999; Crane 2000; Hodgkin and Radstone 2003; Huyssen 2003), museums, heritage and tourism studies (Black 2012; Kidd, 2011c; MacDonald 2009; Ross 2004; Sandell 2007; Silverman 2010; Simpson 2006; Smith 2006; Thaler 2008; Tyson 2008; Uzzell 1989; Witcomb 2003), identity studies (Lidchi 1997; Weedon 2004) and performance studies (Jackson and Kidd 2011).

4 See Lynch, Chapter 6, and Gunn and Ward, Chapter 9, this volume.

Cameron and Lynda Kelly, in one of the most comprehensive appraisals of this field to date,[5] refer to these as 'hot topics', 'taboo subjects, revisionist histories and political issues' (Cameron and Kelly 2010: 1). This is a helpful and succinct definition but perhaps belies an assumption that such topics might eventually cool, abate or become subject to control. Kelly and Cameron's text deals in large part with science museums, with Emlyn Koster saying in one of the contributions looking at such institutions:

> Public opinion around a hot topic can be visualised as a bell curve, or possibly a bimodal curve, that morphs over the time span of controversy, from left skewed to right skewed, ultimately to flatten out as acceptance grows, and often ultimately to disappear. (Koster 2010: 86)

This might be the case with issues like smoking in public or the wearing of seat belts (two examples used by Koster), but I have noted elsewhere that this is clearly less the case with religion, contested place or coming to terms with genocide: some of the knottier heritages being dealt with in social history museums, war museums, at memorials or in sites of continuing conflict (Kidd 2013). And so the editors have committed here to the concept of 'challenging history', seeing it as a perpetual, rebellious and provocative call to arms, full of the potential to disrupt and to transform.

Some Context

> History museums have a responsibility to bear witness to the past, however difficult that past may be. (Kavanagh 2002: 116)

Since the advent of the new museology movement in the 1970s, heritage itself has become a contested site, seen as subjective and subjectifying, incoherent, multiple and (of course) 'difficult'. Histories have, according to Walkowitz and Knauer, been 'destabilized' if not 'discredited' (2009: 4). Museums have become live sites of struggle, through and in which groups and individuals have questioned authority, authenticity, ownership, voice, absence and silence. This is a far cry from the modern public museum which, since the seventeenth century, had 'disseminated knowledge through purposeful collecting and display strategies' with 'the concept of "right" at their core' (Orange and Carter 2012).[6]

In response, museum 'making' has become a creative meeting point for both those collective memories that are traditionally celebrated in cultural institutions

5 In *Hot Topics, Public Culture, Museums* Lynda Kelly and Fiona Cameron bring together a range of case studies and authors, some of which represent different geographical and institutional constituencies from those represented here.

6 See also Drago, Introduction to Part 1, this volume.

such as museums or heritage sites but also the personal memories of those who increasingly opt to volunteer them. The museum is then (and indeed always was) a site of identity construction as opposed to merely a site for exploration of identities 'past'. As Coser demonstrates, 'it is, of course individuals who remember, not groups or institutions, but these individuals, being located in a specific group context, draw on that context to remember or recreate the past' (1992: 22). Museum visitors thus not only construct their own identities but re-cast the past in light of those identities.

Heritage then is increasingly recognised as performative: 'Exhibitions are fundamentally theatrical, for they are how museums perform the knowledge they create' (Kirschenblatt-Gimblett 1998: 3). This of course is a reminder that we are in the business of playing roles: as professional history 'makers', as visitors and, in an increasing number of instances, as both (see also Smith 2006). These (principally unconscious) performances are repeated daily across the globe in contexts which define themselves through their relationship with heritage, but of course our understanding of the past (and what is challenging about it) is informed by the performance of heritage being played out across other media also. It is helpful to be reminded that we do not consume museum 'texts' (exhibitions, artefacts, projects, websites) in isolation. They are in dialogue with a range of other cultural representations that are themselves partial and political.

The relationship between the museum's role as an arbiter of collective memory and as an active constituent in the making and re-making of individual identities renders ambiguous any sense of an objective past, especially when it comes to heritages that challenge in the ways outlined above. There has consequently been an increasing recognition of history as itself a fiction,[7] not 'existing' in the world, but in fact created (and created unevenly). A case in point is the way material heritage is made: 'Simply put, museums turn things into objects' (Henning 2006: 7; but see also Kirschenblatt-Gimblett, 1998; Smith, 2006; Vergo 1989). It is recognised that the institution (literally, spatially, institutionally) also bears witness to a potentially infinite complex of visitor narratives and interpretations (to extend Gaynor Kavanagh's conceptualisation above).

For the museum professionals I have worked with in my research, the role of 'witness' involves daily embodiment and navigation of a complex internal paradox, a double witnessing necessitating navigation of individual identity on the one hand, and professional and institutional identity on the other (Kidd 2011a). Such identities of course, may not always be in alignment, especially when working with heritages that are perceived as sensitive. Museum professionals' internal struggles are difficult to articulate and seldom called forth for consideration and acknowledgement within museum contexts. It seems that despite recent

7 In fact history and memory are increasingly blurred.

recognition of museum visitors as multifarious, complex and unpredictable, we have neglected the fact that museum staff are all of those things also.[8]

Given such gravity and complexity, we might ask why it continues to be important to 'challenge' history in the ways outlined above. For Eva Hoffman, it remains an act of psycho-social responsibility:

> Surely if we are to understand the legacy of the Holocaust, and other disturbing pasts, we must stand in an investigative relationship to memory; we must acknowledge our distance – both generational and cultural – from the events which we're trying to comprehend. But it seems to me that if we are to deepen our comprehension, we need also to use that distance to try to see aspects of the past that may not have been perceptible at other moments and from other perspectives. (Hoffman 2000: 9)

In this view, moving towards understanding and comprehension of the past is a crucial ongoing (and endless) endeavour: one that is inseparable from the present within which we seek to comprehend. Indeed, every present demands such a re-appraisal of the past. It is an ethical responsibility, but also Hoffman asserts, an 'obligation' (2000: 8).

As complex and fragmented as heritage might be, it is, lest we forget, charged with doing very real work in the world through its institutional forms and educative functions: formal and informal, lifelong and curriculum-based. Through these learning opportunities also, the constructed nature of heritage is increasingly being recognised and even addressed.

For all of the above reasons, the challenge in 'challenging history' is made all the more evident. If heritage is a construction, who has constructed it? Whose voices are heard? And whose are consigned to silence? How are challenging histories 'made available' to visitors? And are they available to staff? Can it be too early to work with such a heritage? Or indeed, too late? And, perhaps crucially, are the controversies that might cause us to falter a matter of fact or mere perception?

Challenging History

In 2009, the 'Challenging History' network was set up to make a case and to provide a space for increased intellectual, ethical and professional consideration of the issues raised above.[9] Since that time, there have been numerous seminars,

8 Yet simultaneously, there is concern about the homogeneity of the museums workforce, in the UK at least. It is seen to be lacking in diversity: educationally, socially, culturally and with regards to ethnicity. This is evidenced in Davies and Shaw 2008; Cultural Leadership n.d.

9 Challenging History was designed to draw upon the experiences of the Imperial War Museums' 'Their Past Your Future' InSite programme and started as a partnership project

conferences, meetings, fieldtrips and discussions, which have informed the look and feel of this book.

Those discussions have been detailed elsewhere (Kidd 2009, 2011a, 2013), but it is perhaps fruitful to note a number of ongoing concerns that emerge from the group's work in consideration of challenging histories.

Challenging Institutional Contexts

The heritage professionals we have worked with (in the UK and beyond) often view 'museum culture' as permissive of only certain kinds of enquiry and as operating in a manner that can frustrate attempts to do things differently. Perceptions of such a culture can lead to institutional inertia and feelings of disempowerment, rendering museum staff reluctant to take risks or to challenge the norms of their institutions. So, within a museum, the sense of authority, mission and purpose which staff operate with can itself be limiting, and this perception can be amplified by pressures from stakeholders (including community groups).

One theme that arises continually in the network's discussions is that of sustainability. Just what might a sustainable approach to an institution's challenging histories look like? How might it be bargained for? And protected? This issue can be particularly frustrating, especially when the visibility and perceived relevance of a topic can fluctuate in line with the wider political and social agenda. All too often work with 'hot topics' is confined to particular interest groups or, at worst, notable diary entries.[10] We might note that this book is published in 2014, the centenary of the outbreak of World War One, and the subject of a vast number of global commemorative activities.

In consideration of such practical and contextual issues of museums' operation, Fiona Cameron has called for increased 'collective individualism' (Cameron and Kelly 2010: 65), as a rejoinder to historical processes of 'organised irresponsibility' (Beck 1999). That is, rather than disavowing responsibility at an organisational, political or business level, we might envisage a scenario where all of those who work in an institution are, with regard to their individual specialisms and roles, rendered responsible for the 'burden' of decision-making as pertaining to work with challenging histories. They become implicated in its relative success or failure and 'organised irresponsibility' is potentially undone. In that mix, risk, choice and ethical consideration might infuse and inform dialogues at all levels of the museum (Cameron and Kelly 2010).

between Historic Royal Palaces Tower of London, Imperial War Museums, MLA London and City University London funded through the MLA TPYF phase 2 grants programme, supported by Big Lottery. Latest partners, projects and outputs can be found at <www.challenginghistorynetwork.wordpress.com>.

10 A trend that has recently been investigated by members of the Challenging History network (and others) as part of the AHRC funded Significance of the Centenary research network led by Joanne Sayner at the University of Birmingham (2013).

But institutional challenge also manifests itself at the level of everyday practicalities and limitations. Not least in discussions about museum spaces. Programmes founded in difficult and sensitive heritages might have varying requirements from other curatorial or education initiatives, needing to make room for silence or equally for heated outpourings. There is a need to think creatively and sensitively about visitors' transitions between the relative safety of the real world and a programme about a challenging history (or perhaps the converse is true). How the various layers of a site allow for such affordances remains problematic.

Challenging Definitions of Learning

Heritage institutions contribute variously to a number of educative endeavours: to increase knowledge about the past; to aid in the understanding and construction of identity; to transform our relationships with our landscape, communities and 'nation'; and, with any luck, to make us 'good citizens', increasingly, enmeshed within talk of 'social justice'.[11]

But, in projects that seek to engage with difficult and sensitive heritages, questions arise about what a successful learning programme should achieve. What are the ethics of 'teaching'? For some, tangible learning outcomes are a must (that is, ones measured by the museum and not by the visitor). For others, it is enough for visitors to be given the opportunity to think and feel: just to 'be' within the space and place of the institution. Thinking about what can realistically be achieved in learning programmes emerges as crucial, as does articulating the particular understanding of learning that might be appropriate for a project: factual, emotional, social, political, ethical, material, embodied, experiential, perspectival or indeed any combination of these.

For some, nothing less than transformative experience is good enough, yet assuming that transformation is an achievable result of such programmes can be intensely problematic, not least because impact is notoriously difficult to articulate and measure. Challenging history, as we have seen, involves working with heritages that are complex and/or contested and where, in many cases, 'changing opinion' may not be possible or even desirable. For example, whilst slavery and the racism that underpinned it are taken in 2013 as being noxious and wholly unacceptable, other projects may have to work with heritages where there is no such conviction in terms of underpinning sensibility or consensus. The view rather relies on an overarching narrative that can be agreed upon and enacted through programmes, a view of rationality, objectivity and 'truth' that needs disrupting again and again through useful but disconcerting ontological reminders.

11 Which is not to say that museums uniformly accept and/or feel comfortable with these agendas.

Challenging Visitors

Fiona Cameron's research has shown that many museum visitors are open to reflection on challenging topics and feel it is a museum's duty to engage with them (2003, 2006). However, we have seen in our work with heritage professionals a perception of most visitors as fairly traditional in their outlook and unadventurous in their consumption of 'Other' heritages. As a consequence, work with difficult heritages is often confined to non-traditional audiences.

However, those audiences can often emerge as rather *too* challenging in their intensity and in their 'closeness' to the heritage. Debate about ownership and appropriation emerges as a central problematic: who has the 'right' to 'deal with' a subject matter, and who might museum staff need to go to in order to legitimise the work or 'ask permission' to do it?

In this sense, it seems true that, as Ruth Abram (one of the founders of the International Coalition of Sites of Conscience) has noted, 'there is, in the museum profession, a certain fear of the public' (2002: 133). That fear is rooted in questions about authority, legitimacy and perhaps even guilt, which are amplified through a perception of isolation from the 'core' practice and function of an institution.

The Museum as a Site of Complex Interactivity

My own research into museums' use of digital media is concerned with the ways in which digital technologies can frustrate, and sometimes even become, forms of museological power (see Kidd 2011b, 2013). I have noted elsewhere that the colonisation of the online environment by museums has been pacey and as a result, at times, ill-considered, and museums' uses of interactive technologies on site have also had their limitations.[12] The assumption inherent in the way that we continue to articulate the value of digital technologies for museums holds that they might be a means for eliciting community, democracy and engagement, even empowerment. There is a hope that they might, in their very apparentness, re-frame or re-present the museum as a forum, an open public meeting place where all voices are equal and all ideas also. Digital media (and social media especially) have re-invigorated debate about the 'contact zone' (Clifford 1997), being touted as the great panacea, a remedy for museological ills. Yet the end-goals of such practice remain unclear, as do the parameters within which their success or failure will be determined. Curiously, as Adair, Feline and Koloski noted, participatory work and public curation 'demand not less but more from history museums and their expert staffs' (2011: 12). There has been an increase in literature in recent years which seeks to explore the reality of the contribution such media can make,[13]

12 For a review of literature outlining current thinking about interactive technologies on site, see Kidd, Ntalla and Lyons 2011.

13 See e.g. Parry 2009; Adair, Feline and Koloski 2011; Simon 2010; Tallon and Walker 2008; Henning 2006.

and we might cite work on 'virtual repatriation' as being particularly interesting (Hennessy 2009; Simpson 2006), but the role of new media in debates about difficult and sensitive heritages in particular is relatively unexplored (although see Cameron and Kelly 2010 for a start).

The language of digital possibility is also beginning to bleed into other museum operations. It is now common to talk about co-production and co-curation, crowdsourcing and gamification with ease, and some abandon, in other realms of museums practice. But to what end? There is a commodification of community happening and an exaltation of participatory processes in and of themselves that we would do well do question.

We might ask: How does the online experience extend, complement or even replace the 'offline' museum? How might the use of social media inform current debate about ethics and responsibility in the re-presentation of heritage? How can participants' contributions be valued? What challenges must be overcome before those currently defined as 'user', 'visitor' or 'audience' can demonstrate more sophisticated forms of agency? And crucially, is the challenge such media present to the authority of the museum one that the project of history can bear?

Structure of this Book

This book is divided into four parts, each with an introduction written by one of the editorial team. Each editor provides an introduction to the chapters and to the themes contained therein, using their own experiences of the sector to navigate the issues. This has been a collaborative project from the start, and it was always our intention to present a range of voices, viewpoints, discourses and knowledges side-by-side. To this end, a number of case-study chapters have been included, which take as their specific focus the work of institutions that might otherwise have been neglected in the text. These short case-studies are written from the perspective of the professionals who work at the sharp end of project delivery and are invaluable for the honesty, experience and insight they display. Alongside these are more 'traditional' academic chapters, written by a range of scholar-practitioners and practitioner-scholars. We hope you will find the mix to be a valuable and unique insight and our cross-references a helpful means for navigating the themes that they explore.

Given the range of voices, there are however some discordances: with such a subject matter it is inevitable. We have respected these differences in the editorial process, opting where possible to let the nuances of each of those contexts filter through. Language is one 'challenge' that we have experienced in that process: how not to stifle the tone, passion and sense of purpose we find in individual voices? In different geographic contexts, there are words, phrases and ideas that are permissible that might not be in others. To 'censor' a voice or a viewpoint seems incongruous with the subject matter we are dealing with here, so that

squeamishness has been confronted in the numerous editorial meetings we have had.

The book draws on work in varied geographical contexts including Brazil, Cambodia, Canada, England, Germany, Japan, Northern Ireland, Norway, Scotland, South Africa, Spain and the United States of America. It is divided into four parts: 'The Emotional Museum'; 'Challenging Collaborations'; 'Ethics, Ownership and Identity'; and '"Teaching" Challenging History'. As is always the case with such collections, the split into sections is in some senses arbitrary. For example, many of the chapters in this book tell us something about how we might understand the emotional museum, just as most have something to say about ethical practice. But, in order to give the text a narrative, and to aid navigation by the reader, we have made the split none-the-less.

We have opted for the term 'museum' in the title where it serves as a catch-all for heritage institutions and sites that are defined through their role as makers, curators, narrators, educators and arbitrators of history, culture and memory. We are aware that this may seem problematic to some, but there are of course pragmatic reasons for that specificity. In the chapters that follow, we think it is clear what the parameters of individual studies are and, moreover, consider it useful to observe how themes pervade and are apparent throughout the range of sites, heritages and interest groups that constitute our global heritage sector.

Part 1 of this book, curated by Alex Drago, takes as its focus various elements of the heritage encounter that arouse emotion. The 'emotional museum', a term used by National Museums Liverpool Director David Fleming (Chapter 1, this volume) is a radical reconceptualisation of the museological mission. It seeks to foreground the emotional work done in heritage interpretation practices, taking ownership of it within institutions, rather than seeing it solely as an 'outcome' to be 'experienced' by the visitor.

In the Challenging History research more broadly, we have seen great anxiety about the use-value of emotion in learning programmes that work with sensitive histories. Many museum professionals find the balance between empathic engagement and the pursuit of a wider, objective, rational understanding of 'a past' a difficult one to strike. If empathy is feeling yourself 'into the consciousness of another person' (Wispé 1987), might assuming that perspective limit the wider understandings that can be achieved? In research carried out at Manchester University between 2005 and 2008 (funded by the AHRC), Anthony Jackson and I found that this can indeed be the case. Empathy was evidenced as a powerful emotional tool giving depth of insight – into the lives of individuals especially – that was difficult to achieve through other more formal, cognition-based modes of learning. But we noted that there were narrowing aspects also. Empathy can, in certain circumstances, offer a rather partial 'monocular' reading of events, narrowing our vision in a way that we called the 'empathy paradox' (Jackson and Kidd 2008). For others, it was an incredibly useful tool for creating 'empathic unsettlement' – to use La Capra's term (2001). The unsettling nature of the empathetic encounter can highlight vividly the very limits of our understanding

in ways that can be incredibly fruitful for long-term cognition (see also Williams 2010). Questions about what can and cannot be known, learnt, felt and made sense of, often hang in the air at the end of a heritage encounter that asks us to 'feel'. Paradoxically then, such an approach can actually prevent over-identification and help us to acknowledge that our understanding of the Other can never be complete. Juliet Steyn says that 'understanding and comprehension come slowly. Their efforts cannot be short-circuited' (Chapter 10, this volume) and this realisation is pertinent to any discussion about what we are trying to achieve when inciting emotion. Perhaps 'empty empathy' (Kaplin 2011) is as likely an outcome as any if we are over-exposed to representations of trauma. Such encounters might, unless very carefully conceived and executed, cause only fleeting and transitory feelings of empathy which are replaced by feelings of hopelessness or bland sentimentality in the longer term.

We can only conclude that our understanding of how emotion and empathy work to produce meaning, in the museums context at least, is currently limited and in real need of thorough longitudinal empirical study. Such research might ask questions about whether the ultimate goal of empathic engagement should be knowledge or action; whether such approaches are manipulative, or worse, akin to appropriation; whether we can (and should) empathise with those who perform atrocious acts; how we account for empathy as a learning outcome (and an e-learning outcome also); and whether empathic accuracy matters – what if it turns out our feelings are incongruent with those felt by the other individual? Or if we find our empathy 'fails'? Exploring such questions may yet give heritage educationalists a lexicon to talk confidently about the one thing they feel they do best but has been the hardest to articulate.

In Part 2, Amy Ryall and four authors pick up on the challenge outlined above about the nature of collaborative and participatory endeavour. Collaboration in itself can of course be a challenging approach, as many of our research participants attest to, and recent research (not least Lynch 2011; Chapter 6, this volume) has revealed its potentials to disempower, contain and trivialise. The role and function of the institution and the individual in those processes are in desperate need of close examination.

This section aims to explore a number of dichotomies that underpin much work in this area: professional knowledge versus local knowledge, morally 'good' grassroots participation versus morally 'bad' top-down programming, the powerful versus the powerless, 'the institution' versus 'the community', and activity versus passivity. Assumptions about what constitutes 'legitimate', 'genuine' or 'authentic' participation are questioned. In current participatory practice it seems, the perceived end (empowerment, openness, democracy) always justifies the means, and this is something we need to think more, and more ethically, about.

Part 3 takes a focused look at issues around ethics, ownership and identity, and how they manifest as discourses about power. As Miranda Stearn attests in her introduction, at stake in all of this is people's desire for representation and fundamental questions about who has the right to re-present. If representational

texts (including exhibitions, artworks, artefacts and the larger museum 'text' that is constructed) are one of the 'central practices that produce culture' (Hall 1997: 1), then the museum is implicated at every level of meaning-making. Museum representations, rather than simply presenting or mirroring reality, actually help to re-present it, or even create it anew. How the various 'languages' of our museums produce 'meaning', and what the transcultural implications of those representations might be – how they become 'commonsense' – is often overlooked. This is not just a cultural issue but a political one, having implications for how we participate at a civic and community level, as well as how we perform our identities at an individual level.

In light of the discussions in Part 2, we might note that participatory projects increasingly seek to hand the 'burden' of representation to (some members of) communities themselves, in the hope that this might result in increased 'representational adequacy' (Bennet 1995), but such practices still operate from the normative position of the museum as host and, if need be, arbitrator of the process. They rely also, in many different contexts, on the model of the Western museum, one which carries associations which are inherently problematic for many potential stakeholder groups and visitors (see Marstine 2006, 2011; Walkowitz and Knauer 2009). Indeed, it is worth reminding ourselves that communities, groups, visitors, societies, publics and constituencies, are heterogeneous and incongruent. As such, rather than thinking about a museum's public 'it is perhaps more accurate and helpful to conceive of multiple publics with divergent and often competing interests and different stakes in how histories are represented' (Walkowitz and Knauer 2009: 3). An understanding of that can help us to critique the modernist, traditionalist museum as a project of 'nation', as celebratory in tone and unifying in purpose.

It also behoves us to note the relationship between museums and the tourist gaze, sometimes a completely different 'constituency': 'dark' tourists or 'grief' tourists. Here, we might find sites where the 'presentation of death or suffering [is] the raison d'etre' (Stone 2005: 2). This phenomenon, although not new, has seen 'death in touristic form [as] an increasing feature of the contemporary landscape' (Stone 2005: 3). We might like to think about how we position our programmes alongside, or as contrary to, such offerings, considering the ways in which we articulate difference, asking perhaps uncomfortable questions about whether our work with a challenging history is merely a 'branding exercise' (Cameron and Kelly 2010) or something else entirely.

In Part 4, Samantha Cairns introduces four chapters which help us to explore the ethics of teaching as they relate to challenging histories. Here, our use of the word 'teaching' is intentionally provocative, asking education staff and other readers to evaluate their stance on the extent to which it is possible to frame and anticipate learning in any traditional sense in work with difficult topics. How far, we ask, must educators let go of their understandings of what a 'good' or 'moral' education might look like? Museums can only partly direct the experiential elements of a museum encounter. They can design the exhibits, dictate the formal structure, but

they cannot control how the museum will be inhabited and 'felt', and, as such, what and how much learning might take place in programmes.

Being from a media and cultural studies background, I am endlessly fascinated by the ways in which meaning is encoded and decoded in the various cultural texts we consume, including the museum.[14] The process of encoding, the construction of meaning, the formation and manifestation of the museum message, is, of course, potentially frustrated in the moment of reception, as it is decoded by the visitor. That visitor can accept the intended meanings of the museum texts they 'consume', the 'preferred' readings (Hall 1973). Equally, they can negotiate a reading that accepts some but not all of the message as intended by the curator. Alternatively of course, they might (intentionally or otherwise) read it in a completely oppositional fashion.

The encoding–decoding model has informed the work of eminent scholars of culture and museums, such as Sharon MacDonald (1998) and Richard Sandell in his discussion of museum communication (2007), and is worth noting because it raises as yet underexplored questions about how museum visitors decipher, intellectualise and perhaps reject the messages that are offered up for their consumption within museum spaces (online or offline). An exploration of such thematics as they relate to visitors' actual encounters with challenging history is long overdue, and we only begin to scratch the surface here. This is perhaps one of the principal reasons why work with challenging histories is so daunting to museum educators: what people take away from those experiences may be only in part speakable; in many instances it is perhaps profoundly unspeakable. Evaluation of learning programmes that seek to engage in the ways identified in Part 1 of the book is intensely problematic for ethical and operational reasons and due to ongoing uncertainty about how and whether 'learning' accounts for such encounters and the memories they forge.

These four sections, 18 chapters, nearly 100,000 words make a unique and timely contribution to our understandings of challenge, difficulty, sensitivity and contestation in museums work.

This is a book about the ways in which common ground can be found even in the most unlikely of places. It is a book about what is at stake when such commonality cannot be found.[15] It is a testament to risks taken and the difficult journeys that heritage institutions have knowingly embarked on in order to explore meaning with the communities of interest that they serve. It is also a call for a renewed research agenda and dialogue about what it means to seek social justice and transformative experience as outcomes of heritage work, about how likely

14 Stuart Hall's groundbreaking work on encoding/decoding was first published in 1973.

15 Museums have not always got the balance right here. We know that to be true from a range of high profile incidents such as, most famously perhaps, the Enola Gay exhibition at the Smithsonian Institution, Washington DC in 1995, which caused great controversy. For a creative exploration, see Gallagher n.d.

sustainability in our approach to our difficult past might be, about who 'owns' the outcomes of participatory endeavour and what their use-value is as they are institutionalised, and about how we understand and articulate success – and indeed failure – in heritage interpretation programmes and curation that seeks to engage visitors with our most difficult, but arguably most important, heritages. This book is an attempt to further that dialogue and to begin to close the gulf in understanding and expectation between the differing communities who give of themselves in ways personal and professional in the pursuit of comprehension.

References

Abram, R. 2002. 'Harnessing the Power of History', in R. Sandell (ed.), *Museums, Society, Inequality.* London: Routledge.

Adair, B., B. Feline and L. Koloski 2011. *Letting Go? Sharing Historical Authority in a User-Generated World.* Philadelphia: Pew Centre for Arts and Heritage.

Bal, M., J. Crewe and L. Spitzer 1999. *Acts of Memory: Cultural Recall in the Present.* Hanover: University Press of New England.

Beck, U. 1999. *World Risk Society.* Cambridge: Polity Press.

Bennett, T. 1995. *The Birth of the Museum: History, Theory, Politics.* London: Routledge.

Black, G. 2012. *Transforming Museums in the Twenty-First Century.* Abingdon: Routledge.

Cameron, F. 2003. 'Transcending Fear: Engaging Emotions and Opinions: A Case for Museums in the 21st Century', *Open Museum Journal* 6. Available at <http://hosting.collectionsaustralia.net/omj/vol6/pdfs/cameron.pdf> (accessed 15 Jan. 2011).

—— 2006. 'Beyond Surface Representations: Museums, Edgy Topics, Civic Responsibilities and Modes of Engagement', *Open Museum Journal* 8. Available at <http://hosting.collectionsaustralia.net/omj/vol8/pdfs/cameron-paper.pdf> (accessed 15 Jan. 2011).

—— and L. Kelly 2010. *Hot Topics, Public Culture, Museums.* Newcastle: Cambridge Scholars.

Clifford, J. 1997. *Routes: Travel and Translation in the Late Twentieth Century.* Cambridge, MA: Harvard University Press.

Cole, E., and J. Barsalou 2006. *Unite or Divide? The Challenges of Teaching History in Societies Emerging from Violent Conflict.* United States Institute of Peace. Available at <http://www.usip.org/files/resources/sr163.pdf> (accessed 13 Feb. 2013).

Coser, L.A. 1992. 'Introduction', in M. Halbwachs, *On Collective Memory*, trans. L.A. Coser. Chicago and London: University of Chicago Press.

Crane, S. 2000. *Museums and Memory.* Stanford: Stanford University Press.

Cultural Leadership n.d. 'Black, Asian and Minority Ethnic Leadership in the Creative and Cultural Sector'. Available at <http://www.culturalleadership.

org.uk/uploads/tx_rtgfiles/Black__Asian_and_Minority_Ethnic_Leadership. pdf> (accessed 26 Feb. 2013).

Davies, M., and L. Shaw 2008. 'The Ethnic Diversity of the Museum Workforce'. Museums Association, UK. Available at <http://www.museumsassociation.org/ news/16092010-minority-ethnic-staff-still-under-represented-in-museums> (accessed 26 Feb 2013).

Gallagher, E.J. n.d. 'The Enola Gay Controversy', *History on Trial*. Available at <http://digital.lib.lehigh.edu/trial/enola/about/> (accessed 26 Feb. 2013).

Hall, S. 1973. *Encoding and Decoding in the Television Discourse*. Birmingham: Centre for Contemporary Cultural Studies.

—— (ed.) 1997. *Representation: Cultural Representations and Signifying Practices*. London: Sage.

Hennessy, K. 2009. 'Virtual Repatriation and Digital Cultural Heritage: The Ethics of Managing Online Collections', *Anthropology News* 50(4): 5–6.

Henning, M. 2006. *Museums, Media and Cultural Theory*. New York: Oxford University Press.

Historical Association 2007. *T.E.A.C.H.: Teaching Emotive and Controversial History*. Available at <http://www.history.org.uk/resources/resource_780. html> (accessed 1 June 2009).

Hodgkin, K., and H. Radstone 2003. *Contested Pasts: The Politics of Memory*. London: Routledge.

Hoffman, E. 2000. *Complex Histories, Contested Memories: Some Reflections on Remembering Difficult Pasts*, Occasional Papers of the Doreen B. Townsend Center for the Humanities 23. Berkeley: University of California Press.

Huyssen, A. 2003. *Present Pasts: Urban Palimpsests and the Politics of Memory*. Stanford: Stanford University Press.

Jackson, A., and J. Kidd 2008. *Performance, Learning and Heritage*. Centre for Applied Theatre Research, University of Manchester. Available at <http:// www.plh.manchester.ac.uk/documents/Performance,%20Learning%20&%20 Heritage%20-%20Report.pdf> (accessed 1 Dec. 2013).

—— and —— (eds) 2011. *Performing Heritage Research, Practice and Innovation in Museum Theatre and Live Interpretation*. Manchester: Manchester University Press.

Kaplan, E.A. 2011. 'Empathy and Trauma Culture: Imaging Catastrophe', in A. Coplin and P. Goldie (eds), *Empathy: Philosophical and Psychological Perspectives*. Oxford: Oxford University Press.

Kavanagh, G. 2002. 'Remembering Ourselves in the Work of Museums: Trauma and the Place of the Personal in the Public', in R. Sandell (ed.), *Museums, Society, Inequality*. London: Routledge.

Kidd, J. 2009. *Challenging History: Summative Document*. Available at <http:// www.city.ac.uk/__data/assets/pdf_file/0004/84082/Challenging-History-Summative-Document.pdf > (accessed 15 Feb. 2013).

—— 2011a. 'Challenging History: Reviewing Debate within the Heritage Sector on the "Challenge" of History', *Museum and Society* 9(3): 245–8.

—— 2011b. 'Enacting Engagement Online: Framing Social Media Use for the Museum', *Information, Technology and People* 24(1): 64–77.

—— 2011c. 'Performing the Knowing Archive: Heritage Performance and Authenticity', *International Journal of Heritage Studies* 17(1): 22–35.

—— 2013. 'Review of *Hot Topics, Public Culture, Museums*, Fiona Cameron and Lynda Kelly (eds)', *Curator: The Museum Journal* 56(2): 289–93.

—— I. Ntalla and W. Lyons 2011. 'Multi-Touch Interfaces in Museum Spaces: Reporting Preliminary Findings on the Nature of Interaction', in L. Ciolfi, K. Scott and S. Barbieri (eds), *Proceedings of the International Conference 'Re-thinking Technology in Museums 2011: Emerging Experiences'*. Limerick: University of Limerick.

Kirshenblatt-Gimblett, B. 1998. *Destination Culture: Tourism, Museums and Heritage*. Berkeley: University of California Press.

Koster, E. 2010. 'Evolution of Purpose in Science Museums and Science Centres', in F. Cameron and L. Kelly (eds), *Hot Topics, Public Culture, Museums*. Newcastle: Cambridge Scholars.

La Capra, D. 2001. *Writing History, Writing Trauma*. Baltimore: Johns Hopkins University Press.

Lidchi, H. 1997. 'The Poetics and Politics of Exhibiting Other Cultures', in Stuart Hall (ed.), *Representation: Cultural Representations and Signifying Practices*. London: Sage.

Lynch, B. 2011. *Whose Cake is it Anyway?* 'Report for the Paul Hamlyn Foundation. Available at <http://www.phf.org.uk/page.asp?id=1417> (accessed 6 June 2011).

MacDonald, S. (ed.) 1998. *The Politics of Display*. London: Routledge.

—— 2009. *Difficult Heritage: Negotiating the Nazi Past in Nuremberg and Beyond*. London: Routledge.

Marstine, J. (ed.) 2006. *New Museum Theory and Practice: An Introduction*. Oxford: Blackwell.

—— (ed) 2011. *The Routledge Companion to Museum Ethics*. London and New York: Routledge.

Morris-Suzuki, T. 2005. *The Past Within Us: Media, Memory, History*. London and New York: Verso.

Orange, J., and J. Carter 2012. '"It's Time to Pause and Reflect": Museums and Human Rights', *Curator: The Museums Journal* 55(3): 259–66.

Parry, R. 2009. *Museums in a Digital Age*. Abingdon: Routledge.

Ross, M. 2004. 'Interpreting the New Museology', *Museum and Society* 2(2): 84–103.

Sandell, R. 2007. *Museums, Prejudice and the Reframing of Difference*. London and New York: Routledge.

Silverman, L. 2010. *The Social Work of Museums*. Abingdon: Routledge.

Simon, N. 2010. *The Participatory Museum*. Santa Cruz, CA: Museum 2.0.

Simpson, M. 2006. 'Revealing and Concealing: Museums, Objects, and the Transmission of Knowledge in Aboriginal Australia', in J. Marstine (ed.), *New Museums Theory and Practice: An Introduction*. Oxford: Blackwell.

Smith, L. 2006. *The Uses of Heritage*. London: Routledge.

Stone, P. 2005. 'Dark Tourism: An Old Concept in a New World'. Available at <http://works.bepress.com/philip_stone/26> (accessed 26 Feb. 2013).

Tallon, L., and K. Walker (eds) 2008. *Digital Technologies and the Museum Experience: Handheld Guides and Other Media*. Lanham, NY, Toronto and Plymouth: Altamira Press.

Thaler, H.L. 2008. 'Holocaust Lists and the Memorial Museum', *Museum and Society* 6(3): 196–215.

Tyson, A.M. 2008. 'Crafting Emotional Comfort: Interpreting the Painful Past at Living History Museums in the New Economy', *Museum and Society* 6(3): 246–62.

Uzzell, D.L. 1989. 'The Hot Interpretation of War and Conflict', in D.L. Uzzell (ed.), *Heritage Interpretation*, vol. 1. London: Belhaven.

Vergo, P. (ed.) 1989. *The New Museology*. London: Reaktion Books.

Walkowitz, D.J., and L.M. Knauer (eds) 2009. *Contested Histories in Public Space*. Durham, NC, and London: Duke University Press.

Weedon, C. 2004. *Identity and Culture: Narratives of Difference and Belonging*. Maidenhead, Berks.: Open University Press.

Weinland, T.P., and R.L. Bennett 1984. 'Museum Education: Monologue or Dialogue?', in S.K. Nichols (ed.), *Museum Education Anthology*. Washington: Museum Education Roundtable.

Williams, P. 2010. 'Hailing the Cosmopolitan Conscience', in F. Cameron and L. Kelly (eds), *Hot Topics, Public Culture, Museums*. Newcastle: Cambridge Scholars.

Winter, J. 2006. *Remembering War*. New Haven: Yale University Press.

Wispé, L. 1987. 'History of the Concept of Empathy', in N. Eisenberg and J. Strayer (eds), *Empathy and its Development*. Cambridge: Cambridge University Press.

Witcomb, A. 2003. *Re-imagining the Museum: Beyond the Mausoleum*. London and New York: Routledge.

PART 1
The Emotional Museum

Alex Drago

Historically, museums developed as Enlightenment (or post-Enlightenment) institutions grounded in reason and intellect and, within this framework, came to house the greatest and most significant cultural artefacts in line with those values. The museum's role quickly developed into one of preservation, of collections and ideas, and communication, of a narrative – an interpretation – of our past achievements and failures (Bennett 1995). Historical, economical, political and cultural factors have shaped these complex and diverse narratives, and it is this combination of variables that has made museums and their collections such nuanced and absorbing subjects to deconstruct.

If museums were ever radical it was in the period of their birth as institutions that distanced themselves from accepted interpretations of history based on both tradition and dominant religious viewpoints. Over time, and as there was a general societal shift toward secularism, museums lost this radical edge, as their emphasis shifted toward exploring and maintaining their cultural value and communicating this to their visitors.

In this mode museums have a tendency to look backwards, towards the past. Their collections are steeped in ideology and entrenched in meta-narratives that are so embedded that most museums have become conservative, traditional and slow to embrace change. That said, this approach has generally worked in the favour of museums. Not only does it reinforce the value of the collection, both culturally and economically, which in turn justifies the museum's privileged existence, but it also reinforces the expertise of the curator and endows them with their own 'aura' to complement that of the museum object (Benjamin 1936).

One significant development in museological history has been in the strategic repositioning of museums as learning institutions (Hooper-Greenhill 2007). In an era in which formal learning was largely characterised by the one-way delivery of information from teacher to student it is no surprise that the prevailing museum-as-learning-institution model that developed (and has endured) has been similarly so: the museum-as-expert imparts specialist technical information to the visitor who passively receives.

With this in mind, then, the traditional museum exhibition tended to be about specific subjects. A visit may be interesting, even inspiring, sometimes exhausting, but with any luck visitors will leave a museum having learned more about a

subject. It has been a rare thing indeed to visit a museum to learn how to do or become. A museum may be a learning institution, but it is certainly no school, college or university.

Part 1 of this volume seeks to explore what happens when museums are asked to do more. To make visitors feel, inhabit and engage in ways that are emotional and often embodied. It picks up on those questions identified in Kidd's Introduction about how, why and on what basis empathetic engagement with heritage is seen as desirable.

Given their long history of prizing reason, intellect and objectivity, the idea of provoking emotional engagement may be something of an uncomfortable one for many museums, introducing a lexicon that makes us squeamish. Emotion, empathy, experience: are these outcomes not too difficult to articulate, to 'measure'? Perhaps, and we should acknowledge these challenges, but it is also important to recognise that museums can offer much more to their audiences than the traditional passive learning experience described above. Museum learning should be a more active process, an engagement with experience that results in a changed perception or behaviour for the learner. Accepting this definition casts new light on the museum's current and potential future role as a learning institution and empowers museums to engage responsibly with the lexicon noted above.

It is not our intention to suggest that we dispense with traditional core institutional values wholesale and replace them with intellectual subjectivity and emotional exploitation. Rather, the chapters in this section on the emotional museum respond to a recognised need within the sector to offer alternative means of engagement. Indeed, they recognise that, to varying degrees, emotional 'work' is what museums have been doing all along, not least in programmes that seek to deal with challenging histories. Such engagements offer one means by which challenging museum objects or narratives might be better interpreted, taking visitors from a 'So what?' response to a position where they can better connect with their significance.

The contributions that follow are not dismissive of the values that have made museums such important institutions. Instead, being deeply respectful of them, they fully acknowledge the curatorial expertise that gives them their authority, as well as the need to find ways of engaging with emotions appropriately and ethically.

On an institutional level, David Fleming's work on the concept of the emotional museum has revolutionised National Museums Liverpool. While it has its critics, this approach has been hugely successful, and Chapter 1 highlights the potential for transformative institutional impact when a museum better understands its audience, their needs and expectations as related to their locality and its specificities and infuses the galleries with this knowledge.

Onciul's case-study of the representation of indigenous history in Canadian museums in Chapter 2 and Rosendahl and Ruhaven's comments on the challenges associated with delivering an appropriate visitor experience at Stiftelsen Arkivet, a former Gestapo regional headquarters in Norway, in Chapter 5 raise interesting

questions and sensitivities about the interpretation process in dealing with difficult and challenging histories, the importance of relationships with their communities in delivering this, and the role that museums can play in community cohesion, whether local or global.

Storytelling is a universal human language, and its role in exploring difficult and sensitive histories is assessed in the work of both Bryan (Chapter 4) and Powers-Jones (Chapter 3). Bryan's work on theatrical performances inside the museum highlights the medium's power to re-animate collections and spaces and therefore history itself, asking questions about authenticity and its consequences. Through the writings of Hugh Miller, Powers-Jones explores the use of the personal narrative as a means of engaging visitors on an emotional level with those who witnessed historic events.

While these chapters represent individual responses to specific challenges or areas of interest, there is sufficient complementary evidence to suggest that museums are becoming more astute, intuitive and capable of successfully using emotion as a means of engaging visitors within their spaces. But it is not solely within the physical spaces of the museum that emotional responses are being courted.

Explosive growth in the use of social media and the recent proliferation in mobile 'smart' technologies, while undoubtedly falling short of transforming democracy itself, is at least revolutionising communication, making information infinitely more accessible and redefining personal relationships on many levels. While the initial fear was that museums would lose control of their authoritative voice, there has instead been a collapse in the distance between expert and audience and the emergence of a global community who want to interact with museum experts in ways that reinforce, even as they re-negotiate, that authority in the museum.

Through such media, groups and individuals are finding new ways of defining themselves in relation to object heritage, of using collections to tell stories, to curate their own archives and construct their identities. In so doing, they are not only involved in a creative exploration of notions of authenticity as they relate to the museum, but they are also creating and participating in a variety of experience.

This brief foray into the online space is a useful reminder that museums do not exist in isolation. They are now part of a consumer industry and a leisure society in which emotion, not particular products or services, is currency. This trend, although not new, has now achieved hyper-real ubiquity. I see this daily in my work at the Tower of London, where both formal and informal learners arrive fully expectant of 'experience': emotional, immersive and engaging. Indeed, those learning programmes that deliver the deepest transformational outcomes do so precisely because the audience's learning journey is specifically designed to be an immersive, emotive and purposeful 'experience'.

At the time of writing, an economic depression has enveloped much of the globe. This has had a significant impact on museums through the withdrawal of public funding, and, while this is a significant economic challenge, it also

highlights a political challenge – how do museums position themselves to maintain innovation and relevance? The immediate response has been to institute cutbacks, often retrenching education and outreach programmes, and focusing on income generation. This generally means squeezing more out of the same audiences: cafes and shops become less an afterthought and more a destination, while a clear emphasis on delivering blockbuster exhibitions has emerged (for those that can). In this climate, audience-engagement work risks becoming again a marginal activity in the museum. In light of this assertion, it might be pertinent to be more wary of seeking emotional responses than ever. If we are not confident that we have the capacity for reflexivity, ethics, responsiveness and above all clarity in our agenda as we work with emotion and ask people to 'feel', then perhaps there are serious questions to be asked about the purpose of the museum.

References

Benjamin, W. 1936. *The Work of Art in the Age of Mechanical Reproduction*, trans. J.A. Underwood. London: Penguin [2008].

Bennett, T. 1995. *The Birth of the Museum: History, Theory, Politics*. London: Routledge.

Hooper-Greenhill, E. 2007. *Museums and Education: Purpose, Pedagogy, Performance*. Abingdon: Routledge.

Chapter 1

The Emotional Museum:
The Case of National Museums Liverpool

David Fleming

A few years ago I made my first visit to the United States Holocaust Memorial Museum in Washington DC. As I ascended in the elevator to reach the displays, I found myself in the company of a group of teenagers, of both sexes, laughing and making a lot of noise. I could do with getting away from this lot, I thought, as I am on something of a pilgrimage, and the last thing I need is a gang of giggling teenagers distracting me from the serious business of studying the Holocaust. As soon as the elevator door opened, I shot off ahead, leaving the teenagers behind. Half an hour later, I encountered them again. This time they weren't giggling. In fact, they seemed almost to be in a state of shock. Welcome to the emotional museum.

The United States Holocaust Memorial Museum is a social history museum, and it might be argued that all social history museums are challenging and emotional (or at least they ought to be), because they deal in human experience, in human behaviours. As a result, it might be said that visitors more readily feel an emotional attachment than they might in an art museum or a science museum or a natural history museum.

Julian Spalding wrote in *The Poetic Museum*, echoing museum traditionalists the world over, that collections are at the heart of museums (2002), but I believe that at the heart of social history museums are emotions – pride, anger, joy, shame, sorrow. Emotions which arise from an epic range of stories. Social history museums are about people not objects, and people are about emotions, not things. It is the contention of this chapter that emotions lie deeper within the museum psyche than collections.

Another example: Birkenhead-born William McMurray, aged 43, lived with his wife and three young children at 60 Empress Road, Kensington, Liverpool. On 13 April 1912, his 10-year-old daughter, May Louise, sat down to pen her first-ever letter, to her father, who, like many Liverpudlians, worked away at sea and was often absent for long periods. This time, William McMurray had been away in Belfast for several weeks before taking up his job as a first class bedroom steward on a magnificent new White Star liner.

May Louise wrote, in her best handwriting (Figure 1.1):

60 Empress Road
Kensington
Liverpool

13.4.12

Dear Father

It seems ages since I last seen you. I wish we where in Southampton with you it is very lonely without you Dear Father have not been so very well I have had a bad throat hoping I will soon get better for Mama worries so much little Ernie as not been

so well but he as got better now hoping you are keeping well dada st ta love from Ivy and and Ernie thank dada for the presents love from all dada hoping to see you soon with love from Ivy and Mam and Ernie Oxxxxxxxxx kisses for dada x

Dada this is my first letter

Figure 1.1 Letter sent by May Louise McMurray to her father William McMurray, 1912

[Dear Father

It seems ages since I last seen you. I wish we where in Southampton with you it is very lonely without you Dear Father I have not been very well I have had a bad throat hoping I will soon get better for Mama worries so much little Ernie as not been so well but he as got better now hoping you are keeping well dada so ta love from Ivy and and Ernie thank dada for the presents love from all dada hoping to see you soon with love from Ivy and May and Ernie xxxxxxxxxx kisses for dada x

Dada this is my first letter.]

McMurray never received the letter from May Louise, because it arrived in Southampton after his brand new ship had sailed, bound for New York. Two days later he was one of more than 1,500 passengers and crew who died in the *Titanic* disaster. On 17 April, the date of her wedding anniversary, William's wife received the shattering news of the loss of her husband. May Louise's letter to her father was returned to Liverpool and treasured for many years by her family. It was donated to Merseyside Maritime Museum in 1989 by her own daughter. The letter is now on show in the museum.

There is no doubt that May Louise's letter is an important piece of evidence. But it is its emotional impact that is its true value: the way in which it helps us get inside the minds of the people concerned. This is not just a letter, it is the only letter ever written to her father by a young girl, who only a few days later learned of his death. It speaks to us about family, love, childhood and loss. The letter breathes life – it breathes emotion – into what has become a historical narrative: the sinking of the *Titanic*.

Here, we touch upon a fundamental issue about museums, which is their very role in society – why we have them, why we fund them, indeed how we run them. We need to consider what we, the people who run museums, think we are here to do.

Museums have to connect with and have an impact upon the public. If they do not do that, there is not much point in having the museum in the first place. This may seem obvious, but if so, it does not explain why most UK museums still do not appeal to most people.[1] I want to consider the mission and values of my museum service, National Museums Liverpool (NML) in the UK.

Our mission statement reads: 'To change lives and enable millions of people, from all backgrounds, to engage with our world-class museums' (NML 2012). Our values include the following statements:

1 See e.g. Arts Council England 2011. The 2011 statistical release shows figures are up, to 47 per cent, but that these still constitute a relatively narrow socio-economic group.

- We believe that museums are fundamentally educational in purpose.
- We believe that museums are places for ideas and dialogue that use collections to inspire people.
- We are a democratic museum service and we believe in the concept of social justice: we are funded by the whole of the public and in return we strive to provide an excellent service to the whole of the public.
- We believe in the power of museums to help promote good and active citizenship, and to act as agents of social change. (NML 2012)

We acknowledge that museums can change people, and the underlying premise is that it is what museums do to people, their impact, that is important. Giving access to ideas and provoking an emotional response is, arguably, the most important function of museums – and this can be applied to all types of museum not just those concerned with social history.

Let us look at some other examples of emotion in the museum, continuing in Liverpool. In 2003, at Merseyside Maritime Museum, we created an exhibition on the Liverpool Blitz. The Maritime Museum was in those days rather a dispassionate place, with an emphasis on the technology of shipping and the maritime industries, which some liked, but which caused many never to go near the place. It had the distinction of losing visitors even after free admission was introduced for the first time in 2002. As the new director of NML, I noticed that the museum did not have a special exhibitions space and suggested to our maritime staff that they might like to have one. They bit my hand off and told me that because so few people ever visited the old ship model displays, they would like to convert the ship model gallery into an exhibition space. The result was the removal of a hundred or so model ships from view and their replacement by the new exhibitions gallery.

I found myself castigated by some who thought it was the end of the world when the model ships disappeared from permanent view ('Fleming should be sacked' read one of the more polite messages in the visitors' book) but the 'Spirit of the Blitz' exhibition that replaced them was a huge success, not least with my 3-year-old daughter, who, after having had the chance to dress up in a miniature 1940s outfit, declared the museum now to be 'the best in the world'.

What 'Spirit of the Blitz' brought to the Maritime Museum was emotion. There had never been an exhibition in Liverpool that acknowledged the Blitz, which claimed almost 4,000 lives and rendered 10,000 homeless, and there was a powerful public reaction: the museum attracted more visitors in 2003/4 than in any other year in its history, reversing the recent trend of decline.

We invited visitors to express themselves after seeing the exhibition through comments. Here are some of their responses:

> My husband was killed in 1941, no choice but to go on with my children, not easy! No help but well worth it. Such spirit of all Liverpudlians.

I remember the pub off Stanley road called 'Dead House' where they took dead bodies from Celia Street. I was 14 years old.

I lived in New Ferry and I remember the May Blitz. After the 'all clear' sounded we all went down to the river and it looked as if the whole of Liverpool was on fire. It was a terrible sight.

And so we come to Liverpool's International Slavery Museum. We live in a world where perhaps 30 million people are held in slavery, perhaps 12 million children and adults are the victims of forced labour, and there are millions who have been trafficked and are subject to sexual or labour exploitation. According to the US International Labor Affairs Bureau, 134 types of product (footwear, clothing, rice, fruit, fireworks, gold, coffee) have some link to forced labour practices in 74 countries (Labor Affairs Bureau 2012: viii).

There was a time when the idea of museums joining in the fight for human rights would have been greeted by museums professionals with derision: 'Museums should concentrate on looking after their collections, documenting them properly, producing catalogues, doing research' – I can still hear the advice I was given in the 1980s. But museums have discovered different roles since then. They have discovered that, in fact, they are held in high regard by the public not just as places where the past can be viewed but where ideas can be explored.

That human rights are denied to many millions of people throughout the world is a revelation to some and a barely acknowledged fact to others. It is clear, though, that when museums choose to tackle human rights issues, the public responds positively. This is something they want museums to do. As places where ideas are explored, there can be no more important role for museums than that of helping fight for human rights for all. Museums have a cultural authority and access to audiences that is envied by organisations that work in the field of human rights.

The approach of our International Slavery Museum can be summarised in three ways. We no longer look purely to collections for inspiration when relating histories – we now look much more to people, to people's stories and to ideas. We embrace the histories of minority or oppressed groups: oppressed, alienated and excluded because of their class or their ethnicity or their gender or their sexuality. We have become more emotive, and even emotional, which means that we are better able to communicate ideas.

Here are some visitor comments from the International Slavery Museum:

What a truly inspiring day we have all had today, feel privileged to be able to show my children age 11 and 3 all about my ancestors. Feel quite sad and emotional but will be back.

This touched me deeply, may all who see it take note and give love and dignity to everyone. Slavery is still alive in 2009, don't forget the past and hope the future will be better.

Very insightful, inspiring and thought provoking. Thank you for raising awareness so effectively.

Some people can be heartless it made me realise what suffering really is. Great museum I really learnt lots.

And now to the Museum of Liverpool, opened in July 2011, which has since welcomed almost 2 million visitors. What are the reasons for the museum's success? In a presentation to BBC executives, we answered this question in a number of ways. We have great ambition: to create the best city museum in the world. We aim high. We created the museum as at its core people- and story-led. Opinion and debate are central, for example in the People's Republic gallery. Throughout, the museum contains the authentic Liverpool voice. It uses humour; it sets out to involve local people. The museum's leadership is creative, risk-taking, stubborn and determined, with a powerful vision and ability to keep its nerve. We have resisted siren voices to do nothing, to scale down the project, to do something else instead. Liverpool is an argumentative city, and if you are to manage the city's museums you need to be very robust or you will founder. In addition, we have empathetic partners – such as Hurricane Films – who are prepared to listen to the museum and to take risks themselves. Partners who were less empathetic fell by the wayside, including architects, designers and project managers. The museum takes families seriously. Museums are physical places for intergenerational activity, and we aim (just like the BBC) to 'inform, educate and entertain' families. And, as with the BBC, 'audiences are at the heart of everything we do' (BBC 2012). The museum features great variety, of medium and message. It is large scale for a city museum, with great scope. The museum is readily changeable, an essential characteristic of a city museum so that it can capture the essence of a living, changing city. Finally, and crucially, we continue to iterate that the museum is an emotional place, yet we avoid absolutely a celebratory approach.

One example of the Museum of Liverpool's approach to emotion is *Kicking and Screaming*, a film that looks at the subject of being a football fan in this football-mad city. Perhaps more than any other, this example engages with the currency, potency and importance of the emotional museum in Liverpool.

Two of the sequences in the film deal respectively with the Heysel and Hillsborough disasters, which together claimed the lives of 135 people in the 1980s. The scars of Hillsborough have never healed in Liverpool, and emotions run very high to this day, not least because of the shameful actions of the South Yorkshire police in covering up their own failures and blaming innocent Liverpool supporters for causing the disaster. Two significant campaigns have been waged for many years by Liverpudlians as a result of the disaster and the subsequent lies and cover-ups, and both campaigns are still going strong. One is 'Justice for the 96' (96 people lost their lives as a result of the Hillsborough disaster) and the other is 'Don't Buy *The Sun*'.

The Sun newspaper, outrageously and unforgivably, chose to print gross untruths under the headline 'The Truth' about what happened at Hillsborough, and while its then-editor, Kelvin MacKenzie, has since blamed the South Yorkshire police for feeding him misinformation, needless to say, his weasel words have been treated with the contempt they deserve in Liverpool, and very many people in the city will never, ever, buy *The Sun*.

The day before the keynote on which this chapter is based was given at the Challenging History conference, this is what the Scousers' bible, the *Liverpool Echo*, said in its editorial:

> Rupert Murdoch hasn't done the world of journalism many favours – but he did when he unceremoniously ditched the News of the World.
>
> That disgraceful, disgusting and depressing rag was dumped after the revelations that it was involved in the hacking of the phone of murdered teenager Milly Dowler while she was still missing.
>
> But this weekend, what was the world's most discredited newspaper is to be replaced by The Sun – the newspaper that is the most despised by Merseysiders and all those who were sickened by the poisonous lies it peddled about Liverpool fans in the wake of the Hillsborough disaster … .
>
> Is The Sun On Sunday a joke? Well, if it is it's a very sick one. (*Liverpool Echo* 2012)

Both Hillsborough campaigns are featured in *Kicking and Screaming*, and the area in the museum in which it is shown is openly dedicated to the 'Justice for the 96' campaign.

This is an example of how far the museum has travelled in its exploration of the emotional museum, showcasing raw emotions including grief, rage and sorrow. Indeed, the museum has taken a stance right alongside those who still seek justice for the 96, giving the campaign a justified and tangible place in the history of the city. In so doing the museum has shown that, like the city itself, it is made up of people who are themselves emotional. It is of the city, not just a dispassionate institution that belongs to someone else.

References

Arts Council England 2011. 'Taking Part: The National Survey of Culture, Leisure and Sport'. Available at <https://www.gov.uk/government/uploads/system/uploads/attachment_data/file/77449/Taking_Part_Y6_Q3_Jan-Dec10.pdf> (accessed 31 Jan. 2013).

BBC 2012. 'Mission and Values'. Available at <http://www.bbc.co.uk/aboutthebbc/insidethebbc/whoweare/mission_and_values/> (accessed 22 Jan. 2013).

Labor Affairs Bureau 2012. 'US Department of Labor's List of Goods Produced by Child Labor or Forced Labor'. Available at <http://www.dol.gov/ilab/programs/ocft/2012TVPRA.pdf> (accessed 31 Jan. 2013).

Liverpool Echo 2012. 'Another Sick Murdoch Joke'. Available at <http://www.liverpoolecho.co.uk/views/our-view/2012/02/22/another-sick-murdoch-joke-100252-30378484/> (accessed 28 Dec. 2012).

NML (National Museums Liverpool) 2012. 'Mission, Values and Strategy'. Available at <http://www.liverpoolmuseums.org.uk/about/corporate/strategic-plan/> (accessed 28 Dec. 2012).

Spalding, J. 2012. *The Poetic Museum*. New York: Prestel.

Chapter 2

Telling Hard Truths and the Process of Decolonising Indigenous Representations in Canadian Museums

Bryony Onciul

For many Indigenous peoples of North America, museums have an unpleasant history that is directly linked to the colonial past. Many museums with ethnographic collections from the colonial period have begun to recognise the need to decolonise the narratives told by exhibitions about Indigenous peoples. A key feature of this change has been to work with communities and engage them in the re-interpretation and re-presentation of their own cultures within museums. Along with Indigenous community engagement in mainstream museums, many communities have also established their own museums, community centres and cultural 'keeping places' (Simpson 1996: 108).

Despite these efforts, the process of decolonisation is far from complete. The engagement process can be tokenistic and the onus is placed on Indigenous communities to counter and correct the misinformation given about them by others. Nancy Mithlo notes that 'the museum enterprise, built upon a colonial heritage that demanded control of Native people, now has need of Native informants to both correctly identify objects and serve as negotiators between two parties with vested interests' (2004: 757). Criticism of current attempts to decolonise museums have come from scholars, many of whom are Indigenous, who feel the changes do not yet go far enough to indigenise practice or counter naturalised Western approaches that continue to dominate museology (see Sleeper-Smith 2009).

Amy Lonetree emphasises the 'need to tell [the] hard truths of colonization – explicitly and specifically – in our twenty-first-century museums' to enable decolonisation (2009: 334). While it is very important for the 'hard truths of colonization' to be known and publicly acknowledged, there remains the questions of how, when and by whom they should be told. In this chapter, I consider why a community may choose not to be explicit or specific when telling the hard truths of colonisation and how decolonisation may be envisioned through different means.

To do so, I analyse two museum exhibits produced by Indigenous Blackfoot community members, in southern Alberta, Canada. One exhibit was created through a partnership between the Glenbow Museum in Calgary and 17 Blackfoot

Elders from the four Blackfoot nations in Canada and America.[1] The other exhibit was developed by the Siksika Blackfoot Nation working with their Elders at Blackfoot Crossing Historical Park, a community developed and run cultural institution on the Siksika Reserve.

This chapter uses data from 48 original in-depth interviews, collected over three years, with Blackfoot Elders and museum professionals who were involved in developing these, and similar, exhibits. The chapter analyses how, why, and to what extent difficult colonial history, such as the residential school era, is addressed in these two exhibits. By examining the difficulties of discussing sensitive subjects with those who experienced them first hand, the chapter explores the notion of limited sharing and 'displayed withholding' (Lawlor 2006: 5). The chapter indicates that culture can be strategically presented to support efforts to rebuild community pride, which can contribute to the process of decolonisation.

Telling Hard Truths and Decolonisation

Battiste and Henderson argue that 'reclaiming and revitalising Indigenous heritage and knowledge is a vital part of any process of decolonisation, as is reclaiming land, language, and nationhood' (2000: 13). Museums are key sites for reclaiming and decolonising public representations of Indigenous heritage; however, how to implement this change is a much debated topic.

Waziyatawin Wilson argues that there is a need for public recognition and acknowledgement of the wrongs done to Indigenous peoples through colonisation to enable decolonisation. She highlights the 2001 Truth Commission into Genocide in Canada which released a report entitled *Hidden from History: The Canadian Holocaust*, 'which documents the crimes perpetrated against the Indigenous Peoples of Canada, such as murder, torture, and forced sterilisation' (Wilson 2005: 200). Wilson argues that public recognition is acutely needed given the current status of colonial amnesia and denial:

> While policies of genocide, ethnic cleansing, and ethnocide have been perpetrated against us and our lands, and resources have been threatened decade after decade, century after century, not only are we taught that we are to blame, we are taught that we should just get over it. (Wilson 2005: 190)

1　Elders are cultural specialists, historians and spiritual leaders who have high standing in Blackfoot communities. They have earned their knowledge through Blackfoot sacred societies, transfers of sacred objects and knowledge, and they continue many of the traditional customs of pre-contact Blackfoot life. The Elders, known as *kaaahsinnooniksi* in Blackfoot, are the custodians of traditional knowledge and they teach it to the new generations through age-graded societies, ceremonies and cultural events (Bastien 2004: 222).

To right past wrongs and end the ongoing victimisation of Indigenous peoples, she argues that 'the truths of these experiences need to be disclosed, the carriers of this suffering need a validating and supportive forum in which to tell their stories' (Wilson 2005: 191). While Wilson proposes that truth commissions could act as such forums, Amy Lonetree recommends that museums should contribute to this process:

> As we look to the future, I believe it is critical that museums support Indigenous communities in our efforts towards decolonization, through privileging Indigenous voice and perspective, through challenging stereotypical representations of Native people that were produced in the past, and by serving as educational forums for our own communities and the general public. Furthermore, the hard truths of our history need to be conveyed, both for the good of our communities and the general public, to a nation that has wilfully sought to silence our versions of the past. We need to tell these hard truths of colonization – explicitly and specifically – in our twenty-first-century museums. (Lonetree 2009: 334)

She terms this a 'truth telling and healing process'. However, 'privileging Indigenous voice and perspective' is not always compatible with telling 'these hard truths of colonization', as hard truths can be difficult for communities to tell (Lonetree 2009: 334). Communities may choose to avoid emphasising the difficult history of colonialism and instead use self-representation as part of a strategy to build community pride and reconnect pre-contact life with current living traditions and oral history.

The Case-Study Exhibitions

The two case-studies discussed in this chapter had to navigate the difficult history of colonisation with their stakeholders, staff, community participants, funding bodies and audience. At both the Glenbow Museum and Blackfoot Crossing Historical Park, the debate circled around what to display and how much to share.

The Glenbow Museum opened in 1954 with the support of its founder Eric Harvie and housed Harvie's vast personal collection, which he donated to the people of Alberta in 1966. The museum is now run by the Glenbow–Alberta Institute whose vision is to be 'Where the World Meets the West' (Glenbow Museum 2012). In 1988, the Glenbow Museum became the focus of international debate after the 'Spirit Sings' exhibition sparked controversy over museum representations of Indigenous peoples. Ethnology curators from Glenbow participated in the Assembly of First Nations and the Canadian Museums Association Task Force and used the guidelines set out in the Task Force Report on Museums and First Peoples (AFN and CMA 1992) to inform their practice.

The curators built upon their relationship with Elders in the Blackfoot community, which had been developed through the loaning and repatriation of sacred material to the community. Glenbow Museum developed a partnership with 17 Elders from the four Blackfoot nations (Siksika, Piikani, Kainai and Blackfeet) and worked with them on the development of 'Niitsitapiisinni: Our Way of Life', the Blackfoot Gallery for four years. The Blackfoot Elders whom I interviewed, saw the partnership as an opportunity to tell their history from their point of view. They wanted to correct misunderstandings and to speak to their own youth and build pride within their community. On 3 November 2001, Glenbow opened the 760m², $1.915m gallery (Conaty 2003: 238) to positive reviews from the Blackfoot community (Jerry Potts, interview: 10 Oct. 2008; Frank Weasel Head, interview 13 Nov. 2008).[2]

In comparison, Blackfoot Crossing Historical Park is a grassroots Siksika Blackfoot community development, located on the Siksika Reserve within an important heritage landscape which includes the site of the signing of Treaty Seven in 1877.[3] The idea for the centre developed from the centenary celebrations of the signing of Treaty Seven, and after decades of community engagement, planning and funding, it opened to the public in 2007. Blackfoot Crossing is run by the community, for community members and visitors, and its mission is the 'Promotion and Preservation of the Siksika Nation Peoples' Language, Culture and Traditions' (BCHP 2012). The museum at Blackfoot Crossing began as the Siksika Museum, established in 1967. Before the collection was moved to Blackfoot Crossing, it was displayed and cared for in the former Old Sun Residential School building (Scalplock 2006: 65).

Both of these museums had to consider if and how they would address the 'hard truths' of the colonial period. Interviewees from both case-study sites emphasised that the participating Elders had the final say over the exhibitions' content and storyline, in accordance with Blackfoot protocol. However, 'final say' was framed within the limits of what was possible at each site, as both museums had finite space, collections, time and finances; and both operate within the remits of their institutional policy, wider professional standards and Canadian law. The decisions made by the museums through their engagement with the community highlight the political and sensitive nature of telling 'hard truths'.

The 'Hard Truths' of the Residential School System

The residential school era (1842–1996) is a particularly painful part of Canadian and First Nations history. Described as 'genocide' (Churchill 2004) and the

2 The interviews were conducted as part of my PhD research, funded by the Arts and Humanities Research Council.

3 Treaty Seven was the peace treaty made between the British Crown and the Siksika, Piikani, Kainai, Tsuu T'ina, and Nakoda (see Dempsey 1987).

'Canadian holocaust' (Truth Commission into Genocide in Canada 2001: 5), it is a history that has been hidden for generations. As Blackfoot Crossing director Jack Royal explained: 'the whole residential school experience, those things weren't communicated because it was like a black eye on Canadian history. So because of that there was ignorance because it wasn't mentioned' (interview: 25 Aug. 2008).

The last federally run residential school closed in 1996 (Health Canada 2011). The Canadian government issued 'a formal expression of regret' in 1998 'for native aboriginals who suffered physical and sexual abuse [which had been] widespread in residential schools that operated across the country until the 1970s' (BBC 1998). On Wednesday 11 June 2008, the Prime Minister of Canada, Stephen Harper, made a Statement of Apology to former students of Indian residential schools, on behalf of the government of Canada. The Canadian government set up a Truth and Reconciliation Commission to publicly address the hidden history (Truth and Reconciliation Commission of Canada 2011) and the apology came as part of the Indian Residential Schools Class Action Settlement Agreement which included a Common Experience Payment to former students (Service Canada 2011).

The Blackfoot nations had residential schools imposed upon their reserves and Blackfoot children were forced to attend as part of a nationwide government effort to assimilate Indigenous children through Christian-based education. Children were discouraged from practising their culture or speaking their language in the schools (Miller 2004: 246) and disobedience was, at times, severely punished (Milloy 1999: 282). Some children were enrolled at a young age and remained in the schools till their late teens without being allowed to visit their homes (Brown and Peers 2006: 26). The schools were often unsanitary, and ill-health and neglect was common (Brown and Peers 2006: 27; Milloy 1999: 98–9). 'Sexual and physical abuse by staff and students was widespread' (Blackfoot Gallery Committee 2001: 76).

In the national apology by the government, M.P. Duceppe made special mention of the Siksika Blackfoot Nation's Old Sun Residential School for the high death toll of students:

> Nearly 150,000 people have waited their whole lives for this day of truth and reconciliation; 90,000 of them are still with us. These 90,000 are true survivors. Over 100 years ago, the Bryce report revealed that the mortality rate in residential schools was close to 25%. In the Old Sun's Residential School in Alberta, the death rate was as high as 47%. That is why I consider these former students to be survivors. (Duceppe 2008)

Siksika's Old Sun Residential School, established in 1886, repeatedly appeared in government reports stating the unsanitary and poor conditions of the school and ill-health of the children (Milloy 1999).

> In the decade before WWI, disease outbreaks at the Old Sun School affected most of the student body, causing many deaths, quarantines and several temporary school closings ordered by the government. (General Synod Archives 2008)

Bryce condemned the school in 1907 and Cobett's survey of the schools in 1920 and 1922 'found that little had changed' (Milloy 1999: 98).

> Such conditions had left their indelible and mortal mark on the children who Corbett found to be 'below par in health and appearance.' Seventy percent of them were infected. They had 'enlarged lymphatic glands, many with scrofulous sores requiring prompt medical attention.' ... But it was the discovery that sixty percent of the children had 'scabies or itch in an aggravated form' that most upset Corbett, for this was unnecessary and a sign of gross neglect. (Milloy 1999: 99)

By 1957, the situation was still dire: the visiting medical doctor was recorded as saying: 'The children are dirty. The building is dirty, dingy and is actually going backwards rather than forwards' (quoted in Milloy 1999: 263). In 1971, the Calgary-based Mount Royal College took over most of the Old Sun school building for use as a Native Learning Centre and renamed it the Old Sun Community College, and in 1978 the college became a separate institution run by the Siksika Blackfoot Nation (General Synod Archives 2008).

This painful history is within living memory, and the effects of the residential school era continue to be felt today in Blackfoot communities, affecting the survivors, their children and grandchildren. Consequently it was a particularly sensitive issue to address in the exhibitions developed by the Blackfoot community at the case-study sites.

Representing Genocide within the Museum

While neither museum set out solely to interpret the residential school experience, it is mentioned in each exhibit. At the Glenbow Museum the Nitsitapiisinni Gallery features a display on residential schools. The exhibit recreates two corridors from Old Sun school on the Siksika Reserve: one from when it was a residential school and one from its current use as a community college. Visitors can look through the windows and see images of Siksika children at school. The exhibit is a small part of the gallery, and the text panel directly addresses the trauma the residential schools caused their students by stating:

> Schools destroyed our family structure, our sense of belonging and our identity. Schools tried to make us ashamed of our traditional teachings and practices. Schools told us that our grandparents were heathens. Schools almost destroyed us. Physical and sexual abuse was common. The healing will take a long time.

While the text panel addresses the hard truths of this period directly, the narrative does not go into detail. The history is framed in terms of survival, with the modern community college depicting the vibrancy of current Siksika youth and the continuation of Blackfoot culture.

Glenbow's online Niitsitapiisinni Gallery teacher toolkit adds more details to supplement the exhibit, explaining the damage the residential schools did to Blackfoot society:

> Sexual and physical abuse by staff and students was widespread. The children were helpless. They learned institutional behaviour – how to bully the young and weak. They learned to treat each other with contempt and violence. Residential schools created many dysfunctional people with low self-esteem, and these people in turn created a dysfunctional society. This process has been going on for five or six generations. It will take a long time to heal. (Glenbow Museum 2011)

Like the exhibition and the toolkit, the accompanying book specifically addresses the hard truths of colonisation, as Lonetree recommended (2009: 334), but emphases the positive message of survival and reclaiming control:

> The residential schools were hateful places. These buildings are constant reminders of the physical and sexual abuse we suffered at the hands of staff and other students. Their presence told us that we were still dominated by the government and the policies which sought to destroy us. We have torn most of these buildings down. We have converted two former residential schools into community colleges. These colleges are physical evidence of how we have taken control of our lives. We have turned tools of oppression into opportunities for developing pride and self-esteem. (Blackfoot Gallery Committee 2001: 76)

Thus the Blackfoot Elders who worked with the Glenbow Museum decided to address the hard truths of the residential school era in a brief but direct way and were careful to balance the negative history with a positive message of community revival.

In comparison, Blackfoot Crossing presents the residential school as part of a three-dimensional collage of buildings that represent the difficult colonial period: the residential schools system, the reserve system, the influence of Christianity, labouring on the farms and down the mines. The collage is framed within one of four tepee spaces within the exhibit, entitled the Survival Tipi (Figure 2.1). The exhibit uses audio-visual footage of current Elders who lived through the period telling their stories about their experience as children at the residential school. The films emphasise that the trauma is within living memory on the reserve, although the narrative is kept relatively light and even contains some humour (about childhood mischief), avoiding explicitly and specifically describing painful events.

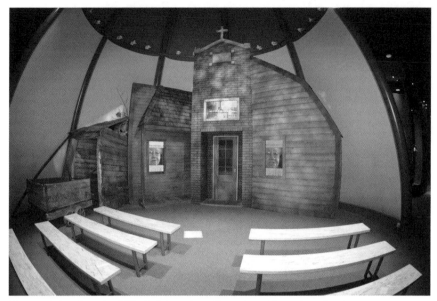

Figure 2.1 Survival Tipi, Blackfoot Crossing Historical Park

Source: Photo: Bryony Onciul.

In this sense, the exhibit performs what Mary Lawlor has termed 'displayed withholding' (2006: 5) to share limited aspects of this sensitive history, whilst emphasising that there is more to the story than what is being presented. 'Displayed withholding' is 'the point where the performance or display says, "There is more, but we choose not to show you". the gesture points towards a dimension of being and knowing that cannot or will not be shared with visitors' (Lawlor 2006: 62). Visitors are introduced to the topic, but it is clear that only a limited amount of information is being shared, graphic details of survival are not discussed.

Sharing Hard Truths

While the residential era is clearly important to these museums, it was not the main focus of the exhibits. Glenbow's Nitsitapiisinni presented Blackfoot culture and heritage from pre-history to today, and at Blackfoot Crossing the exhibition presented the history and living culture of the Siksika community.

Nevertheless, the limited information presented on the residential school era is significant. Discussing the residential school experience was a challenging and emotional process, particularly for many of the Blackfoot Elders, engaged in the development of the exhibits, who had attended these schools in their childhood.

Kainai Elder, Frank Weasel Head, recounts the discussions about representing the schools in the Glenbow exhibit:

The residential school took us maybe five, six, seven meetings. It took us a long time because it was a hard subject … [but] we have to tell the story, we have to let people know what happened to us … If everything there in those several meetings was said, put on display on the residential school, they would have covered the third floor. That would have been the only exhibit. (Frank Weasel Head, interview: 13 Nov. 2008)

Piikani Elder and Blackfoot Gallery team member at Glenbow, Jerry Potts explained: 'I think the idea was that if you can show enough, then if somebody's interested there is enough there to kind of make them want to look deeper' (interview: 10 Oct. 2008).

The residential school era raised very sensitive personal memories that were hard for individuals to share and not necessarily suitable for permanent public display in a museum. When the videos were made for the audio-visual displays at Blackfoot Crossing the exhibit designer, Irene Kerr, was concerned about publicly displaying such personal films and decided to edit the material:

I mean there was a lot of stuff I wouldn't let [the film company] use. Especially that one … on the residential school; we had some footage there that I just said we just can't [use], we have to draw the line somewhere. But same thing, [the Elders] saw the videos, they approved them all. (interview: 20 Aug. 2008)

Kerr's action appears to support other staff members' approaches to balancing the dilemma between telling 'hard truths' and 'opening old sores' as exhibit team member and archives director at Blackfoot Crossing, Colleen Sitting Eagle, explained:

What one of the Elders said was why open an old sore? … People can read about it elsewhere and if they want verification they can find it, they can personally talk to somebody, but we're not going to open an old [sore], because it's also hurting to [the survivors], hurting to their families, and they don't want to show that … Keep a balance in what you want to tell, but more on the positive side, because people have always, are [always], labelling our stereotype. (Colleen Sitting Eagle, interview: 4 Sept. 2008)

Blackfoot Crossing assistant curator, Michelle Crow Chief, reinforced this point:

We tried not to make it a biased point. We did it so that … we'll touch base on it but not sit there and 'well this is what they did to us, this is bad'. We just kind of touched it and just kind of steered away from it. If [visitors] wanted to learn more, you know that is where the archives are; and they can do their own research in there on that topic. (Michelle Crow Chief, interview: 2 Sept. 2008)

The Elders who worked at Blackfoot Crossing and Glenbow decided to share, but only so much. For them, these exhibits were not the right forums for the explicit and specific discussion of the 'hard truths of colonization' as recommended by Lonetree (2009: 334).

Building Pride

At Glenbow the Elders decided to represent the residential school experience through a process of displayed withholding, partly because of the difficult and private nature of the personal memories recollected by survivors, but also because the Elders wanted to present a public Blackfoot identity that their youth could be proud of. In the early discussions about the Glenbow Niitsitapiisinni Gallery, the meeting notes show the importance of representing the 'negative era' and the key issue about how much to share:

> Frank: It's hard to leave out the bad times such as residential schools.
>
> Pat: We don't want to focus too much on the negative era. Look at the past and the present. Look at the positive side – how did we survive through that era? The young people need to look at the positive – the positive energy that brought us through that era. (Glenbow Museum 1999: 3)

Building community pride was described by participants as an important part of sharing Blackfoot culture in the Glenbow exhibit. Glenbow curator Beth Carter explained:

> In terms of the sensitive issues that are historical, [the Elders] wanted to very clearly show those as only a blip in time, in their 10,000 years history. So really in the last 100 years they've had a lot of problems, but they have been around for 10,000 years, so it is really only that tiny bit at the end. They wanted people to understand the beauty and the depth and the greater significance of Blackfoot culture and not just focus on the historical controversies …They did want to celebrate the really good things about Blackfoot culture …You have to remember that the Blackfoot team members came to Glenbow and worked with us specifically to speak to their own youth. [That] was the reason they were willing to work with us. (Beth Carter, interview: 28 Aug. 2008)

Carter went on to explain that:

> There has been so much racism and negative stereotypes that bombard these young [Blackfoot] people and they need to have things they can be very proud of … and things that they can hope for the future. And have a message that gives them hope for where their life can go. (Beth Carter, interview: 28 Aug. 2008)

Former Glenbow interpreter, Clifford Crane Bear, notes that they were successful in so far as: 'the first thing we were doing, and we accomplished, was that people walked out of there with heads up in the air, especially the Blackfoot people, and they were very, very, very proud' (interview: 8 Oct. 2008).

Conclusion

While the hard truths of the residential schools system are specifically addressed in community-created exhibits and given authority as official history by their inclusion in these museums, they are not discussed in detail nor are they the focus of the exhibitions. What is shared is limited, to highlight the issue but not dwell upon it. Lonetree recognised the difficulty of performing 'truth telling' stating:

> I greatly respect [a community's] willingness to speak of what we as Indigenous people know but are somewhat reluctant to talk about within a museum context. All too often our concern of coming across as if we are subscribing to the language of victimization, or perhaps the more legitimate concern that this information could potentially reinforce stereotypes, prevents us from speaking the hard truths about our present social problems and connecting those issues to the colonization process. (Lonetree 2009: 332)

While I agree that addressing this history and connecting present social problems to their colonial origins is extremely important, it is also important to recognise that, as a newly unveiled hidden history, the very inclusion of these hard truths is a vital first step in the process of decolonisation.

The community chose to be sensitive to the living survivors of the residential school system and to show respect for the fact that these historical traumas continue to affect all of the close-knit Blackfoot community today. The Elders decided not to discuss the current socio-economic hardships that can be directly linked to colonisation, but rather identify some of the key causes for the current situation, such as the residential school system, to encourage people to look into these subjects further.

While the exhibits could be seen to underplay the negative impact the residential school system had on Blackfoot society, there was a desire not to reduce the long history and complex culture of the Blackfoot peoples to nothing more than a brutal period of colonisation. By not focusing on colonisation, but instead emphasising the history before and future after colonialism, the Elders refuse the status of passive victims, instead framing their community in terms of survival, revival and cultural pride.

What is shared in the exhibitions and the efforts made to present a positive image of the community to engender cultural pride is, I would argue, crucial to countering the enduring legacies of colonialism within the Blackfoot community. Building community pride is a way to challenge negative self-images engrained

in the community by the colonial teachings forced upon them in the residential schools. Building a community that is aware of its history and proud of its identity is perhaps the first stage of addressing and countering these difficult histories.

Blackfoot community members may decide to specifically focus upon the horrors of the residential school system in future exhibits. However, as Waziyatawin Wilson argues, 'the colonisers must also take responsibility for and own the injustices that they have helped directly or indirectly perpetrate' (2005: 193). As such, mainstream Canadian museums, such as the new Canadian Museum for Human Rights, should perhaps take the lead in addressing and owning these hard truths so that the burden of responsibility to educate others about this difficult history is not placed upon the communities who survived it. First Nations peoples have a rich cultural heritage that extends long before the violence of colonialism and continues to thrive despite these atrocities. While the hard truths of colonisation do need to be told in museums and acknowledged by the wider public, it is the positive history of survival and revival that Blackfoot communities want to celebrate.

References

AFN (Assembly of First Nations) and CMA (Canadian Museums Association) 1992. *Turning the Page: Forging New Partnerships Between Museums and First Peoples*, Task Force Report on Museums and First Peoples. Ottawa: Carleton University.

Bastien, B. 2004. *Blackfoot Ways of Knowing: The Worldview of the Siksikaitsitapi*. Calgary: University of Calgary Press.

Battiste, M., and J. Youngblood Henderson (Sa'ke'j) 2000. *Protecting Indigenous Knowledge and Heritage: A Global Challenge*. Saskatoon: Purich.

BBC 1998. 'Despatches: Vancouver', *BBC News* (7 Jan.). Available at <http://news.bbc.co.uk/1/hi/despatches/45547.stm> (accessed 29 Jan. 2008).

BCHP (Blackfoot Crossing Historical Park) 2012. 'About Us: Mission Statement'. Available at <http://www.blackfootcrossing.ca/aboutus.html> (accessed 21 Sept. 2012).

Blackfoot Gallery Committee 2001. *Nitsitapiisinni: The Story of the Blackfoot People*. Toronto: Key Porter Books.

Brown, A.K., and L. Peers 2006. *Pictures Bring Us Messages / Sinaakssiiksi aohtsimaahpihkookiyaawa: Photographs and Histories from the Kainai Nation*. Toronto: University of Toronto Press.

Churchill, W. 2004. *Kill the Indian, Save the Man: The Genocidal Impact of American Indian Residential Schools*. San Francisco: City Lights Books.

Conaty, G.T. 2003. 'Glenbow's Blackfoot Gallery: Working Towards Co-existence', in L. Peers and A.K. Brown (eds), *Museums and Source Communities: A Routledge Reader*. London: Routledge.

Dempsey, H.A. 1987. *Treaty Research Report: Treaty Seven (1877)*. Available at <http://www.aadnc-aandc.gc.ca/DAM/DAM-INTER-HQ/STAGING/texte-text/tre7_1100100028790_eng.pdf> (accessed 6 Aug. 2012).

Duceppe, G. 2008. 'Statement by Ministers'. Available at <http://www2.parl.gc.ca/HousePublications/Publication.aspx?DocId=3568890&Language=E&Mode=1&Parl=39&Ses=2> (accessed 6 June 2011).

General Synod Archives 2008. 'Old Sun School: Gleichen, AB'. Available at <http://www.anglican.ca/relationships/trc/histories/old-sun> (accessed 7 Jan 2012).

Glenbow Museum 1999. Blackfoot exhibit team meeting minutes (15 Jan.). Unlisted, Glenbow Archives, Calgary.

—— 2011. 'Reserves and Residential Schools', *Niitsitapiisinni Gallery Teacher Toolkit*. Available at <http://www.glenbow.org/blackfoot/teacher_toolkit/english/culture/reserves.htm> (accessed 10 May 2011).

—— 2012. *History of Glenbow*. Available at <http://www.glenbow.org/about/history.cfm> (accessed 7 Aug. 2011).

Health Canada 2011. *Indian Residential Schools*. Available at <http://www.hc-sc.gc.ca/fniah-spnia/services/indiresident/index-eng.php> (accessed 3 Aug. 2011).

Lawlor, M. 2006. 'Public Native America: Tribal Self-Representations', in *Casinos, Museums, and Powwows*. London: Rutgers University Press.

Lonetree, A. 2009. 'Museums as Sites of Decolonization: Truth Telling in National and Tribal Museums', in S. Sleeper-Smith (ed.), *Contesting Knowledge: Museums and Indigenous Perspectives*. London: University of Nebraska Press.

Miller, J.R. 2004. *Lethal Legacy: Current Native Controversies in Canada*. Toronto: McClelland & Stewart.

Milloy, J.S. 1999. *A National Crime: The Canadian Government and the Residential School System 1879 to 1986*. Winnipeg: University of Manitoba Press.

Mithlo, N.M. 2004. '"Red Man's Burden": The Politics of Inclusion in Museum Settings', *American Indian Quarterly* 28(3–4): 743–63.

Scalplock, I.J. 2006. 'Tribal Museums and the Siksika Experience', in K. Coody Cooper and N.I. Sandoval (eds), *Living Homes for Cultural Expression: North American Native Perspectives on Creating Community Museums*. Washington DC: National Museum of the American Indian, Smithsonian Institution.

Service Canada 2011. 'Common Experience Payment (CEP)'. Available at <http://www.servicecanada.gc.ca/eng/goc/cep/index.shtml> (accessed 23 June 2011).

Simpson, M.G. 1996. *Making Representations: Museums in the Post-Colonial Era*. London: Routledge.

Sleeper-Smith, S. (ed.) 2009. *Contesting Knowledge: Museums and Indigenous Perspective*. London: University of Nebraska Press.

Truth and Reconciliation Commission of Canada 2011. 'Residential Schools'. Available at <http://www.trc.ca/websites/trcinstitution/index.php?p=4> (accessed 10 July 2011).

Truth Commission into Genocide in Canada 2001. *Hidden from History: The Canadian Holocaust. The Untold Story of the Genocide of Aboriginal Peoples by Church and State in Canada.* Available at <http://canadiangenocide.nativeweb.org/genocide.pdf> (accessed 12 Jan. 2012).

Wilson, W.A. 2005. 'Relieving Our Suffering: Indigenous Decolonization and a United States Truth Commission', in W.A. Wilson and M. Yellow Bird (eds), *For Indigenous Eyes Only: A Decolonizing Handbook.* Santa Fe: School of American Research Press.

Chapter 3

Ripples in the Pebble Pool: Dark Narrative as Maxim, Metaphor and Memorial

Alix H.J. Powers-Jones

Personal narrative is all around us. The telling and retelling of events as eyewitness history, through the familiar medium of personal expression, has a long and eminent pedigree. As children listening to the retelling of a favourite fairytale (or folk tale), we are comfortable in the repetition of a familiar account. Fears of the unknown, of those things beyond our control, are brought within our command, no matter how gruesome the plot. The term 'dark narrative' is used here to encompass a particular type of personal narrative that relates to tales on topics, which are 'uncomfortable' or 'difficult' to talk about and/or to listen to being retold. Here it is taken to be a spectrum of topics that includes, but is not limited to, those that may elicit feelings of revulsion or horror in the listener, such as deliberate personal or group violence, or cruelty through tales of indiscriminate accidental tragedy and loss to scary tales of apparitions and spirits.

Hugh Miller, the renowned nineteenth-century Cromarty geologist, writer and subject of this chapter, was an expansive writer whose works encompasses the whole gamut of dark narrative. Although somewhat obscure today, Miller once stood at the forefront of hugely significant scientific and societal changes in Scotland (Taylor 2007). This chapter concentrates on Miller's range of popular descriptive writing and social commentary, rather than on his more erudite scientific compositions, with an examination of three strands of Miller's popular social commentary, namely, maxim, metaphor and memorial.

Maxims are rules or principles by which to live. They govern personal and social conduct and are a form of 'etiquette' by which social behaviour is moderated and purport to illustrate what happens when social conventions (acceptable norms) are adhered to – behaviour which is cited as leading to personal success or reward – or the reverse, when conventions are flouted – leading to personal downfall. Maxims are familiar to us as fairytales or folk tales and Miller's capacity for narrative observation began at an early age with the collection and retelling of local folk tales. Metaphorical writing, where a phrase or expression is not used literally but is symbolic of something else, is a more subtle form of narrative expression. Although most frequently a literal writer with a reputation for plain-speaking, Miller was not above making allusions, which are interpretable as metaphorical in nature, and examples occur in his writing on the minutiae of rural Highland life for the local *Inverness Courier* newspaper (Gostwick 2006). Examples of narrative

as memorial also occur in Miller's writing for the *Courier*, where he recorded significant events and/or people for posterity.

In the twenty-first century, we look again at more recent historical events, which, recounted as eyewitness history, are often at variance with official accounts. This 'unofficial' history is told through the media of the written word, creative form, the collecting habit and the spoken word. What witnesses choose to exclude or include in this incomplete memorial makes this multiplicity of sources compelling. One may question the reliability of witnesses, but this narrative history is a powerful resonant art and not a science. What emerges through individual perspective, analogy, metaphor is a personal truth whose power rests in the ability to evoke a recognitive response from the audience and an ability to make heritage and history live. Personal narrative (storytelling) is a vital tool in the search for methods of improving intellectual and societal access to museums, heritage and cultural sites (for the sake of brevity in this chapter collectively referred to as 'museums').

'I know, because I was there'

In the 1970s and 1980s, a Welsh songwriter and storyteller called Max Boyce became a British phenomenon, telling the folklore of the Welsh mining villages in a series of delightful songs and sketches. In the midst of political upheaval, social unrest and labour strikes, Boyce captured the public imagination by the retelling of hilarious observational stories of absurd and unbelievable events, each qualified with the statement 'I know, because I was there' (1979). This single, simple sentence is a uniquely powerful statement that instantly evokes resonance with the listener, both elevating the position of the speaker and creating provenance and legitimacy for the story. However, this does not make that story the absolute truth, because narrative is not just a method of conveying information (facts) it is an interpretation of those facts (Ganzevoort 1993). My truth is not necessarily your truth, and that, in a way, is the whole point about personal narrative or eyewitness history: it adds colour, texture, depth to official historical accounts from the speaker's perspective and filtered through the speaker's experiences. Personal narrative is a subjective parallel voice that may run alongside (or contrary to) official, often dry accounts, that may be written in dispassionate or legalistic phraseology.

In fact, personal narrative is all around us, in private and public contexts, in the spoken or written word, as art or sculpture (Brandon 2005). Questions of narrative validity or truthfulness and objectivity pervade diverse subject areas including criminology (Hollway 2001), justice (Bock et al. 2006), theology (Ganzevoort 1993), autobiography (Freeman 2002) and medicine (Paley and Eva 2005). Museums as venues for public, rather than private, narrative are similarly challenging. Personal narrative used in the story-telling process, creates context and so aids the interpretation of historical events or objects (Black 2011). Narrative story-telling can be an essential tool in the process of visitor engagement (Bedford

2001, 2004; Rounds 2002), and its absence in a museum context can be noted and regretted (Lohrey 2010).

Personal narrative as an eyewitness account is a primary source of information, while personal narratives as stories retold in a family or community are secondary sources. However, the interpretation of facts through all speakers' experiences and expectations may, at best, be subjective, or at worst, deliberate untruths or works of the imagination. These shortcomings do not prevent the use of narrative as long as these limitations are borne in mind, although their use can be troubling to collectors and users of narrative for interpretation and display, particularly if the history associated with the narrative is dark and troubling (Kidd 2011).

The idea of 'challenging history' conjures up, at the same time, both an idea of some history as being difficult or uncomfortable to hear and a form of historical record that questions the accepted view or received wisdom. It is apparent that personal narrative can, and often does, fulfil both these criteria. It is often difficult to hear and challenges our ideas. Museums function as sources of information in a broad learning capacity and as venues of entertainment. If museums exist to delight and entertain, do they also exist to horrify and challenge? Surely, the 'bright' and the 'dark' history are two sides of the same coin? If we are to understand one, we must understand the other.

The underlying, underpinning function of a museum ought to be to impart information that may be consciously or unconsciously used by the visitor to update, revise or support their view of the world or their understanding of events, times or ideas. This process of information transfer may be formal, such as educator-led classes for schoolchildren, or may be a more informal, experiential process where learning derives from observation, interaction and exploration of sites, objects or stories (Bedford 2001; Kelly 2007a; Rounds 2002). This informal learning may be considered by participants to be more entertainment than formal learning (Kelly 2007b). Such learning may increasingly be delivered in an informal rather than formal way, but, if visitors enter a museum with the intention of whiling away an afternoon and are engaged, entertained and have experiences different to their everyday lives, they will, by definition, have acquired new, or been reminded of previously known, facts. That acquisition and experience may be something exciting, funny, horrifying, shocking or, indeed, a mixture of all of these.

In practice, museums and other cultural sites have always shown some dark history to a greater or lesser extent – Egyptian mummies, for example, are, perhaps, a macabre subject but still fascinate many people. Humans are, in general, remarkably tolerant of scary and disturbing things, but often these topics and stories are remote from the modern viewer and in a way almost 'safe', because they happened so long ago or because the people are unnamed or unknown to us.

The advent of exhibitions or even whole museums dealing with contemporary dark history is a striking phenomenon. The Holocaust Exhibition in the Imperial War Museum London opened in 2000. It tells the unimaginable story of Nazism's attempt to eradicate completely whole ethnic groups (Jews, Gypsies) during the Second World War on a scale and with an industrial efficiency hitherto not seen.

Due to effective record keeping and the advent of sound and picture media, it is easier to see, for example, Hungarians Jews as real people because we know their names, have photographs and films of their faces, read their words, hear their voices. It is easier for us to relate to a twentieth-century Hungarian than to a 3,000-year-old Egyptian. It is too easy, and therefore more uncomfortable, to imagine ourselves bundled into a train heading east. Do museums have an obligation to tell their difficult stories despite the discomfort it may cause to the visitor? Are lessons learnt from past events? Coleridge argued that 'if men could learn from history, what lessons it might teach us! But passion and party blind our eyes, and the light which experience gives is a lantern on the stern, which shines only on the waves behind us!' (Coleridge 1835: 121). In other words, that history only illuminates what has gone before, not what is to come. However, events recalled through narrative and exhibition can inform and may warn the unwary listener, but this erudition becomes more difficult if we are divided from people or events by geographical, temporal or cultural distance. Under these circumstances, narrative accounts are a potent mechanism for understanding difficult stories by 'reducing' these distances. This is the difficult power of the narrative record.

In order to address this question of the display of difficult stories, it is useful first to consider in more detail the nature of dark narrative. Simply put, dark narrative is not a single, uniform type of evidence but a multiplicity of forms. An example of the heterogeneous nature of narrative form is found in the work of the (now) little-known eighteenth-century observational polymath and writer, the Cromarty-born highlander Hugh Miller (1802–56). To have a greater understanding of Miller's dark narrative, one must consider the creative context as to a great extent Miller's writing was a product of place. So, who was Hugh Miller and where is Cromarty?

The name Cromarty is familiar to many BBC Radio 4 listeners as an area of sea mentioned in the *Shipping Forecast*, a report of weather and sea conditions around the British Isles. But most would be unable to locate the place accurately on a map, other than to say that it is located in northern Scotland. Cromarty is, in fact, a rural and remote town on the east coast of the Highlands of Scotland. It is located on an exposed, arrowhead-shaped piece of land on the farthest tip of a distinctive geographical feature known as the Black Isle, which is neither black nor an island. This rich agricultural area is, in reality, a peninsula, separated from its nearest town of any size (Inverness) by the broad, deep waters of Beauly Firth, into which flow the waters of the infamous Loch Ness. Crossing the firth today is by means of a large suspension bridge, but in Miller's time the crossing took place by ferry. The alternative was to circumvent the firth by a circuitous road journey of 40 miles, which even today would take the best part of two hours to drive by car. This is a distinct, idiosyncratic, remote area, and its very 'differentness' had a huge impact on the life and direction of a boy born at the start of the nineteenth century.

Hugh Miller was born in the Cromarty fishing town, the rebellious third child of a local shipmaster and his wife. Cromarty inhabitants earned their money herring fishing, crofting and farming or trading. In the eighteenth and nineteenth centuries, a combination of isolation, poverty, disease, poor sanitation and

dangerous occupations meant that death rates were high, particularly of infants and children. Death was a constant visitor to the fisherfolk of Cromarty. Hugh's father and great uncles were lost at sea, his two sisters died of a fever aged 10 and 12 years respectively, and Miller's first child (Eliza) died aged 17 months (Gostwick 2008). In the absence of orthodox medicine, frantic families often turned to Celtic pre-Christian beliefs in the 'magical' healing powers of local springs. Despairing, desperate people hung 'cloots' or scraps of cloth belonging to a sick person in the trees above a 'charmed' spring in the hope that the cloth would rot and with it the illness. A 'clootie well' still exists on the Black Isle just outside Munlochy, and cloots hang still in the trees above the spring, making this a bizarre and disconcerting place, by today's standards at least.

Against this background of the persistence of pre-Christian beliefs and the presence of this 'constant visitor', it is perhaps not surprising that ghost stories were a common form of entertainment. Well regarded as a self-taught geologist (Miller 1899), Miller was widely known as a social commentator and successful newspaper editor (Taylor 2007), but he started his writing career by scribbling down the ghost tales and local stories he heard at the kitchen hearth. In the low-ceilinged thatched cottage, it is easy to imagine the wide-eyed Miller as a boy listening to tall tales in the twilight gloom of flicking candles, his imagination working overtime, caught up in the expectation and rhythm of familiar stories.

We are all familiar with maxims – a general truth drawn from science or experience; principle, rule of conduct. A Persian proverb states with apt sagacity: 'He who wants a rose must respect the thorn', a warning that the viewer should not be so bewitched by beauty that he fails to comprehend the (obscured) dark side of the object. Personal narrative as maxim is a well-known phenomenon. It flourishes around us, to the amusement of generations of children, if we recognise it. Fairytales are told to us at our parents' knee, but they are dark tales indeed. 'Little Red Riding Hood' is on the surface a folk tale about a little girl travelling unaccompanied through a forest taking food to her sick grandmother. A wolf takes the place of her bed-bound granny, and the little girl is nearly eaten up by the wolf before she eventually triumphs. In reality, this is a maxim and can be seen as a metaphor on the dangers of sexually predatory men to unworldly young women and girls (Warner 1995).

In a piece published in the *Inverness Courier* on 13 May 1829, Miller retold a local folktale, called the 'Story of the Noble Smuggler' (Gostwick 2006). This piece of oral history, originally set in 1773, tells the story of a boat in Cromarty harbour, sailed by Lord Byron – a member of the landed gentry who was a genius writer with a touch of madness. This touch of madness extended to selling casks of smuggled gin to a local fisherman called George Hossack (Gostwick 2006: 5). Miller's retelling of this tale belies perhaps a sneaking admiration for the aristocrat and fellow writer Lord Byron but infers that some social conventions should not be ignored. Miller was not too damning about either Lord Byron or the fisherman supplementing their incomes by smuggling gin to evade the customs. However, both the fisherman and Miller were scandalised by the presence on board Byron's

ship of three women with 'characters worse than doubtful' (Gostwick 2006: 7). The implication of this story is that 'loose morals' in one aspect of Lord Byron's life simply lead to his social decline and madness.

In an interesting twist, when Miller retold this same story in *Tales and Sketches*, the three women were missing from the tale (Miller 1869; Gostwick 2006: 7). Perhaps Miller felt it would no longer be appropriate for him to write about individuals on the periphery of society now that he himself was a respectable married man and a bank accountant. What it does illustrate is that narrative accounts can change through time, perhaps because of a change in the speaker's personal circumstances. This example reveals an essential truth about information or data, including narrative accounts: that 'absence of evidence, is not evidence of absence' (Burn 1969). This archaeological adage is used to remind us that just because there is no evidence for items or events from the past, it does not mean that these items or events did not exist, rather that they left no evidence or that the evidence has subsequently been lost or omitted.

Oral history and narrative records are, by the nature of their transmission, fluid and subject to change. The nature of a personal narrative changes in the telling of that narrative, and this shared story is not the same as the narrator's inner or original story (Ganzevoort 1993). Variations in the narrative may result from external factors, such as the constituency of the audience, or from internal factors, such as the impact of new experiences, age and memory of the speaker, the attitude of the speaker or the speaker's perception of what the listener expects to hear (Ganzevoort 1993). A loquacious, skilled speaker may embroider and embellish to enhance and add colour to a familiar tale, while an inexperienced, hesitant or hurried speaker may include only the highlights and leave it up to the audience to fill in the missing pieces. Ashliman gave a classic example of the natural evolution and maturing of a narrative tale when he compared the Brothers Grimm's tale 'The Frog King', first published in 1812, with the final edition published in 1857 (Ashliman 2004). What is absent (or intentionally omitted) from narrative can be just as fascinating as what is present.

Absences, voids and omissions are not always just empty spaces: they are missing things in the material or narrative record. Deliberate absences may be subtle, skilfully hidden and apparent only to the consummate observer who is already familiar with earlier iterations of a piece or its subject. Alternatively, an 'absence' in a narrative piece maybe something hidden in plain sight from the observer. In Berlin, at the Grunewald S-Bahn station is a stonewall, approximately 3m high, skilfully created with vertical lamina to simulate a geological formation and over-topped with lush green vegetation. Interspersed along this geological 'section' are a number of irregularly spaced holes or cavities. To a casual observer, the cavities are just faults in the wall, but, on closer inspection, some contain candles or flowers. Only when one stands back and really looks is it possible to discern the partial, incomplete outlines of people. This wall leads the viewer up a ramp to the infamous Gleis 17 (Track 17) from which tens of thousands of Berlin Jews were transported directly to the concentration camps of Theresienstadt

and Auschwitz during the Second World War (Ehmann 1993). This inconspicuous sculpture created by Karol Broniatowski in 1991 is a powerful reminder that the transit of thousands of people through the station left little or no material evidence at the site. There are no abandoned personal possessions or bodies to mark their passing. It is the narrative record from survivors and contemporary witnesses that colour the detailed transportation records and help us to understand what occurred at what is essentially a bland and suburban railway station.

The idea of absence continues in Miller's use of narrative as metaphor. The *Concise Oxford Dictionary* describes metaphor as the 'application of name or descriptive term or phrase to an object or action which is imaginatively but not literally applicable'. If maxims are commonplace, then the use of metaphors is likewise. In Scotland, one of the most common lyrical metaphors that is heard comes from the eighteenth-century Borders poet Robert Burns: 'O, my luve's like a red, red rose' (1993: 4). Nothing so poetic for Miller, instead he talks of ghosts as a metaphor for loss. Cromarty, like many other coastal communities suffered from losses at sea due to fishing, cargo and passenger boats floundering in rough seas. Miller thought it worthy of note that from between the autumn of 1829 and the following summer 'a greater number of the inhabitants of Cromarty have perished by the sea than for the thirty years preceding' (Gostwick 2006: 31). Miller wrote in the *Inverness Courier* accounts of 23 people drowned at sea from five separate sailings, detailing the impact of these losses on those with dependant spouses and children and highlighting where these drownings were further insult to those families who had already lost brothers, sons and nephews to the sea. Hugh Miller himself lost members of his immediate and extended family drowned at sea, and Gostwick argues that this had a lasting impact on him and his writing (2006: 31).

In an early biography of Miller, P. Bayne recounted the tale of Miller seeing a ghostly severed hand at the door of the room in which he and his mother, sister and housemaid were sitting (Bayne 1871). He was careful to recall that the weather was calm with no intimation of a storm and that the family had no occasion to worry about his father as they had only just received a positive letter from Miller senior from the port of Peterhead where a storm had forced him, in a ship laden with kelp from the Hebrides, to make anchorage before setting out for home and disappearing in a subsequent storm the following day (Miller 1889: 23). In the event the apparition is suggested by Miller to have coincided with the probable time of his father's death, and Bayne remarks that 'Miller seems to have been persuaded at fifty that the livid hand he saw at [age] five was preternatural' (1871: 13). Miller himself stated that seamen of his generation were firm believers in 'wraiths, ghosts and death-warnings' (Miller 1889: 362), and indeed peppered throughout Miller's autobiography are allusions to spirits and ghosts associated with incidents or places of death and loss.

The final form of narrative that I wish to mention here, memorial, is where Miller's writing is at its most compelling. A memorial marks a place or event that can be joyous, but is more frequently a pungent reminder of some tragic or horrific happenstance, which bears remembrance as an object lesson in avoiding repetition.

One of the most troubling episodes in the history of the Scottish Highlands was the Highland Clearances. In the eighteenth and nineteenth centuries there was the wholesale eviction (or clearance) of tenant families of farmers and crofters (family-sized units of subsistence farmers) from their homes. Flocks of sheep, which afford a more profitable economic return to the landowners, replaced the crofters (Prebble 1982). The clearances left great tracts of Highland hinterland devoid of human occupation. In his article in *The Witness* newspaper, reproduced as a pamphlet *Sutherland as it Was and Is* Miller described the clearances of 15,000 people as 'the fatal experiment' (Miller 1843) and wrote of the desolated, cleared lands of this northernmost country in the UK.

The lairds (landowners) offered their erstwhile crofters, alternative land on the coastal fringes of their estates, but this land was exposed, uncultivated (and therefore, not enriched) and incapable in most parts of supporting cattle, crops or people. The people faced a bleak choice: starvation or emigration. Unsurprisingly, many people chose the uncertainty of new lands over the certainty of a slow death. In 1831, some 1500 people left via Cromarty for a new life in the Americas or Australasia (Gostwick 2006). The departure of one of the ships, called the *Cleopatra*, was witnessed by Miller, who described his impressions in an article entitled 'Unpeopled for Centuries' printed in the *Inverness Courier* on 22 June 1831. Miller wrote that the faint huzzas (cheers) echoing from the departing ship sounded like 'wailing and lamentation rather than congratulatory farewells' (Miller 1831). It was not a joyous departure of the emigrants for the New World.

In all, 38 emigrant ships left Cromarty in the 1830s and 1840s. A stone raised on the foreshore at Cromarty in 2002 commemorates the traumatic departure of so many people from their homeland in search of foreign salvation. Carved by the eminent sculptor Richard Kindersley the standing stone harks back to an earlier tradition of the prehistoric age when stones were place or boundary markers (Piggott 1982). Carved with the names of the 38 migrant ships is Miller's quote about the *Cleopatra*. This modern standing stone marks the transition point for those nineteenth-century travellers: a transition between hopelessness and redemption, starvation and survival, ancient allegiances and striving independence. In addition, however, the stone is the marker between land and sea, past and future, known and unknown, familiar and foreign. Those migrants must have had very mixed feelings when they boarded those small wooden ships and sailed from desperation to a (literally) new world.

Knowing and understanding people's motivations for certain actions is rarely straightforward. An object is an object, but what it means to one person can be entirely different to what it represents to another individual. The material record may also appear to be more accessible and understandable than the narrative record, but, in fact, it is the story behind an object that gives it meaning, colour and context. A most striking example of the use of personal narrative in the museum context is the narrative statement shown at the end of the Holocaust Exhibition at the Imperial War Museum London.

Arguably, any exhibition about the Holocaust is going to be a difficult experience or at least it should be. The topic fills us with such revulsion and horror that comprehension may be limited. How does the visitor imagine the unimaginable? The answer comes in the form of video witness statements from elderly people who were children or young people when these events occurred. In particular, the narrative from Ruth Foster, a survivor of Auschwitz concentration camp, is particularly powerful.

> I have been asked many times when I tell my story, 'could you ever forget?' Then I tell them, it is as when you stand on a lake, and you throw a stone into a lake, first you have large ripples, then the ripples get smaller and smaller still, then the surface is calm but the stone is still at the bottom. That is the same with me and that sums me up. I am, appear, like an ordinary human being, but the stone of my experiences is still lying in my heart. (Foster 1998)

Foster's use of the metaphorical image of the ordinary pebble in the pool to represent her experiences is a most resonant insight into circumstances that are far outside of the normal experiences of the average museum visitor. Eyewitness narrative allows the listener to sympathise, perhaps empathise, with the eyewitness and helps them gain insight that is both authoritative and compelling and which would not otherwise be available.

At the start of this chapter the question was posed about the desirability or legitimacy of museums and heritage sites, whose primary function may be considered as engagement, to display images or interpret stories that are challenging or difficult for the visitor. It is the contention of this chapter that not to do so is an abrogation of our duty as the temporary custodians of material and narrative records. Narrative is not without its limitations, it is not a 'forensic' truth but one interpreted by the speaker and the listener. However, that does not make narrative intrinsically unreliable or unusable. Narrative records have an exceptional ability to enable the listener (or viewer) to make a meaningful connection with people, events or topics that would otherwise be difficult to understand.

To this end, the narrative record is a valuable tool to facilitate engagement and understanding (Bedford 2001, 2004; Rounds 2002). Eyewitness history is a resonant art, not a fixed science. It is a fluid, variable medium, affected by the experiences of the speaker and the listener. The omissions (absences) from the narrative can be equally, or even more, significant, than the inclusions. Personal narrative is a unique, powerful and insightful form that can evoke empathetic recognition. Ultimately, our most compelling experiences, good or bad, provoke in us a uniquely personal response that can persist over a lifetime.

Acknowledgements

Thanks are due to the following organisations and people, without whose assistance this chapter would not have been written. The staff and volunteers of the Highlanders' Museum and later, the National Trust for Scotland's Hugh Miller Birthplace Cottage and Museum for their generosity and patience in allowing me to abrogate my responsibilities in the day-to-day running of the museums in order to wander off and study memorial and commemoration. Jenny Kidd, Sam Cairns, Alex Drago and the other members of the organising committee of the Challenging History Conference, London 2012, for making me put pen to paper. Amy Ryall and Emily Fuggle at the Imperial War Museum, London, for their assistance in obtaining the verbatim quote from the Holocaust Exhibition. Finally, to Ruth Foster for allowing me to temporarily hold her heart stone in my hand.

References

Ashliman, D.L. 2004. *Folk and Fairy Tales. A Handbook*. Westport, Conn.: Greenwood Press.

Bayne, P. 1871. *The Life and Letters of Hugh Miller*. London: Strahan & Co.

Bedford, L. 2001. 'Storytelling: The Real Work of Museums', *Curator: The Museums Journal* 44(1): 27–34.

—— 2004. 'Working in the Subjunctive Mood: Imagination and Museums', *Curator: The Museums Journal* 47(1): 5–11.

Black, G. 2011. 'Museums, Memory and History', *Cultural and Social History* 8(3): 412–27.

Bock, Z., et al. 2006. 'An Analysis of What has been "Lost" in the Interpretation and Transcription Process of Selected TRC Testimonies', *Stellenbosch Papers in Linguistics PLUS* 33: 1–26.

Boyce, M. 1979. *I Was There*. London: Weidenfeld & Nicholson.

Brandon, L. 2005. *Art or Memorial: The Forgotten History of Canada's War Art*. Calgary: University of Calgary Press.

Burn, A.R. 1969. 'Review of W.F. Grimes, *The Excavation of Roman and Mediaeval London*', *Classical Review* 19(2): 321.

Burns, R. 1993. *The Complete Poetical Works*, ed. James A. Mackay. Darvel, Ayrshire: Alloway Publishing Ltd.

Coleridge, H.N. 1835. *Specimens of the Table Talk of the Late Samuel Taylor Coleridge*. London: John Murray.

Ehmann, A. 1993. *Die Grunewald-Rampe: Die Deportation der Berliner Juden*. Berlin: Edition Colloquium.

Foster, R. 1998. Interview for the Imperial War Museum (October Films). EXH 166, Reel 30-32. Imperial War Museum, London.

Freeman, M. 2002. 'Charting the Narrative Unconscious: Cultural Memory and the Challenge of Autobiography', *Narrative Inquiry* 12(1): 193–211.

Ganzevoort, R.R. 1993. 'Investigating Life Stories: Personal Narrative in Pastoral Psychology', *Journal of Psychology and Theology* 21(4): 277–87.

Gostwick, M. (ed.) 2006. *A Noble Smuggler and Other Stories*, 2nd edn. Inverness: The Inverness Courier.

—— 2008. *In the Steps of Hugh Miller: Hugh Miller Museum and Birthplace Cottage.* Edinburgh: National Trust for Scotland.

Hollway, W. 2001. 'The Psycho-Social Subject in Evidence-Based Practice', *Journal of Social Work Practice* 15(1): 9–22.

Kelly, L. 2007a. 'Visitors and Learners: Adult Museum Visitors' Learning Identities'. Paper presented at the ICOM-CECA Conference, Vienna, Nov. 2007.

—— 2007b. 'The Interrelationships between Adult Museum Visitors' Learning Identities and their Museum Experiences'. PhD thesis: University of Technology, Sydney.

Kidd, J. 2011. 'Challenging History: Reviewing Debate within the Heritage Sector on the "Challenge" of History', *Museum and Society* 9(3): 245–8.

Lohrey, A. 2010. 'The Absent Heart', *The Monthly* 57 (June). Available at <http://www.themonthly.com.au/issue/2010/june/1276143346/amanda-lohrey/absent-heart?page=1> (accessed 15 Sept. 2013).

Miller, H. 1831. 'Unpeopled for Centuries', *Inverness Courier* (22 June); repr. in M. Gostwick (ed.), *A Noble Smuggler and Other Stories*, 2nd edn. Inverness: The Inverness Courier, 2008.

—— 1843. *Sutherland as it Was and Is; or, How a Country may be Ruined* [pamphlet]. Edinburgh: John Johnston.

—— 1869. *Tales and Sketches from Northern Scotland or, the Traditional History of Cromarty*, 3rd edn. Edinburgh: William Nimmo.

—— 1889. *My Schools and Schoolmasters or, the Story of my Education.* Edinburgh: William Nimmo, Hay and Mitchell.

—— 1899. *The Old Red Sandstone, or, New Walks in an Old Field*, 7th edn. Edinburgh: William Nimmo.

Paley, J., and G. Eva 2005. 'Narrative Vigilance: The Analysis of Stories in Health Care', *Nursing Philosophy* 6: 83–97.

Piggott, S. 1982. *Scotland before History*. Edinburgh: Edinburgh University Press.

Prebble, J. 1982. *The Highland Clearances*. London: Penguin.

Rounds, J. 2002. 'Storytelling in Science Exhibits', *Exhibitionist* 21(2): 40–43.

Taylor, M.A. 2007. *Hugh Miller: Stonemason, Geologist, Writer.* Edinburgh: National Museums of Scotland.

Warner, M. 1995. *From the Beast to the Blonde: On Fairy Tales and Their Tellers.* London: Vintage Press.

Chapter 4
Making Them Laugh, Making Them Cry: Theatre's Role in Challenging History

Judith Bryan

Memory, history and theatre are often metonymic, using symbols, images and fragments to awaken the past. Through interpretation, both the museum and the visitor, directed by the former, are actively engaged in constructing narratives through which to understand history. Kirschenblatt-Gimblett reminds us of the fundamental theatricality of heritage, in which 'museums perform the knowledge they create' (1998: 3). Artefacts encode individual and collective human experience. History is re-animated through visual, aural and linguistic stimuli. Reconstructed sites and spaces, vibrating with invisible human presence, are like stage sets awaiting actors. Live performances in museums, from costumed interpreters to complete narratives, use all of the above: the added dimension is 'liveness', the active embodiment of lived experience, a powerful tool to capture and potentially keep the viewer's attention.

This chapter proposes that live performance creates, through audiences' experience and memory, an enduring artefact uniquely suited to facilitate museum visitors' exploration of challenging material. Specifically, the chapter examines two theatrical events that took place in museums during 2011. The research takes the form of an analysis of each production and conversations with key practitioners at both museums and with both theatre companies. Neither production originated with the host museum, although both were deeply relevant to the museums' collections. Only one was site-specific. Both caused logistical challenges for their respective hosts. However, by reframing 'visitors' as 'audiences', these productions suggest intriguing ways of interpreting challenging histories. Additionally, by virtue of being performance runs as opposed to one-off events, the two productions provide an opportunity to consider the effect of *duration* in using theatre as an interpretative and re-interpretative tool.

Whose Blood, by Alex Burger, enjoyed a sell-out 18 day performance run at the Old Operating Theatre Museum and Herb Garret (OOTM),[1] located in the roof of St Thomas' Church tower, within the old city of London beside London Bridge.[2]

1 <www.thegarret.org.uk>.

2 *Whose Blood*, written by Alex Burger (2011), produced by Bank Cider Productions and directed by Karena Johnson, was first performed at the Old Operating Theatre Museum, London (23 Feb.–12 Mar. 2011). During this time there were two performances at Guys and

St Thomas' Hospital (now part of the Guys and St Thomas' Hospital Trust) grew around the church, providing medical care for parishioners. In 1822, the operating theatre was built for the treatment of female patients. The original herb garret, an early apothecary and dispensary, was an essential part of this provision. With a seating and standing capacity of over 60 persons in the operating theatre, visiting surgeons, medical students and esteemed guests could witness for themselves the wonders of 'modern' surgical practice. Abandoned in 1862, the space was rediscovered in 1956 and fully reconstructed as a heritage site and museum.

Inspired by this unique setting, the play was commissioned by the London Fringe Theatre Festival and funded by the Arts Council and the Wellcome Trust.[3] The title derives from the museum's education resource pack, 'Our Blood', which covers the history of medicine from the fifteenth to the nineteenth century. In his choice of title, therefore, Burger marked his intention to interrogate history.

Set in 1831, the story concerns a Ghanaian couple's fatal encounter with the nascent medical establishment. Prior to the 1832 Anatomy Act, only the corpses of executed murderers could be used for medical dissection. By 1831, following a decline in executions, the legal supply of bodies had become scarce. Abakah and Efua are immigrants, free black people seeking a new life in an increasingly diverse and metropolitan London. When Abakah becomes ill, his wife rejects traditional herbs and rites in favour of the knowledge of their adopted country. To please her, Abakah attempts to get treatment at St Thomas' Hospital but parish Poor Laws mean he is turned away.[4] In the gin parlour where Efua works, she meets Hugo, an ambitious young surgeon. Attracted both to this unusual woman and to the opportunity for medical advancement, he persuades his superior, Samuel Carter, to operate on the ailing man. But Carter is addicted to laudanum. He self-medicates to escape his revulsion at the gore and distress of surgery. So Hugo operates instead, using an experimental procedure. The surgery fails; Abakah dies. Having sold his body to the surgeons in the event of his death, Abakah's corpse is retained for medical science. Efua returns to Ghana with their child, her adventure in the new world of the Old World tragically over.

The space works with the text to create in audience members the sensation of going back in time. They enter through the steeply winding stairs of the church tower and pass through the museum shop then the museum, navigating the glass display cases of bones, foetus hooks and amputation saws, before arriving in the old operating theatre itself. It is night. Inside, the lights are dim; the small, crowded

St Thomas' Hospital. The play transferred to Broadway Barking Theatre (6 Oct. 2011) as part of Black History Month.

3 <www.wellcome.ac.uk>. The Wellcome Trust offers a number of funding schemes to support 'research at the interface of medical science, history and the wider humanities'. They provided a small grant to enable research and development of the play.

4 The Poor Laws provided relief for indigent parishioners. Immigrants were automatically excluded, unless they could prove settlement of between one and three years (Senior 1905).

room is windowless, save for a darkening skylight. Surgeons' aprons hang on the wall; a cabinet contains wood and metal instruments. The operating table squats in the centre of the room, surrounded on three sides by narrow seating, precipitously raked. The resulting atmosphere is intimate, almost claustrophobic. And then a black woman enters, dressed in West African clothing.

The text notes state: '[Efua] performs a libation [as she] sings a song to ... the Deity of the River, who intercedes in difficult cases' (Burger 2011). The Fante words are not translated. Unless they are themselves Fante speakers, the audience has to rely on the actor's intonation and gesture to intuit the scene's meaning. They are in unfamiliar territory and must work to locate themselves in relation to the unfolding story. Efua then addresses the audience in English, as 'surgeons in training from Guys and St Thomas' come to observe an operation. She invites them to go with her 'into the land of ghosts and memory'. The central action of the play is an extended flashback, framed by the Fante ritual. In the final scene she reveals that it is a year since her husband's death and the eve of her return to Ghana: the ritual has served to ease both her passage home and Abakah's passage to the afterlife.

A large part of the play's power is in what Anthony Jackson terms 'un-settlement': an audience's experience of 'having expectations overturned, assumptions about the subject matter challenged, or finding that they were personally confronted with strong emotion' (Jackson 2011: 18). Having enabled a double defamiliarisation, Burger foregrounds notions of 'seeking'. The surgeons' endeavours are representative of the imperial quest – a literal and metaphorical examination of the African body. Efua's quest represents its inversion, as she attempts to acquire the knowledge and habits of England. All four characters make accommodations and sacrifices, adjust to expediency and compromise their values in the face of difficult choices. The text recalls Foucault's notion of 'the great strategies of geopolitics' married to 'the little tactics of the habitat' (1980: 149). For the audience, bearing witness to the characters' pain and struggle, the feeling of voyeuristic complicity is inescapable. Those struggles resonate with the stories of modern migrants, whether in flight from repressive regimes or in pursuit of dreams. There are contemporary parallels also with recent medical scandals over unauthorised tissue retention, unregulated experimentation, the sale of organs by impoverished living donors and the treatment of patients in hospitals.

By giving the lead role – the literal voice of the play – to the Ghanain woman, Burger reframes history. He makes clear associations between urbanisation, scientific exploration and the transatlantic slave trade. In doing so, he interrogates Enlightenment notions of progress and of primitiveness versus civilisation. In keeping with the museum's collection of herbs, potions and cupping jars, the medical advances of the age – when doctors were recommending snail-water for venereal disease and blood-letting for just about everything else – are exposed as largely speculative, bounded by superstition and myth. By comparison, the belief systems of the Ghanain couple are presented as at least of equal validity to those of the surgeons, whose vaulted rationality is undermined by moral and physical

frailty. The character Carter is representative of historical medical pioneers. His addiction to laudanum allows us to reflect on the great burden of progress: the fates of all four characters enable us to see its costs.

Where *Whose Blood* examined the societal and historical confluences of a single year, George C. Wolfe's *The Colored Museum* (1988) takes its audience on a whistle-stop tour of 200 years of African American identity. Originally written and performed in 1986, the play was revived at the Victoria and Albert Museum (V&A)[5] to mark the twenty-fifth anniversary of Britain's foremost black theatre company, Talawa.[6] Patricia Cumper, Talawa's then artistic director, was in the process of setting up the company archive at the V&A, when she came across the text in the museum's Theatre and Performance collections. She thought it would be a good idea to stage a commemorative production. She approached Geoffrey Marsh, the museum's director of the Department of Theatre and Performance: his response to her request was an immediate and unequivocal 'Yes' (Patricia Cumper, interview: 2011). Directed by Don Warrington, the production ran for nine days (15–23 Oct. 2011) in the V&A's Lydia and Manfred Gorvy Lecture Theatre. Originally completed in 1869, the room forms part of the museum's Grade 1 listed building status. Featuring an ornate gilded half dome over the stage, it was fully refurbished in 2011 with walnut-veneered acoustic panelling, candelabras and new padding to the raked seating.

The play comprises a series of vignettes and comedy sketches, presenting 11 singing and dancing 'living exhibits'. It begins and ends with Miss Pat, 'flight attendant' on a slave-ship bound for Savannah. In the opening sketch, titled 'Git on Board', she offers complimentary shackles and warns passengers about the strict 'no-drumming' policy. In the words of one reviewer, 'the rest is history' (Fisher 2011). There is Aunt Ethel, cooking up 'a batch of negroes' on her parody of a TV cooking show. In 'The Hairpiece', two wigs debate the sexual politics of the afro over straight tresses until their owner fears she is having a breakdown. In 'Symbiosis', Man, in a business suit and tie, battles with Kid, the personification of his more hip, more racially conscious teenage self. And in 'The-Last-Mama-on-the-Couch-Play', Wolfe lampoons a variety of black theatrical icons including Lorraine Hansbury's hallowed drama, *A Raisin in the Sun* (1958).

Where *Whose Blood* contains a focused, largely linear storyline, *The Colored Museum* is a fractured narrative, a collage of scenes that, both within themselves and taken as a whole, eschew resolution. This open-ended nature encourages a subjective interpretation of meaning. Wolfe recognises history and personal experience as multiple, contradictory and complex. However, in their essential structure the plays are similar: both employ a narrator as the framing device, and in

5 <www.vam.ac.uk>.

6 Talawa's website states: 'We create outstanding work informed by the wealth and diversity of the Black British experience. We invest in talent, build audiences and inspire dialogue with and within communities across Britain. By doing so we enrich British cultural life' (Talawa Theatre Company 2012).

both cases that narrator is a black female. The black woman's voice is one of those least heard in history. She is frequently without agency, unacknowledged, invisible to the white gaze. But in these texts, as a deep provocation to the audiences' assumptions, the black woman controls the drama. In Burger's play, she reveals herself to be curious, wilful, passionate, adaptable, even wily. In Wolfe's she is similarly multifaceted, each new black female character first embodying and then exploding a black female stereotype.

This multiplicity of voices and perspectives concurs with Jackson's exploration of Bakhtin's theory of 'heteroglossia' as applied to museum theatre:

> If heteroglossia is at work in the drama then there will be a range of voices, world views and dramatic registers ... that will challenge the audience to participate because there is no one clear authorial stance that governs the meanings we take from the event, or that does the work for us. (Jackson 2011: 21–3)

In the duality of his characters' personas, Wolfe acknowledges 'the internalization of the self-as-other' (Hall 1996: 445). Wolfe provokes an internal conversation within each audience member by staging a conversation between the conflicting selves of his characters. This is most explicit in 'The Hairpiece' and 'Symbiosis', where the performative nature of identity is observable through the characters' choices of accessories or cultural icons. In 'Symbiosis', Man declares: 'If I'm to become what I'm to become then you've got to go. ... I have no history. I have no past.' Later in the scene, Kid counters with: 'Well, look at Mr. Cream-of-the-Crop, Mr. Colored-Man-on-Top. ... you may put all kinds of silk ties 'round your neck and white lines up your nose but the Kid is here to stay.' Their final battle takes place over an iconic Motown album by The Temptations (Wolfe 1988: 34–6).

As in *Whose Blood*, actors directly address the audience, positioning its members as active participants in the drama. When Miss Pat gives instruction in slave-ship etiquette, Wolfe's text reads: 'Repeat after me. "I don't hear any drums." (*The audience repeats.*) "And I will not rebel." (*The audience repeats. The drumming grows*)' (1988: 3). At the performance I attended, the audience spontaneously joined Man in an acappella rendition of The Temptations' song 'My Girl', punctuated by nostalgic laughter.

The play's closing words belong to perky stewardess, Miss Pat: 'Before exiting, check the overhead as any baggage you don't claim, we trash' (Wolfe 1988: 53). Which aspects of identity are 'trash' and which 'baggage' is not always clear. Indeed, Wolfe suggests some burdens are too precious to discard; although aspects of self may be inconvenient, irksome even insane, they must at least be recognised. He raises a last, sly question: who is the 'you' instructed to check the lockers, and who is the 'we' who trashes unclaimed baggage?

For Kirschenblatt-Gimblett, 'while an artefact may be viewed as a record of the process of its manufacture, as an indexical sign ... performance is all process. Through the kind of repetition required by stage appearances, long runs and

extensive tours, [folkloric] performances can become artefacts. They freeze. They can become canonical' (1998: 64).

The Colored Museum functions both as a parody of folkloric performance and a celebration of the form. Wolfe consistently discomfits the audience with the tension between the two and by refusing binary oppositions. Whilst the actors' singing and dancing are virtuoso, they are also stereotypical. Wolfe proposes that black identity has 'frozen' because it is detached from its performative context. Literally taken out of Africa, combined with the antithetical norms and values of the slavemasters, the performance of self becomes fixed in a 'time warp' so that contemporary emendations serve only to further distort or dilute.

Staged in the beautiful surroundings of the Lydia and Manfred Gorvy Lecture Theatre, *The Colored Museum* is a high-octane, high-volume extravaganza. Anarchic and alive, it forms a provocative contrast to the whispering stillness of the Silver Gallery, gleaming with vast punch bowls, candelabras and plaques, through which the audience walks in order to gain access. Writing in *The Guardian*, theatre critic Lyn Gardner suggested that, '[the event] would be more effective still if it was played out amid the display cases in one of the galleries' (2011). Without this literal spatial juxtaposition, the audience instead carries the recent memory of the wider museum into the enclosed space of the lecture theatre. There they find a pared down set, by designer Jonathan Fensom, consisting of three huge wooden storage crates that open and unfold like magician's boxes. Through clever use of lights, the wood-panelled walls, inlaid parquet floor and painted ceiling recede. The specifics of the V&A become subsumed into a museum of the imagination.

Because the event is a museum within a museum, the audience is encouraged to reappraise the idea of 'the museum'. Does it exist to preserve, to catalogue or to commemorate? In relation to its artefacts, are we to revere them, judge them as outmoded or merely to look? Are we consumers or participants? (Casey 2005). Ultimately the question becomes, are we made by history or do we make it? Marsh says the production's ability to interrogate these issues was its primary attraction. For him, museums mark and commemorate moments of change and should continue to do so, rather than rely on aestheticising history through artefacts. An advantage of theatre is its capacity to make history provocative in the sense of stimulating an interrogation, thus enabling new ways of seeing (Geoffrey Marsh, interview: 2011).

Both plays, like all effective theatre, handle a number of simultaneous themes in complex yet accessible ways, to create an experience that is both visceral and cerebral (Edgar 2009). Like museums, playwrights and other theatre professionals have expertise in analysing, interpreting and communicating research materials for an audience. Because drama's stock in trade is conflict, theatre professionals are also skilled in addressing difficult, potentially painful subject matter. Crucially, theatre attaches human experience to abstract ideas and, through the imagination, moves beyond bare facts to a re-animation of the past. What begins as a dialogue between characters (and within characters) on a stage, continues between actors and audience and within the audience itself.

The OOTM's curator, Karen Howell, has extensive experience of working with arts projects, including performance collaborations with nearby theatre Southwark Playhouse. However, she and playwright Alex Burger both spoke to the author, with much sympathy for the other's position, of the logistical difficulties of putting theatre in the museum.

Howell provided Burger with initial source material and directed him to archives but she and the small staff team were busy managing the museum and unable to provide ongoing consultation. The daily business of the museum could not be displaced, prohibiting daytime rehearsals. The production was scheduled at night for the same reason, necessitating overtime pay for staff. The narrow staircase made the bringing in of bulky equipment painfully difficult. Nor could the company store equipment due to lack of surplus storage space in the building. Installing lighting rigs and sound equipment is often problematic in a protected heritage site. What was originally conceived of as a three-month project took almost two years from conception to first performance.

Despite this, Howell remains committed to using theatre and other arts in the museum. She recognises that performance in the OOTM foregrounds the performative nature of medicine (Karen Howell, interview: 2011). The very act of seating an audience for a show restores the space to its original function. That audience brings to the operating theatre a similar sense of anticipation and risk, a similar desire to be entertained and informed, as did its first visitors.

Nor is Howell risk averse. For her, the instinctive conservatism of medicine together with the inherent conservatism of museums and heritage sites necessitates interpretive methodologies able to disrupt assumptions, radicalise visitors and open up debate. She recommends that theatres and museums first decide why they want to work together and whether the organisations are a good fit. As part of this, the purpose of the production should be mutually agreed. Both she and Burger attributed many difficulties to a lack of clarity in the initial stages of their working relationship. However, Burger states: 'It was difficult until the first performance, and then it was easy' (Alex Burger, interview: 2011). Ultimately, both agreed that the shared benefits of the product compensated for the challenges of the process.

Talawa and the very large, very well-resourced V&A echoed some of the *Whose Blood* collaborators' logistical concerns. The issue of night staffing and security, with its attendant costs, is for Marsh symptomatic of the conflicting modes of operation between museums and theatre companies: the production cost £600 per night, meaning that the V&A funded the production to the tune of £1,200 to allow for two evening performances (Geoffrey Marsh, interview: 2011). However, these obstacles were ameliorated by several pre-existing conditions. Marsh had already established a professional relationship with Cumper, the former having recently agreed to house Talawa's archives. Talawa itself constitutes an established team, accustomed to staging work in non-traditional theatre spaces and therefore able to anticipate many potential problems. Cumper engaged the services of a production manager with a track record of staging work in museums, 'because he understood the culture'. Additionally, the company had a clear methodology: for example,

Cumper instituted a RACI (Responsible, Accountable, Consulting, Informing) spreadsheet system identifying every stage of the process and assigning roles. The team was able to track every task and who was doing it. The company had its own rehearsal space. Publicity was two-pronged, using both Talawa's and the V&A's marketing machinery. The museum made available a group of four interns throughout the planning period and for the duration of the production. Lastly, the collaboration centred on an extant text. The process from idea to first performance took barely nine months.

Some commentators have suggested that a few of the play's references were dated or obscure in the British context (Gardner 2011; Fisher 2011). Arguably, the production would have benefitted from a longer gestation, to allow for the text to be updated and possibly relocated. However, for Cumper not only was time (and money) of the essence, with Talawa's twenty-fifth anniversary approaching, but the original text actually facilitated each audience member asking and answering for themselves the question: 'How far have we come from these stereotypes in the past twenty five years?' (Patricia Cumper, interview: 2011).

Handbooks on using theatre in museums, such as Bridal's *Exploring Museum Theatre* (2004) and Hughes's *Museum Theatre* (1998), identify similar difficulties to those encountered by both productions. However, as Jackson and Kidd assert, 'just because this research has unearthed the complexity of performance in museums, it is critically important not to see this as overly daunting' (2008: 141). An examination of each production's methodology suggests that creative constraints are to be embraced for their potential to provoke innovative responses and apposite outcomes. Wolfe's notes for *The Colored Museum* suggest the staging should be 'white walls and recessed lights. A starkness befitting a museum where the myths and madness of black/Negro/colored Americans are stored' (Wolfe 1988: 3). Unable to transform the aesthetics of the V&A's lecture theatre, Fensom's resulting set had an improvisational, ad hoc feel that mirrored the content and thesis of the play.

Similarly, the physical limitations of the Old Operating Theatre Museum led to *Whose Blood* enjoying two performances in Guys and St Thomas' Hospital. Burger says, 'the Arts people at Guys and St Thomas' ... gave us a little bit of money but more than that, it was important in terms of disability access. You couldn't get wheelchairs and so on [into the OOTM], so to open it up ... to get access, to show it to actual patients and doctors, it was exciting' (Alex Burger, interview: 2011). When the play transferred to Barking Theatre, where Karena Johnson is the artistic director, the production team were much facilitated by having already staged the play outside the original site. Vitally, because the play began life as a site-specific event, they took with them across London the work of OOTM and a physical manifestation of the space.

The audience for a performance run is not the same as the 'passing trade' of a one-off show: they come to the performance prepared for an experience. In the example given above, the audience at Guys and St Thomas' hospital were given advance information about the production; similarly, the community groups

attending the V&A. For general audience members, individuals symbolically buy into the event through the literal act of purchasing tickets. They can inform themselves in advance as to the nature of the production. They may have read reviews, seen publicity materials or had word of mouth recommendations. Crucially, they are probably primed for any potentially challenging aspects. In the words of Janet Browne, the V&A's programme manager, Black Heritage and Culture, 'audiences [for performance runs] are already in a mode of acceptance' (Janet Browne, interview: 2011).

Performance runs are expensive. The need to elicit the support of external funders helps raise awareness of the museum's activities. This becomes part of taking the museum out of the museum and actively engaging third parties in its development. For *Whose Blood*, the Wellcome Trust requested that the writer undertake additional historical research to satisfy its funding criteria. Burger consulted William Bynum, professor emeritus of the history of medicine at University College London, and Helen Bynum, medical historian, whose joint expertise underpins the complexity of medical issues the play successfully explores. Additionally, Helen Bynum's review of the play appears on the Wellcome Trust website, effectively advertising both the play and the work of the OOTM, whilst underlining in content and context the relationship between art, history and scientific research (Bynum 2011).

The museum and the theatre must invest time and energy in marketing to ensure an audience commensurate with the initial expenditure of staging the event. Talawa Theatre Company is based in a commercial, urban district in north London. By staging the production at the V&A, it generated audiences new to the museum, which is in the heart of South Kensington, an exclusive, leafy district in west London. This was achieved, in part, through the theatre company's existing relationships with black elders and youth groups. At the same time, the huge marketing machinery of the V&A, partly staffed by unpaid, multifunctional volunteers, ensured consistently good ticket sales. Browne is quite clear that the production brought 'a different audience and engaged with audiences in a different way. That might allow visitors to [also] see the regular collections in a different way' (Janet Browne, interview: 2011).

For *Whose Blood*, there were limitations to collaboration between museum and production team. At the V&A, because staff seconded to the production were interns rather than employees, expertise developed during the process is likely to be lost, so that each new production risks having to reinvent procedures. Nonetheless, the sustained cross-fertilisation of expertise and resources offered by performance runs has great potential for addressing the museum sector's concerns regarding staff training in relation to challenging histories, as identified in *Challenging History: Summative Document* (Kidd 2009).

Arguably, the very transience of theatre in the museum disrupts the fixed nature of the museum. However, theatre is only superficially transient. It evokes deep emotions that linger long in the memory, creating a sustained impact. As evidenced by the findings of the *Performance, Learning and Heritage Report*, this

is especially true of work which used 'un-settlement' (Jackson and Kidd 2008). In performance runs, the extended nature of the process necessarily serves to broaden and deepen this impact. Both productions attracted wide (and almost entirely favourable) critical attention precisely because they were staged in their respective museums. Talawa held a post-performance talk with Dr Robert Beckford, 'Black Myth versus History', that had to be extended by almost an hour, so engaged were the participants. Audience evaluations urged the company to take production on tour and explicitly stated a wish to 'keep talking about the issues raised' (Talawa, audience response: 2011).

Theatre is essentially dialogic, therefore apposite to the disruption of monologic 'big' narratives. Performance runs in museums stimulate a conversation: between funders and recipients, amongst audience members and between museum staff, the theatre company, critics and the public. In our multi-media age, where readers respond to online reviews and blogs, this conversation remains as tangible documentation. Moreover, memories of the performance, and the personal responses thus evoked, become themselves a form of artefact – but one that explicitly acknowledges multiple interpretations. Thus Kirschenblatt-Gimblett's warning against performance becoming fixed is overturned; instead, performances, and particularly performance runs, create a vibrant and fluid element in the museum's interpretation of history.

References

Bridal, T. 2004. *Exploring Museum Theatre*. Waltnut Creek, CA: Alta Mira Press.

Burger, A. 2011. *Whose Blood* [unpublished play script].

Bynum, H. 2011. 'Whose Blood: A Tale of Desire and Despair Set in a 19th-Century Operating Theatre'. Available at <http://wellcomehistory.wordpress.com/2011/12/12/whose-blood-a-tale-of-desire-and-despair-set-in-a-19th-century-operating-theatre/> (accessed 8 Sept. 2012).

Casey, V. 2005. 'Staging Meaning: Performance in the Modern Museum', *TDR: The Drama Review* 49(3): 78–95.

Edgar, D. 2009. *How Plays Work*. London: Nick Hern Books.

Fisher, G. 2011. 'The Colored Museum: Victoria and Albert Museum', *Afridiziak Theatre News*. Available at <http://www.afridiziak.com/theatrenews/reviews/oct2011/the-colored-museum.html> (accessed 2 Feb. 2012).

Foucault, M. 1980. 'The Eye of Power', in *Power/Knowledge: Selected Interviews and Other Writings 1972–1977*, ed. C. Gordon. New York: Pantheon Books.

Gardner, L. 2011. 'Colored Museum Review', *The Guardian*. Available at <http://www.guardian.co.uk/stage/2011/oct/17/colored-museum-review> (accessed 2 Feb. 2012).

Hall, S. 1996. 'New Ethnicities', in David Morely and Kuan-Hsing Chen (eds), *Stuart Hall: Critical Dialogues in Cultural Studies*. London: Routledge.

Hansbury, L. 1958. *A Raisin in the Sun*. New York: Vintage Books [1994].

Hughes, C. 1998. *Museum Theatre: Communicating with Visitors Through Drama.* Portsmouth: Heinemann.

Jackson, A. 2011. 'Engaging the Audience: Negotiating Performance in the Museum', in A. Jackson and J. Kidd (eds), *Performing Heritage: Research, Practice and Innovation in Museum Theatre and Live Interpretation.* Manchester: Manchester University Press.

—— and J. Kidd 2008. *Performance, Learning and Heritage Report.* Centre for Applied Theatre Research, University of Manchester. Available at <http://www.plh.manchester.ac.uk/documents/Performance,%20Learning%20&%20Heritage%20-%20Report.pdf> (accessed 1 Dec. 2013).

Kidd, J. 2009. *Challenging History: Summative Document.* Available at <http://challenginghistorynetwork.wordpress.com/resources/> (accessed 20 Dec. 2012).

Kirschenblatt-Gimblett, B. 1998. *Destination Culture: Tourism, Museums and Heritage.* Berkeley: University of California Press.

Senior, N. 1905. *Poor Laws Commissioners' Report of 1834.* Library of Economics and Liberty. Available at <http://www.econlib.org/library/YPDBooks/Reports/rptPLC.html> (accessed 10 Feb. 2012).

Talawa Theatre Company 2012. 'About Talawa'. Available at <http://www.talawa.com/about_talawa.php> (accessed 5 Feb. 2012).

Wolfe, George C. 1988. *The Colored Museum.* New York: Grove Press.

Chapter 5

The Stiftelsen Arkivet Experience:
A Second World War Gestapo Regional
Headquarters in Norway

Bjørn Tore Rosendahl and Ingvild Ruhaven

In January 1942, the German Security Police (SiPo) and the Gestapo established their regional headquarters in the state archive building in Kristiansand in the southern part of Norway. Waves of arrests followed, and the site soon became renowned among the local population for the cruel torture the Gestapo used during the interrogations that took place there. In the trials that followed the war, the court found evidence of over 300 cases of brutal torture and the execution of almost 50 Soviet prisoners of war by Gestapo personnel.

After the war, the building returned to its original use until, in 1998, the state archive moved to other premises. In 2001, this former Gestapo headquarters was opened as a centre for historical reflection and peace-building, led by Stiftelsen Arkivet (Archive Foundation), and with several humanitarian organisations present on-site: the UN Association, Save the Children, the Red Cross and Amnesty International.

Stiftelsen Arkivet is a historic site, but it is also a war memorial, because of the human suffering that is commemorated in different ways on-site.[1] In the basement, an exhibition has been installed where visitors can learn about the events that took place through traditional interpretive displays including text, objects and reconstructed rooms. The site is also an education centre, delivering educational programs to about 7,000 learners annually. Audiences largely consist of 15-year-old students, who get a guided tour of the exhibition followed by a session in the education centre, where the historical events are used as a basis for developing greater reflective skills toward the past and present. Values like human rights, human dignity and democracy are explicitly promoted.[2]

Funded by Norway's Ministry of Education and Research and trusted by the local schools, it is expected that Stiftelsen Arkivet's learning programmes are based

1 A widespread assumption is that memorials recall only tragic events, but this is contested by the influential professor James E. Young (Young 1993: 3–4). Stiftelsen Arkivet can be understood as a memorial in both views.

2 Promotion of values in education is both controversial and challenging, but will not be discussed in this chapter (see Rosendahl 2011).

on contemporary pedagogical practice and correlate with the national curriculum, in which, among other things, the development of historical consciousness is vital (see also Ceri Jones, Chapter 17, this volume).[3] Learning programmes are also informed by international standards provided by the Council of Europe that history teaching must be in accordance with 'up to date' historical research and encourage critical thinking (Council of Europe 2011).

But is it possible to promote critical analysis at a historic site like a war memorial? According to the British–Dutch writer Ian Buruma, it is not. In *Wages of Guilt*, he describes a memorial as a 'religious or quasi-religious monument where remembrance of the past is a collective ritual. People pray at monuments, they light torches, they lay wreaths' (2009: 218). This, Buruma argues, comes in direct contrast to a goal of striving for independent scholarship, and such ceremonies and analysis cannot be combined at the same time or place (2009: 238).

Staff and volunteers at Stiftelsen Arkivet regularly light both candles and peace flames in ceremonies to commemorate the dead and the victims of torture (Figure 5.1). This is a way to focus attention on the values of democracy, human rights and dignity, so important to Stiftelsen Arkivet.

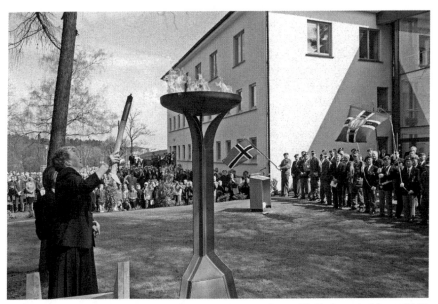

Figure 5.1　Lighting the peace flame at the opening of Stiftelsen Arkivet, 2001
Source: Photo: Stiftelsen Arkivet.

3　Historical consciousness permeates the curriculum for social studies (see Norwegian Directorate for Education and Training: <http://www.udir.no/Stottemeny/English/Curriculum-in-English/_english/Upper-secondary-education-/#fellesfag>).

But since Stiftelsen Arkivet's ambition is to provide informed learning programmes, it also attempts to engage with some of the challenges Buruma identifies. In this chapter, three categories of challenges will be discussed – obligations, narratives and authenticity – with reflection on the institution's attempts to meet these challenges by involving visitors in open discussion and critical reflection about both the historical representation and the use of history onsite.

Obligations

At Stiftelsen Arkivet there is a narrative to tell, namely the story of what happened there during the Second World War. The exhibition, together with monuments, plaques and other markers, are intended as reminders for visitors to recall the experiences of those who suffered there.

Despite the passage of time, the institution still welcomes those individuals who have their own traumatic experiences of this place, but also their children, for whom a visit can also be very emotional. While 70 years is a long time, it is not long enough to create sufficient emotional distance to the Second World War as there is currently to the Napoleonic Wars or perhaps even the First World War. The fact that many living witnesses have experiences from the place brings the sense of obligation centre stage, and the need to show respect towards the people who have suffered there is very potent.

So, does this lead to perceived limitations in practice and response? For example, is it 'permissible' for visitors to laugh? If so, is it acceptable to laugh in the torture chamber? How appropriate is it for the Education Department to let students perform role plays in the reconstructed cells? Is it acceptable to serve alcohol during informal talks and seminars held in the basement? Over the years many different approaches have been tried, and some have been curtailed precisely because they have been felt to be improper, for example, informal talks that included alcohol. This is a reminder that this space is not at all neutral.

Another aspect of commemoration is focusing on remembering the victims of atrocities and the causes people fought for. This reasoning underpins the establishment of Stiftelsen Arkivet. When the building was left empty in 1998, a grass-roots movement formed to prevent it being sold to commercial interests and to campaign instead for the establishment of a centre for historical documentation and peace-building. The obligation to transform the archive into an arena for 'lessons learned' was very evident. Osmund Faremo, a victim of Gestapo torture and an advocate of Stiftelsen Arkivet, stated that 'the voices from the Archive can – and should – become an important component in the education of civilised behaviour towards our fellow human beings' (Stiftelsen Arkivet n.d.). The obligations are then not merely present as a backdrop; rather, they are a very deliberate choice that informs all of the work of Stiftelsen Arkivet.

Narratives

A challenge for war memorials is to avoid the preservation or even cultivation of old conflicts between nations – a potential and unwitting by-product of their existence. Stiftelsen Arkivet, for example, will have failed in its mission, if learners walk out of the exhibition with nationalistic 'us and them' thinking or with (renewed) hatred toward Germans. As such, guides and educators are trained to use the description 'Nazi' instead of 'German'. Certainly not all Germans were Nazis, not all Nazis were perpetrators, and not all Nazis were Germans. Many Norwegians joined the Nazi Party during the war, and some of them even contributed to the torture of fellow Norwegians.

The Council of Europe warns against nationalistic and dichotomised teaching in their advice for history teaching in schools (2011). Multi-perspectivity is one way to avoid this, by focusing on teaching students how history often looks different, depending on what country, people or culture you belong to. When studying the image of the Other in history teaching, students are trained to see and look for different views on challenging issues. By developing such skills, it is hoped, stereotypes can be dismantled.

In interpretive terms, one possible model for achieving this is that used at the exhibition in the crypt of the ruins of the church of St Nikolai in Hamburg where, together with the story of the Allied bombing of Hamburg during the Second World War, the Nazi bombing and destruction of the cities of Coventry and Warsaw are also interpreted. But this approach can be problematic, it would be highly inappropriate to transfer this method to Auschwitz and provide the Nazi perspective on the Final Solution. Similarly, at Stiftelsen Arkivet, a site with close ties to its local community, it would also be problematic to present the perspectives of the perpetrators. The site is not on neutral ground, feelings are much more intense, and this makes it far more controversial to raise questions and perspectives that can be interpreted as an attempt to defend or even absolve the perpetrator. The question of how to present the perpetrators no doubt remains a challenge at war memorials and associated historic sites. It is easier to demonise perpetrators, and visitors may not be exposed to important knowledge about how ordinary people can commit cruel atrocities under extraordinary circumstances. At Stiftelsen Arkivet, multi-perspectivity might instead mean studying stories of war and torture from Berlin, Warsaw or Moscow which may reveal multiple perspectives from which visitors may benefit.

It is possible to openly discuss the actions of the Gestapo without excusing them or removing their responsibility, and Stiftelsen Arkivet has had some success in education programmes by actively involving learners in discussions about how such atrocities happen. This has helped many learners understand more fully that the perpetrators were individuals with different reasons for taking part in torture. Young people naturally tend toward focusing on individual reasons, and these discussions give an opportunity to show that there are also structural issues, like

ideology and political systems, that influence an individual's choices in their respective societies.

There is, of course, much to learn from focusing on the people who risked their lives in their struggle for freedom and democracy during the war. Stories about such people can be motivating for young people, as they encourage reflection on choice and responsibility. If learning programmes focus only on wrongdoing and atrocities from the past, this gives a distorted picture of reality. Young people also need to hear stories about people doing good. For example, when Desmond Tutu visited the exhibition at Stiftelsen Arkivet he emphasised that students need to 'learn that there were people – who in those difficult times – were brave' (Vestad 2009). But just as in dealing with the perpetrators, the reasons for good choices should not be over-simplified, especially at an historic site which has an implied responsibility to remember past events. There is perhaps a tendency at war memorials to paint too bright a picture of the so-called heroes.

Authenticity

Visitors know that Stiftelsen Arkivet is a historic site, and for many its immersive nature facilitates a greater emotional investment, to the extent that some arrive 'tuned in' for an emotional tour. Historic sites, to a greater extent than object-based museums in their grand buildings, communicate more convincingly the concept that 'these are the same steps ...' and 'this is the room in which ...'. This approach is informed not only by the historic authenticity of the site itself, but is also encouraged by the guides who refer to this during delivery of guided tours. That the stories told are connected with human suffering only adds to the emotional impact of the site. The experience can be very challenging in many ways: seeing illustrations and installations on methods of torture, hearing stories about individuals who have experienced this treatment, entering a torture chamber and claustrophobic cells in a stuffy basement, seeing photographs of executed Soviet prisoners-of-war, and possibly discovering the name of one of your relatives in memorial plaques, or even on a list of Norwegian 'traitors', simultaneously engage and shock.

The involvement of emotions can create an interest in the topic and also carry meaning. However, there is still a very real danger that a visit may evoke emotions only and that these emotions become an end in themselves.[4] Moreover, focusing on emotions only may create an unbalanced process that is potentially open to

4 There is an interesting discussion on so-called emotive and controversial history teaching in the *Sense and Sensitivity* special issue of *Teaching History*. Particularly interesting are perhaps the brief information about T.E.A.C.H. (Teaching Emotive and Controversial Issues in History) on p. 11 and Wrenn and Lomas 2007. Among other things Wrenn and Lomas discuss the rationale as well as the dangers of emotive and controversial history teaching.

misinterpretation or manipulation. According to the influential Beutelsbach Consensus of 1976,[5] the danger of manipulation increases if the pupil is unprepared or is caught by surprise. But preparation is, after all, in the hands of the teacher, and many students arrive with a very thin knowledge base and limited mental and emotional preparation for their visit to Stiftelsen Arkivet.

Another dilemma is that the authenticity of the site may communicate a sense of truth, a feeling in the visitor that this is what it must have been like and that this is a true and accurate representation of events. But the felt authenticity may be exaggerated. One example in Stiftelsen Arkivet is that the walls of the torture chamber are authentic, but the prison cells are reconstructed. This is clearly communicated to visitors, but do they really take notice of this distinction in what is a highly emotionally invested visit? Moreover, in the two cells and the torture chamber visitors see installations of human sized mannequins that illustrate various scenes from that time (Figure 5.2). Their place as part of the exhibition has been and is still much debated, but it is students and their teachers who are most eager to keep them, arguing that the mannequins give a clear and consistent idea of what it must have been like, despite these being reconstructions and installations that provide only one interpretation.

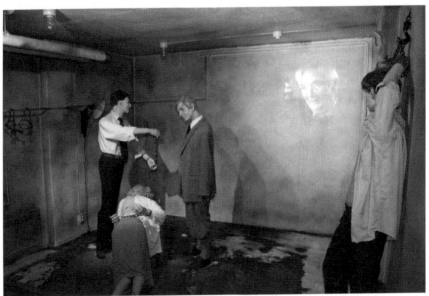

**Figure 5.2 Torture scene with smiling perpetrator, Torture chamber,
 Stiftelsen Arkivet**

Source: Photo: Stiftelsen Arkivet.

5 <http://www.lpb-bw.de/beutelsbacher-konsens.html>.

The difference between history and the reconstruction of history is a complicated issue for most 15-year-olds, and one may argue that as an education provider Stiftelsen Arkivet should help learners to reflect on this during a visit. In the torture-scene installation illustrated, one of the figures appears to be smiling. In an education programme, this could be approached by asking visiting students whether perpetrators actually enjoyed dispensing torture. The broad spectrum of responses to this question illustrates the pedagogical possibilities at a historic site to develop students' critical thinking. Being at a place where history actually happened makes it possible to involve young people – to whom concrete examples are often a must – in a discussion about interpretation versus truth.

In the autumn of 2011, the exhibition was reopened after having been updated to reflect contemporary historical research and documentation.[6] In the new exhibition, the number of torture instruments on display has been reduced from around 50 to 10, a substantial reduction. Some were proven to be fake, and others were removed because they had not been used in incidents of torture at the site. Interestingly enough, this attempt to make the exhibition more authentic comes across as less authentic to some visitors who come with very clear expectations (based on other visitors' accounts), which cannot now be met. An explanation that the objects have been removed in order to make the representation more authentic and further discussion of whether this change is positive, negative, necessary or irrelevant may be needed to better manage visitor expectations.

The use of living witnesses as guides may add to a historic site's authenticity. At Stiftelsen Arkivet approximately 15 senior citizens do the guided tours on a voluntary basis, but none of the guides have personal experience from the site during the war, although some guides' fathers were interrogated or tortured there. The important point to highlight is that most of the guides have little, if any, personal experience of the Second World War, and while this does not constitute a problem with regard to knowledge or enthusiasm, many students think these people look old enough to have lived during the war, and that gives them a status of living witnesses, and therefore carriers of truth as related to the site.

The stories told by the living witnesses can be much more difficult to discuss critically with the students. While a reflection on individual memories and interpretations is very interesting, it is also difficult, in that there is considerable loyalty generated toward guides who deliver on a voluntary basis. Turning them into objects of critical analysis, in which their testimonies are challenged by students or professionals, seems problematic and perhaps a little unfair. Some

6 When Stiftelsen Arkivet was opened in 2001, the exhibition was created on a voluntary basis, based on objects and documents donated by people in the area. Over time Stiftelsen Arkivet has become more professionalised, with historians doing independent historical research.

guides recognise their presentations are adding an interpretive layer and may comment upon this themselves to visitors in order to encourage discussion.[7]

Conclusion

Stiftelsen Arkivet was originally established as a historic site and memorial, and its historic authenticity remains the cornerstone of its activities, while its role as a learning provider came as a result of a clear decision by the organisation to engage more formally with its visitors. As shown in this chapter, when these two roles are combined a range of different dilemmas and challenges emerge. Isolated storytelling, while engaging on an emotional level, does not meet the standards expected of effective history teaching. However, visitors risk losing the emotive impact of being immersed at a historic site, if there is too much deconstruction and critical analysis of the means of interpretation. It seems necessary to find a good balance between 'telling a story' and deconstructing it.

Despite these challenges, there are clear benefits to combining formal learning at an authentic and highly emotive historic site, and there is considerable potential for Stiftelsen Arkivet to refine its role as an arena for facilitating objective discussions about the complicated relationship between history, memory and truth regarding the Second World War. However, in light of discussions held in the aftermath of the tragic events that took place on 22 July 2011 in which Anders Behring Breivik killed 77 people and injured hundreds more, the role of Stiftelsen Arkivet has again been uniquely and contemporaneously realised. The approach used at Stiftelsen Arkivet has a great potential for framing informed discussion around current emotive events also, and, as a result, students may better make sense of the present.

References

Buruma, I. 2009. *The Wages of Guilt: Memories of War in Germany and Japan.* New York: Atlantic Books.

Council of Europe 2011. *Recommendation CM/Rec (2011) 6 of the Committee of Ministers to Member States on Intercultural Dialogue and the Image of the Other in History Teaching.* Available at <https://wcd.coe.int/ViewDoc. jsp?id=1813461&Site=CM> (accessed 15 Dec. 2012).

Rosendahl, B.T. 2011. 'Historieformidling som verktøy for gode holdninger? Refleksjoner rundt Stiftelsen Arkivets formidlingsvirksomhet', in B.E. Johnsen

7 See http://memoriesatschool.aranzadi-zientziak.org. The website presents resources from the project 'Sharing European Memories at School' (SEM@S), funded by the European Commission, in which Stiftelsen Arkivet was one of six European partners.

and K. Pabst (eds), *Formidling: Bruk og misbruk av historie*. Kristiansand: Høyskoleforlaget.

Stiftelsen Arkivet n.d. 'Responsibility for a Common Future'. Available at <http://www.stiftelsen-arkivet.no/responsibility-for-a-common-future> (accessed 15 Dec. 2012).

Vestad, F. (dir.) 2009. *Fra menneskeforakt til menneskeverd* [documentary]. Dokufilm A/S.

Wrenn, A., and T. Lomas 2007. 'Music, Blood and Terror: Making Emotive and Controversial History Matter', in *Sense and Sensitivity*. Special issue of *Teaching History* 127: 4–12.

Young, J.E. 1993. *The Texture of Memory: Holocaust Memorials and Meaning*. New Haven and London: Yale University Press.

PART 2
Challenging Collaborations

Amy Ryall

'Challenging Collaborations' outlines the many issues, opportunities and pitfalls associated with working alongside communities and artists in museums and galleries. The overall narrative is one of bravery: bravery to enter into collaboration; to take on difficult histories, whether personal, national or international; and to address them in a collective way. Museums and galleries can be conservative institutions, constrained by organisational process, by funding, by staffing and a whole host of other local issues (see Holden 2004). Yet the fact that collaboration is seen as a crucial part of heritage is positive, and the contributions here indicate that organisations do see its value and are keen to look outside their usual sphere in order to improve their engagement with their audiences. They all acknowledge though, that this is not easy or always done well.

Tales of conflict are common, as are accounts of the lengthy, difficult and inexact processes of building trust. True collaboration requires organisations to let go of some of their processes and ownership of their work, which is not always straightforward. Museums and galleries strive to be inclusive: a noble aim, but one that can be difficult to execute in a meaningful and unpatronising way. Much is made of the heritage sector's contribution to well-being, that culture has a key role in making society a better place (see Cultural Learning Alliance 2011). It is illustrated clearly here that this can be the case, but that it can conversely make people feel more isolated from the society that they live in and/or be seen as tokenistic. What is certain is that the impetus is there for organisations to overcome the difficulties they may encounter, but that they may need to become even braver in order to truly embrace collaboration and face the challenges that it raises.

One of the difficulties is that there are many terms used within the heritage sector to describe the process of working with those outside their organisations. Collaboration itself means different things to different people. It could be straightforward consultation, where community partners are presented with options by the museum and asked for contributions to decisions. It could be co-production, a more involved process, where the partners have equal standing in the development of an exhibition or programme. In this method, goals are defined jointly and shared, and it is the shared goals which make it distinct from consultation. Nina Simon, in her influential book *The Participatory Museum*, makes a useful distinction between contributory projects and collaboration:

'If contributory projects are casual flings between participants and institutions, collaborative projects are committed relationships' (Simon 2010: ch. 7).

This becomes inherently more problematic when partners define terms in different ways. Heritage organisations know that collaboration is important and that it is a way of working that they should embrace. They know that the outcomes, both in material and intellectual terms are valuable, perhaps more valuable than working alone, but they also know that this way of working is challenging. Art interventions in museums, as analysed by Stearn in Chapter 7, are often used as ways of dealing with material or subjects that are challenging and there are many examples of this. Arts Council England, the funding and development agency for the arts in England,[1] recognise the importance of this kind of partnership working and in June 2012 held a day at the British Museum exploring just this topic. Dame Liz Forgan, the then Chair of Arts Council England gave a keynote speech in which she pointed out that these types of collaborations are not without historical precedent. In the seventeenth century, the Oxford University Collection displayed a sword given to Henry VIII by the pope alongside contemporary portraits (Arts Council England 2012).

Museums and the heritage sector can have a romantic view of collaboration: that it is, or can be, cathartic, altruistic and transformational for all concerned. This view is not unique to the heritage sector: universities are equally guilty of this organisational hazard. Projects that require firm outcomes are by their very nature, inflexible, and it is this need for firm outcomes that can damage collaboration. This is true for both working with communities and artists. Participation does not eliminate the power differential and funding models can mean that the power is always retained by the budget holder. In Chapter 6, Bernadette Lynch's use of the question 'What is it you want to do to me?' asked by a community member working with the Manchester Museum can be reworked by the museum to 'What is it you want me to do for you?' It is also often the case that large organisations remain in control of these situations. There is a timidity in their approach which can damage the value of the collaboration and make it an awkward rather than productive relationship. The need for the 'correct' response, the right thing, can stifle creativity, and the necessity of rules, in many cases essential for organisations to function, can prevent true collaboration and co-production because it does not allow for enough flexibility.

It is evident that we are still learning about how to work in this way and that the people teaching us about it are those we are collaborating with. We must accept that a collaborative relationship contains within it elements of conflict and not be intimidated by that. We must accept that the relationship might be messy, uncomfortable, awkward, critical, emotional. In inviting alternative forms of knowledge into the museum, we must be honest about our reasons for this and brave with the outcomes. We must not allow institutional angst to override

1 <http://www.artscouncil.org.uk>.

the benefits of collaboration, and, as individuals, we must have the courage and conviction to convince our institutions of the value of this challenge.

From my current point of view, in higher education, the challenge has become convincing external organisations that we are not stuck in our ivory towers, that we are keen to work with those outside the academy and that we are willing to work in a collaborative way. Our mantra is one of mutual benefit: projects are of no value to either party if they are not mutually beneficial, and the monetary support that comes as a result of that is almost incidental. It allows the process to happen, rather than being the process. This stance is essential to avoid the university's public engagement funding being seen as a replacement for organisations struggling with cuts to support for the arts.

As a Faculty of Arts and Humanities, we have recently been working with Chatsworth, a stately home in Derbyshire, England, and home of the Duke and Duchess of Devonshire. Chatsworth has an extensive library, possibly the most significant of any stately home in the UK, as well as a comprehensive archive. Neither are well catalogued or used, beyond the steady, but relatively small stream of private researchers that are accommodated by the collections staff. Collaboration with the University of Sheffield started to open up the collection, to use it as research material for academics, but, at the same time, benefitting Chatsworth with knowledge of their collection and supporting their use of it in different ways. This idea of mutual benefit has been embedded in the partnership from the beginning. In partnerships where this has not been the case, the process has been more difficult. We are learning a lot about how to negotiate this, sometimes rocky, path and about how to set out on the right course in the first place.

Simon suggests that a 'design challenge' (2010) is essential in order to embark upon the right road. This is something that an organisation articulates before starting a collaboration, and in order to decide who to approach to work with. She gives an example of a design challenge: 'How can we tell the story of children's immigrant experiences in a way that is authentic, respectful, and compelling to immigrant and non-immigrant audiences?' (Simon 2010). I suggest that this approach must be taken one step further. In order to secure mutual benefit, the 'design challenge' must be co-produced by the organisation alongside their partner. By doing this and acknowledging and using the expertise that partners bring, clear roles for both parties are negotiated and collaboration has a better chance of success.

Acknowledging failure and attempting to analyse it is important too. Kate Pahl, Richard Steadman-Jones and Steve Pool present a picture of collaboration gone wrong in their article 'Dividing the Drawers' (2013). Their aim was to work together to present academic research in an exhibition that was open to the public. This, perhaps somewhat cathartic, article presents a picture of two academics (Steadman-Jones and Pahl) and a practitioner (Pool) working collaboratively, yet apart, aiming towards the same goal. They were operating within the definition of collaboration, yet, by their own admission, the finished exhibition was not the product of a successful collaboration. That is not to say that this is not a valuable end in itself, and the point of their article was to acknowledge

this and the importance of reflection as part of the process of collaboration itself. It does not always go right or as expected, but the journey is as valuable as the outcome. The authors cite a conversation between the three collaborators, discussing whether they would do it again. Steadman-Jones was definite in his response:

> Yes, well I almost think we need to. To have gone through it all – to have survived the arguments – in a way we have got to do more. I think that in the future we might understand what we are doing better and have a clearer idea of how to move it on. (Pahl, Steadman-Jones and Pool 2013: 85)

Success comes from taking risks, being brave and acknowledging things do not always go to plan. It also means failing sometimes and learning from the process. As organisations we must rethink the way that we work and be flexible. We must be ready to break the rules and we must be willing to do things informally, find our own version of the coffee and cigarettes that Åshild Andrea Brekke advocates in Chapter 8. As Miranda Stearn acknowledges in her analysis of the National Gallery and the British Museum, this might be easier for smaller organisations or ones that are not national in scope. In the context of challenging histories, collaboration, particularly with artists, can be seen as an easy fix, a way to deal with difficult subjects in an abstract way. It also absolves the organisation from responsibility by allowing them to defer to a higher artistic aim.

In Chapter 9, David Gunn and Victoria Ward point out that participation is an obsession of the cultural landscape but that it can often be meaningless. Their account of unapproved participation in a museum display in Cambodia's Tuol Sleng Museum illustrates the value of spontaneous participation which has nothing to do with organisational goals: a challenge in itself. Lynch shows that museums are often uncomfortable with this rule-breaking and that they want to be in control of the process, even when this does not make sense to those they are working with.

What is clear from the contributors' experiences is that collaboration is something that must be considered on a case-by-case basis. Whilst there are some overarching principles that should be adhered to, which are mainly to do with the treatment of groups from a humanitarian and ethical point of view, there is no right or wrong approach to collaboration as a whole. It is challenging and therefore time-consuming; it can also be transformative, a point acknowledged by the International Council of Museums in point 6 of their code of ethics[2] and by the UK Museums Association in their 'Museums 2020' consultation.[3] Both make reference to collaboration as essential for museums. The very reason why museums exist has changed dramatically in recent times. They are no longer repositories of, and for, the great and the good. In order to develop through difficult times, to remain relevant and for the case for museums to be made, we must formulate a

2 <www.icom.museum/the-vision/code-of-ethics>.

3 <http://www.museumsassociation.org/museums2020>.

new narrative, one which has collaboration, with all its difficulties, pressures and rewards, at its heart.

References

Arts Council England 2012. 'Arts Council England and British Museum Join Forces to Explore Artistic Collaboration in the Arts and Museum Sectors'. Available at <http://www.artscouncil.org.uk/news/arts-council-news/arts-council-england-and-british-museum-join-force/> (accessed 1 Feb. 2013).

Cultural Learning Alliance 2011. 'Imagine Nation: The Case for Cultural Learning'. Available at <http://www.culturallearningalliance.org.uk/page.aspx?p=100> (accessed 1 Feb. 2013).

Holden, J. 2004. 'Capturing Cultural Value'. Available at <http://www.demos.co.uk/publications/culturalvalue> (accessed 1 Feb. 2013).

Pahl, K., R. Steadman-Jones and S. Pool 2013. 'Dividing the Drawers', *Creative Approaches to Research* 6(1): 71–88.

Simon, N. 2010. *The Participatory Museum.* Santa Cruz, CA: Museum 2.0. Available at <http://www.participatorymuseum.org> (accessed 1 Feb. 2013).

Chapter 6

Challenging Ourselves: Uncomfortable Histories and Current Museum Practices

Bernadette Lynch

In 2000, I was approached at the Manchester Museum (a university museum in the north of England where I was then Deputy Director) by a couple of local health workers. They came to see me on behalf of a group of Somali refugee women. I was told that the women were socially isolated and apparently mentally depressed and wanted some means to be able to talk about their cultural heritage.

In fact, as it turned out, they wanted to talk about themselves – with all the complexity of their experience: the loneliness, anger, frustration and sometimes resignation that this evoked. Through a process of object-handling and story-telling the women, tentatively at first, expressed what it felt like to be uprooted from a nomadic existence to living an uncertain life, six floors up in a tower block in Moss Side, Manchester. From time to time their frustration was focused on the museum itself, by means of the cathartic experience of speaking through museum objects.

Museums are uniquely well placed to offer such opportunities for the interpretation of objects in which anyone may take a view. I have written elsewhere, borrowing from the British psychoanalyst D.W. Winnicott, on the 'transitional' or amenable museum object (Lynch 2007; see Winnicott 1971). The museum object is amenable to symbolism. Acting as symbol, it can unlock experience and thus become an immensely useful device as the focal point for projective imagination in story-telling and memory work: as inspiration or provocation; for discussion and debate – and sometimes spontaneous song, as was the case with the Somali women. The object can help unlock experience and become the catalyst for emotion, communication, intercultural understanding and, sometimes, resistance.

In cases in which people have undergone terrifyingly dramatic, life-altering experiences, such as those of these refugee women emerging from a war zone, the stories they tell themselves no longer even hold an appearance of continuity, the illusion of life's 'progress' to which most of us cling. 'Regular life' is thus clearly severed, blown apart. In these cases, the urge to recount the story can be very great indeed, significantly adding to the responsibility of the museum to be extremely careful in its ethical handling of the psychological impact of such experiences. But what if the telling of the narrative is itself a form of resistance – of struggle?

Extensive, long-term work with refugees and asylum seekers followed the first contact with the refugee women at the Manchester Museum. Inspired by

the overwhelming evidence of the affective impact of objects when working with these women refugees in object-handling programmes (Lynch 2007), we subsequently created a museum-wide strategy and programme called 'Collective Conversations'. The programme was, at the time, unique and won various awards. It was based on the idea of offering ongoing opportunities for inter- and intra-cultural dialogue through developing an expanded 'community of interpretation' with participants from local (mainly diaspora) communities. The participants were invited to negotiate the interpretation of the museum's collections – there was a particular focus on using the museum's large, underused collections in store (see Figure 6.1).

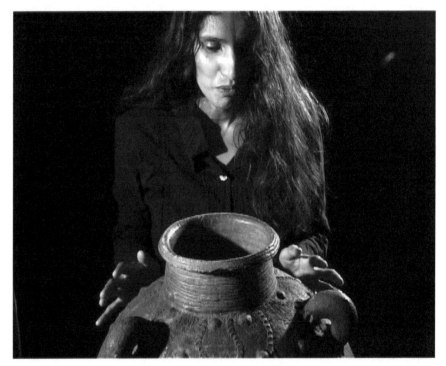

**Figure 6.1 Manchester-based poet Shamshad Khan with a clay pot in
 Re-Kindle, a video inspired by 'Collective Conversations':
 installation by Kooj (Kuljit) Chuhan, Living Cultures Gallery,
 Manchester Museum**

Source: Photo: Manchester Museum; filmmaker/media artist Kooj Chuhan.

The programme was inspired by the Somali women. With no prior knowledge of museums, they had disrupted precedent – picked up the exalted objects, passed them round, discussed and debated them and then turned to us, the museum staff, often to challenge us. They took particular pride in angrily correcting the museum's knowledge and interpretation of 'Somali' collections, which they frequently (correctly) identified as Ethiopian. By ignoring museum norms and prohibitions, these women demonstrated to the very nervous museum staff members the use-value of heritage, and the complexity of the relationship between museums, objects and people.

Yet what was the museum's response? In retrospect it was a subtle but concerted effort to acculturate the women into the norms of the museum, to regain control. While apparently acting as 'co-participants', joining in the activities with the women, the museum maintained its position of distance, objectivity and privilege.[1] Never once did the museum willingly relinquish this position in the exchange, as 'someone who does not, and can afford not to, engage in a genuine dialogue' (Asad 1973: 17). This unwillingness to relinquish position points to a level of fear, fear of loss of control, as though there is realisation that behind the generous casting of relations between the two parties, there is always the danger of antagonism. According to Gramsci the complexes of associations in civil society, such as those between the museum and these women, 'constitute the "trenches" and permanent fortifications of the front in the war of position' (1971: 243). Despite an avowed, and genuine, commitment to shared authority, the museum jealously guarded its position throughout its relationship with these women.[2] In subsequent situations where the 'offer' of open and equitable 'interpretation' of collections was ostensibly made available to community groups and individuals (for example, through 'Collective Conversations') this offer can, in retrospect, be seen to have been largely fictitious (Lynch 2011a; Lynch and Alberti 2010).

Typically, for the colonised, power is fundamentally coercive, and it is this 'coercive seduction' that reveals the power at work within the museum 'exchange' that has interested me throughout my career in museum theory and practice – the very power that was so blithely ignored by these women who had not yet been enculturated into the norms and expectations of the museum. I also knew that it was only a matter of time before this moment would pass, that the women would learn the prohibitive culture of the museum – and they did. As can be seen in much engagement work in museums, participation does not eliminate a power differential that may be inextricably bound with race and other social, economic

1 I further explore the ethical implications of institutional fear of the Other in Lynch 2011a.

2 I wish to note that I am critically reflecting upon my own practice here, looking back at its evolution, examining in hindsight what did and did not work. In no way is this a reflection upon those inspiring professionals within my team (while I was deputy director of the Manchester Museum), who helped develop and lead on what was, at the time, ground-breaking work from which there has been so much to learn.

and cultural factors and museums may marginalise their community participants if they do not acknowledge this (Lynch and Alberti 2010).

As Price put it, 'instead of trying to erase this [reality] by the magic of generous recasting, [the institution] should be making people aware of all that silently conditions their perceptions' (2007: 174). The subtleties of how power works in this 'contact zone' are set in motion as soon as the museum operates as an 'invited space', to borrow from Nancy Fraser (1992). In the instance with the Somali women, the limits of engagement were thus set in place as soon as the museum assumed the position of carer, with the Somalis as the unwitting recipients – the cared-for. While ostensibly offering 'empowerment', museums may thus undermine the very possibility of its realisation through reminding people of the limitations of their power within the institutional setting and placing them in the position of beneficiaries.

There is a growing tendency within the UK public sector to inflate the problem of emotional vulnerability and minimise the ability of the person to cope. Thus low self-esteem is presented as an invisible disease that undermines the ability of people to control their lives. This is apparent in the growth industry of 'wellness' in museums as a strategy – and claimed outcome – of engagement

Conflict in the Contact Zone

It is frequently forgotten that James Clifford, so instrumental in giving birth to the pervading strategy of 'contact zone' work in museums, had pointed out the limitations of museum contact work when engagement continues to be based on a centre–periphery model (Clifford 1997).[3] For Clifford, it was clear that the contact zone was a place of conflict between different interests and experiences involving implicit or explicit struggle. Clifford plainly saw contact as a negotiation, 'an on-going historical, political and moral *relationship*, a power-charged set of exchanges, of push and pull' (1997: 192). Yet, the imposition of an idealisation of consensual contact so prevalent in this 'contact' work in museums does not recognise the social, political and ideological forces at work inside and around people when invited into museums. It is the value of challenges to the hegemony of the museum within these relations that demonstrate what I like to call 'the use-value of conflict' as an essential part of the democratic process of engagement.

Yet Timothy Luke notes that such conflict avoidance is embedded in museums, despite the turbulent world just outside their doors:

> Amid … intense social, political, and cultural anxieties, it is no surprise that museums today are a crossroads of cultural conflict, dissent, and struggle … .
> These institutions must serve as crucibles of conceptual, ethical, and aesthetic

3 This had also been the main concern of the anthropologist, Mary Louise Pratt when she originally coined the term 'contact zone' (1992).

confrontation, [but] too many museum boards, curators and patrons ... see clash as always and everywhere a bad thing. (Luke 2006: 22)

The Somali women brought that 'outside' reality into the museum. Was the museum aware that the experience for the diaspora participant may, in this way, be very different than that of the museum, with a very different motivation for participating in this cultural exercise? As Tuhiwai Smith points out, 'some knowledges are actively in competition with each other' (1999: 43). She speaks of the Maori motivation behind sharing oral histories with museums, which may be at odds with the museum's purpose. For most Maoris, she says:

> It is not simply about giving an oral account ... but a very powerful need to give testimony to and restore a spirit, to bring back into existence a world fragmented and dying. The sense of history in these accounts is not the same thing as the discipline of history, and so our accounts collide, crash into each other. ... The need to tell our stories remains the powerful imperative of a powerful form of resistance. (Tuhiwai Smith 1999: 28, 35)

The institution's avoidance of 'clash' underlies an expressed aim to deliver 'social cohesion', resulting in the museum's overemphasis on 'consensuality' and denying the opportunity for resistance to be made manifest. The institution achieves this by ignoring 'passion and partisanship' (Mouffe 2005: 2), both central elements of democratic dialogue, and by rewarding those whose behaviour is less challenging and more in keeping with its own behavioural ethos – thus reinforcing what John Gaventa calls 'false consensus' within the relationship (2004). As Mouffe reminds us, this is a dangerous strategy, actually at odds with democratic principles and practice:

> Instead of helping to create a vibrant, agonistic public sphere with which democracy can be kept alive and indeed deepened, all those who proclaim the end of antagonism and the arrival of a consensual society are – by creating the conditions for the emergence of antagonisms that democratic institutions will be unable to manage – actually jeopardizing democracy. (Mouffe 2002: 15)[4]

Thus, the prime task of a democratic approach is neither to eliminate passion and partisanship nor to relegate them to the private sphere in order to establish a rational consensus in the public sphere, it is, rather, to mobilise them for democratic ends, working together to create collective forms of identification around democratic objectives (Mouffe 2002: 9).

4 Mouffe promotes what she calls, an 'agonistic pluralism' that acknowledges the tensions between conflicting interpretations of liberal-democratic values through 'agonistic confrontation' (Mouffe 2000).

Instead, the museum institution continues to maintain order and control, not through violence and political or even economic coercion, but ideologically, through a hegemonic culture in which the values of the institution become the 'commonsense' values of all (and participants, such as the Somali women, become acculturated and complicit). In this way passion, conflict and any form of challenge is effectively avoided. As Leela Gandhi puts it, 'the forgotten archive of the colonial encounter narrates multiple stories of contestation and its discomfiting other, complicity' (1998: 5).

For me, much of my own 'contact zone' work in museums, right back to the Somalis in 2000, raised a range of ethical and methodological questions, from people's right to reinterpret objects and challenge the museum according to their own experiences in the world, to the role of the museum as 'objective' facilitator of dialogue and debate. Looking back, I see that as we women from very different experiences of the world faced one another across a table inside the Manchester Museum, it might as well have been as vast as the desert landscape they had come from for all the shared understanding available to us. I question now what exactly I, and my team, thought we were doing with these women – what we were going to do for or to them in our attempt to transform or improve them.

Triumphant Liberalism of Museum Engagement

Hence a more recent question posed by a Chinese woman who stood at the far end of a room at a consultation session at a large museum and asked why the museum wanted to engage communities? She said: 'What's it for? What is it you want to do to me?'

This woman's question goes right to the heart of cultural heritage as a form of triumphant liberalism increasingly based upon a perceived relationship between culture and public 'wellbeing'. By placing people in the position of beneficiaries, the liberal morality that informs and permeates engagement work in museums exercises invisible power and thereby continues to rob people of their active agency and the necessary possibility of resistance.[5]

In what was in effect an examination of their contact zone work, I recently conducted a study of 12 major museums across the UK for the Paul Hamlyn Foundation, looking into the impact of public engagement and participation following decades of government investment. (Lynch 2011b). During the study, a discussion was underway at one of the institutions, a large city museum. At a certain point in the proceedings the leader of a local group involved in setting up training opportunities for young unemployed African Caribbeans, walked over to a side table and grabbed a plate of sliced cake. The task he and the group of participants (the museum staff and their community partners) had been given was

5 Some of this is explored further and the process broken down through the example of an attempt at co-creating an exhibition in Lynch and Alberti 2010.

to create an 'image' to depict the current relationship between the museum and its local communities.

Handing the plate of cake to the museum's director, he proceeded to direct the mixed group of workshop participants into positions, so that the staff members were holding out the plate of cake, while the community participants formed an orderly queue, awaiting their allotted piece. This for him was the reality of the postcolonial contact zone. It became evident in the subsequent discussions with staff members at this institution and others in the study, that there is little shared understanding of how power influences the development and delivery of this complex work.[6] The more overt use of institutional power includes decision-making and agenda-setting that clearly influences outcomes through inducement and persuasion based on the institution's authority.

As the study found, power also acts in invisible ways on those upon whom the practice is based, as well as on those charged with its delivery, as can be found in the language of the policy documents on engagement and participation from the 12 museums and galleries within the study. Consider the following words taken in an analysis of one museum's policy document (since revised). These words are typical of a variety of organisational documents in the study (and within the sector as a whole), including vision, mission statements and engagement strategies:

- we believe
- we have a responsibility
- we have a strong sense
- we can make people's lives better
- [we are] generators of well-being
- we play a leading role
- [we] increase racial tolerance
- we nurture a sense of belonging, cohesion, identity and pride

And we

- provide
- develop
- expand
- foster
- ensure
- target
- encourage

6 The seminal work of political and social theorist, Steven Lukes outlines the visible and invisible ways that institutions such as museums exercise their power. Lukes described the dimensions of power as: 'ability to get its way despite opposition or resistance; … ability to keep issues off the political agenda in the first place; … the shaping of the public domain through beliefs, values and wants that are considered normal or acceptable' (1974).

- promote
- pursue
- enhance
- articulate
- tell

One can acknowledge that the ambition here is genuinely to be of service, to help those in need. Yet, the meaning behind words can be very subtle. In the language of the policy document quoted above, the museum reveals a centre–periphery view of its communities, in which the organisation is firmly placed in the centre. Despite its undoubted wish to be of service, it displays an almost nineteenth-century view of a passive subject, awaiting improvement. The rhetoric of service within the policy documents of the organisations in the study (as in the case of the Somali women) too often places the subject (community member) in the role of supplicant or beneficiary and the museum and its staff in the role of carer.

While an illusion of creative participation is what is on offer, consensual decisions tend to be coerced or rushed through on the basis of the institution's agenda or strategic plan, manipulating a group consensus of what is inevitable, usual or expected (Lynch 2011a). The Hamlyn study found evidence again and again that participation in these contact zones is generally on the terms set by those who create and maintain those spaces. What gets on to the agenda and what remains off limits for discussion may be implicitly rather than explicitly controlled by those doing the inviting (Gaventa 2004). The agenda is rarely set by the participants. Despite the best of intentions, imposing the institutions' coercive authority places the museum's community partners in the position of being co-opted into supporting, often resentfully, the museum's goals, while silencing any potential resistance or opposition. The experience for participants is that of 'empowerment-lite' (Cornwall 2008), while the concerns, complexities and 'messiness' of people's everyday lives, their realities, are filtered out. Such experiences unsurprisingly lead to disillusionment and a break in the relationship between museum and community partner (discussed further below).

Agonistic Energy in the Museum

Carl Schmitt attacked the 'liberal–neutralist' and 'utopian' notions that politics can be removed of all agonistic energy, arguing conflict is embedded in existence itself (Mouffe 1999). The emphasis on 'reciprocity' and 'consensuality' that has guided much of this work in museums ever since Clifford's work on the contact zone can produce the following reaction reported by one museum in the study in the aftermath of an experience of community collaboration in co-producing an exhibition:

There was a feeling of weariness, of disappointment, of frustration from the community members and the museum staff (two of whom had left). One member of the community embarked on an almost fanatical vitriolic series of complaints and criticisms – that the museum had no real understanding or knowledge of the community, that it lacked commitment and experience, that it was misappropriating the funds, that it was not transparent in its dealings with the community, that it was unprofessional and exclusive, that it was only concerned with completing the project for its own aims and not for any benefit to the community and finally, and most damning, that the museum encouraged (and I quote) 'subterfuge, distrust and competition' within the community.[7]

Mouffe claims that it is the idealised, consensual form of democracy permeating such contact zone work that continues to promote a view that is profoundly mistaken and bound to fail (2005). By seeking to avoid conflict, the museum suppresses the politics of the process, and thereby continues to exercise its cultural authority (Honig 1993), effectively ensuring those uneasy perceptions remain hidden from view – until they explode in anger, in instances such as reported above.

Typically, museum professionals meet such conflict with a cool, managerial or academic response, concealing a fear of the public rather than owning up to and embracing this fear of conflict: working with and through it. Perhaps something more honest and human is all that is required in these interactions. At a debate at the Manchester Museum a member of the local community said:

> We're here to challenge and I fear that others may not challenge us back. It's not for you to just listen to us being angry and *just* listen. The point is the dialogue. The point is that we could be totally wrong. I don't personally believe I am wrong – but I am willing to listen to somebody who totally disagrees with me. (Revealing Histories 2007)

Disillusionment on the part of the participants is the unsurprising consequence of the institution avoiding any real offer of active agency or the possibility of engaging with conflict. Thus, implicitly and unintentionally, certain individuals and groups continue to be silenced and excluded (Gaventa 2006). Thus liberal-minded, contact zone type museum work, inevitably creates resentment and antagonism simply because it ignores issues of power and, most importantly, the political dimension within these encounters and relationships, and prevents any opposition from being articulated or acted upon.

What disciplines, what skills might be required of museum professionals to change this practice and to understand and prepare for the complex new roles required of them in facilitating political disagreement and debate in tackling

7 As reported by a curator of the Hackney Museum at the Museums Association Conference discussion, 'Can Museums Really Co-Create Everything With the Public?' (Liverpool, 7 Oct. 2008).

messy problems? Instituting ongoing reflective practice in which museum staff work with community partners and each other, openly, as critical friends is essential. In addition, some museums have actively begun enlisting the help of other agencies (including closer collaboration with academic research) to help the museum reflect on its civil society role. Such collaborative reflexivity must include an awareness and development of new tools of analysis on such areas as social justice, power, participation and conflict, as well as new forms of participatory communication (dialogue and debate). The 'Challenging Histories' project is a good example of collaborative academic research drawn from a wider range of academic specialisms, but we need also to include an even wider range of academic specialisms, professions and social agencies – democracy studies, welfare economics, resistance theory and new areas of practice for which most of us were not trained. We need to include such areas as international development for studies in the dynamics of public participation and community development worldwide and for new skills in facilitating and participating from areas such as peace and conflict / reconciliation studies. We need to speak to specialists and organisers for whom passion and partisanship in dialogue, debate and collaborative reflection and action – activism – are clearly understood as central to an important process of communication in a democratic practice.

Conclusion

Participants in an ethico-political dialogue are rarely equal and almost never equally represented in the final consensus. Insofar as this dialogue is already projected towards some predetermined end – notions of 'wellness' for example – the field of possibilities is always delimited, certain behaviours, outcomes and evidence favoured (Chakrabarty 1995). One of the participants invariably 'knows better' than the other, whose world-view, in turn, must be modified or 'improved'. To break through this, as Yuval-Davis points out, what is instead called for is an 'acknowledgement of one's own positioning(s) while empathising with the ways others' positionings construct their gaze at the world'. Yuval-Davis calls for 'dialogues that give recognition to the specific positionings of those who participate in them' (1999: 7).

To return to the example of the Somali women: instead of providing opportunities for the women to gain confidence by actively resisting the museum's subtly coercive exercises of power, a consensus-based, tolerant, empathetic, therapeutic culture in the museum worked to undermine this process so that the participants were asked to identify their own good with the good of the institution and thus helped to maintain the status quo rather than challenge it. Unwittingly, they thereby colluded in their own marginalisation, disempowerment and even exclusion. The imposition of a museum utopianism, with its notions of a consensus-based 'dialogic' tolerant museum ' can thus, as Bhabha reminds us, serve to deprive such minorities of those 'marginal, liminal spaces from which they can intervene

in the unifying and totalising *myths* of the national culture' (1994: 241). For the 'well-intentioned' imposition of an imagined future that is not their own, perhaps more than anything else, can ultimately serve to deprive the excluded from the chance to create their own reality. Furthermore, it is fraught with dangers, because it produces the opposite effect, exacerbating the antagonistic potential existing within social relations, evidence of which can be seen throughout engagement work, when people do not choose to repeat the experience with the museum (Mouffe 2005). Beneath the rhetoric of the utopian, democratic, therapeutic, dialogic museum, the space is always contested and political – the very reality the museum does all in its power to ignore.

The task for museums in not to embrace clash-avoidance through the safety and control of adopting a therapeutic culture. Such a turn towards embracing an overtly tolerant and therapeutic approach serves to undermine the democratic aims of participation. As Wendy Brown puts it, cultivating tolerance as a political end, implicitly constitutes a rejection of politics as a domain in which conflict can be productively articulated and addressed, a domain in which citizens can be transformed by their participation (Brown 2006: 89). The contact zone task we have in museums therefore , is to embrace conflict as a return to the political, to borrow from Mouffe –we must envisage the museum as a vibrant public sphere of contestation where different views can be usefully confronted, for it is through struggle that new identities may be forged (Mouffe 2005: 5). Thus the museum as contact zone becomes, as Cornwall and Coelho suggest in relation to the institutions of civil society, a 'space … where in learning to participate, [participants] can cut their teeth and acquire new skills that can be transferred to other spheres – whether those of formal politics or neighbourhood action' (2007: 8).

Within the cultural heritage sector, it is increasingly maintained that museums can change people, but people can also change museums, as has been my more recent experience of emerging museum and gallery practice that is courageously working with community partners, taking risks and embracing these challenging issues.[8] Looking back, it is likely that, without knowing it, the Somali women challenged the museum's edifice of knowledge and power – visible, hidden and invisible (Gaventa 2006), a challenge that goes right to the heart of the museum project, contesting the interpretation of collections and changing our perception of the purpose of the museum's participatory practice.

8 Another recent action research project, led by Lynch, culminated in a co-produced publication based on innovative work with a range of publics/participants through the use of contested collections and subject matter. This project was a collaboration between UCL, Glasgow and Tyne and Wear museums – 3 large museum services in the UK – which courageously engaged in an exercise in reflective practice. We called this project 'I Object! Working Through Conflict in Museums' (see www.objectsinconflict.wordpress.com). Museum Management and Curatorship published a series special issue on the results of this work for a special issue (see Lynch 2013).

Taking lessons from this, heterogeneity of thought can thus be preserved in the museum through the refusal of unanimity and the search for radical 'discensus' (Gandhi 1998: 28). This radical discensus, initially so freely and wonderfully demonstrated by the Somali women, calls for nothing less than organisational destabilising: releasing control, so that gaps can be created within the museum institution, fissures pried open between inside and out for creative conflict to be made available. This is what was learned from the Somali women, and it is this that will mark the beginning of real dialogue in the museum.

References

Asad, T. 1973. *Anthropology and the Colonial Encounter*. New York: Ithaca Press.

Bhabha, H.K. 1994. *The Location of Culture*. New York: Routledge.

Brown, W. 2006. *Regulating Aversion: Tolerance in the Age of Identity and Empire*. Princeton, NJ: Princeton University Press.

Chakrabarty, D. 1995. 'Radical Histories and Questions of Enlightenment Rationalism: Some Recent Critiques of Subaltern Studies', *Economic and Political Weekly* 30: 751–9.

Clifford, J. 1997. *Routes: Travel and Translation in the Late Twentieth Century*. Cambridge, MA: Harvard University Press.

Cornwall, A. 2008. *Democratising Engagement: What the UK can Learn from International Experience*. London: Demos. Available at <www.demos.co.uk/publications/democratisingengagement> (accessed 1 Apr. 2012).

—— and V.S.P. Coelho 2007. 'Spaces for Change? The Politics of Citizen Participation in New Democratic Arenas', in A. Cornwall and V.S.P. Coelho (eds), *Spaces for Change? The Politics of Citizen Participation in New Democratic Arenas*. London: Zed Books.

Fraser, N. 1992. 'Rethinking the Public Sphere: A Contribution to the Critique of Actually Existing Democracy', in C. Calhoun (ed.), *Habermas and the Public Sphere*. Cambridge, MA: MIT Press.

Gandhi, L. 1998. *Postcolonial Theory: A Critical Introduction*. New York: Columbia University Press.

Gaventa, J. 2004. 'Towards Participatory Governance: Assessing the Transformative Possibilities', in S. Hickey and G. Mohan (eds), *Participation: From Tyranny to Transformation? Exploring New Approaches to Participation in Development*. New York: Zed Books.

—— 2006. *Triumph, Deficit or Contestation? Deepening the 'Deepening Democracy' Debate*. Brighton: Institute of Development Studies.

Gramsci, A. 1971. *Selections from the Prison Notebooks*. London: Lawrence & Wishart.

Honig, B. 1993. *Political Theory and the Displacement of Politics*. Ithaca, NY: Cornell University Press.

Luke, T. 2006. 'The Museum: Where Civilizations Clash or Clash Civilizes', in H.H. Genoways (ed.), *Museum Philosophy for the Twenty-First Century*. Lanham, MD: Altamira.

Lukes, S. 1974. *Power: A Radical View*. London: Macmillan Press.

Lynch, B. 2007. 'A Psychoanalysis of Touch with Diaspora Communities', in H. Chatterjee (ed.), *Touch and the Value of Object Handling in Museums*. London: Berg.

—— 2011a. 'Collaboration, Contestation, and Creative Conflict: On the Efficacy of Museum/Community Partnerships', in J. Marstine (ed.), *Redefining Museum Ethics*. London: Routledge.

—— 2013 'Working through conflict in museums: Museums, objects and participatory democracy', Museum Management and Curatorship, Special Issue, Volume 28, Issue 1, 2013 available online: http://www.tandfonline.com/toc/rmmc20/28/1.

—— 2011b. *Whose Cake is it Anyway? A Collaborative Investigation into Engagement and Participation in Twelve Museums and Galleries in the UK*. London: Paul Hamlyn Foundation. Available at <phf.org.uk> (accessed 1 Apr. 2012).

—— and S.J.M.M. Alberti 2010. 'Legacies of Prejudice: Racism, Co-production and Radical Trust in the Museum', *Museum Management and Curatorship* 25(1): 13–35 (DOI: 10.1080/09647770903529061).

Mouffe, C. (ed.) 1999. *The Challenge of Carl Schmitt*. London: Verso.

—— 2000. *The Democratic Paradox*. London: Verso.

—— *2002. Politics and Passions: The Stakes of Democracy*. London: Centre for the Study of Democracy, University of Westminster. Available at <http://www.westminster.ac.uk/_data/assets/pdf_file/0003/6456/Politics-and-Passions.pdf> (accessed 1 Apr. 2012).

—— 2005. *On the Political*. Oxford: New York: Routledge.

Pratt, M.L. 1992. *Imperial Eyes: Travel Writing and Transculturation*. London: Routledge.

Price, S. 2007. *Paris Primitive: Jacques Chirac's Museum on the Quai Branley*. London: University of Chicago Press.

Revealing Histories 2007. 'Are Museums Racist?' (Public debate at Manchester Museum, 4 Oct. 2007) [AV recording]. Available at <www.revealinghistories.org.uk/are-museums-and-galleries-racist> (accessed 1 Apr. 2012).

Tuhiwai Smith, L. 1999. *Decolonising Methodologies: Research and Indigenous Peoples*. London and New York: Zed Books.

Winnicott, D.W. 1971. *Playing and Reality*. London: Routledge.

Yuval-Davis, N. 1999. 'Institutional Racism, Cultural Diversity and Citizenship: Some Reflections on Reading the Stephen Lawrence Inquiry Report', *Sociological Research Online* 4(1). Available at <http://www.socresonline.org.uk/4/lawrence/yuval-davis.html> (accessed 1 Apr. 2012).

Chapter 7

Contemporary Challenges:
Artist Interventions in Museums and
Galleries Dealing with Challenging Histories

Miranda Stearn

I called the installation *Mining the Museum* because it could mean mining as in a
gold mine – digging up something rich with meaning – or mining as in landmine –
exploding myths and perceptions – or it could mean making it mine. (Fred Wilson
in Putnam 2001: 158)

Fred Wilson's influential 1992 intervention at the Maryland Historical Society
'Mining the Museum' saw the artist redisplaying objects from the museum's
collection, creating juxtapositions which brought to the fore narratives concerning
challenging aspects of Maryland's history, above all slavery, racism and the ill-
treatment of Native Americans. The project provides one example of the role of
the artist invited to intervene by museums and galleries keen to diversify their
institutional narratives and tackle head-on challenging histories, and we find
the aspirations around Wilson's three-fold meaning of the verb 'to mine' – to
uncover, to challenge or attack and to appropriate – echoing through many such
interventions.

This chapter will examine two such interventions and their contexts, exploring
examples where inviting an artist into the museum is part of a deliberately
revisionist strategy to tackle difficult or uncomfortable histories – coming out of the
tradition of institutional critique but at the invitation of the gallery. It will consider
the motivations that shape these projects and think particularly about the role of
the commissioned artist within the museum or gallery. Central to this investigation
has been the question of why artist interventions are considered a particularly
appropriate and effective strategy in the context of museums and galleries dealing
with these histories, what they achieve that could not happen without the intervention
of an artist, and the implications of this practice for museums and galleries, artists
and audiences. Both examples discussed are from the UK and from the 2007
commemorations of the Slave Trade Act, although similar projects have taken place
in the United States, France, Holland and Denmark to name a few. From the many
examples available, I have selected these two because, for me personally, they
worked as highly effective and affective works of art. This chapter will consider
how (and how effectively) they operated in the context of the public presentation
of challenging histories, the issues they throw up and the lessons we might learn.

La Bouche du Roi, British Museum

As a major aspect of their response to the 2007 bicentenary, the British Museum acquired and exhibited *La Bouche du Roi* (1997–2005), an artwork by Beninese artist Romuald Hazoumé. The title of the work alludes to a location on the Benin coast from which slaves were transported.

The piece consists of 304 plastic petrol cans, distorted and arranged so that from above they resemble the layout of the diagrammatic representation of the slave ship *Brookes* produced in 1789 for anti-slavery campaigner Thomas Clarkson (a copy of which is held in the collection of the British Museum). The individual petrol cans, when viewed from above, take on an anthropomorphic quality resembling faces or masks. The cans are closely packed, echoing the arrangement of the slaves depicted in the *Brookes* engraving. While appearing uniform from a distance, each mask is individualised through the addition of various objects symbolising connections to the gods of Benin. Also incorporated in the installation are objects representing commodities linked to the slave trade, for example gin bottles, guns, tobacco, beads, cowrie shells, spices, mirrors and cloth. As part of the installation, an ambient soundscape evokes voices calling out in the languages of Benin, while odours including tobacco, spices as well as faeces and urine permeate the gallery space. A film piece also included in the installation shows petrol being transported illegally between Nigeria and the Republic of Benin by motorbike in the present day, the same distorted petrol cans that make up the slave ship here shown in use.

By focusing their 2007 commemoration around this piece, the British Museum demonstrated a conviction, or at least a suspicion, that an intervention by a contemporary artist would provide a high impact and politically appropriate response to the high profile, controversial anniversary, in contrast to a more conventional exhibition of historical material which might be more in keeping with the public's expectations of the museum (some more conventional displays and events programming did take place as part of the wider bicentenary season but *La Bouche du Roi* was certainly the museum's main commemoration event). The fact that the work alludes to the famous engraving of the slave ship *Brookes*, itself a piece of British anti-slave trade propaganda, subtly allowed the British Museum not only to evoke the horrors of the slave trade in which Britain was an active agent, but also to allude to the British role in abolishing the trade which was the initial focus of the bicentenary commemorations. The interpretation material created to accompany the exhibition brings out both these aspects of Britain's involvement. The fact that the British Museum holds a copy of the *Brookes* engraving, which was displayed within the *La Bouche du Roi* installation, also allowed the museum to link the new artwork to its own collection.

Hazoumé's use of the *Brookes* engraving not only alludes to but also challenges the earlier image. While playing an important part in the abolition campaign in the UK by drawing attention to the inhuman conditions on board the slave ships, at the same time the engraving might be seen to participate in the dehumanisation of the enslaved Africans through its schematic mode of representation which removes any

sense of individuality. Through the use of sound and by making each mask distinct through the addition of a variety of spiritual objects, *La Bouche du Roi* provides a contrasting approach. This potentially raises awareness of this lack in the original engraving. This challenge to what has become an iconic image in the history of the British anti-slavery campaign might also function metonymically to suggest the limitations of traditional abolition narratives which privileged the role of a few (predominantly white) individuals as the 'heroes' of abolition while ignoring a vast array of grass-roots activities and casting the enslaved as passive recipients rather than active participants in the struggles for abolition. This broadening of public understanding of the histories of abolition was a key aim of many of the 2007 bicentenary projects, reflecting a strong directive from the Department for Culture, Media and Sport (DCMS) that rehearsing familiar, Eurocentric histories of the abolition movement would not be an adequate response to the bicentenary:

> Many will already know a little about those great heroes of the abolition movement such as William Wilberforce or Thomas Clarkson. But it is clear that the abolition of the slave trade was not only the work of a few parliamentarians and members of the church. It was a grass-roots movement, similar in its day to the tens of thousands that joined the campaign to abolish apartheid in South Africa or who supported the Make Poverty History movement last year. 2007 is our chance to celebrate all those other men and women, both black and white, who campaigned before, alongside and behind the figureheads of the abolitionist movement. People of courage and principle who chose to make their voices heard when it might have been unpopular to do so. The people who fought against slavery came from all walks of life, including slaves and former slaves, church leaders, and the countless ordinary British citizens who signed petitions, marched, lobbied and prayed for change. (DCMS 2006: 8)

As well as challenging the traditional narratives of abolition, it was hoped that the piece would affect how visitors related to other objects and displays within the museum, especially those from the era of slavery:

> Although *La Bouche du Roi* isn't a historical artefact from the time of the slave trade, it helps the Museum tell the story of what happened then and what is happening now. But by putting it on display in the context of the anniversary, Museum staff could also offer visitors a different way to think about objects in other galleries, such as the Enlightenment gallery, which displays artefacts from the eighteenth century. In this way a work of contemporary art can have a different kind of value in the collection of a museum than in an art gallery. (British Museum 2007)

The reference to 'what is happening now' is significant. In *La Bouche du Roi*, Hazoumé addresses contemporary exploitation in West Africa, using the film piece to make explicit the link between the petrol cans which provide his working material

and the highly dangerous activity of smuggling petrol between West African states as a form of modern day exploitation. This emphasis on the continuation of exploitation and a refusal to present slavery as a purely historic phenomenon would have made him an appealing choice of artist for any museum or gallery seeking to commemorate 2007, as acknowledgement of contemporary forms of slavery and people-trafficking played an important part in official rhetoric around the 2007 bicentenary (DCMS 2006: 9).[1] A quotation from the artist, included in the interpretation material for the exhibition, emphasises the work's dual role as a reflection on the past and a protest in the present:

> In many ways, slavery has never ended – many people live in the same kind of conditions, bound to work their whole lives for rich bosses, who use them without regard for their humanity, and who then throw them away, like refuse. (Romauld Hazoumé in British Museum 2007)

In interpretation materials created by the British Museum, the work is described as 'a meditation on human greed and exploitation: the Atlantic Slave Trade of the past, and the different forms of oppression that continue today' (British Museum 2007). The description of the work as a 'meditation' seems key to the museum's aspirations for what the piece might offer its visitors. Rather than focusing on providing historical information, which might enable visitors to enhance their knowledge of the Atlantic slave trade and its abolition, through *La Bouche du Roi* the museum instead offered a thinking space, encouraging visitors to reflect upon the slave trade as well as contemporary forms of exploitation as one manifestation of a more universal human quality – greed.

The multi-sensory, experiential nature of the installation encouraged a response which was primarily emotional rather than intellectual. While some historical information was provided, particularly in the form of written interpretations which explained the meaning behind various aspects of the installation, elements such as the soundscape and ambient smells encouraged visitors to think about the human experience of the slave trade, responding empathetically to the evocation of its horrors, experiencing empathy, sympathy, shock, discomfort, sadness, as well as perhaps anger and guilt – emotions which could equally be transferred to the contemporary forms of exploitation highlighted by Hazoumé.[2] Instead of a safe, contained, unemotional and therefore un-biased, account of history presented according to standard museum exhibition conventions, visitors were temporarily

1 Published for distribution to cultural organisations and community groups around the UK, underlining the government's commitment to mark the 2007 bicentenary of the 1807 Slave Trade Act.

2 Visitor comments reflecting upon the impact of the multi-sensory experience included: 'The dark and aromatic atmosphere was powerful', 'The darkness created a mysterious atmosphere', 'The sounds that were coming out and the smell – it was evocative' (Morris Hargreaves McIntyre 2007: 33).

transported into an unfamiliar, uncomfortable environment where emotional response was paramount.

'Scratch the Surface', The National Gallery

Like the British Museum, the National Gallery chose to mark the 2007 bicentenary through the prominent display of work by one individual contemporary artist, in this case Yinka Shonibare MBE. Rather than acquiring an existing work, the National Gallery opted to commission Shonibare to create new work to mark the bicentenary. The result was a two-part exhibition, 'Scratch the Surface'.

The fact that 'Scratch the Surface' was a commissioned intervention enabled the gallery to present a contemporary response to the bicentenary which was also a specific response to their collection. National Gallery curators had identified works within the collection which could be linked to the slave trade: *Colonel Tarleton* (1782) by Sir Joshua Reynolds and *Mrs Oswald* (1763–64) by Johann Zoffany. In both cases, the sitters were implicated in slavery and the slave trade: Colonel Tarleton, as MP for Liverpool during the 1790s, was a strong opponent of abolition in Parliament, while Mrs Oswald had inherited estates in Jamaica from her father and went on to marry Richard Oswald, whose trading empire included slaving. Shonibare was commissioned to create work in response to these two portraits.

His response, *Colonel Tarleton and Mrs Oswald Shooting* (2007), consisted of two headless mannequins, one representing each of the sitters, attired in costumes inspired by those depicted in the original portraits but remade in African Dutch wax fabrics. The mannequins were installed in two corners of the Barry Room of the National Gallery, an impressive domed space, displacing the original paintings which were relocated to Room 1 and displayed alongside another part of Shonibare's response, *Colonel Tarleton's Hat* (2007), as well as interpretative text explaining the historical links between the sitters and the slave trade and a video interview with the artist. Both mannequins were posed in the act of shooting a pheasant, which was suspended beneath the apex of the dome, emitting streams of red fabric to indicate the impact of their bullets.

Shonibare's response incorporated several strategies familiar from his own previous works such as *Mr. and Mrs. Andrews without their Heads* (1998),[3] *The Swing (after Fragonard)* (2001)[4] and *Reverend on Ice* (2005):[5] the use of headless mannequins; the appropriation of works by European artists, particularly those working in the eighteenth century whose subject matter included the lives of

3 After Thomas Gainsborough, *Mr. and Mrs. Andrews* (c. 1750, National Gallery, London).

4 After Jean-Honore Fragonard, *The Swing* (1767, Wallace Collection, London).

5 After Sir Henry Raeburn, *Reverend Robert Walker (1755–1808) Skating on Duddingston Loch* (c. 1795, National Gallery of Scotland, Edinburgh).

the leisured classes; the use of African wax fabric as a polyvalent sign; and the use of humour to approach political content.

Representing Colonel Tarleton and Mrs Oswald without their heads introduces a complex web of ideas. Commenting on his use of this device in the context of *Mr. and Mrs. Andrews without their Heads* (1998), Shonibare emphasised the revolutionary symbolism of the act of beheading his aristocratic sitters by alluding to the guillotines of the French Revolution and explored how, when applied to cultural icons such as Gainsborough's painting, this might function metaphorically in terms of overthrowing established power structures – or perhaps, to switch to more religious imagery, slaughtering sacred cows. Shonibare replays the quintessential act of violence against the upper classes as an act of cultural iconoclasm, with a result that seems irreverent rather than violent, perhaps suggesting that our unquestioning reverence for these artistic products of eighteenth-century society might be just as laughably anachronistic as if we were to cling to the power structures or lifestyles which they celebrate:

> It amused me to explore the possibility of bringing back the guillotine in the late 1990s, not for use on people of course – my figures are mannequins – but for use on the historical icons of power and deference. (Yinka Shonibare in Kent et al. 2008: 40)

There is also an element of humour in the resulting figures which, despite having been deprived of their heads, continue their enjoyment of the hunt regardless – this apparent stiff-upper-lipped disregard for such a debilitating lack, a refusal to acknowledge they are no longer in control, endows the piece with a sense of the ridiculous.

Shonibare acknowledges the vital importance of humour in encouraging people to engage with his work:

> I think that if I were just to produce a polemic, and I said to people 'You know what, slavery is bad, slavery was terrible … and look at me, my ancestors are the victims of slavery', I think people would be rather bored and they'd just switch off. I think that actually with humour, and with paradox as well, you are more likely to actually engage people, and get them to think a bit further. (Yinka Shonibare in National Gallery 2007)

The idea of getting people to think, rather than not think, about colonial histories is key. For the headless-ness of the figures in the installation can also suggest mindlessness – in terms of the frivolity of a carefree aristocratic life but also perhaps a more deliberate lack of mindfulness which allowed the aristocracy and others to not connect their luxurious lifestyles with the exploitation of others – a lack of mindfulness that persists and is mirrored in contemporary historical narratives whenever the historic links between wealth and exploitation continue to be ignored or brushed under the carpet. Perhaps more significant to Shonibare

than this lack of mindfulness in the histories we present is the present day manifestation of the same lack of mindfulness that wealth and extravagance in the western world continue to depend upon exploitation elsewhere. Discussing *Jardin d'amour* (2007), created the same year as 'Scratch the Surface' and displayed at Musée du Quai Branly, Paris, Shonibare emphasised the importance he places on this parallel:

> I am deliberately taking this period as a metaphor for the contemporary situation, showing very wealthy Europeans in very wealthy clothes, but because I've changed their clothes to African textiles, I give an indication that the luxury they enjoy, the labour of making the clothes, is supplied by others less fortunate. (Yinka Shonibare in Viatte 2007: 19–20)

In 'Scratch the Surface', the fabrics serve as reminders of interdependence both historic and current – encouraging viewers to be mindful rather than mindless on this score. Even without knowledge of the colonial origins of the fabrics,[6] their unexpected, incongruous use in the construction of eighteenth-century British costumes emphasises that Africa may have far more to do with the history of these figures than we tend to acknowledge. By linking this to the interdependence of extravagance and exploitation in the present day, Shonibare, like Hazoumé in *La Bouche du Roi*, was able to use his 2007 commission to suggest current parallels and continuities with the exploitation of the slave trade, picking up on one of the main themes of the national commemorations (DCMS 2006: 9).

Some Possibilities

A Space for Meditation or Emotion

Artist interventions can allow the museum or gallery to acknowledge that, for some episodes of history, traditional, rational museum text and exhibitions, however revisionist the content, seem an inadequate response. In the case of the

6 The history of these fabrics endows them with complex, contradictory associations: descended from the European textiles which operated as exchange currency in the gold, ivory and slave trades, they were inspired by Indonesian batik, manufactured in the Netherlands and Manchester, and exported to West Africa. By the twentieth century they had come to symbolise African pride and identity – a role they still fulfil for many diaspora Londoners who, like Shonibare, purchase them in Brixton market. The fabrics used by Shonibare, manufactured by Dutch company Visco, are still created by Dutch designers inspired by visits to Africa. For Shonibare, the paradoxical status of the fabrics as symbols of African pan-nationalism with their roots in European colonial trade, and their 'fakeness' as expressions of African identity actually designed by European designers, make them appealing polyvalent signifiers suggesting interdependence and hybridity.

2007 bicentenary, some commentators felt that the majority of exhibitions lacked necessary emotional intelligence.[7] The '1807 Commemorated' research project likewise noted:

> Alternative forms of representation might be required above and beyond formal historical exhibitions. That is perhaps the main function of contemporary art in the bicentenary, to render what was the unspeakable past into understanding in the present. ('1807 Commemorated' 2007)

Certainly Hazoumé's *La Bouche du Roi*, with its multi-sensory impact, anthropomorphic masks, plaintive soundscape and dramatic scale, can be seen as an attempt to provoke an emotional response to a history that was barely verbalised within the exhibition. 'Spiritual' or 'emotional' impacts were recorded by 86 per cent of visitors to the exhibition. In contrast, only 12 per cent felt the impact had been primarily 'intellectual'. This was in marked contrast to visitors' expectations: only 21 per cent expected a 'spiritual' or 'emotional' experience from their visit (Morris Hargreaves McIntyre 2007: 21, 35).

Not all audiences find this step away from the deliberately unemotional curatorial mode welcome or acceptable. While visitors were generally positive about the experience, some expressed a measure of disappointment that the exhibition had failed to deliver the educational experience they had expected, with 16 per cent of those surveyed either not very or not at all satisfied with the amount of information about the slave trade and its history (Morris Hargreaves McIntyre 2007: 30).[8] Perhaps too there is an anxiety that museums should think carefully before working with artists to unleash the emotive power of their collections; one visitor, in response to the question: 'Which part of *Mining the Museum* did you find most powerful?', responded, 'Powerful? Yes, it has the ability to promote *racism* and *hate* in young blacks' (Corrin 1994: 61). In stepping away from the 'safe' territory and inviting emotion, as provided by artist interventions, into the museum, we enter unfamiliar territory which is still being negotiated.

7 'It has been bugging me for some time. Why, when I walk into exhibitions on the theme of the transatlantic slave trade, don't I feel the emotion I expect and that the subject matter warrants? ... I am starting to feel that an academic treatment of the subject is to its detriment. It feels somehow disconnected from me – the emotion has been replaced by cold facts and figures. This is one of the drawbacks of museums in the western world. The concentration on an academic approach robs us of our ability to feel – makes us theorise over and above connecting on a human level' (Heywood 2008: 19).

8 Some specific comments included: 'I'd have liked to have seen more background to the slave trade', 'There should have been more information on the history of the slave trade', 'More historical background, more information about slavery' (Morris Hargreaves McIntyre, 2007: 30).

How Many Artists Does it Take to Change a Museum?

> Yes, okay, I am here to protest, but I am going to do it like a gentleman. It is going to look very nice. You are not even going to realise I am protesting, you are going to invite me into your museum because the work is nice. (Yinka Shonibare in Guldemond and Mackert 2004: 41).

Many invited artist interventions, particularly those dealing with challenging histories, draw upon the tradition of institutional critique practised from the 1960s onwards. The increased frequency with which critique is brought into the museum reflects the convergence of this challenging artist practice with revisionist, self-reflective trends emerging within museums, and an awareness among curators that artists might become enablers, facilitators or partners in this process.

This modified role for the artist, working within rather than outside the museum or gallery, presents challenges in the context of the practice of institutional critique, as several commentators have been quick to note. Hal Foster comments on instances in which such invited interventions 'often seem a museum event in which the institution imports critique, whether as a show of tolerance or for the purpose of inoculation (against a critique undertaken by the institution, within the institution)' (Foster 1996: 191).

This delegation of critique to artists external to the institution can be seen as an avoidance of curatorial responsibility – in relation to the 2007 bicentenary one commentator described the widespread practice as evidence of 'curatorial cop-out' ('1807 Commemorated' 2007), avoiding dealing with the challenging histories at hand. Sue Latimer, writing on artist interventions in *Museums Journal* as far back as 2001, asked: 'Why don't museum curators do it themselves rather than turn to contemporary artists?' (2001: 31)˙ Among possible answers, she suggests the notion that it might be easier for a curator to convince colleagues to allow an artist to take a new approach than to take that new approach internally, thus 'transferring the risk element'. To this, one might add that the risk element is not only transferred but contained, isolated to a one-off project rather than threatening to become part of ongoing practice. In this context, it is interesting to look at the legacies of these interventions – the National Gallery online catalogue information relating to Reynolds *Colonel Tarleton*, for example, does not mention the latter's adamant support of the slave trade, suggesting that the project as a whole did, after all, just scratch the surface.[9]

There are alternative, more hopeful readings of the 1990s and 2000s trend for artist-commissioned critique, emphasising the idea that, even when practising at the invitation of the institution, the critical potential of the détournement provided by the artist should not be ruled out or underestimated (González 2008: 100). Certainly Shonibare seems to suggest this dynamic with the assertion: 'You are not

9 <http://www.nationalgallery.org.uk/paintings/sir-joshua-reynolds-colonel-tarleton>.

even going to realise I am protesting, you are going to invite me into your museum because the work is nice' (Yinka Shonibare in Guldemond and Mackert 2004: 41).

Frazer Ward challenges the notion that invited institutional critique always ends up serving the institution under scrutiny by emphasising the role of the artist in creating a more questioning visiting public who will continue enacting the project of critique rather than passively accepting museum narratives (1995: 84). Isabelle Graw offers a slightly different take on the notion of the artist as institutional ventriloquist, suggesting that curators turn to artists to deliver critical interventions not because they are unwilling or unable to take responsibility for doing so themselves but because as 'insiders' they lack the position of authority to do so, creating 'an absurd situation in which the commissioning institution (the museum or gallery) turns to an artist as a person who has the legitimacy to point out the contradictions and irregularities of which they themselves disapprove (1990: 137).

Authenticity and Legitimacy

The idea of the artist as an authentic voice exterior to the museum and therefore somehow inherently more trustworthy, honest, perhaps even more objective, certainly provides a part of the reason why museums invite artists with a specific remit to challenge existing historical narratives. While a part of this sense of authenticity rests on simply being outside the institution and the paradox that in the deconstructed museum world only the openly personal and biased is trustworthy, in a postcolonial context authenticity can also become aligned with cultural or ethnic identity that is Other to the museum or specifically relevant to the collection/subject in hand. This presents both challenges and opportunities for artists in terms of their own positioning.

The notion of authenticity derived from ethnic or cultural identity raises challenging questions – relating to racial or cultural essentialism, ghettoisation of artists according to cultural background, and artistic identity. Hal Foster describes this oversimplification as 'the assumption that if the involved artist is *not* perceived as socially and or culturally other, he or she has but limited access to this transformative alterity, and that if he or she *is* perceived as other, he or she has automatic access to it' (1996: 173).

Ability to enact authentic critique it thus predicated on Otherness. While this potentially misplaced assumption of alterity has serious implications for museums commissioning interventions, its implications for artists are all the more challenging. In this context, we should ask what it means to be a black artist invited as a black artist and to accept? To an extent, taking on a 2007 bicentenary commission could be seen as accepting the designation of 'black artist', making ethnicity or cultural heritage the dominant feature of one's artistic identity and accepting and perpetuating the designation as Other. It seems hardly a coincidence that in 2007 a-n The Artists Information Company (a UK-based organisation with a mission to stimulate and support contemporary visual arts practice and affirm the

value of artists in society through advocacy and information) published a set of research papers entitled *Boxed In: How Cultural Diversity Polices Constrict Black Artists* (Dyer 2007).

For some, such as Shonibare, resistance to this essentialised positioning is inherent in the art they produce, allowing them to find a productive starting point in deconstructing the over-simplified position of Other imposed by such commissions. For many however, the positioning imposed by these museum intervention projects inevitably contributes to the assumption that 'every Afro-Asian artist is seen to be a *black* artist producing *black art*' (Araeen 2002: 362). Elaborating on this challenge, Rasheed Araeen writes:

> Since it is assumed that they are part of their communities – and only their communities whose problems are seen to be intrinsic to their specific cultures, Afro-Asian artists are pushed into communal and essentialist cultural frameworks. After being reduced to *ethnic minority* artists, and being thus denied their own *individual* aspirations, perceptions and experiences, black or Afro-Asian artists are removed from the authentic space or experiences of the modern age. (Araeen 2002: 361)

For any artist accepting an invitation to intervene in a gallery, and indeed for any curator commissioning such interventions to tackle challenging histories, the risk that such projects participate in and perpetuate these essentialist categories, as opposed to hybrid, transnational, or transcultural avant-garde identities that many artists themselves favour, remains an alarming possibility.

Audiences

Audience development provides the context for many commissioned artist interventions, whether postcolonial in bent or not. The idea of attracting more culturally diverse audiences through interventions which introduce either more diverse histories or more diverse artists (or ideally both) to the museum can seem a logical one, and is to an extent backed up by evidence.[10] It is not however without essentialist assumptions about what diverse audiences might want to see in a museum (and indeed the assumption that they can be treated as a homogenous

10 'Statistical evidence of the use of museums by ethnic minorities is scarce, but it seems from *Cultural Trends* 12, that most Asians and African-Caribbeans do not translate their strong commitment to general post-school education across into museum visiting. Research, including a study for Croydon Museums by Tanya Du Bery, suggests that barriers may include the following: lack of coverage in museums of non-European cultures; language barriers; the mono-culturalism of the staff, services and public mage of most museums; the lack of awareness on the part of museums of the norms of other cultures, including their educational traditions; and, in some cases, the absence of a tradition of museum visiting within a particular cultural group' (Anderson 1999: 97).

group when attempting to respond to their needs or interests). Certainly Jonah Albert, curator of 'Scratch the Surface', put forward the hope that by bringing content related to the history of the African diaspora and the slave trade in particular into the National Gallery, the institution would begin to feel more relevant to non-white audiences because it could be seen to present their history too. Interestingly, most of the 103 online respondents to the *Observer* article in which he expressed this opinion were in broad disagreement with him, though many did reinforce the idea that the reason they did not attend galleries was because they did not consider them relevant or interesting (Albert 2007).

These assumptions are hard to test without rigorous audience data, which is not available in the case of 'Scratch the Surface'. As well as audience demographic monitoring data, museums need to capture audience response, if they are to test the assumptions which lie behind the programming decisions that bring artist interventions into museums. Data collection in this area is patchy, one suspects because detailed data collection is expensive and may be motivated by a need to demonstrate impact to a corporate sponsor. Many postcolonial interventions are funded internally or by grants rather than corporate brands who perhaps recognise the essential ambivalence of linking their brand to more controversial projects.

There are however exceptions; both *La Bouche du Roi* and 'Mining the Museum', the Fred Wilson project with which we began the chapter, were subject to audience research within their own institutions, providing helpful insight into audience response (Morris Hargreaves McIntyre 2007; Corrin 1994). In addition, in relation to 2007 bicentenary projects, the AHRC-funded '1807 Commemorated' project based at the University of York carried out extensive research into how the anniversary was marked in museums and heritage sites around the UK ('1807 Commemorated' 2007; Fouseki 2010; Smith 2010). In the case of 'Mining the Museum', extensive visitor questionnaires as well as feedback focus groups and transcripts of discussions amongst the gallery docents reflecting on visitor responses were published as part of the exhibition catalogue. Visitor responses to this exhibition were mixed and often divided along ethnic lines, with those identifying as African Americans welcoming the revisionist agenda while many white visitors viewed the exhibition with suspicion as pretentious, racist, uninformative or simply evidence of the general poor standards of contemporary art. Many responses did seem to add credence to Jonah Albert's ideas, expressing the notion that the exhibition was meaningful because, unusually, the history of slavery and black experience in Maryland was not hidden. Responding to the, admittedly leading, question, 'Could you find your own history in the installation?', responses included 'Yes. EVERYWHERE! … this exhibit reflected my history, which was a change from the usual Eurocentric displays', and:

> Yes, I'm a 4th generation African-American and Native American. The photos of the 20th century people of color remind me of my forbears. But, I saw my history everywhere, not just in the photos. I wonder if white people can find their

heritage in the exhibit? It is there. … I always knew that mainstream exhibits left out all the history of people who look like me. (Corrin 1994: 62–4)

As mixed audience feedback from *La Bouche du Roi* and 'Mining the Museum' suggests, by inviting artists to intervene in the museum, institutions challenge not only themselves but their visitors, not simply by presenting challenging or uncomfortable content but because bringing in contemporary arts practice defies expectations of what the museum offers and requires challenging, often unfamiliar modes of viewing. In this context, working with contemporary artists to address postcolonial themes can present audiences with a double challenge of unfamiliar, problematic content presented in what is for many an unfamiliar, problematic mode, and any assumption that contemporary art interventions necessarily make the museum more accessible or provide coherent means to address challenging topics needs further testing. Work with contemporary artists to interpret challenging histories has the potential to offer audiences experiences that are both complex and compelling, but such projects should always be understood as highly charged calculated risks not default responses to difficult histories.

Acknowledgements

I am grateful to Jonah Albert, Xerxes Mazda and Emma Rehm, who generously gave of their time to enable me to interview them during my research.

References

'1807 Commemorated' 2007. Topic Four: The Present Past: The Use of Art in the Marking of the Bicentenary. York: Institute for the Public Understanding of the Past and the Institute for Historical Research. Available at <http://www.history.ac.uk/1807commemorated/////discussion/present_past.html> (accessed 12 Mar. 2013).

Albert, J. 2007. 'Where are the Black Visitors in my Gallery?', The Observer (Sun. 7 Jan.). Available at <http://www.guardian.co.uk/commentisfree/2007/jan/07/arts.visualarts> (accessed 12 Mar. 2013).

Anderson, D. 1999. A Common Wealth: Museums in the Learning Age. London: Department for Culture, Media and Sport.

Araeen, R. 2002. 'The Other Immigrant', in K.N. Pinder (ed.), Race-ing Art History: Critical Readings in Race and Art History. New York and London: Routledge.

British Museum 2007. La Bouche du Roi, an Artwork by Romauld Hazoumé: A British Museum Tour [exhibition pamphlet]. London: British Museum.

Corrin, L.G. (ed.) 1994. Fred Wilson: Mining the Museum. New Press: New York.

DCMS (Department for Culture, Media and Sport) 2006. Reflecting on the Past and Looking to the Future: The 2007 Bicentenary of the Abolition of the Slave Trade in the British Empire. London: Home Office.

Dyer, S. (ed.) 2007. Boxed In: How Cultural Diversity Policies Constrict Black Artists. London: a-n The Artists Information Company.

Foster, H. 1996. 'The Artist as Ethnographer', in The Return of the Real: The Avant-Garde at the End of the Century. Cambridge, MA: MIT Press.

Fouseki, K. 2010. '"Community Voices: Curatorial Choices": Community Consultation for the 1807 Exhibitions', Museum and Society 8(3): 180–92.

González, J. 2008. Subject to Display: Reframing Race in Contemporary Installation Art. Cambridge, MA: MIT Press.

Graw, I. 1990. 'Field Work', Flash Art (Nov.–Dec.): 137.

Guldemond, J., and G. Mackert 2004. 'To Entertain and Provoke: Western Influences in the Work of Yinka Shonibare', in Yinka Shonibare: Double Dutch [exhibition catalogue]. Rotterdam: Museum Boijmans Van Beuingen, Rotterdam, and Kunsthalle, Vienna.

Heywood, F. 2008. 'From Where I'm Standing: The Academic Approach Taken by Most Museums can Lead to Emotionless Displays', Museums Journal (June): 19.

Kent, R., et al. 2008. Yinka Shonibare MBE. Sydney: Museum of Contemporary Art.

Latimer, S. 2001. 'Artistic Licence: Using Contemporary Artists to Inspire Displays of Collections Requires a Clear Mutual Understanding of What is Desired', Museums Journal (Aug.): 29–31.

Morris Hargreaves McIntyre 2007. '"The Life You Don't Live": Visitor Responses to La Bouche du Roi' [unpublished evaluation report for internal use, British Museum, London].

National Gallery 2007. National Gallery Podcast: Episode 9. Available at <http://www.nationalgallery.org.uk/podcasts/the-national-gallery-podcast-episode-nine> (accessed 12 Mar. 2013).

Putnam, J. 2001. Art and Artifact: The Museum as Medium. London: Thames & Hudson.

Smith, L. 2010. '"Man's Inhumanity to Man" and other Platitudes of Avoidance and Misrecognition: An Analysis of Visitor Responses to Exhibitions Marking the 1807 Bicentenary', Museum and Society 8(3): 193–214.

Viatte, G. (ed.) 2007. Yinka Shonibare MBE: Jardin d'amour [exhibition catalogue]. Paris: Musée de Quay Branly.

Ward, F. 1995. 'The Haunted Museum: Institutional Critique and Publicity', October 73: 71–90.

Chapter 8

Coffee and Cigarettes:
On Trust-Building Processes between the
Norwegian Government and the Romani
Traveller Community

Åshild Andrea Brekke

In 1996, in close collaboration with a traditional folk museum (Glomdalsmuseet, Glomdal Museum[1]), Arts Council Norway (ACN),[2] started the long and demanding process of establishing and facilitating dialogue and participation with the Romani/ Tater.[3] At the time, this particular national minority had all but disappeared from the public consciousness due to severe and systematic assimilation measures implemented by the Norwegian state over many years. Their voice had remained absent from public and political arenas for a long time.

The main aim of the project was to develop and maintain a relationship of trust with the Romani minority through extensive and long-term contact, with a view to ensuring the Romani's right to protect and preserve their cultural heritage.[4] One important objective was to establish a centre for documentation and involve the community in developing a permanent exhibition of Romani culture at the Glomdal Museum, thus increasing public awareness and understanding of the

1 <www.glomdal.museum.no>.

2 Arts Council Norway merged with the Norwegian Museum, Library and Archive Council (ABM-utvikling) in 2011. The latter was created in 2003, following the fusion of Norsk Museumsutvikling (Norwegian Museum Development) and two library and archive organisations. It was thus NMU which originally started this process. For simplicity, I only refer to the Arts Council Norway in the chapter.

3 In this chapter I refer to Romani and Tater, which are two names for the same ethnic group. 'Traveller' is another term which is used. Furthermore, I specifically use the Norwegian spelling for Romani, in an attempt to underline that this is a particular ethnic group in Norway, distinct from other Romany or Rom peoples in Europe.

4 Rights to access, representation and participation in cultural heritage, are fundamentals which have been set down in several international conventions ratified by the Norwegian state: the UN Convention on Human Rights, the UN Convention on the Rights of the Child, the UNESCO Convention on the Protection of Intangible Cultural Heritage and the Framework Convention on the Protection of National Minorities (see <www.ud.dep.no>).

Romani minority. The result of this painstaking and sometimes painful process is astounding: today, the Romani people have a strong sense of ownership of the Glomdal Museum and pride in *their* exhibition which opened in 2006.

This chapter describes how Norwegian museum authorities started the slow and uncertain process of securing a forgotten national minority's rights to their own culture. It is a case narrated from my point of view as an employee of the Norwegian state, and my objective is to show the importance of 'competent flexibility'[5] in the implementation of political decisions.

Five Hundred Years of Repression

A little known but particularly grim side of Norwegian history concerns the brutal repression and forced assimilation of the Romani/Tater people of Norway. This Traveller community, whose presence in the country has been recorded as far back as the early 1500s (Ekeland Bastrup and Sivertsen 1996), has been marginalised to the point of invisibility and/or extinction, and only recently received recognition as a national minority. Historically, the community's itinerant lifestyle brought useful cultural impulses, skills, news, products and trade to the sedentary 'buro'[6] majority, but still scepticism and prejudice seem to have dominated the majority perception of the Romani. This is starkly reflected in the history of government policies vis-a-vis this minority (see Ekeland Bastrup and Sivertsen 1996).

It was only in the 1990s that stories of abuse started to trickle into the public sphere, thanks to the tireless awareness-raising efforts of different individuals and non-governmental organisations, including the Romani's own organisations.[7] In 1999, the Romani were finally recognised as one of five national minorities in Norway with special rights to protection and the preservation of their culture along with the Rom,[8] the Jews, the Kvens and the Forest Finns (Holmesland 2006).[9]

5　By this I mean making sure that official procedures, rules and practices do not become counter-productive to a constructive process. In this case it has been necessary to recognise and deal with the uneven balance of power inherent in the relationship between academically educated representatives of the government and the Romani community, many of whom have little or no formal education. Adjusting the map to the terrain and not the other way around, so to speak.

6　'Buro' is the Romani word for 'non-Romani' or 'peasant' (Møystad 2009).

7　The first Tater organisation, Taternes Landsforening (TL) was founded in 1995, the second, Landsorganisasjonen for Romanifolket, in 2000 (see <www.taterne.com>; <www.lor.no>).

8　In Norway, the gypsies are called Rom and speak romanès. Despite a possible common ancestry, today the Norwegian Rom are ethnically and linguistically different from the Romani/Tater, who speak Norwegian romani.

9　In 1996, the issue was formally raised in Parliament (Stortinget) followed by discussions on how the government should best attempt to improve the situation for the Norwegian Romani. Norway finally signed the Framework Convention for the Protection

Today few obvious and tangible material traces of the Romani/Tater community exist, except when looked for with a trained eye. Different objects and artefacts crafted by the Romani are still around, although they are not necessarily recognised as such by younger generations. Shawls, silver pocket-watches, embroidered tablecloths, handcrafted kitchen utensils, pewter candleholders and knives are just some of the objects that can still be found in older kitchens, attics and thrift shops. There are also traces in the more intangible heritage: in the names of places where communities used to camp and especially in music, as the Romani were popular musicians and skilled fiddlers who promoted and influenced Norwegian folk music across the country, picking up and disseminating new impulses (Gotaas 2000). In short, the cultural heritage of the Romani has been hidden in plain view.

It is only recently that there has been more research into this history and its implications for Norway.[10] This presented in itself several ethical and methodological challenges for the Arts Council. On the one hand, the Romani still have, quite understandably, great difficulty in trusting outsiders, such as researchers, and the issue of their identity and ethnicity remains a sensitive topic[11] (Hilde Holmesland, Senior Advisor on National Minorities at the Arts Council Norway, personal communication). On the other hand, paradoxically and inconsistently, it is only researchers who have had access to certain restricted institutional archives containing the dossiers of Romani/Tater who were subjected to the medical and social service systems in charge of lobotomy, sterilisation and foster-care. In time, it is hoped that the scope of research will widen and strengthen and that consequently the level of public knowledge about this part of Norwegian culture and history will rise also. As has been stated, there is still a widespread lack of knowledge and quite a bit of prejudice in Norwegian society as evidenced when in 2009 the Glomdal Museum, in collaboration with the Tater community, developed an exhibition project for primary and secondary schools. The school project was effectively stopped by concerned parents who did not want their children exposed to this sort of subject (Mari Østhaug Møystad, former curator at the Glomdal Museum, personal communication). Such ignorance, of course, exposes the potential for further injustice.

of National Minorities of the Council of Europe in 1995, ratifying it four years later (see Council of Europe 1995; Stortingsproposisjon 80 1997–98).

10 Most of the research into Romani culture has been done by historians, who also have documented the history of the systematic repression and assimilation on the part of the Norwegian state. For further exploration, see Ekeland Bastrup and Sivertsen 1999; Gotaas 2000; Dyrlid and Bjerkan 1999; as well as suggested reading list on the exhibition website (in Norwegian only).

11 The issue of openly claiming a Romani/Tater identity has been, and to a certain degree still is, extremely shameful and taboo, not least internally in the Romani community (see <www.latjodrom.no>). The membership lists of their organisations are not made public (Halvorsen 2004).

Towards a Centre for Documentation and Permanent Exhibition

Following Norway's ratification of the Framework Convention on the Protection of National Minorities, work started developing and implementing measures safeguarding the cultural heritage of the Romani. As mentioned earlier, one important objective was to establish a centre for documentation and involve the community in developing a permanent exhibition of Romani/Tater culture at the Glomdal Museum in the county of Hedmark.

In 1997, a working group with representatives from the Romani/Tater organisation Taternes Landsforening, as well as from the municipality, county, ACN and the museum was put together in order to start planning the documentation centre. The working group drew up formal terms of cooperation and held regular formal meetings during the whole process (Halvorsen 2004).

Later, a reference group to discuss and approve the theme, content and form of the exhibition was established, and the exhibition started to take shape. The Romani participated in all phases: developing the vision and overall goals for the exhibition, collecting objects, designing the exhibition, and communicating with museum visitors. One of the employees at the museum is also of Romani origin.[12]

Active participation by the Romani community was a necessary principle through all phases of the process. The museum even changed its overall strategic goals to make sure the cooperation with national and other minorities was robustly and permanently anchored in the whole institution and all their work,[13] underlining their status as a centre for documentation of Romani culture.

A Question of Trust

A formidable stumbling block in the process turned out to be the almost complete and historically justifiable lack of trust from the Romani community towards anyone representing the majority society, not least representatives of the government, which is essentially what Arts Council workers are (Hilde Holmesland, personal communication). Moreover, the Romani were afraid that the prejudices, which still exist, would be amplified should there be more focus on their group and situation. At the same time they were interested in the initiative as they were afraid that their culture would otherwise be completely forgotten (Hilde Holmesland, personal communication). An important stepping stone in the process towards a real and lasting improvement of the situation for the Romani minority was thus developing and maintaining a relationship of trust with the Romani community. This trust-building process has not previously been documented formally and so

12 For further information on the exhibition itself, see <www.latjodrom.no>.

13 The Glomdal museum mission document states that the museum has a particular responsibility for the Romani/Tater cultural heritage as well as other newer minority groups in the county of Hedmark (Glomdal Museum 2006).

this section is largely based on personal communication with Hilde Holmesland at ACN, and Mari Møystad, anthropologist and former curator at the Glomdal Museum. Both were instrumental in the exhibition project, demonstrating a lot of competent flexibility throughout the whole process. As the process of building trust is fragile and ongoing, the Romani community small and the majority society still largely in ignorance, any description needs to be extremely discerning.

The two groups involved in planning the centre and developing the exhibition, held formal meetings and had written terms of cooperation, but it was the informal aspect of this process that turned out to be the pivotal factor in building trust. As Holmesland has said: 'it took a lot of shared coffee and cigarettes'. Such informal moments helped the ACN representatives to better understand the community's deep-seated anger and the sometimes aggressive recriminations that would surface. These difficulties of trust tended to surface around two themes: representation and expectations.

Representation

It was quickly evident that there was considerable internal disagreement within the group about whether one should talk to the government at all and why the Romani/ Tater community would want a museum. The Romani community, like any community, is not a homogeneous group, especially regarding regional cultural differences.[14] Even the Romani's own organisation, TL, struggled in its attempts to find common ground within the community: for example, whether members with higher education, seen as being better placed to deal with a bureaucratic culture, would be seen as credible representatives by the community. There was in general a high turnover of working group members from the Romani community, making it challenging to keep continuity in the process (Halvorsen 2004).

Expectations

Another fundamental challenge throughout the process was the differences in expectations held by the various stakeholders. There seemed to be a gap between the expectations of the highly educated bureaucrats and the ability of the Romani community to meet them.[15] However, over time the different parties seemed to adjust better to one another (Halvorsen 2004) so that the process and the dialogue could continue.

In 2005, new, updated terms of cooperation were negotiated as a result of resolving a good number of the conflicts (Halvorsen 2004). These terms stressed

14 The brutal assimilation politics had contributed to disrupting old loyalties and trust: reduced travelling and going into hiding meant less contact within the community and thus weaker relations (Halvorsen 2004).

15 Many Romani lack basic literacy skills due to the assimilation politics of the Norwegian state (Halvorsen 2004).

the need for the work to be marked by transparency and trust and that the members of the working group should be bound by the decisions taken by the group. Any conflicts were to be discussed and dealt with in the working group before involving other actors (Halvorsen 2004: 85). This mutually negotiated recognition that conflict can be fruitful if properly handled also contributed to driving the process forward: all stakeholders had to give some ground in order to keep the dialogue open.

Another key issue regarding the relative success of this process was the fact that it was initiated, funded and sustained without anyone knowing quite where, if anywhere, it would lead. The Ministry of Culture recognised the need for considerable latitude both financially and with regard to time: they showed 'competent flexibility' in that they did not interfere in the process and did not demand quick results which might jeopardise the effort. This patience turned out to have its rewards – after almost ten years of challenging dialogue between the stakeholders, the first ever permanent exhibition on Romani/Tater cultural heritage was opened at the Glomdal Museum in 2006.

Concluding Remarks

The permanent Romani/Tater exhibition at the Glomdal Museum came about through a long, tough process of establishing and maintaining trust, in close dialogue with the Romani themselves. The key elements which proved important for the relative success of the process can be summed up as follows:

1. The first and most crucial component of the dialogue, but also the most difficult, was *developing and maintaining trust through formal and informal contact* with the Romani community.
2. The different stakeholders in the process were *allowed the time and resources required to establish and maintain trust*. In this case, almost ten years passed from the initial dialogues to the completed exhibition.
3. Throughout the whole process, the Romani community *was ensured active participation in all phases*. This was part of the agreement for cooperation guiding the working group.
4. The *focus was kept on the process itself rather than the end-result.*
5. The *process has been allowed to continue.*

The results of this process are astounding: the exhibition officially opened in 2006 and today, the Romani/Tater have a strong sense of ownership of the Glomdal Museum and pride in the exhibition about their culture. The museum has become a true intercultural meeting place, as well as a place where the Romani people feel

at home.[16] The museum and community now collaborate on issues ranging from documentation of Romani culture to organising cultural events (Mari Østhaug Møystad, personal communication).

Given the strong injunctions laid down in international conventions (as noted at the start of this chapter), it is imperative not only for all government bodies but also for museums to shoulder their responsibility when it comes to fulfilling these rights. Given enough time and resources, museums have an exciting potential as empowering and critically thinking agents for social justice and positive change. In Norway, a white paper on social inclusion in the cultural sector was issued in December 2011, putting further pressure on the sector to focus on inclusion and empowerment.[17]

The story of the Norwegian Romani/Tater is an important one, not least because of the shocking recentness of the invasive and abusive state policies. Important steps have been taken to rectify past wrongdoings and avoid future ones. The role of adequate political tools (conventions, white papers, etc.), dedicated individuals and open-minded museum staff can unquestionably be instrumental in this area, as this chapter has shown. Moreover, it is a case which shows the importance of both formal and informal processes when engaging with vulnerable groups. It is about exercising competent flexibility: letting a process develop and run its course without being in total control of where it may lead, and without expecting quick fixes and guaranteed results. In short, it is about sharing enough coffee and cigarettes.

References

Council of Europe 1995. *Framework Convention on the Protection of National Minorities*. Available at <http://www.regjeringen.no/en/dep/ud/Documents/ Propositions-and-reports/Propositions-to-the-Storting/19971998/stprp-nr-80-1997-98-/9.html?id=202022> (accessed 31 Jan. 2013).

Dyrlid, L., and L. Bjerkan 1999. *Om likhet, likeverd – og annerledeshet. Et antropologisk blikk på taternes livshistorier*. Rapport fra delprosjekt nr. 112955/510. Trondheim: Sosialantropologisk intitutt. NTNU.

Ekeland Bastrup, O.R., and A.G. Sivertsen 1996. *En landevei mot undergangen*. Oslo: Universitetsforlaget.

Glomdal Museum 2006. 'Mission Statement'. Available at <www.http://glomdal. wpprod.kulturit.no/wp-content/uploads/2011/08/Glomdalsmuseet_Vedtekter. pdf> (accessed 31 Jan. 2013).

Gotaas, T. 2000. *Taterne – livskampen og eventyret*. Oslo: Andresen og Butenschøn.

16 The museum is often used as a venue for events and activities organised by the Romani community.

17 See <http://www.regjeringen.no/nb/dep/kud/dok/regpubl/stmeld/2011-2012/meld-st-10-20112012.html?id=666017>.

Halvorsen, R. 2004. *Taternes arbeid for oppreisning og anerkjennelse i Norge.* Trondheim: Tapir Akademisk forlag.

Holmesland, H. 2006. *Arkivene, bibliotekene, museene og de nasjonale minoritetene.* ABM skrift 25, Oslo: ABM-utvikling (Norwegian Archive, Library and Museum Authority).

Møystad, M.Ø. (ed.) 2009. *Latjo drom – Romanifolkets/taternes kultur og historie.* Elverum: Glomdalsmuseet.

Stortingsproposisjon 80 1997–98. 'Om samtykke til ratifikasjon av Europarådets rammekonvensjon av 1. februar 1995 om beskyttelse av nasjonale minoriteter'. Available at <http://www.regjeringen.no/en/dep/ud/Documents/Propositions-and-reports/Propositions-to-the-Storting/19971998/stprp-nr-80-1997-98-.html?id=202013> (accessed 31 Jan. 2013).

Chapter 9

Fieldnotes from a Challenging History

David Gunn and Victoria Ward

Truth and the Fieldnote

Let's begin with the before. This chapter emerges from the intersection of two quite different individuals and practices: Victoria, who has led story-telling consultancy Sparknow since 1997 in an enquiry into the use of narrative within organisations and those who advise them; David, founding director of inter-disciplinary creative organisation Incidental, has worked on a range of projects that explore notions of participation, site and the creative act; and somewhere in the middle, a growing body of work undertaken together as a 'third mind' (Burroughs and Gysin, 1979) exploring forms of participation, knowledge and narrative in partnership with third sector institutions and government. Occurring in different places and to different ends, our work in each of these areas shares a repeated involvement with questions of site, of history and memory, of participation and power, of silence and being silenced. In particular we have both constantly wondered, separately and together, about the balance between products and processes:

> In any research topic, there are two overarching questions that have to be addressed: what is the object of enquiry and how can it be enquired into? (Hollway and Jefferson, 2000: 6)

As part of these explorations, in 2009, Victoria found herself working with Sam Cairns, Alex Drago and Amy Ryall and was asked to develop a structure for workshops and discussions for the seminar series held at the Tower of London which seeded the 'Challenging History' manifesto and community of practice. Victoria then shared this work with David, and together we explored our shared and individual projects through this lens – conversations began over coffee and by email, continued more publicly during our workshop session for the inaugural 2012 Challenging History Conference and then found their way onto paper as the ideas contained in this chapter.

As the preceding comments might imply, we approach the specific questions of 'Challenging History' as part of a broader continuum of enquiry that touches on a range of social, cultural and organisational contexts. As we began to prepare this chapter, we wrestled individually and collectively with how to connect these discussions in a way that helped to frame this emergent thing that might be called 'Challenging History'. We are not academic researchers, historians or curators. We

are not a museum. At some level, our concerns related to the codes of discourse within museum curatorship or the academic community, but we also struggled with how to hold thoughts open and to present a form of learning experience that was not yet knowledge. And of course, these two issues were intimately connected. As experimental anthropologist Michael Taussig has observed, academic discourse prizes the apparent objectivity of fact, engendering a situation where 'anything subjective is not so much erased as disguised and distorted by this language' (2011: location 753). Re-evaluating the value of raw fieldnotes as a communicative tool and as a subject for research, Taussig writes:

> Much of anthropology, certainly most that is funded, thus turns out to be telling other people's stories without realizing that's what you are doing, and telling them badly, very badly indeed – because, like drawings, such stories are seen as mere steps toward the Greater Truth of the Abstraction. This is why the fieldworker's notebook, with at least one foot in the art of sensuous immediacy, is so valuable as an alternate form of knowledge to what eventually gets into print. (Taussig 2011: location 761)

In our respective practices, both authors are closely concerned with such 'alternative forms of knowledge', with things that do not easily find their way into the conscious mind, let alone into print. For us, the most challenging aspect of 'Challenging History' seemed to be situated exactly in this point. This does not simply mean uncovering alternative histories or viewpoints, but exploring different modes in which one might communicate, inhabiting more open and messy forms of thinking and experiencing, different ways of knowing and not-knowing. In the context of the emerging notion of challenging history, it means we must not only ask what challenging history might be, but to consider quite explicitly who we are when we challenge history. To account not only for the things we choose to notice and what to ignore, but where we are positioned in relation to ourselves, to each other and to the thing being enquired into, and how particular stances and positions may afford new perspectives, may cast shadows or even block out the sun.

Accordingly, this chapter seeks not simply to review our own ideas about the emerging notion of challenging histories, but to view our own relationship to this process of arriving at such ideas as a kind of challenging history in its own right. To do so, we have thought of this chapter as a kind of fieldnote of our own investigation – one that self-reflexively considers the way in which our ideas around 'Challenging History' emerged and embraces its own incompletion and uncertainty as a key quality. Throughout we have taken care to ensure the subjective *I* of experience has not been hidden under the fictitious third-person passive of academic literature and also been clear about the ways in which the thoughts contained here emerged: not in order to put us as individuals at centre stage but simply to make it clear that these are thoughts that are emerging from our individual practices and the overlap between them, in ways that we may not quite understand ourselves, and to present this information itself as part of the data

of this chapter, something suitable for further analysis and interpretation by both the reader and ourselves.

The remaining content of this chapter is organised into three main areas. First, we show how our experiences and reading habits around the time of the conference helped to frame our understanding of the emerging 'Challenging History' community of practice and the structural challenges faced by museums and other institutions as they seek to engage with this issue. We then begin to draw together a few examples that we believe begin to indicate alternative approaches to this same issue. Finally, we sketch out three thematic areas that we believe may help to frame the emerging practice of challenging history, specifically a renewed consideration of time, emptiness and the process of inscription.

The Discomfort of Learning

As we began to collect our thoughts for this chapter, Victoria was processing the aftermath of her own challenged and interrupted history of studying working groups at the Tavistock Institute for a year. Initially undertaking a two-year postgraduate masters degree in understanding group dynamics, Victoria's experiences with the course became rather painful (ironically characterised by the same fight and flight dynamics the course sought to explore) resulting in an abbreviated one-year postgraduate certificate. But, in doing so, she came across the work of Wilfred Ruprecht Bion, which seemed to offer some useful structures to help frame our engagement with the topic of this chapter and particularly to understand how we individually and collectively respond to difficult and challenging histories. Working in the aftermath of the First World War as soldiers returned home from the battlefields, Bion established a series of classes and workshops to deal with the overwhelming numbers of those experiencing forms of post-traumatic stress, and in doing so began to establish thinking about groups that are still a primary reference point for conducting therapeutic groups (Bion 1961, 1962). Emailing David, Victoria paraphrased some of Bion's later thinking as follows:

> His overall thesis focused upon our intense dislike of learning and the avoidance of learning – the fact that both groups and individuals will try very hard to avoid the discomfort of learning from experience and he postulated a model of learning, based round the notion of K, which could be flipped to the negative and so result in –K, a kind of defensive stripping or denuding of meaning through the accumulation of defensive knowledge as a means to avoid the necessary emotional engagement for the growth of integrated knowledge.

In Bion's model, we are all endowed with the capacity to embrace complexity and uncertainty, to discriminate and discern reality in the round. This is something he terms the Alpha Function. But all too easily we fall back on endlessly collecting 'beta-elements' as our defence against reality, that endless knowledge we build up

to shore ourselves against being exposed to the emotional disturbance of learning. Or to put it another way:

> Cram them full of non-combustible data, chock them so damned full of 'facts' they feel stuffed, but absolutely 'brilliant' with information. Then they'll feel they are thinking, they'll get a sense of motion without moving. And they'll be happy because facts of that sort don't change. Don't give them any slippery stuff like philosophy or sociology to tie things up with. That way lies melancholy. (Bradbury 1953: 61)

Isn't the nature of the subject that we are always split, suppressing the complex emotions of reality and unconsciously choosing to live in the simpler black-and-white of fantasy? Necessarily confused, reacting to complex and unknowable forces of contradictory emotion, love, hate, guilt, fear, envy, rage? As individuals, don't we all fall back on the beta-elements, cramming ourselves full of non-combustible data? Weren't all of us at the Challenging History Conference so chocked full of facts that we felt stuffed but absolutely 'brilliant' with information? Whilst at the same time we risked nothing?

The Art Kettle

From:	david gunn
Subject:	There are times
Date:	20 April 2012 16:34:14 GMT+01:00

To: Victoria Ward

When things just fall into place. Your Bion quotes are a perfect match to the art kettle stuff, dovetail beautifully with some arguments I had been starting to make.

Sent from my mobile

In our post-conference exchanges, Victoria emailed about Bion as David was reading Sinead Murphy's *The Art Kettle* (2010) and seeking to sharpen his own thinking around the forms of culture and creativity that are excluded from the contemporary formulations of art and cultural practice. The connections were instructive. Murphy's sharp critique focuses upon the ways in which the Arts commonly operate not as a force for social good but as a containment device, something that serves to 'kettle' public opinion as effectively as police had

kettled bodies in the spate of recent public protests across London.[1] At the heart of Murphy's book is an extended analysis of Mark Wallinger's *State Britain*, an artwork that, for her, provides an exemplary case of the way in which Art acts upon real world issues and politics. *State Britain* had its roots in the protests of Brian Haw, as he camped at Parliament Square alongside a series of placards and objects that expressed opposition to the British invasion of Iraq. After a new act was passed outlawing unauthorised protests within one kilometre of Parliament Square, the protest was dismantled and then subsequently reconstructed by Mark Wallinger as a work of art within Tate Britain. To quote from Murphy's analysis:

> The [Turner Prize] jury recommended Wallinger's work for its 'immediacy, visceral intensity and historical importance', and for its being a 'bold political statement'. Given however that, by comparison with the protest of which Wallinger's work is described as a 'direct representation'. State Britain is characterised precisely by its lack of immediacy (it is no longer in view of anyone but a very controlled number of the public) and its lack of immediacy (Wallinger did not live with his work for 24 hours a day, traffic was not rushing by, the Prime Minister was unlikely to see it ... need we go on?) ... [the work] functions much more consistently to remove art – and the imaginative, bold and immediate resistances of which the creative, the 'artistic' spirit is capable – from life. Parliament Square is clear again; free thinking, resistance, protest is hidden away in the art museum and life goes on as before. (Murphy 2011: location 170)

In Murphy's reading, the inclusion of radical ideas and actions within the gallery space inherently denudes them of their radical value – indeed, it seems that it is only on account of this denuding that these voices are permitted into the space. Of course, sites of conscience, memorials and museums are not art galleries, but in a world where art galleries are listed alongside dark tourism sites as must see places in city guides, it is hard not to view such places as simply one part of an ever-widening ecosystem of entertainment experiences within which previously distinct areas of public experience and discourse are consumed. *State Britain* seems to offer an unusually clear depiction of how cultural institutions commonly interact with difficult histories – one that marks very directly the creation of the institutional archive – the process by which events are removed from real life and turned into something else. Is this not, at an institutional level, very close to Bion's portrayal of the transition from Alpha Function to beta-elements, that defensive stripping or denuding of meaning? Is it unreasonable to suggest that the contemporary formulation of the museum and its archival function has evolved

1 'Kettling' refers to a controversial technique of crowd control based upon encircling and then restricting the movement of large crowds. Kettling was regularly used by UK police at a range of public protests, including Parliamentary Square Disability Rights Demonstration (1995), G8 (2005), G20 (2009) and Anti-Cuts Protests (2011).

precisely to serve this human impulse? That museums are almost built to denude histories of their radical value?

Participation and Paralysis

Institutions and their archives do not exist in a vacuum, and the emerging community of practice of 'Challenging History' clearly needs to better understand the ways in which we wish to conceive of and interact with visitors and audiences, but in the contemporary landscape, this issue of participation and engagement is a particularly vexed one. Bernadette Lynch's 2011 study *Whose Cake is it Anyway?* for the Paul Hamlyn Foundation provides a instructive analysis of the dynamics at work within the UK cultural sector, identifying a fundamental ambiguity at the heart of the way in which cultural institutions interact with the people that surround them, and the places in which they find themselves – seeking to be inclusive and to invite participation, but finding themselves stuck in something else entirely:

> Communities remain, or at least perceive themselves to be, fundamentally separated from processes within these organisations: rather than engaging at every level of their work, they are relegated to mere consumption of museums' and galleries' *'products'*. (Lynch 2011: 5; see Lynch, Chapter 6, this volume)

This is complex territory, and we should not assume that institutions are entirely to blame for these dynamics. For institutions are enmeshed within a broader network of actors, each of which has varying degrees of agency and influence. To help us frame this issue, it is worth doubling back for a moment to earlier phases of Bion's thought and particularly some of his earlier works that focus more directly upon the dynamics of group behaviour. To quote once again from Victoria's email:

> Bion developed an understanding of the three 'basic assumptions' of groups which have lost sight of the 'primary task' and so move through different states of dependency on a magical leader who will sort everything out (baD, basic assumption Dependency) fight or flight, where the group behaves as though its main task is to fight or run from a common enemy without or outside the group (baF, basic assumption Flight) or a group frozen in a fantasy assumption that some kind of pair in the group will lead the group to the promised place (baP, basic assumption Pairing).

Cue a snappy title – the Paradox of Participation, or something similar. For we find ourselves in a cultural landscape that is obsessed with participation and engagement, but is almost completely unable to achieve it in any meaningful sense. Lynch's report suggests that the shortcomings in participation can be addressed by modifying how institutions work with those around them, but we can't escape the feeling that there is something more structural at work here. Perhaps one of the

underlying challenges for museums and other institutions is that most are poorly equipped to resist this slide amongst their audiences and visitors into the basic assumptions, that they enable precisely the kind of dysfunctions that Bion outlines – dependency on someone else to make sense of it all, the instinctive recourse to fight or flight, the paralysing fantasy of a just-around-the-corner transformative experience. That museums are by their very nature caught in a double bind of institutional structure and audience behaviour – that the customary ways in which museums construct meaning and audiences consume it mean that participation remains little more than a footnote, and all histories remain fundamentally unchallenged.

Genocide and Tipp-ex

But things are not always so. And often, around the edges of more formalised responses and presentations of history, other things are visible. Things that one might see, for example, in the final, often overlooked side rooms of Cambodia's Tuol Sleng Genocide Museum. This is a topic of particular relevance to David's practice, having spent the past six years developing a series of projects in Phnom Penh in collaboration with local artists and organisations. Here once again we touch upon another challenged history – as David struggled meaningfully to engage with this city of dark past in ways that succumbed to neither the all-too-easy invocation of such histories as a way to invest projects with borrowed meaning and the easy retreat into blithe avoidance and blindness.

A former site of Khmer Rouge torture and death, Tuol Sleng was established as a museum in 1980 in the immediate aftermath of the Khmer Rouge regime. It seems no accident that as Cambodia became a significant waypoint of the tourist trail of South East Asia, the character of Tuol Sleng and other sites of memorial has been gradually changed in small but significant ways – most famously with the removal of a map of the country constructed from human skulls – as they transitioned from improvised forms of memorialisation to other, more controlled and conventional forms of representation. But something still leaks out. After a tour of the buildings, the torture chambers, incarceration rooms and photographs of victims from the period, one could stumble across an often-overlooked room, a series of large-scale reproductions of senior and junior Khmer Rouge participants are mounted on the wall. After being installed, these photographs were subjected to constant violation, as visitor after visitor scrawled upon them in pen, pencil, paint and Tipp-ex. From heartfelt angst and hatred to the almost-humorous cartoon elements of glasses and eyebrows, the images became an accumulated scrawl of every emotion.

For one visitor at least, after carefully assembled statistics of murder and carefully curated detail, this room of annotated photographs was the most emotionally resonant of the entire museum: a sacred site, in the most complex reading of that term. And, although we may see this as closely related to the

comment walls in contemporary museums across the world, they are something else entirely. These are not welcomed interactions, approved contributions in a museum's walled-off safe zone, but a space that has been actively occupied by the visitors. The meaning of the space is not constructed through approved participation, but by a succession of visitors who stepped over the threshold of that which they were expected to do in a way that was both modest and forbidden. Over time, individuals came together on these printed photographs to carve our their own transitional space, one that enabled them to step away from the increasingly institutionalised presentation of history and to sketch a new relationship between site, archive and people.

After the submission of the first version of this chapter, the editor Alex Drago responded specifically to the preceding paragraph with the following comment:

> This is an interesting premise and is valid precisely because it is an approved space with unapproved intervention. If an institution were to do this knowingly could it work again or does it lose its power because it is manipulated? Does it just become a comment wall? Are visitors sufficiently fluent enough in the language to be able to understand that they have negotiated their own transitional space? Or is it just you using an academic language to place a frame round it? Complex.

It is a fair question – is the model we seem to be proposing here predicated upon the notion of transgression? Are we offering museums the impossible – and rather useless – insight that only unauthorised contributions offer genuine forms of participation? That the minute one invites participation it is invalidated? That any planned activity inevitably sows a trail of breadcrumbs that leads participants back to the basic assumption dependencies, denuding cultural spaces of real experience and learning?

We're not sure that we know the answer to these questions. But we'd suggest that that the case of Tuol Sleng is not unique and that one can find comparable approaches to challenging history that do not rely upon transgression. Take, for example, the work undertaken by District 6 Museum in South Africa. Situated on the site of a forcibly evicted community, the museum is remarkable for the extent to which it has been, since its inception, an active site of research, activism and the locale for the re-establishment of social bonds amongst displaced people. It is a place where archival materials and artistic interventions sit side-by-side with no clear demarcation between the two, and even morph from one to the other. More than a museum about what occurred there, it is an archive of what happened since – it is a museum about the process of memory, of sense-making, a container for the residue of actions that have taken place within its walls.

As authors, we instinctively feel that examples like these begin to offer a way beyond the challenges we outlined earlier, but, for us, they do not as yet yield a coherent vision for how to move forward. We have reached the end of our certainties and our essay-as-fieldnote must begin to acknowledge its own incompletion – the

point at which our argument begins to disassemble into a handful of hunches, analogies and half-thoughts. And so we conclude this chapter with a consideration of three openings, a term we are using in two ways: in one sense, to denote what we believe to be areas of opportunity, themes which institutions can begin to embrace to deal more effectively with challenging history; but, at the same time, these openings are also holes within the fabric of the text – questions to which we do not have the answers. We conclude this chapter with these openings, both as a way to map out our own future study and to invite further conversation with those who may read this work.

Opening: Time

Earlier in this chapter, we pursued a line of argument that seemed to suggest that the challenges facing museums might stem from the very creation of the historical archive itself, but we suspect there is something more subtle going on. For what seems to be at stake here is not simply a question of the archive per se, but how time and history are perceived within it. Perhaps there is something important in the tendency of cultural institutions of all kinds to exhibit work in ways that seals it off as a discrete unit of meaning, to construct a kind of 'epic past' explored so extensively by Bahktin in his seminal studies of the novel:

> The epic past is called the *absolute past* for good reason: it is both monochronic and valorised (hierarchical); it lacks any relativity, that is, any gradual, purely temporal progressions that might connect it with the present. It is walled off absolutely from all subsequent times, and above all from those times in which the singer and his listeners are located. This boundary, consequently, is immanent in the form of the epic itself and is felt and heard in its every word. (Bahktin 1941: location 463)

In contrast to this epic past, Bahktin juxtaposes novelistic forms of narrative, which are characterised by the deployment of colloquial speech, a predisposition to satirise or destabilise existing narrative conventions, and a fundamentally different approach to time – with the subject matter seen as something connected to and interweaved with the present-day reality of the reader. Might this contrast help us to consider how we approach challenging histories? Taking a cue from District 6, should we not only consider the depiction of a particular period or subject, but the relationship to and position within time – and history – itself? And what if we seek to destabilise the conventional relationships between museums and time? What if we as individuals cultivate the ability to see one's own actions differently within time, to replace monochromic views with a sense of time that is synchronous as well as diachronous? What would such institutions look like? Can we conceive of museums that thrive upon their own contingency and incompletion? Collections

that actively seek to disassemble the conventions of the museum in which they are located? Exhibitions which prepare the way for their own obsolescence?

Opening: Emptiness

Bahktin also talks about epic time as something that is 'valorised' (1941) – by which he means that events are invested with specific value and meaning and that such value is final and closed off from change. It seems to us that a more thorough examination of the ways objects and events are assigned value is also key to the processes of challenging history. Once again, we find ourselves turning to literary references, pursuing a hunch that experimental forms of narrative have much to offer as we move forward with 'Challenging History'. Take Virginia Woolf's *To The Lighthouse*, a novel subtly obsessed with the challenging history of the First World War and the collapse of Victorian society but one that treats this subject matter in a highly unusual manner. In a sensitive reading of this core text of literary modernism, Anne Carson writes:

> These changes are glimpsed as if from underneath; Virginia Woolf's narrative is a catalogue of silent bedrooms, motionless chests of drawers, apples left on the dining room table. ... Down across these phenomena come facts from the waking world ... they convey surprising information about the Ramsays and their friends yet they float past the narrative like the muffled shock of a sound heard while sleeping. No one wakes up. Night plunges on. (Carson 2006: 23)

In Carson's words, *To the Lighthouse* insists upon coming at events 'from the sleep side' (2006: 20), celebrating 'the emptiness of things before we make use of them, a glimpse of reality prior to its efficacy' (2006: 24). The narrative techniques it employs release events from their traditional meaning, from 'the analytic of the day'. In doing so, the novel offers an approach to value that is an exact inversion of the traditional approach of the museum. During the Challenging History Conference, we heard a lot about these more customary techniques, about using objects as a way of moving people and we weren't always at ease with the idea that heightened emotion should be one of the primary goals of 'Challenging History'. Tearing up over a letter that was sent to but never received by a steward on board the Titanic teeters on easy sentimentality rather than grappling with something more visceral and hard to get hold of (see Fleming, Chapter 1, this volume), but Woolf does something entirely different. She approaches history from the sleep side. Her narrative stumbles over what one might assume would be key events, indeed actively resists the urge to imbue events with predetermined value. In doing so, meaning is released from elsewhere, and we as readers are invited into the possibilities of these unknown and unknowing empty rooms.

　　In the context of programmes that seek to engage with difficult histories, how can we resist this temptation to assign objects and events, artefacts and articles

with a particular historical value and curatorial purpose? How can we hold on to the emptiness of things, the not making use of them? And might this kind of non-functioning exhibition actually enable us to challenge history more effectively? Can we conceive of exhibitions and museums that do not seek to communicate a static notion of challenging history but establish an emptiness where history may actually be challenged by those who occupy it? Do we understand the surge of emotion, the inchoate scrawls we witness on the walls of Tuol Sleng as the beginnings of such a liminal space, a necessary precondition for emptiness?

Opening: Inscription

As authors, we have found ourselves asking what might arise from such an emptiness. And perhaps the examples of District 6 and the annotated rooms of Tuol Sleng provide a clue. As we noted earlier, these locations move away from the formal attributes of most museums and seem to approach a different kind of social space, of which the prehistoric painted caves of Les Trois Frere and Chauvet are perhaps the earliest known survivors. For a moment, let us follow this connection. These spaces draw attention to forms of cultural activity and collective memory that are neglected by contemporary understanding of the arts and the museum. For as with those photographs, those spaces are populated by vast panels in which drawings are sketched one over another in haphazard ways that defy conventional composition and demonstrates little care for the visual integrity of the previous work. Carbon dating suggests that in some instances overlapping drawings were made at intervals over 1,000 years apart.

We wonder, finally, whether these prehistoric spaces offer some provocative metaphors by which we might approach a different vision of challenging history. Where each inscription negotiates the particularities of the site, the curvature of the stone, the residue of ideas and images from those who have come before. A space where the individual arrives to write him- or herself into a vision of time that is both diachronic and synchronic.

And so finally, we ask ourselves: how might our museums change if participation is not simply conceived as response to formal works, but that the work itself is precisely the record and process of this activity? And more provocatively, if concepts of truth are understood to be less significant than the fact of inscription itself and the content of the space less valuable than the movement of inscription through it and the shadows cast upon the walls?

Coda: Incognito

Let us return once more to Anne Carson's 'Every Exit is an Entrance (in Praise of Sleep)':

I wish to praise sleep, as a glimpse of something incognito. Both words are important. Incognito means 'unrecognized, hidden, unknown'. Something means not nothing. What is incognito hides from us because it has something worth hiding, or so we judge. ... [There is] a continuity between the realm of waking and sleeping, whereby a bit of something incognito may cross over from night to day and change the life of the sleeper. (Carson 2006: 20)

Is this something near the heart of it, the centre around which our thoughts are circling? Maybe we are all too much filled with the cognito, driven by our own tendency to populate our selves with that which can be known, recognised and shown. Perhaps we need learn how to prize that which must inevitably remain incognito and to make space for it. As institutions and audiences, as we find ourselves exploring dark times and darker places, can we try less to make use of the museum or exhibit experience and more to be with it and make room for what comes of it? Can we loosen our hold on time, on value and truth? And if we do so, might something still more precious cross over from the night?

References

Bahktin, M. 1941. 'Epic and the Novel: Towards a Methodology for the Study of the Novel', in M. Bahktin, *The Dialogic Imagination: Four Essays*, ed. M. Holquist, trans. C. Emerson, Kindle edn. Austin: University of Texas Press [1981].

Bion, W. 1961. *Experiences in Groups and Other Papers*. London: Tavistock Publications; repr. Hove: Routledge, 1989.

——— 1962. *Learning from Experience*. London: William Heinemann Medical Books; repr. London: Karnac Books, 1984.

Bradbury, R. 1953. *Fahrenheit 451*. New York City: Ballantine Books.

Burroughs, W., and B. Gysin 1979. *The Third Mind*. New York: Viking Press.

Carson, A. 2006. 'Every Exit is an Entrance (in Praise of Sleep)', in A. Carson, *Decreation*. London: Jonathan Cape.

Hollway, W., and T. Jefferson 2000. *Doing Qualitative Research Differently: Free Association, Narrative and the Interview Method*. London: Sage.

Lynch, B. 2011. *Whose Cake is it Anyway? A Collaborative Investigation into Engagement and Participation in 12 Museums and Galleries in the UK*. London: Paul Hamlyn Foundation. Available at <phf.org.uk> (accessed 1 Apr. 2012).

Murphy, S. 2010. *The Art Kettle*, Kindle Edn. Winchester: Zero Books.

Taussig, M. 2011. *I Swear I Saw This: Drawings in Fieldwork Notebooks, Namely My Own*, Kindle edn. London: University of Chicago Press.

PART 3
Ethics, Ownership and Identity

Miranda Stearn

It's Holocaust Memorial Day 2013. Despite working in the heritage sector this fact had passed me by. I was mildly surprised. As well as considering myself to be reasonably well informed about significant points on the heritage calendar from a professional point of view, I probably should have noticed that Holocaust Memorial Day was approaching. After all, our living room mantelpiece still sports the menorah that I failed to return to its cupboard after Hanukkah last month. A 'Jewish Americans for Obama' pin badge and a small dreidel from a Lower East Side synagogue sit between the London 2012 mascot and framed holiday photos on my bookshelves. Surrounded by these markers of my engagement with Jewish cultural (if not religious) identity, the least I could do was take note of an international memorial day which places 'my people' at its heart.

On the television, Holocaust Memorial Day got a mention as the two invited guests (a Conservative Member of Parliament and the London correspondent for German newpaper *Die Zeit*) went through the weekend papers. It was the *Die Zeit* correspondent who had selected a Holocaust Memorial Day story to discuss, commenting;

> I always find that the way the British deal with twentieth-century history is often too much focused on hero worship and the achievement of their great military heroes, and really the story of the 1940s has to be the Holocaust, I think, and it was only in 1998 that the Holocaust day was introduced. (John Jungclaussen in BBC 2013)

This commentary prompted a somewhat sceptical expression from his fellow guest, and indeed there was a frisson to listening to a German man offer an opinion on how we in the UK approach our twentieth-century history, particularly in the context of the Second World War. A bit of wry Germanic commentary on our current government's EU-related posturing may be welcome, but to offer approbation or otherwise on how we approach the Holocaust? Who did he think he was?

And yet, in some ways, who better than a German to tell us that 'the story of the 1940s has to be the Holocaust'?

I share this anecdote because I feel it speaks to some of the issues around ethics, ownership and identity that echo through the chapters contained in this section. Why should my response to forgetting (or indeed not even noticing) a day dedicated to the memory of millions of victims of genocide be coloured by the knowledge that, three generations back, some people who would have been my great-great-aunts and uncles were among those millions? Why should the fact that a newspaper commentator happens to be German (a German clearly too young to have been alive during the historic episode under discussion) have an impact on how I feel about his right to comment on that episode? Why should it be more my duty to remember the Holocaust? Why should he be overstepping the mark when he suggests we (Brits) have historically paid too little official attention to its memorialisation? More broadly, who has privileged rights, and responsibilities, in relation to particular histories? Who owns these histories, and how do these issues of ownership relate to questions of identity and ethics?

Chapter 10 begins this section with a closer look at Holocaust memorialisation and the thorny question of just what can constitute appropriate or effective approaches in this context. Considering the plethora of cultural representations dealing with the Holocaust, Juliet Steyn notes the 'exponential growth of museums in the Holocaust industries' and the explicit call to 'identify' deployed as an engagement strategy within some of these museums. This complex dynamic between our own identities and the implicit or explicit call to identify with others in order to understand or care about historic events informs other chapters in this section too, particularly Chapters 12 and 14. Teasing out the implications of this approach, Steyn asks, 'Does this mean that "understanding" history means that one has to have had an experience of it, to be in it?' with the implication that if our actual identity does not make a particular challenging history sufficiently 'ours', the museum must temporarily endow us with a new identity in order for us to understand and engage with it?

In Chapter 12, Jolene Mairs' descriptions of responses to video testimony shared by women associated with Armagh Gaol suggest a linked challenge. Where the accounts shared did not align with individuals' personal experience or fit with their preconceptions, they sometimes simply refused to accept them as accurate. This suggests that sometimes our own identities may have the potential to limit our receptiveness to such testimonies, the possibility of empathy (or even the possibility of accepting the veracity of the filmed story) being undermined by a prevailing sense of 'us' and 'them'.

At the UK Border Agency Museum described in Chapter 13, the call to identify takes a different form – not to empathise with those who have lived through complex or distressing historical episodes, whether as victims, perpetrators, witnesses or some combination of the above, but to identify with the officials of the Border Agency and their mission to protect the nation's borders by assessing who might constitute a threat. This is a subtly different form of identification, one that assumes we already partake in a shared identity (as legitimate dwellers of our island nation, with a shared interest in keeping out those who might do us harm),

but which at the same time seeks to reinforce that identity through setting it in contrast to that of the dangerous Other. While this assumed identification informs the whole museum presentation, Sutherland finds its most explicit manifestation in the form of a simulation in which visitors play the part of Border Agency staff trying to spot suspicious individuals.

What this project and the Holocaust museums described in Chapter 10 perhaps share, and what the authors of these chapters explore, is a sense of identification and understanding that is false, misplaced or exaggerated: that we know what it was like to experience the Holocaust, because we have vicariously lived through its uncertainties on a borrowed identity – an identity we can safely discard at the end of the visit; that we understand the complex process through which people who constitute 'threats' to the UK borders are identified, because we have enacted a simulation.

Jolene Mairs' account of the Armagh Gaol project also explores who 'owns' particular histories in a literal sense in the context of video-recorded testimonies and the ethics of ensuring that participants in oral-history projects retain control over their testimonies, legally and editorially. Her project throws up other questions too – if a story or history is 'ours', do we have a right to 'edit' it as we see fit? If, in agreeing to share, we at the same time assert the right to withhold, what measures can be put in place to ensure those who wish to learn about that history understand the partial (in all senses) nature of what is being shared? The use of film as a medium makes these questions explicit, playing out in the actual rather than the metaphorical realm, but self-editing and its implications are of course at play whenever we invite people to share their experiences.

In Chapter 14, Amy Ryall's exploration of an intergenerational project built around eyewitness testimony of the Second Word War in the Pacific arena raises some similar questions. How might we best frame eyewitness testimony as both valuable and limited? How do we work with people who are willing to share 'their story', respect the fact that they will tell it with whatever inflection they see fit and, at the same time, ensure that the stories they present are not received uncritically? What happens when such stories contradict one another, or work against desired narratives around understanding and reconciliation? The testimony of a former prisoner-of-war who, despite horrific suffering at the hands of the Japanese army, went on to accept a Japanese woman as his daughter-in-law, visit the site of his suffering and engage with school children there is obviously inspiring. It provides Imperial War Museums with the opportunity to introduce school pupils to someone who could describe the prisoner-of-war experience at first hand, but whose story moves beyond the trope of the Japanese as cruel Other to re-humanise them through his encounter with his daughter-in-law and her culture. But what do we do with narratives that are less compromising, with the prisoner-of-war whose attitude to 'the Japs' rests solely on his wartime experience? How do we avoid perpetuating mistrust and anger two generations old?

Mikel Errazkin Agirrezabala and Rosa Martínez Rodríguez deal with a history that has been repressed for the sake of reconciliation. In Chapter 11, they

examine the official silence that prevailed during the initial years of the post-Franco democracy in Spain, during which memorialisation (or even basic fact-finding) relating to the victims of the Francoist dictatorship and to republican casualties of the Spanish Civil War was considered off-limits as too risky in the context of a push for reconciliation and national reconstruction. Yet the desire to understand what happened to parents and grandparents and to have historic injustices publicly acknowledged cannot be wished away in the cause of national unity, as the frustration captured in the chapter makes clear. People feel a right to access and share their own histories. The chapter also raises challenging questions regarding who should take responsibility (particularly financial responsibility) for recovering these histories, for literally unearthing the past. Those who have a particular interest or the state?

Chapter 11 suggests another question relating to ownership. For me when I first read it, it made for somewhat uncomfortable reading. Not just because (like so many of the chapters in this volume) it deals with uncomfortable, violent, distressing histories and injustices, but because it seems to contain anger and passion, hovering between making an argument and fighting a cause. I wish not to suggest that there is anything 'wrong' with this approach, rather I find something worth exploring in my own discomfort with it. As Part 1 explores, we 'heritage professionals' – museum workers, academics, historians – are still not sure how we feel about emotional presentations of history. While accepting that no account we offer will ever be truly neutral, we still tend to trust cool analysis over undisguised outrage. To put it another way, what happens when the histories we are presenting feel very much our own and when our ownership of them, our stake in them, shines through in the way we talk about them? As historians, how much ownership is too much?

Thinking back to Juliet Steyn's discussion in Chapter 10, some interesting tensions arise. Why is it that in some cases (a visitor learning about the history of the Holocaust in a museum, for example), we see ownership and personal identification as a prerequisite for understanding – so much so that we ask visitors to temporarily assume new identities for the duration of the visit – while in other cases (a historian carrying out research), ownership seems to make us uncomfortable, and detachment instead seems the prerequisite for understanding? These are big questions, and by considering these ideals in tension with one another – the detached historian and the emotionally engaged, empathetic visitor – perhaps we can learn something from the inconsistency in our own thinking about what we mean by 'understanding' in the context of challenging histories.

A few days before Holocaust Memorial Day, the UK *Museums Journal* posted a blog on their website entitled 'The Crying Game', in which the author posed the question 'When was the last time you cried in a museum or gallery?' (Stephens 2013). This got me thinking. I do not often cry in museums, but I have done. It struck me that the most recent time was probably in Berlin. At the Jewish Museum? No. At the Neues Museum, looking at small displays relating to the destruction of the museum and some of its collections during the Second World War. What this

says about my emotional priorities, I'm not sure, but if nothing else it is a reminder that ownership and identity are complicated, individual things. Perhaps the history of the destruction of the Neues Museum and its artefacts resonated more with me because I could more readily identify – to put it crudely, being a museum professional is a bigger, more active part of my identity than my slightly nostalgic attitude to my Jewish ancestry. Sometimes it is difficult to know in advance which histories will turn out to be the ones we own.

References

BBC 2013. *The Andrew Marr Show* [TV politics programme] (Sun. 27 Jan.).

Stephens, S. 2013. 'The Crying Game: When was the Last Time you Cried in a Museum or Gallery?', *Museums Journal Blog* (23 Jan.). Available at <http://www.museumsassociation.org/museums-journal-blog/23012013-crying-game-in-museums?csort=like> (accessed 4 Feb. 2013).

Chapter 10

Vicissitudes of Representation: Remembering and Forgetting

Juliet Steyn

It is perhaps extraordinary that it took so long for the historical meaning of the Holocaust and systematic genocide to have become subjects of critical reflection. It was in the 1960s that the intellectual silence which shrouded the *disaster* was broken, when earlier accounts from survivors, like Primo Levi, and German refugees, such as Thomas Mann, Hannah Arendt, Theodore Adorno and Max Horkheimer, were acknowledged.

In an essay 'Reflections on Forgetting', Yosef Hayim Yerushalmi, citing Friedrich Nietzsche, observed: 'We must know the right time to forget as well as the right time to remember' (Yerushalmi 1989: 107). I imagine that most people would assent to this assertion because the point is essentially banal. But, more importantly, it begs the question – given the need both to remember and to forget – where are the lines to be drawn? So Yerushalmi went on to ask: How much history and what kind of history? What should we remember? What can we afford to forget? Although, as he reminds us, these questions are irresolvable, they are urgent, and always, in the course of things, apparently resolved.

My contribution to 'Challenging Histories' is to consider the problematic nature and precarious vicissitudes of representations of the Holocaust. Tracing the ways in which the Holocaust is and has been represented and understood is a continuous project. A recurring issue is how to memorialise the Holocaust.

During the last years there has been an explosion of museums from Argentina to Australia, Bulgaria and Belarus, Italy, Macedonia, South Africa and Germany – the list goes on to include in the USA, museums in New York, Washington DC and Los Angeles amongst many others. In London, the permanent exhibition in the Imperial War Museum opened in 2000. Then there are films, such as *Sophie's Choice* (1982), *Schindler's List* (1993) and more recently *The Reader* (2008) and *Sarah's Key* (2010). According to a *Wikipedia* list of Holocaust films – not including documentaries – 5 were made in the 1940s, 6 in the 1950s, 12 in the 1960s, 20 in the 1970s, 30 in the 1980s, 49 in the 1990s and 39 in the first decade of the 2000s (*Wikipedia* 2012). If there was a drop in number of feature films in the last two decades, this was compensated for by a rise to 117 in the number documentaries made between 1990 and 2010. There are comic books, including Art Spiegelman's *Maus* (1986, 1991), winner of a Pulitzer Prize Special Award (1992), and Stuart Hood and Litza Jansz's *Holocaust for Beginners* (1996).

Each of these representations attempts to expose the disastrous events and educate us by providing explanations for this human-inflicted horror. Each provoke us to question the ways in which the Holocaust is mediated and circulated in the institutions, discourses and the memory of contemporary culture. Yet it is not possible and probably not even desirable to agree upon criteria to judge the legitimacy of these different endeavours. Rather we might see each as preferred but temporary solutions and as such open to doubt and critical reasoning.

Representation works as an inconstant, changeable and ambivalent sign whose signifiers are like shifting sands subject to endless equivocation. I recall a nightmare question that occurred to me in 2000 when I viewed the 'Holocaust Exhibition' at the Imperial War Museum for the first time, a question I tried to ignore: would this exhibition have looked any different if Hitler had not been defeated? An eerie and terrifying sense that the very documentation itself – the quotations from Hitler, the escalating inevitability of systematic genocide would have been the same path that a triumphant Nazi museum of a disappeared world, such as the one intended for Prague, would also have taken. Of course the 'end' is different, 'liberation' followed, but memory remains ensnared. A recent visit did not entirely assuage my anxiety. While historical elaboration and knowledge remain vital, representation and the way it structures memory and knowledge no longer pertain in an unproblematic sense.

Long ago, Walter Benjamin observed in the 'Theses on the Philosophy of History', that the task of history is to eliminate the myth of objectivity. Writing history, he argued, does not mean to describe events the 'way they were' but rather separate them from the course of history to seize hold of a 'memory as it flashes up at a moment of danger' (Benjamin 1940: 257). Historical narratives, he contended, are already bestowed with the values of the present. Inevitably the historian interprets the past through identifying issues that are significant to the exigencies of the present.

History in this sense is a form of praxis and is always and inevitably positioned and thereby partial. Yet, even if it is already partial, history is also, in the words of Patrick Wright, 'disciplined, rational and informed' (2009: 236). The conventions of history, in which truth-value is based on empirically verifiable evidence gleaned from primary texts (objectivity) are always in friction with subjectivities that are already invested in both the writing and the receiving subject. It is the position of author and reader, of museum curator and visitor in relation to the past that is crucial, in that it provides the pivot of the ethical, demanding decision and judgement. Vigilance is called for, especially in a context which witnesses the exponential growth of museums in the Holocaust cultural industries.

The mode of display, the nature of representation, in the Holocaust Memorial Museum, (Washington DC) is problematical and demands critical scrutiny. Here history is promoted as an experience of identification. The museum strategy is discussed by Ken Johnson, in 'Art and Memory'. He cautions that it is not so much the 'intellect' that the permanent exhibition seeks to engage, but the 'emotions'. He describes the experience which starts unfurling even before we enter the museum

proper. Each visitor receives from a vending machine a card with the name, picture and information about a real victim of the Holocaust. As we proceed through the museum, we gather more information about our assumed 'companion'. Johnson comments upon the impact for him of such an identification which 'creates a feeling of considerable intimacy, which can be startlingly palpable should you find at the exhibition's end, as I did, that your companion did not survive' (1993: 97). This occurrence, he concludes, is a very effective attempt to 'make you experience the Holocaust from a close, personal range, as something that happened to real people in real places' (Johnson 1993: 97). Resting upon notions of empathy and identification, an assumption is at work which asserts that experience naturally pertains to comprehension.

There is a tragic literalness or perhaps a tragedy invested in the literalness that is being described here. Does this mean that 'understanding' history means that one has to have had an experience of it, to be in it? That the distinction between the 'real' and 'representation' is no longer sustainable as a critical force? That, in order to overcome this 'loss' of distinction, the loss itself must be actually inscribed? That we only have recourse to the 'real' through the drama of identification? That the self is reduced so as to become merely an elaboration or reflection of the Other, in other words, the same as. Indifferent to difference, the problematic project of how we think about history and ethics is side-stepped to be replaced by one which forces the visitor into a strait-jacket which is in this case identification with a victim. James E. Young suggests, imagining oneself as a past victim is not the same as imagining oneself as a potential victim (1996: 300) and, as importantly I think, as imagining one's own potential complicity and responsibility: we could all become like that. Claude Lanzmann has argued that 'any approach that seeks to bring this violence to life is the absurd dream of the non-violent' (Lanzmann 1986: 11). Genocide cannot be brought alive, and to attempt this is surely to deny the reality of violence.

Identification can be benign – even productive – as it encourages us to be empathetic, but it may also be tyrannical and work as projection, that is to say, as a mechanism of defence. Thus the Holocaust Memorial Museum experience may create in its 'spectators' a response which, in its effects, is one of counter-attack and denial. To give one extreme and crude example, a white supremacist, James von Brunn, shot and killed a black security guard on 10 June 2009, at the Holocaust Memorial Museum as a protest against what he claimed was a Jewish takeover of America (Pilkington 2010).

Inevitably the Holocaust Memorial Museum has produced diverse responses, and has created, as Young argues, a competition between the 'various cults of victimization' (1996: 304). In other words, it may have produced the reverse of the outcome that the museum narrative had intended: 'to inspire citizens and leaders worldwide to confront hatred, prevent genocide and promote human dignity' (United States Holocaust Museum n.d.). The 'good' intentions of the museum to give the facts and the data concerning the Holocaust thus may rebound, and little

knowledge of the portentous evil is necessarily disseminated: it might even be obscured or even obstructed.

Another possible 'retreat from knowledge' is the wilful, self-conscious refusal of engagement, because the artefacts and 'logic' of the atrocity are too painful to consider. Why must we see to know? This may be one way of explaining the attitude of people who refuse to watch films or attend any 'exhibition' dealing with the Holocaust. As cultural critic, Zeena Feldman, in a personal email, told me:

> One time I was forced to go to Yad Vashem and inside, I actively resisted looking. I did not want to see because I did not want to be co-opted into a project of identification. I did not want to see the 'evidence' because it seemed superfluous.[1]

The 'actualities' of the event the Holocaust Memorial Museum seeks to recreate may emerge as remote yet thrilling, pleasurable and disturbing: in short, it may reproduce the tropes of the horror film or the ghost train.

Brecht's ideas about theatre, his notions of the 'alienation' technique, his attempts to render the familiar strange (1940), provide powerful antidotes to the tactics deployed in the Holocaust Memorial Museum. Brecht developed a method through which the theatrical tradition based on empathy could be turned over or displaced. He strove to explode the division between 'emotion' and 'intellect', the very schism that the Holocaust Memorial Museum experience seems to reinforce. The museum display uses similar conventions to those of Naturalism, showing real objects, such as 2,000 shoes retrieved from Auschwitz and actual barracks from Birkenau. For Brecht, Naturalism was to be distinguished from Realism. 'Realism' did not mean for him representing things as they are – as in Naturalism. Realism for him was 'a representation of "what is real" but a re-ordering of our assumptions' about reality (Brecht 1980: 82). In the rupture between Naturalism and Realism, that is to say, between our regular acceptance of appearances and our questioning of why they may be that way, a testing of reality takes place. 'This is a political confrontation' (Key 1997[2]). At this moment of breach, it becomes possible to ask ourselves why this particular structure of the 'real' is in place and what are its precursors and consequences.

Therefore, if, as in the case of the Memorial Museum, a narrative is presented in which the inevitability of its own conclusions are borne out – survival or non-survival, life or death – assumptions are merely reiterated, and the individuals' sufferings and fate are not referred back to the operations of power – in which we are all implicated – from whence they derived. In a chronological account such as this, there is always a series of 'befores' and 'afters' which make the outcome appear timely and inevitable. The event just happened. We can leave the museum secure in our knowledge that after all it did not happen to 'me': unjustly, just to

1 Reproduced with permission.
2 Kindly loaned to me by the author.

my 'companion', in another time and another place. In the street, as we approach or depart, we can see rubbish bins overflowing with debris – the discarded identity cards – and either way we return to the safety of home.

Inadvertently perhaps, the museum display has staged a limit, a limit to identification, by claiming to know and to feel what is in essence unknowable. The museum experience suggests that in order to overcome the loss of memory (history), the loss itself must be actually inscribed. The Holocaust is aestheticised by linking it to experience. We witness in the Memorial Museum the 'virtual' and its consequences.

Paul Virilio has argued that Fukayama is right: 'it is the end of history and the start of another history, that of events, of the "live"' (Virilio 1997: 19). In the Los Angeles Museum of the Holocaust the architecture and layout deliberately construct an experience for the visitor. The rooms descend and light decreases as visitors walk towards the 'darkest part of history' from there 'to ascend and return to a world of normalcy and illumination' (LAMOTH n.d.). Spectators have become a manoeuvre of the exhibition. They are literally projected into the exhibition – subjects of it and also subject to an experience which is calculated and manipulated. We witness the reification of experience at the expense of critical reflection.

One of the traditions of democracy is to have granted reflection as a right. All history requires painstaking research in books, in chronicles and archives. As has been said, contemplative thought takes a long time and cannot be short-circuited. We must pay attention to the types of history, to the types of engagement and reflection that are brought about. The museums I have been discussing remind us of the difficulty occasioned by the respectful connecting of memory to history. Moreover, they leave us with the uncertain task of elaborating a critical recovery, in the present, of the past, which, counter to the museums' own assumptions, is not assimilable to accessible experience.

By way of contrast: 'After Auschwitz: Responses to the Holocaust in Contemporary Art' (23 Feb. – 29 May 1995) was a small, carefully crafted exhibition held in the Imperial War Museum London. The gallery was divided into discrete spaces for each display. Well-orchestrated, the works quietly resounded. Each artist created a work which addressed the Holocaust and its aftermath. Jean-Sylvain Bieth's *Phoenix*, was a subtle comment on the resistance to management structures and systems that engineered the Holocaust. In Melissa Gould's installation *Schadenfreude: The Delight Experienced in Someone Else's Misfortune*, the banality of the six wallpaper patterns, derived from illustrations from a 1935 Brockhaus dictionary, denoted what it masked in its horrifying connotations. Pam Skelton, in *Dangerous Places: Ponar*, tells the story of one survivor. Without beginning or end, repeated on seven videos in different temporal sequences, the work creates a sense of enervation which is inescapable. *Places to Remember*, a series of photographs by Lily Markiewicz, refuse identification and mark a distancing from one potential meaning at the expense of others. The exhibition as a whole suggested remembrance of the Holocaust and, in its modesty,

avoided glamorising it. It did not rely upon a 'simulation' of the event. Everything shown was ordinary but precisely extraordinary, as it subverted familiar views of the Holocaust. With precision and economy, 'After Auschwitz' took us to the boundary of a lingering horror which was after all, in the details of its operations, prosaic and orderly.

Theodor Adorno's declaration that 'to write lyric poetry after Auschwitz is barbaric' is an interdiction (1980: 188), but the stricture that he imposed alludes to the danger of sentimentalising Auschwitz, not to a prohibition on the writing of poetry: 'It is now virtually in art alone that suffering can still find its own voice, consolation, without immediately being betrayed by it' (Adorno 1980: 199). Adorno set a limit which is a question of representation. There can be no triumphant reconciliation. He demands that we reflect and think of what has been taken away. The importance of remembering is matched by forgetting and the impossibility of knowing. Never being able to know poses a limit, an experience of a limit, which the simulated experience fails to know.

I want to end with the poem 'Vielleicht' ('Perhaps', 1983) by Erich Fried. Fried was born in Austria to Jewish parents, Nelly and Hugo, and fled with his mother to London in 1938. His father was murdered by the Gestapo after the *Anschluss*, the annexation of Austria to Nazi Germany.

> To remember
> is perhaps the most painful way
> to forget
> and perhaps
> the kindest way
> to assuage
> that pain. (Fried 2012: 103)

While the historical meaning of systematic genocide has become the subject of critical reflections (Young 1993; the journal *Memory Studies*), it is more than ever time to consider how to respond to those reflections. Risks need to be taken as well as limits drawn in such uncertain and disturbing sites of remembrance.

References

Adorno, T.W. 1980. 'Commitment', in R. Taylor (ed. and trans.), *Aesthetics and Politics: Debates Between Bloch, Lukacs, Brecht, Benjamin, Adorno*. London: Verso.

Benjamin, W. 1940. 'Theses on the Philosophy of History', in W. Benjamin, *Illuminations*, trans. H. Zone. London: Fontana [1973].

Brecht, B. 1940. 'Short Description of a New Technique of Acting which Produces an Alienation Effect', in *Brecht on Theatre: The Development of an Aesthetic*, ed. and trans. J. Willet. London: Methuen [1964].

—— 1980. 'Against George Lukács', in R. Taylor (ed. and trans.), *Aesthetics and Politics: Debates Between Bloch, Lukacs, Brecht, Benjamin, Adorno*. London: Verso.

Fried, E. 2012. *Love Poems*, trans. S. Hood. London: Alma Classics.

Johnson, K. 1993. 'Art and Memory', *Art in America* 81(11): 90–99.

Key, J. 1997. 'The Human Body is Present by Being Absent: Brechtian and Minimal Theatre in Relation to the Work of Mona Hartoum and Andrea Fisher, South London Gallery, 1993' [unpublished essay].

LAMOTH (Los Angeles Museum of the Holocaust) n.d. 'Museum Highlights'. Available at <http://www.lamoth.org/the-museum/museum-highlights/> (accessed 7 Feb. 2013).

Lanzmann, C. 1986. 'Shoah as Counter Myth', *Jewish Quarterly* 33: 11–12.

Pilkington, E. 2010. 'Holocaust Museum Shooting Suspect Dies', *The Guardian*. Available at <http://www.guardian.co.uk/world/2010/jan/07/holocaust-museum-shooting-suspect-dies> (accessed 16 Sept. 2012).

United States Holocaust Museum n.d. 'About the Museum'. Available at <hmm.org/museum/about/> (accessed 7 Feb. 2012).

Virilio, P. 1997. 'Un monde surexposé', in *Image et politique: Acts du colloque des rencontres internationales de la photographie*. Arles: Actes sud / AFFAA.

Wikipedia 2012. 'List of Holocaust Films'. Available at <en.wikipedia.org/wiki/List_of_Holocaust_films> (accessed 12 Feb. 2012).

Wright, P. 2009. *On Living in an Old Country*. Oxford: Oxford University Press.

Yerushalmi, Y.H. 1989. *Zakhor: Jewish History and Jewish Memory*. New York: Schocken Books.

Young, J.E. 1993. *The Texture of Memory*. New Haven: Yale University Press.

—— 1996. 'The U.S. Memorial Museum: Memory and the Politics of Identity', in L. Nochlin and T. Garb (eds), *The Jew in the Text: Modernity and the Construction of Identity*. London and New York: Thames & Hudson.

Chapter 11

Realms of Memory and the Recovery of the Historical Memory of the Spanish Civil War and Franco's Dictatorship (1936–2012)

Mikel Errazkin Agirrezabala and Rosa Martínez Rodríguez

During the Spanish Civil War (1936–39) numerous violations of human rights were committed. Horrors occurred not only from 1936 to 1939, but continued during the following years. After the victory of the rebels, a violent repression of the vanquished republicans took place. Although violations of human rights occurred in different forms and intensity throughout Franco's dictatorship, the experience of the war and subsequent repression were embedded in the memories of those who lived through the period and consequently in Spanish society.

Franco's dictatorship commemorated victory by populating the realms of public memory with the names of those 'fallen for God and Spain' (in the Francoist cause), while simultaneously trying to suppress even the memory of the vanquished republicans, thus imposing a distinctive narrative of the war.

Almost 30 years after Franco's death, an important civil movement has arisen precipitated by a better understanding of the events. This has been the result of work by British and American Hispanists (Brenan 1943; Southworth 1963; Jackson 1965; Malefakis 1970; Payne 1970; Carr 1977; Preston 1978), as well as historical research and the initiatives of victims' associations. It tells us to look back, to clarify the past and to analyse and consider the material and immaterial heritage rendered invisible for more than 75 years. As a result, the material heritage of Franco's dictatorship, as well as memories of the repression, are being reconsidered today within Spanish society.

Violence Enacted by Franco's Troops and Supporters

The Spanish Civil War started after a military rebellion on 17 and 18 July 1936, against the legitimate government of the Second Republic (instituted in 1931). The war ended on 1 April 1939, and a dictatorship was established with General Francisco Franco as head of the state. It lasted until his death in 1975. The rebels desired a return to traditional values, banishing any element which had participated in the republic, in order 'to eliminate past mistakes and clean the plot for constructing a new building' (Franco 1942: 34).

After the war, the repression was 'premeditated, systematic, institutionalized, becoming an objective itself' (Juliá 1999: 26). Two months before the uprising, Emilio Mola, known as 'The Director' and the brains behind the conspiracy, issued private instructions 'to seed the terror ... eliminating without any scruple or hesitation all those that do not think as us'. Consequently, from the very first moment, the physical elimination of the political opponent became a standard method of exercising authority for the rebels (Reig Tapia 1986: 126).[1] Insurgent militaries used four types of violence against the vanquished: political, structural, symbolic and daily violence (see Bourgois 2001).

Franco's regime carried out a strategy for eliminating opponents, breaking any spirit of resistance and creating an atmosphere of fear within the conquered territories. Up to 1 per cent of the Spanish population had perished during the Spanish Civil War. In the years that followed, estimations based on methodological evidence consider there to have been around 150,000–200,000 victims of the Francoist repression (Beevor 2006: 180–81). Executions, military processes and a well-organised prison system were at the basis of the political violence (Rodrigo 2008). Repression reached large groups within the population, leaving a deep imprint in Spanish society. It is also important to remember the number of people exiled, estimated at around 450,000 in 1939. Later, many of these individuals were placed in concentration camps in France.

The violence exerted by the state became structural since it was 'an element of the regime, a basic pillar of the legal and political system during all phases of the dictatorship' (González Calleja 2000: 391; see Figure 11.1). In this sense, the repression is to be understood as a 'multiple strategy', aiming not only to eliminate any political opposition, but also to foster a feeling of subjugation, passivity and self-limitation by fear, in order to ensure the stability of the regime in the future (Richards 1998).

The new regime dominated society through a strategy of intimidation. Based on strict control and an atmosphere of violence, it continued in different forms until Franco's last days. It was based on creating a mood of fear, suspicion and insecurity (Eiroa 2006: 418). Fear itself played an important role as an auxiliary tool of the surveillance network, as well as a demotivating force amongst the population. Symbolic and daily violence included physical violence against families, intervention in private life, moral control and imposition of attitudes, behaviours and values. Women especially suffered from the symbolic repression. Some of the most common humiliations included head-shaving, being forced to drink castor-oil, public humiliation, sexual violence and kidnapping of children.

1 Francoist violence was part of a planned action for exterminating political adversaries. Some of the best evidence of this is the actions of insurgents in areas which immediately fell under their control, where there was no resistance and no republican violence (Rodrigo 2008).

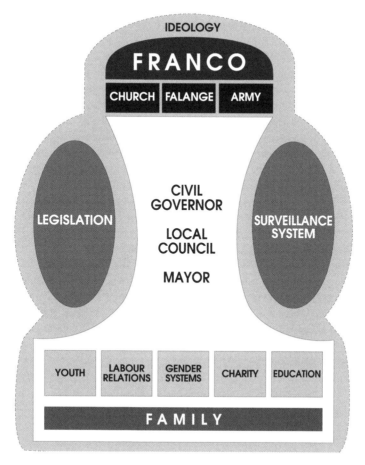

Figure 11.1 Social structure of Franco's dictatorship

Source: Errazkin Agirrezabala 2013: 154.

Repression was organised from above, but people were executed and imprisoned thanks to the collaboration of their fellow citizens. There were many reasons for denunciation: revenge against someone considered responsible for the death of a loved one, personal quarrels and jealousy, desire for the possessions of the vanquished. It was also a consequence of the terror: a denunciation could avoid the threat towards oneself. The breakdown of convictions, emotional bonds and solidarity among neighbours allowed military justice to succeed where otherwise it could never have existed (Richards 1998).

The Realms of Memory of the Victors

After the civil war, Franco's regime built up a new collective identity aiming to promote and disseminate their ideology and values and banish any memory relating to the previous period or to those who had fallen opposing the regime. Public policies of memory of the civil war during Franco's regime were based on the development of a national–Catholic narrative of civil war and propaganda glorifying military victory: their own great men, war events and places, heroes and martyrs became memory objects in cities, calendars, monuments, commemorations and school textbooks. The war was the glorious memory of the victors.

Once in power, the regime imposed this official discourse by force. They silenced and destroyed all references to the Second Spanish Republic (government, figures, political reforms, holidays, monuments, for example), in such a way that it was banished from historical memory for more than 40 years. This oblivion was imposed through a range of practices including material destruction, repression, exile, censure and silence. Both the memory policy and public symbolism used by Franco's dictatorship had four main objectives: to banish any symbolic presence of the Second Spanish Republic, as well as its memory; to become a propaganda tool for the new regime, especially for praising Franco as their leader; to define public space according to the new political, ideological and religious postulates; and to legitimate the new regime and authorities. This resulted in a large number of realms of memory,[2] mostly related to time, space and people, being widespread across Spain (Errazkin Agirrezabala 2013).

Realms of Memory Related to Time: The Calendar

The insurgents literally established a new era. A new dating system was used during the war: I, II, III Triumphal Year (1936, 1937, 1938). Once in power, they created a new official calendar, which regulated political, religious, social and everyday life. It was therefore an excellent tool to influence society. Memorable dates for the republican period were replaced by others appropriated for the new era. Such celebrations as the Day of the Republic (14 April), Carnival and Workers' Day (1 May) were eliminated. Other patriotic and religious celebrations linked to the Spanish tradition were established, including:

2 According to P. Nora, a realm of memory or 'a *lieu de mémoire* is any significant entity, whether material or non-material in nature, which by dint of human will or the work of time has become a symbolic element of the memorial heritage of any community' (1996: xvii). In other words, realms of memory are 'where [cultural] memory crystallizes and secretes itself' (Nora 1989: 7). These include places (such as archives, museums, cathedrals, palaces, cemeteries and memorials), concepts and practices (such as commemorations, generations, mottos and all rituals) and objects (such as inherited property, commemorative monuments, manuals, emblems, basic texts and symbols).

- religious celebrations such as Corpus Christi or Epiphany (6 Jan.), Santiago the Apostle (St James, patron saint of Spain) or Pilar Virgen (Race Day): in some cases previous traditions already existed, but the regime appropriated them as political and national symbols;
- war-related celebrations: Uprising Day, Caudillo Day, Victory Day, The Fallen Day and the anniversary of the captures of several towns;
- celebrations to socialise and promote the values and the ideology of the new state: the fallen student celebration, Falange and JONS Union.[3]

Realms of Memory in Public Spaces: The Street Map

The public promotion of memory was intended to be present in the most important public spaces, so the regime disseminated names, dates and the values of Franco's regime, while eliminating those of the previous period. This appropriation of public space amounted to military and social use of propaganda through renaming streets or public buildings.

Squares and streets are important public spaces in Mediterranean societies and became a key tool for remembering people, values and events. With this process the Francoist regime tried to create a new history of people and dates by means of some common criteria:

- references to insurgent figures who had actively participated in the war (Generals Franco, Mola, Sanjurjo, Queipo de Llan);
- names of fallen heroes (General Mola, José Antonio Primo de Rivera) or anonymous collective heroes (Toledo Fortress Heroes): sometimes they combined heroism with martyrdom, stressing the soldierly and Christian virtues;
- recuperation of military figures representing the glorious past from other times, for example the Reconquest (expulsion of the Muslims during the Middle Ages) or the Carlists Wars (dynastic wars in the nineteenth century which represented the movement against the liberal reforms in Spain).

Realms of Memory Related to Persons: Monuments

Monuments to those 'Fallen for God and Spain' (*Caídos por Dios y por España*) spread across the whole country. These monuments were to be found in cemeteries and squares in almost every important town. Commemorative plaques were also placed in churches listing the local fallen, demonstrating the Spanish Catholic Church's willingness to collaborate by allowing their facilities to exhibit these acknowledged symbols of Franco's regime.

3 Falange Española Tradicionalista de las JONS was a fascist party that took part in the armed struggle against the Spanish Republic from 1936 to 1939. During Franco's dictatorship it was the ruling and only legal party in Spain (Payne 1999).

Together with those monuments and plaques, three large memorial sites were built in Spain after the war: The Monument to the Heroes and Martyrs in Zaragoza (1953), the Monument to the Fallen in Pamplona (1959) and the Valley of the Fallen in Cuelgamuros (1959) (Viejo-Rose 2011: 84). The latest is the most important realm of memory of the victors: a Catholic basilica and a monumental memorial near Madrid, conceived by Franco to honour and bury those who fell during the civil war. It was inaugurated in 1959 and became his own mausoleum at his death in 1975. Franco claimed the monument to be a 'national act of atonement' and reconciliation. Accordingly, between 1959 and 1983, more than 30,000 corpses from the Spanish Civil War were moved there, including republicans, which were clandestinely and anonymously deposited in the crypt of the basilica. The site remains controversial to this day, for (among other reasons) the use of political prisoners, thousands of whom died during the construction, as a workforce (Ferrándiz 2011).

Besides being commemorated through these memorials, victims of the war who had demonstrated loyalty to the victorious side benefited from various other measures. In 1939, for instance, an amnesty was declared for all crimes committed against the republic. In 1940, exhumations of victims of republican violence were carried out and the so called 'General Trial' was held to investigate the crimes of the republican side. A percentage of public jobs were reserved for veterans and disabled servicemen (Aguilar Fernández 1996: 138), and their families received economic and social support (for example educational grants and subsidies).

The Oblivion of the Vanquished

These measures are in stark opposition to those applied to victims who had fought on the vanquished side. Excluded from these benefits, they were also declared enemies of Spain in official propaganda and held solely responsible for the atrocities of the war. For 40 years, there were officially only victims on one side. Franco's regime imposed what Primo Levi defined as 'memoricide' (1991), first on the victims and second on those responsible for the violence.

Under these conditions, many families were obliged to grieve in silence, without any possibility of reparation, afraid to provoke new abuses. The lack of opportunity to mourn, resulting from the absence of a burial place and the necessity of not making public a suffering that was forbidden and officially non-existent, led to the repression of feelings. Fear, and in some cases shame, silenced the family story. Denunciations and repression contributed to eliminating the memory of the victims, but also made people abandon ideology and political fight (Errazkin Agirrezabala 2013: 253–7).

The vanquished nevertheless created their own realms of memory in a clandestine, episodic or family manner (through such things as keeping photos or objects belonging to the victims or anonymously putting flowers on mass graves).

It has not been until recent years, however, that a public and official memory has been acknowledged in relation to those people.

The Transition Silence Pact

Although the Spanish transition to democracy is often considered as an example of a peaceful shift, during that process fear pervaded all political sectors, as well as civil society. The memory of the violence and the war was present throughout the transition as a result of the active role of the army in the process, and through the attacks carried out by extreme right-wing organisations. Between 1975 and 1978 more than 400 people died and states of emergency were common. Those opposed to Franco's regime had to make important concessions: in 1977 an amnesty was declared not only for those condemned for political activities but also for civil servants and public order agents responsible for repression during Franco's rule. The circumstances of the transition forced people to forget the repression and the violence exerted by Franco's regime in order to achieve a smoother transition to a stable democratic process. The myth of the 'national reconciliation' silenced the individual stories.

During the transition, new realms of memory were consolidated. Examples include the return to Spain from New York of Picasso's *Guernica*; the Constitution of 1978; the popularity of songs addressing themes of freedom, peace, change, anti-repression and the national identities of Spanish regions;[4] and the institution of Diada (Catalonia National Day) in 1977. Madrid's Atocha Train Station became a realm of memory following the murder of five labour lawyers by right-wing extremists in 1977, bringing home the fact that not everyone welcomed the transition to democracy, and there were those who were still prepared to oppose the changes with violence. However, most of these icons of freedom and the new era have fallen into disuse nowadays (Aguilar Fernández 1996).

Historical Memory Recovery

In 2000, the first officially organised exhumation of a common grave of people executed during or after the Spanish Civil War was carried out. It was initiated by a man who had tracked his grandfather's whereabouts in order to locate the exact place where he was buried. In this grave, located in Priaranza del Bierzo (León), the physical remains of 13 individuals were recovered, and with the remains the forgotten memory of these 13 people, whose executions had been clandestine

4 Such as 'Libertad sin ira' (Jarcha, 1976), 'Por las paredes' (Joan Manuel Serrat, 1978), 'Están cambiando los tiempos' (Luis Pastor, 1977), 'Txoriak txori' (Joxe Anton Artze and Mikel Laboa, 1974), 'Que tothom' (Raimon, 1976) and 'Estamos chegando ó mar' (Bibiano, 1976).

and unpunished.[5] It became the starting point for the archaeological and forensic opening of mass graves (Ríos et al. 2011).

Although most of the people participating in these exhumations do so on an unpaid basis, there is an ongoing need for funding and this makes the process reliant upon the political standpoint of the public authorities in the geographical area involved. Some regions have special programmes and funds for supporting Franco's victims, while other cases have been promoted by the local authorities. There are also exhumations privately funded by victims' families.

Exhumations, as well as testimonies and research, acted as a catalyst for other processes of historical memory recuperation. The dissemination of the exhumation works brought to attention some events of recent history which were unknown to a large part of society. The media have played an important role in disseminating knowledge of the exhumation works and of this history more generally. There is nothing as eloquent as a mass grave full of skeletons on prime time television. These regular appearances and references have maintained the dialectic and have contradicted the version of events sustained by some revisionist sectors, which questioned the existence of repression during and after the civil war. It is significant to point out that foreign media were the first to be interested in the exhumation works, in a more extensive way than the Spanish national media. Cultural creations, including both literature and film,[6] also started to approach the history of this period from the point of view of those who suffered under the regime, showing the repression, the violence against families and the post-war era (Ferrándiz 2006).

The drive for the exhumations of mass graves and the recuperation of the memory of those who suffered prosecution and repression during Franco's regime has come primarily from civil society. Families suffered a long and repressive silence, not only during Franco's dictatorship, but also during the transition and the first 20 years of democracy. Finding their loved ones accomplishes a long-held wish of many families to recuperate the remains and have a burial place. The generation of grandchildren, who did not experience the war and did not participate in the transition, are asking for a revision of the past (Fernández de Mata 2011).

The mass graves are powerful realms of memory and symbolic and emotional spaces that have opened debate, prompting further projects making the victims of Francoism visible. These include projects such as 'All the Names',[7] the mapping

5 The excavation was under the direction of Dr Paco Etxeberria and Lourdes Herrasti, members of the Aranzadi Society of Sciences.

6 Novels, such as *La voz dormida* (Dulce Chacón, 2002), *Los girasoles ciegos* (Alberto Méndez, 2004), *Las 13 rosas* (Jesús Ferrero, 2005), *El corazón helado* (Almudena Grandes, 2007), and movies, such as *Ay Carmela!* (Carlos Saura, 1990), *Land and Freedom* (Ken Loach, 1994), *Libertarias* (Vicente Aranda, 1996), *La lengua de las mariposas* (José Luis Cuerda, 1999).

7 This project aims to list all republican people killed during and after the war, as well as all those who died abroad fighting against fascism. In January 2013, the database

of mass graves, or local studies on repression. Currently, the realms of memory are increasing and the mass graves are only one part of them.

Nowadays: From Realms of Oblivion to Realms of Memory

The process of recovering the memory of the vanquished has also provoked a debate between those who think that it is unnecessary to re-open old wounds, and those who want to close these wounds before they are healed. Furthermore, there is no consensus as to the ongoing relevance of the topic for Spanish society, with some considering it an already passing trend.

Whether somebody supports the recovery of the historical memory of the Spanish Civil War and Franco's repression or not is not always determined by having someone in the family who suffered the repression. Indeed, it is difficult to find a family who did not suffer somehow the violence or consequences of the war and afterwards. However there are some families who do not want to find a burial place or learn what really happen.[8] Additionally, at that time most of the population lived in rural areas, so perpetrators or informers were often well known and identified. This has been a major issue, although up to now no revenge or condemnation has been demanded by victims' families. Colmeiro suggests that Spanish society is experiencing a memory crisis and it needs to develop a critical approach to the past, as well as giving higher public profile to the historical memory contained within museums and archives (2005: 25).

A Historical Memory Law came into force in October 2007. The law was approved 32 years after Franco's death. On the one side, the law recognises rights and establishes measures for those who suffered persecution or violence during the Spanish Civil War and the Franco dictatorship. It includes recognition of all the victims of the civil war and the dictatorship but does not include economic support for locating and exhuming the corpses of the disappeared.

With regard to Franco's heritage, the Historical Memory Law establishes that symbols and objects that commemorate or exalt the military uprising, civil war and repressive dictatorship are to be removed. This includes not only sculptures and symbols such as shields, badges, plaques and other commemorative objects, but also names of streets and places. Except for some cases, which have recently been removed, most of the symbols had gradually been eliminated from public space. The last of Franco's equestrian sculptures exhibited in public space were withdrawn in Melilla (2010), Santander (2008) and the General Military Academy of Zaragoza (2006): some with public protests (for example, in Madrid and Ferrol).

included 73,319 names (see <www.todoslosnombres.org>).

8 The best-known case is the family of Federico Garcia Lorca, who do not want to find the poet's burial place. Research and work was carried out in 2009, because the families of other people buried with him asked for it, but the search was unfruitful and still today it is unknown what happen to his corpse after he was shot on 16 August 1936.

The most controversial debate prompted by the Historical Memory Law concerns the Valley of the Fallen. The prohibition against staging political events within it puts an end to commemorations by Franco's supporters, neo-Nazi and fascist groups that used to take place in the monument. The most recent socialist government (2008–11) created a commission of experts to propose new uses and symbolism for the monument. The publication of the final report (November 2011) coincided with the arrival of a conservative government, which has put measures proposed by experts (including the transfer of the remains of Franco) at an impasse. The Valley of the Fallen thus provides an example of how cycles of power within current politics influence the redefinition or decline of some realms of memory (Ferrándiz 2011).

We have seen how changes in political and social contexts shifted the history of the vanquished from realms of oblivion to realms of memory. The focus is on naming and registering those killed or disappeared, for example plaques in cemeteries where republicans were murdered (such as in Tolosa, Santander, Zaragoza) and other kinds of memorials. This is very important in the process of recognising and repairing the suffering, since most of the victims of repression do not appear in any official register. Moreover, these plaques and monuments have become spaces where families might put flowers or remember their loved ones.

These sites are primarily promoted by the descendants of the victims. Public institutions and associations are creating monuments and memorials in other places related to repression, for example battlefields, locations of execution, illegal detention centres, prisons, places of torture, police outbuildings, concentration camps, places of forced labour and of exile, and these have become the material heritage of repressed memory.

The Catalonian government has led the initiative with the programme 'Network of Democratic Memory Sites of Catalonia', encompassing routes, interpretation centres, landmarks, and remains. It presents a heritage of tangible and intangible memories relating to the struggle to secure democratic rights and freedom in Catalonia until the 1980s. Sites and memory projects include the interpretation centre The Pyrenees at War (La Pobla de Segur), the concentration camp of Cervera University (Concabella), the Battle of the Ebro Memorial (Gandesa), the Walter Benjamin Memory Centre, the Border of Freedom (Portbou) and an itinerary related to International Brigades in Horta-Guinardó district (Barcelona).

The Historical Memory Documentary Centre (Salamanca) was created in 2007, its main collection being the General Archive of the Spanish Civil War, which was set up by Franco aiming to gather documentation and information from the enemy. It works not only as an archive, but as cultural centre, programming exhibitions and educational activities.

In terms of museums, three significant examples include:

- The Guernica Peace Museum (Basque Country), focusing upon the air raid of 26 April 1937, aims to promote the culture of peace by reflecting on the

consequences of Guernica's bombing. Picasso's famous painting *Guernica* helped to make this small town into a symbol.

- The Bielsa Museum (Aragón) is not only a commemorative museum but also explores the history, ethnography, anthropology and landscape of the town. It too highlights the relationship to the war front, with a large collection of photography of both armies, the evacuation of refugees and the reconstruction of the town.
- The Civil War Shelter Museum of Cartagena (Murcia) is hosted in a shelter and together with information regarding such air-shelters, it provides information on daily life at war and the air raids suffered by Cartagena.

Finally, Belchite provides a paradoxical case. At this site one of the most important battles of the war took place, totally destroying the village. Instead of rebuilding it, Franco's regime decided to create a new village next door, leaving the ruins as a reminder of the civil war and the atrocities of the other side. So far, nothing has been done, and Belchite might be considered as a realm of *abandono* (neglect).

Until recently, few realms of memory have been marked by plaques or monoliths. Concentration camps and prisons in some locations are marked (for example, Albatera and Miranda de Ebro), but in general such memorials are practically non-existent in Spain (Rodrigo 2008). The Park of the Memory of Sartaguda (Navarre) provides an exception. This space commemorates 3,300 people who were murdered in Navarre. Sartaguda, known as 'The Village of Widows', had one of the highest percentages of people killed by Franco's troops and regime.

So far, the focus has been put on immaterial heritage. Projects such as 'The Prisoners' Channel' (*Canal de los Presos*) or 'Disaffects' (*Desafectos*) have collected testimonies of people who lived in concentration camps and were condemned to forced labour.[9] In addition, a wide variety of oral-history initiatives exist across the country, aiming to collect the memories of people who experienced those years. There is also an increasing interest in developing educational projects addressed to primary and secondary students analysing the Spanish Civil War and Franco's regime.[10]

As time passes and witnesses disappear, oral history is expected to give way to other forms of recovery of the historical memory, which are already gaining research and social relevance: museums, exhibitions, educational materials, civil-war archaeology and landscape studies.

Generally speaking, there is no agreement as to the degree of relevance the topic holds for Spanish society, and some think that it has just been a trend which

9 For further information on projects related to mass graves and memory policies, see <http://politicasdelamemoria.org/>.

10 For example, the authors of this article have coordinated the European project 'Sharing European Memories at Schools' (SEM@S) (see <http://memoriesatschool. aranzadi-zientziak.org>).

is already over. However, civil society continues researching and demanding an official memory policy. It remains difficult to build a large political and social agreement on how to deal with these issues. In recent years, the global financial crisis has turned the media attention to other topics,[11] but Spanish institutions cannot just ignore what other countries are doing with their traumatic past. The way Argentina and Chile are dealing with their dictatorships' victims is an example. Contemporary massive violations of human rights will always bring to our minds the systematic repression of the first years of Franco's regime. The question is: how many generations should pass before we can face our past, our history, our heritage in a responsible way without feeling we are challenging the un-written rules?

References

Aguilar Fernández, P. 1996. *Memoria y olvido de la guerra civil española*. Madrid: Alianza Editorial.

Beevor, A. 2006. *The Battle for Spain: The Spanish Civil War 1936–1939*. London: Weidenfeld & Nicolson.

Bourgois, P. 2001. 'The Power of Violence in War and Peace: Post-Cold War Lessons from El Salvador', *Ethnography* 2/1: 5–34.

Brenan, G. 1943. *The Spanish Labyrinth: An Account of the Social and Political Background of the Civil War*. Cambridge: Cambridge University Press.

Carr, R. 1977. *The Spanish Tragedy: The Civil War in Perspective*. London: Phoenix Press.

Colmeiro, J.F. 2005. *Memoria histórica e identidad cultural: De la postguerra a la. Postmodernidad*. Barcelona: Anthropos.

Eiroa, M. 2006. 'Represión, restricción, manipulación: Estrategias para la ordenación de la sociedad y del Estado', *Hispania Nova: Revista de Historia Contemporánea* 6: 411–34.

Errazkin Agirrezabala, M. 2013. *Los nombres de la memoria: La represión y vulneración de los derechos humanos durante la Guerra Civil y el Primer Franquismo en Tolosa (1936–1945)*. San Sebastian: Sociedad de Ciencias Aranzadi.

Fernández de Mata, I. 2011. 'So That We May Rest in Peace: Death Notices and Ongoing Bereavement', *Journal of Spanish Cultural Studies* 12(4): 439–62.

Ferrándiz, F. 2006. 'The Return of Civil War Ghosts: The Ethnography of Exhumations in Contemporary Spain', *Anthropology Today* 22(3): 7–12.

11 An exception is the digital publication *Publico*, which holds *Memoria Pública* (Public Memory) a portal for registering information on Franco's victims. It regularly publishes features and articles on memory issues (see <http://www.publico.es/especial/memoria-publica/>).

—— 2011. 'Guerras sin fin: Guía para descifrar el Valle de los Caídos en la España Contemporánea', *Política y Sociedad* 48(3): 481–500.

Franco, F. 1942. *Palabras del caudillo*. Madrid: Editora Nacional.

González Calleja, E. 2000. 'El estado ante la violencia', in S. Juliá (ed.), *La violencia política en la España del siglo XX*. Madrid: Taurus.

Jackson, G. 1965. *The Spanish Republic and the Civil War, 1931–1939*. Princeton: Princeton University Press.

Juliá, S. 1999. *Víctimas de la guerra civil*. Madrid, Temas de hoy.

Levi, P. 1991. *If This is a Man and The Truce*. London: Little, Brown Book Group.

Malefakis, E. 1970. *Agrarian Reform and Peasant Revolution in Spain: Origins of the Civil War*. New Haven: Yale University Press.

Nora, P. 1989. 'Between Memory and History: Les Lieux de Mémoire', *Representations* 26: 7–25.

—— 1996. *Realms of Memory: Rethinking the French Past*. New York: Columbia University Press.

Payne, S.G. 1970. *The Spanish Revolution*. London: Weidenfeld & Nicolson.

—— 1999. *Fascism in Spain, 1923–1977*. Madison: University of Wisconsin Press.

Preston, P. 1978. *The Coming of the Spanish Civil War*. London: Macmillan.

Reig Tapia, A. 1986. *Ideología e historia: Sobre la represión franquista y la guerra civil*. Madrid: Akal.

Richards, M. 1998. *A Time of Silence: Civil War and the Culture of Repression in Franco's Spain, 1936–1945*. Cambridge: Cambridge University Press.

Ríos, L., et al. 2012. 'Identification Process in Mass Graves from the Spanish Civil War', *Forensic Science International* (DOI: 10.1016/j.forsciint.2011.11.021).

Rodrigo, J. 2008. '"Our Fatherland was Full of Weeds": Violence during the Spanish Civil War and the Franco Dictatorship', in M. Baumeister and S. Schüler-Springorum (eds), *If You Tolerate This: The Spanish Civil War in the Age of Total Wars*. Frankfurt and New York: Campus.

Southworth, H. 1963. *The Myth of Franco's Crusade*. Paris: Ruedo Ibérico.

Viejo-Rose, D. 2011. 'Memorial Functions: Intent, Impact, and the Right to Remember', *Memory Studies* 4(3): 1–16.

Chapter 12

'Unseen Women: Stories from Armagh Gaol': Exhibiting Contrasting Memories of a Contested Space

Jolene Mairs Dyer

This chapter describes the collaborative and inclusive protocols employed in creating a multiple-narrative audio-visual gallery exhibition of interviews recorded at Armagh Gaol, Northern Ireland's prison for political and non-political female prisoners. It argues that the protocols of shared ownership and shared editorial control were essential to bringing these stories to the public.

Context

The conflict in Northern Ireland, commonly known as 'The Troubles', refers to the period between 1969 and the signing of the Good Friday Agreement in 1998, when violence between loyalist and republican paramilitaries and the British state resulted in the deaths of almost 3,700 people. The cumulative effect of intense violence over a 30-year period within this small geographical area has left an indelible mark on the province, the effect of its violence often being referred to as its 'legacy'. G. Dawson provides this statistical summary of the impact of the conflict:

> Most of (the) fatalities – all but 260, thus some 93 per cent – have occurred within the six-county territory itself, an area of only 14,160 square miles. … Some idea of the impact of this scale of loss may be conveyed by extrapolation to the UK as a whole, where the same ratio of killings to the total population of 58 million would have left over 130,000 dead. … In all cases, civilians formed the biggest single category of victims. (Dawson 2007: 9)

Despite political consensus being reached, violence has continued with two police officers (both of whom were Catholic), two British army soldiers, one Catholic community worker and one Protestant prison officer being killed as a result of ongoing violence in the 'post-conflict' period. The threat of dissident republicanism continues through the identification and removal of explosive devices found in various locations around Northern Ireland (*Irish Times* 2011;

BBC 2011) and, more recently, through loyalist protests in Belfast and various locations throughout Scotland and England at the decision by Belfast City Council to fly the union flag at Belfast city hall only on designated days (Devenport 2013; Moriarty 2013). Despite this, the peace process continues, if tenuously, and the devolved power-sharing Stormont Assembly remains in place. Fourteen years after the signing of the agreement, Northern Ireland is in the midst of finding ways to 'deal' with the aftermath of conflict. Methods and motivations for so-called 'dealing' with the past are fraught with political, economic and psychosocial complexities (Dawson 2007: 17–19; Hamber 2009: 53–4). Within the context of Northern Ireland's contested historical narratives, broadly, but not exclusively, categorised as Irish-Republican and British-Protestant, practices that remember, or commemorate, past events in Irish history can consolidate divisions and emphasise selective cultural memories:

> The commemoration of death and suffering strengthens the political identity of the separate traditions. The impact of trauma within selective narratives of political memorialising or amnesia, makes it extremely difficult for either Northern Irish tradition to recognize the trauma of the other, or for the British government to acknowledge its own role. (Leydesdorff et al. 2004: 22)

Acts of commemoration include the annual Easter Rising Parades to celebrate the attempted overthrow of the British State in 1916, emblematic of the ongoing Irish 'struggle' to achieve complete independence from the British state, or the annual Burning of Lundy Ceremony in Londonderry/Derry, emblematic of Protestant resistance to the threat of Irish nationalist rule. What and how to remember, not only in terms of the recent conflict but of many significant events in Irish history, are contested. Within this context of selective cultural memories and commemorative practices, is it possible to create inclusive exhibition practices that allow competing versions of the past to co-exist?

Recording Methodology

'Unseen Women: Stories from Armagh Gaol', a 26-minute documentary and multi-screen gallery exhibition, shown at Belfast Exposed Gallery for two weeks in June 2011, contained material edited from the Prisons Memory Archive (PMA), a collection of approximately 175 filmed recordings of people who experienced Armagh Gaol and the Maze / Long Kesh Prison during the Troubles. The archive, created by Cahal McLaughlin, grew out of his documentary and gallery exhibition, 'Inside Stories', where he filmed a republican former prisoner, a loyalist former prisoner and a prison officer at the Maze (McLaughlin 2006, 2010: 83–107). Recorded in 2006 and 2007, six years after the Maze closed its doors in 2000 and twenty years after Armagh Goal closed in 1986, PMA participants walked and talked their way around the derelict prisons without the use of a formal interview,

using the site itself as a stimulus for their memories. McLaughlin employed specific collaborative protocols, namely shared ownership of the recorded material, shared editorial control, transparency of approach and the right to withdraw from the project at any time. Shared ownership means that participants co-own their final recording with the PMA, which contrasts with traditional models of documentary filmmaking where the subjects relinquish all ownership of recorded material to the production company (see Pryluck 1976: 27). In contrast, the collaborative approach adopted by the PMA aims to reduce the power imbalance between those who share their stories and those who record them. McLaughlin's background in mainstream television production and his prior experience working in community based Belfast Independent Video (BIV) which employed collaborative workshop techniques, influenced the development of his collaborative approach:

> During my years of working in broadcast television, legal accountability had always faced upwards, for example to the producer, the executive producer ... and ultimately the chief executive of the broadcasting company. Working within but also against this system, and based on the workshop ethos from BIV ... I developed a collaborative approach to working with participants and production crew. This collaboration acknowledged the balance of power and skills and allowed for discussion and consensual decision-making, which guaranteed accountability for participants. (McLaughlin 2010: 25–6)

Alongside collaborative protocols, the PMA adopted specific recording strategies which attempted to minimise levels of mediation between the participant and the audience. This non-interventionist recording methodology echoes 'direct cinema', a style of documentary filmmaking that arose in the 1960s as cameras and sound recording equipment became more mobile. Steven Feld defined direct cinema as:

> A process, visual aesthetic, and technology of cinema ... (which) came to mean four things; (1) films composed of first-take, non-staged, non-theatrical, non-scripted material; (2) nonactors doing what they do in natural, spontaneous settings; (3) use of lightweight, hand-held synchronous-sound equipment; and (4) handheld on-the-go interactive filming and recording techniques with little if any artificial lighting. (Feld 2003: 7)

Direct cinema was not just a style of documentary filmmaking, it was also an attempt to capture 'reality'. The North American pioneers of direct cinema believed they could film their subjects without the presence of the camera or the process of being filmed influencing their behaviour. Direct cinema documentary filmmaker Richard Leacock famously stated, 'you can act in such a way as not to affect them' (in Cousins and McDonald 2006: 256). Documentary theorists and filmmakers have since developed a more complex view of documentary and its relationship to reality, with theorists such as Bruzzi arguing that the direct cinema has left a damaging legacy on documentary in general:

It has taken time for documentary filmmaking to rid itself of the burden of expectation imposed by direct cinema. … It can be legitimately argued that filmmakers themselves (and their audiences) have, much more readily than most theorists, accepted documentary's inability to give an undistorted, purely reflective picture of reality. (Bruzzi 2006: 9; see also 73–80; Ward 2005: 4–5; Hampe 1997: 23–4)

The expectation that documentary can provide an unmediated representation of reality that offers an unbiased 'truth' is unattainable. Instead documentaries, and the apparent 'truths' that lie within them, are viewed as a dialectic, or process of negotiation, between subject, filmmaker and audience (Bruzzi 2006: 6–7; Ward 2005: 10–11, 16). Where McLaughlin's approach echoes direct cinema, like most contemporary documentary filmmakers, it is not adopted with the intention of recording its subjects 'as they really are' or with a claim to offering unmediated 'truth' but instead attempts to allow the participants a greater degree of control over how their story is (re)presented. When recording sensitive material in contested spaces, the approach prioritises ethics over aesthetics.

Editing Methodology

As a practice-led PhD student at the University of Ulster working alongside McLaughlin, an opportunity arose for me to find ways of bringing the PMA material to the public within the challenging context of post-conflict Northern Ireland. Of 175 recordings made by the PMA, 34 were of people who had experienced Armagh Gaol, including male and female, republican and loyalist former prisoners, two female former prison officers, tutors, solicitors, visitors, doctors and chaplains. Given the smaller number of recordings made at Armagh Gaol, and its tendency to be overlooked in favour of the Maze / Long Kesh, male, political prisoner experience (Corcoran 2006: xvii), it was agreed that the first exhibition of material from the PMA should focus on female political prisoners and staff. We had recently completed a project working with a group of individuals who had either lost a loved one or were themselves injured as a result of the conflict. We developed a methodology of editing six 5-minute self-contained stories placed alongside one another with a short gap between each to form a linear film. This editorial structure worked well when working with politically sensitive material as it allowed the audience to view contrasting narratives whilst allowing each story to maintain its own integrity. The same editing structure was applied to the Armagh material: six stories were selected from the 31 recordings (some of the 34 participants recorded their stories together), and a short story was edited from each recording to approximately 5 minutes in length. These six stories were placed alongside each other, again with a small gap separating each story, to form a 26-minute linear film. This structure rejects the usual propensity in documentary filmmaking to intercut stories to form a single narrative. Alongside this, the full,

minimally edited,[1] PMA recordings were screened on separate monitors, thereby combining a linear documentary with a multi-screen, multiple narrative exhibition.

Selecting material to exhibit from the PMA within a highly politicised and contentious context, where the reception of the stories of perceived perpetrators was uncertain, made the editorial task complex. Whose story should be told? What was the remit and focus of story selection? There was a general agreement to pay particular attention to narratives that were to date 'unseen', which immediately led us to focus on women. This excluded all the male recordings made at Armagh.[2] Following the principle of inclusivity that drove the PMA, we decided to include women's experiences from multiple perspectives: former political prisoners and prison staff. A further selection strategy, and overall aim of the exhibition was to choose clips that would reduce the practice of Othering. In Northern Ireland the I–Other dichotomy is based on political and religious power structures, ranging from Protestant–Catholic, British–Irish, nationalist–unionist, prisoner–prison officer, victim–perpetrator. As Dawson stated, 'political legacies [of the conflict] include increasingly polarized identities, defined in opposition to the other who is perceived to be responsible for the violence' (2007: 9). These polarised identities become especially problematic when addressing the victim–perpetrator dichotomy. There is a tendency in Northern Irish politics to see these as binary oppositions, exemplified in a statement by a unionist politician, Jeffrey Donaldson, in September 2009:

> What we are not prepared to countenance is a rewriting of the Troubles where the perpetrators, whoever they are, who carried out acts of terrorism are placed on a par with the thousands of people they killed and maimed. (BBC 2009)

Given this context where the I–Other dichotomy remains prevalent, we sought to avoid and even reduce this through the principle of inclusivity and by choosing clips which humanised and personalised each woman. One clip included a loyalist former political prisoner. The selected clip highlighted the 'insular' position of female political prisoners who often became an isolated minority within the prison system, as there were relatively few female loyalists in comparison to republican female prisoners:

> Their number at any stage was very low. There was no formal [loyalist paramilitary group] structures ... although loyalist women were imprisoned for

1 The full recordings were edited for two reasons: firstly, to account for technical glitches, and, secondly, when a participant had mentioned the full name of an individual. Surnames were removed to protect the confidentiality of those mentioned and to protect the participants from potential libel.

2 At the height of the Troubles, overpopulation of male political prisoners at the Maze/Long Kesh and Crumlin Road Gaol, meant that male remand political prisoners were temporarily housed at Armagh Gaol, some of whom made recordings for the PMA in 2006.

various 'criminal' offences. ... The rare presence of women in loyalist active
service units and prison structures, their minority status as a prisoner group vis-
à-vis both 'ordinary' and republican prisoners, and the lack of acknowledgment
they received from their community provided clear reasons for their insularity.
(Aretxaga 1997: 131)

The PMA had also recorded two female prison officers. Initially, both were selected,
however one withdrew her consent due to the current political climate where threats
to the security forces from dissident republican paramilitaries continue.[3] The
prison officer clip that remained in the exhibition shows her describing balancing
family life with shift work: 'I started at eight, which meant I was able to dash
home and leave the children to school.' This story of domestic routine is likely to
be familiar to the audience, challenging the dominant, negative representations
of prison officers as a 'reactionary and obstructionist core, inimical to progress
and motivated by sectional interest' (Corcoran 2006: 168). To replace the clip of
the second prison officer, we maintained the inclusivity principle by including
two female tutors discussing how they taught gender studies to female political
prisoners using a children's book that provided examples of gender stereotyping.
This fitted in with a further emerging theme of how women simultaneously
adopted and adapted traditional female roles whilst in prison.

One issue that seemed to be central to the experience of female political
prisoners was strip searching. Corcoran situated strip searching within the wider
political climate of punishment:

> All the prisoners who spoke about the experience of being strip searched
> considered the practice to be a defining example of State violence against women
> in prison. Whilst the compulsory exposure of their bodies was unambiguously
> connected to sexual domination, its timing, conflictual context and the zeal for
> implementing it led prisoners to place strip searching firmly in the sphere of
> political retribution and deterrence. (Corcoran 2006: 184)

A republican prisoner who spoke about strip searching was therefore also included.
Two main factors contributed to the second choice of clip from a republican
former prisoner. This woman was one of the few people in the Armagh recordings
who described the experiences that brought her into prison. She described how
the development of her republicanism was not historically informed but grew
from directly witnessing acts of injustice to her community by the British state.
This counteracted reductive images of republican prisoners, maintained by
mainstream media to reinforce the view that they had no legitimate agenda other
than 'terrorism' (Aretataxaga 1997: 92). The third choice was a republican former
prisoner who told her story of being pregnant when coming into the jail, giving

3 The participant's concerns were confirmed when a prison officer, the first in almost
20 years, was killed by dissident republicans on 1 November 2012 (see Kearney 2012).

birth to her child, keeping him with her in prison for a defined period and finally handing him over to her family until she had served the remainder of her sentence. The clip ends with her reflecting on the difficulty of her years spent in prison: 'three years. I don't know how I did it, but like everything else you had to do it.' Identifying titles (other than the women's names) were deliberately avoided when they first appeared on screen. Their positions in the prison – prisoner or prison officer, loyalist or republican – were revealed in the course of their testimonies.

After each clip was edited, participants were asked to (re)view their edited clip and full recording and were given the opportunity to remove any section they wished. Four of the seven participants made use of this provision. They removed small sections where they had talked about either a colleague or fellow prisoner and were uncertain if the information they had given was accurate. The changes were minimal and mostly involved the removal of a surname, however the implications for the participants were significant. After making minor changes, they felt comfortable showing their story publicly.

Exhibition

In the final exhibition, the linear film was projected onto a blank white wall. Six monitors showing the minimally edited films were arranged on individual desks on the adjoining and facing walls. The order of the films on each monitor replicated the order in which the stories appeared in the linear film. Headphones were provided for each monitor. By doing so, we sought two modes of engaging visitors through audio-visual storytelling: the individual experience of watching each narrative on a monitor using headphones and the collective experience of watching the linear film in the open space of the gallery. The audience had no control over the linear film which played continuously on a loop. In contrast, whilst sitting at the monitors, the audience could stop, replay and skip sections.

A seminal aspect of the exhibition was the inclusion of audience responses. Bush, Logue and Burns identified the absence of audience response studies to Troubles-related storytelling work as a major gap in current research: 'in terms of the mechanics of storytelling impact, much more attention must be paid to the audience – and the impact of hearing that story on the sense of self, and other' (2011: 66). For that reason, and to gauge audience responses to hearing the story of the perceived Other, we held four public workshops, two of which were organised prior to the exhibition. The first workshop was attended by 12 practitioners, including academics and other creative practitioners, all of whom had a specific interest in Troubles-related material and had either produced, or were in the midst of, similar projects. The second was open to the public and was advertised on the gallery's website and facebook page. It was attended by five women, four or whom were involved in research related to the Troubles and one of whom was a community worker in a loyalist area of East Belfast. Two workshops emerged organically during the exhibition. The gallery was contacted by a group of women

aged 50+ from West Belfast who attend a support group for republican ex-prisoners and their families, all of whom were affected by the conflict and had close relatives who were political prisoners at the Maze / Long Kesh and Armagh Gaol. The group agreed to participate in a workshop discussion after viewing the exhibition. The gallery regularly engages in community outreach work and was conducting a photography project on women and conflict with a group of eight young women aged 14 to 17 in Dunmurry, a suburb of South Belfast. During the exhibition, we brought the linear film to the group in Dunmurry and held a discussion following a screening. All workshops in the gallery involved a screening of the 26-minute linear film and participants were given time to view the minimally edited recordings. A discussion was held after each screening which was recorded using audio recording equipment and later transcribed and summarised.

The Dunmurry youth group reacted empathically to the stories and the workshop acted as a catalyst for the young women to discuss issues of sectarianism that continue to affect their own lives and communities. All of the republican women's group felt that the film reflected their experiences of what it was like for female republican political prisoners. When asked what it was like to hear the stories of the perceived Other (for example, the prison officer and loyalist former prisoner), all women in the group felt that the selected clip from the prisoner officer's narrative did not match their personal experience. One explained:[4]

> She didn't really come across as what my perception was of a screw [prison officer]. ... [They were] very ignorant [rude, abrasive]. There were nice ones ... and other ones where it was more than a job to them it was ... a bitterness. ... They did whatever they were able to do without being pulled over hot coals. ... If you were ten minutes late for your visit they wouldn't let you in even if it was the bus came late for you they wouldn't let you in.

For these women, personal, direct, negative experiences counter-balanced the possibility that a short film might have an impact on their perception of the Other. Similarly, one practitioner, a former member of the security forces also involved in storytelling work, stated that he would have preferred to know why the prisoners were in jail, what crimes they had committed. He asked what value exhibitions like this have:

> What use is it? And how is that going to, in the future, resolve conflict? If you're going to tell your story and for me to acknowledge it in its entirety ... for me it's telling your whole story and how that's impacted on individuals.

4 Specific participants cannot be identified for reasons of confidentiality and the politically sensitive nature of the material being discussed.

In contrast, one of the women who attended the public workshop, who was a community worker engaged in women's projects in predominantly Protestant areas, suggested that the exhibition did reduce the process of Othering:

> The girl that was interviewed about being strip searched and a republican prisoner, I can recall maybe 20 or 30 years ago laughing and lapping that kinda thing up and saying 'Well they deserve it', in all honesty. Through listening and learning and understanding and being able to look at it in that way as a woman and being treated in that way regardless of why you were there and I think it can strike a different chord within you as well and be able to give you an insight into something.

For this woman, her ability to empathise with the experience of being strip searched 'as a woman' reduced her view of the former republican prison as the Other, highlighting the potential of exhibitions such as these to shift perspectives. The former security worker's response also highlights the limitations of audio-visual storytelling and the mechanics of memory recollection: the teller may emphasise, understate or leave out any aspect of their story that they wish. Similarly, the editing rationale of inclusivity, personalisation and humanisation may have excluded more challenging representations of political prisoners or prison staff. For some audience members this absence of what they perceive as the 'full' story may prove disappointing and unrepresentative of their own memories and experiences. For others, the role of public exhibition of stories from conflict should be a form of confessional, where the perpetrator admits their crime and shows contrition and awareness of its impact on the lives of others.[5] In this instance, the editing methodology of choosing clips with the aim of producing an empathic response[6] was more likely to be successful in audience members without direct experience of violence and imprisonment.

The complexity of exhibiting contrasting narratives alongside one another was expressed by one of the film's participants who described how she felt on seeing the stories that were alongside hers for the first time:

> If you are telling the truth I could take it. I can take the truth whether you like the truth or whether you don't. You don't have to accept it, but that's not the truth. That did not happen, that as she tells the story because that is propaganda. I'm a bit apprehensive of being associated with that but I think people will look at me in a different perspective.

5 On ethics and documentary practice, see Aufderheide 2007: 22–5; Nichols 200: 1–19; Sanders 2012.

6 On storytelling and empathic responses, see Kidd 2012 and the work of the AHRC funded project 'Silence, Memory, Empathy' <http://silencememoryempathy.wordpress.com/>.

In contrast, the other six participants were willing to have their story placed alongside the perceived Other. One participant stated:

> It was all true. It was all there. Nothing was made up, everything was true. It was how I felt. It was what happened. Same with the other girls. I mean whatever happens it was all true. I mean nothing was lies so I don't have any problem.

This exposes the challenges involved in editing and exhibiting contrasting narratives where 'truth' is contested. One person's experience is another's mistruth. Differences in perceptions of the past also reinforce the need for caution when interpreting memory-tellings such as these as absolute 'truth'. We do not recall events exactly as they happened: 'memories easily become inaccurate when new ideas and pieces of information are constantly combined with old knowledge to form flexible mental schema' (Van der Kolk and van der Hart 1995: 171). Similarly, Sarkar and Walker stated that whilst remembering, 'truth may also be "proximate"' (2010: 9–10). Instead, McLaughlin suggests that we should view recordings and exhibitions of this kind 'not as historical documents but as interpretive documents of [the] past' (2010: 20). After expressing apprehension at having her story placed alongside a story that she believed to be 'untrue', the participant was offered the choice of withdrawing from the exhibition. She opted to include her story, as she decided 'people will make up their own minds'. The motivating factor to continue was the fact that she would lose the opportunity to present a contrasting narrative to the audience.

Conclusions

The collaborative and ethical protocols employed during this exhibition were essential in bringing competing versions of a contested past to the public. Participants particularly valued the protocols of the right to veto and shared editorial control, citing the latter as a major factor in their decision both to take part and to remain involved in the project. Editorial control in particular, although minimally used, provided participants with a sense of safety and control. Without this protocol, the withdrawal rate could have been much higher.

Collaborative exhibitions of this type are not without limitations. Firstly, the difficulties of representation. It could be argued that 5-minute edits of a complex experience are reductive – it is impossible to fully represent the complex experiences of political prisoners and prison staff.[7] Also, collaborative practice itself may impose limits on adequate representation. The editor may choose clips less likely to contradict each another, in order to prevent participant withdrawal, thereby presenting a safe and non-contentious exhibition. In this case however, although one participant did perceive other stories as directly contradicting her

7 On documentary and the complexities of representation, see Nichols 2001: 5–19.

own, she chose to allow her story to be seen publicly. The workshop discussions highlighted that the potential for the exhibition to reduce Othering was limited for audience members who had had direct, negative experiences of conflict. In contrast, for workshop attendees who had no direct experience of the conflict either through personal injury, imprisonment or losing a loved one, the potential to empathise with the perceived Other was more promising.

In terms of creating a reflective space which allowed competing narratives of contested pasts to co-exist, the editing and exhibition methodologies of allowing individual stories which are not intercut to maintain their integrity within linear narrative structures perhaps offers some indication of how this can be achieved. Not all perspectives need to be merged into a single narrative. We can acknowledge similarities and separateness simultaneously. As a public workshop attendee stated, 'what we are doing is looking through their window'. In other words, an exhibition of this kind allows the post-conflict audience in Northern Ireland to formulate contrasting views of a contested past from multiple perspectives. As Hamber stated, 'any society grappling with mass injustice should seek to open as much social and psychological space as possible' (2009: 139). Multiple-narrative exhibitions of this kind create one such space.

References

Aretxaga, B. 1997. *Shattering Silence. Women, Nationalism and Political Subjectivity in Northern Ireland*. Chichester: Princeton University Press.

Aufderheide, P. 2007. *Documentary Film: A Very Short Introduction*. Oxford: Oxford University Press.

BBC 2009. 'DUP seek Victim Definition Change', *BBC News* (15 Sept.). Available at <http://news.bbc.co.uk/1/hi/northern_ireland/8256468.stm> (accessed 3 Jan. 2012).

—— 2011. 'People Moved Due To Belfast Bomb May Be Able To Return', *BBC News* (27 Jan.). Available at <http://www.bbc.co.uk/news/uk-northern-ireland-12295324> (accessed 28 Jan. 2011).

Bruzzi, S. 2006. *New Documentary*, 2nd edn. Abingdon: Routledge.

Bush, K., P. Logue and S. Burns (eds) 2011. *The Evaluation of Storytelling as a Peace-Building Methodology*, Irish Peace Centres Experiential Learning Paper Series, 5. Belfast: INCORE and Irish Peace Centres. Available at <http://www.incore.ulst.ac.uk/pdfs/250111_StorytellingPB_Meth.pdf> (accessed 15 Sept. 2013).

Corcoran, M. 2006. *Out of Order. The Political Imprisonment of Women in Northern Ireland 1972–1998*. Uffculme, Devon: Willan Publishing.

Cousins, M., and K. Macdonald (eds) 2006. *Imagining Reality*. London: Faber & Faber.

Dawson, G. 2007. *Making Peace with the Past? Memory, Trauma and the Irish Troubles*. Manchester: Manchester University Press.

Devenport, M. 2013. 'National Identity Still a Source of Deep Division in Northern Ireland', *BBC News* (8 Jan.). Available at <http://www.bbc.co.uk/news/uk-northern-ireland-20951202> (accessed 8 Jan. 2013).

Feld, S., 2003. 'Introduction', in J. Rouch, *Ciné-Ethnography*, ed. and trans. S. Feld. Minneapolis: University of Minnesota Press.

Hamber, B. 2009. *Transforming Societies after Political Violence: Truth, Reconciliation and Mental Health*. New York: Springer.

Hampe, B. 1997. *Making Documentary Films and Reality Videos: A Practical Guide to Planning, Filming and Editing Documentaries of Real Events*. New York: Henry Holt.

Irish Times 2011. 'Explosive Device Found in Belfast' (1 Oct.). Available at <http://www.irishtimes.com/newspaper/breaking/2011/1001/breaking11.html> (accessed 4 Jan. 2012).

Kearney, V. 2012. 'NI Prison Officers: The Threat from Dissident Republicans', *BBC News* (1 Nov.). Available at <http://www.bbc.co.uk/news/uk-northern-ireland-20174221> (accessed 7 Jan. 2013).

Kidd, J. 2012. 'Storytelling, Empathy and Impact'. Available at <http://silencememoryempathy.wordpress.com/2012/12/20/456/> (accessed 7 Jan. 2013).

Leydesdorff, F., et al. 2004. 'Introduction: Trauma and Life Stories', in K. Rogers and F. Leydesdorff (eds), *Trauma: Life Stories of Survivors*. New Jersey: Transaction.

McLaughlin, C. 2006. 'Inside Stories, Memories from the Maze and Long Kesh', *Journal of Media Practice* 7(2): 122–33.

—— 2010. *Recording Memories from Political Violence*. Bristol: Intellect.

Moriarty, G. 2013. 'Violence Continues in Belfast as Flags Dispute Shows no Sign of Abating', *Irish Times* (8 Jan.). Available at <http://www.irishtimes.com/newspaper/ireland/2013/0108/1224328565060.html?via=rel> (accessed 8 Jan. 2013).

Nichols, B. 2001. *Introduction to Documentary*. Bloomington: Indiana University Press.

Pryluck, C. 1976. 'Ultimately We Are All Outsiders: The Ethics of Documentary Filming', *Journal of the University Film Association* 28(1): 21–9.

Sanders, W. (ed.) 2012. *Documentary Ethics*. Special issue of *New Review of Film and Television Studies* 10(3).

Sarkar, B., and J. Walker (eds) 2010. 'Introduction: Moving Testimonies', in B. Sarkar and J. Walker (eds), *Documentary Testimonies: Global Archives of Suffering*. Abingdon: Routledge.

Van der Kolk, B.A., and O. van der Hart 1995. 'The Intrusive Past: The Flexibility of Memory and the Engraving of Trauma', in C. Caruth (ed.), *Trauma: Explorations in Memory*. Baltimore: Johns Hopkins University Press.

Ward, P. 2005. *Documentary: The Margins of Reality*. London: Wallflower Press.

Chapter 13

Borders of Belonging: The UK Border Agency Museum as a Nation-Building Site

Claire Sutherland

Museums have a key role to play in both shaping and reflecting public discourse surrounding migration, an eminently contested, but ultimately under-represented, aspect of national memory and public policy. Since the turn of the twenty-first century, a series of emigration and immigration museums have opened across Western Europe, notably in Germany, Spain, Italy and France. The United Kingdom has also seen a range of privately and publicly funded initiatives across the museum sector, aimed at highlighting Britain's contemporary cultural diversity and the history of immigration to the UK. For example, former UK immigration minister Barbara Roche has launched an initiative to create a national museum of migration.[1] Elsewhere, the UK Border Agency Museum, located within Liverpool's National Maritime Museum, has begun integrating the theme of immigration into its permanent exhibition. As the only UK museum – except regimental museums – to be fully funded by and representative of a government ministry, this exhibit already offers valuable insights into how cross-border flows are presented for public consumption. At the same time, the UK Border Agency's very name highlights what its museum has in common with continental European migration museums: all help construct borders of national belonging. Accordingly, the present chapter sets out to analyse the UK Border Agency Museum as a nation-building site. The first section considers the connections between local and national loyalties. The second looks at the conceptual links between nation and citizen in the museums context, leading to an analysis of the UK Border Agency Museum in Section III. As an example of how a sense of British belonging can be constructed by focusing on its borders, the permanent exhibition speaks volumes about the challenges of representing migration in a relatively dispassionate and widely accessible way.

I

Nation-building is defined here as official, government-led nationalism aimed at legitimating the state (Sutherland 2012: 7). The flow of migrants across state

1 <www.migrationmuseum.org>.

borders contributes to shaping nation-building and integration discourses, both in countries of settlement and countries at the origin of a diaspora (Sutherland 2012: 119). Museums also contribute to the dominant discourse of national self-understanding by preserving some aspects of national history and culture while 'forgetting' others (Hobsbawm and Ranger 1983). The influential theorist of nationalism Benedict Anderson recognised the importance of museums to nation-building when he stated that 'museums, and the museumizing imagination, are both profoundly political' (1991: 178). Building on previous analyses of national museums (Sutherland 2005, 2010), this chapter focuses on a museum which forms part of Liverpool's National Maritime Museum complex. It is one element of a larger, ongoing research project into museums that are located at the physical margins of their respective European states, namely Barcelona, Genoa, Bremerhaven, Hamburg, Marseille and Antwerp as well as Liverpool. The research is designed to explore the relevance to nation-building of port cities 'on the sidelines' of states and the migrants who pass(ed) through those ports. Putting these nation-building sites centre stage highlights the importance of migration to delimiting the borders of national belonging. One way of tracing this is through the way museums construct migrant identities, thereby translating the analytical focus on national borders into an empirical focus on how cross-border flows are represented in museums. The aim is to understand how museum constructions of migrants at the margins build the nation itself through the framing of sameness and difference, nation and Other.

John Kelly has criticised Benedict Anderson's widely cited definition of nations as 'imagined communities' (Anderson 1991) or, as Kelly puts it, 'symmetrical units of imagined, communal self-love' (Kelly 1998: 844), because it suggests a horizontal levelling of individuals through notions of national solidarity and comradeship. This is belied by the hierarchies that often pervade nation-building in practice (Sutherland 2012: 47). Similarly, Partha Chatterjee points out that people today draw on many heterogeneous ways of constructing and experiencing the nation, cautioning against Anderson's rather utopian depiction of the nation as promoting horizontal bonds of solidarity, when nation-building often goes hand in hand with enduring inequality (2005). In a book tellingly entitled *Dependent Communities*, Caroline Hughes suggests that 'the task of elites is to create not only a narrative that can elicit allegiance, but a web of practical connections that links the state to society, in a manner that can give form to claims of central representation' (2009: 197). Museums, through the stories they tell in their exhibitions, help create these narratives.

It has been argued 'that the transnational flow of ideas, goods, images and persons – intensified by recent developments in the globalization of capital – … tends to drive a deeper wedge between national space and its urban centers' (Holston and Appadurai 1999: 3). This applies not only to capital cities and global cultural and commercial centres like New York, Los Angeles and Shanghai but also to so-called 'secondary' cities, which often chafe at being overshadowed by their more prominent peers and seek to carve out their own identity. Not for

nothing do places like Bilbao, Stuttgart and Shenzhen employ world-renowned 'starchitects' to heighten their profile (Glancey 2012; Sklair 2006; Souto 2011). Museums in particular have the potential to reach iconic status and quickly forge a close link with the identity of a city. Frank Gehry's Guggenheim Gallery in Bilbao, I.M. Pei's glass pyramid at the Louvre Museum in Paris and Daniel Libeskind's Jewish Museum in Berlin are cases in point, even though the latter two have had to make their mark in already crowded cultural centres. Though less well-known, the museum quarters on Liverpool's riverside and the port of Bremerhaven in Germany are also designed as focal points for culture and tourism, while the Ballinstadt Museum is an explicit attempt to help regenerate a disadvantaged area of Hamburg. How are the peripheral location of museums and the stories they present linked to the ongoing process of nation-building?

In 2011, declassified UK government papers revealed that in 1981, following the Toxteth riots in Liverpool, then Chancellor of the Exchequer Geoffrey Howe wrote a short letter to his Prime Minister Margaret Thatcher suggesting that the city might be allowed to go into 'managed decline' (BBC 2011a). His remarks quickly became notorious as indicative of uneven, hierarchical relations of power between central government in London and the English regions (Dorling 2012). Howe's letter questioned the wisdom of investing in Liverpool and 'having nothing left for possibly more promising areas such as the West Midlands or, even [*sic*], the North East'. Using highly evocative imagery of a barren place, with little potential to grow and flourish, he went on: 'It would be even more regrettable if some of the brighter ideas for renewing economic activity were to be sown only on relatively stony ground on the banks of the Mersey' (BBC 2011a). In 2011, Lord David Alton, a local Liberal MP at the time of the Toxteth riots, responded that 'this idea of managed decline, that you can simply let one of the country's great cities slip into the River Mersey and opt for decay rather than renewal, shows an ambivalence to the north of England which still affects politics to this day'. Employing yet another striking image, he said that Howe's suggestion to let Liverpool decline 'was like creating a museum of horrifying example' as a warning to others (BBC 2011a). This episode highlights a sense of division and detachment between London and Liverpool, with Liverpool cast as peripheral.

The comment and debate ignited by Howe's words, even 30 years on, underscored the enduring tension between regional or local affiliations and nation-building, as represented by central government. At such times, 'the nation appears remote, self-serving and characterised by exclusion and patronage' (Hughes 2009: 206). This tension is evident not only in UK politics, but also in public opinion and popular culture. For example, as a public service broadcaster the BBC has decided to move operations to Salford and Glasgow so as to appear less London-centric. The tension also extends to the BBC's programming (BBC 2011b) and has been documented in UK public opinion surveys (Wyn Jones et al. 2012), think tank reports (Wind-Cowie and Gregory 2011), and newspaper columns (Moore 2012). At the same time, the government seeks to promote a close sense of continuity between local and national belonging. For example, Marinetto points to recent UK

governments' increasing emphasis on 'active citizenship', which is predominantly linked to participation in the local community (2003: 103). Marinetto links the trend to an ideological concern among left-leaning politicians to promote a sense of community on the one hand and the need to balance rights and duties at the other, more right-wing, end of the political spectrum (2003: 117).

On coming to power in 2010, UK Prime Minister David Cameron's attempt to promote voluntary work and community groups through the 'Big Society' initiative sought to connect local activism to a sense of nationwide solidarity. Specifically, the 2010 government coalition agreement aimed 'to create a climate that empowers local people and communities [in] building a Big Society', implicitly understood to mean the national, UK level or at least England (Prime Minister's Office 2010a). In his speech at the initiative's official launch in May 2010, David Cameron also spoke about encouraging 'people to play a more active role in their communities' and explicitly linked this to a proposed National Citizen Service for 16- to 18-year-olds (Prime Minister's Office 2010b). This shows how attempts to link local loyalties with nationwide initiatives still persist in politics, despite well-documented feelings of alienation at the periphery (Wyn Jones et al. 2012). These are summed up by an engraved quote in the Museum of Liverpool, which opened in mid-2011, expressing the sentiment that the great thing about Liverpool is that it is not England! If one accepts that competing identities are principally expressions of power relations, rather than any 'genuine' or 'traditional' characteristics, it becomes possible to relate such debates to constructed dichotomies of centre and periphery (Winter 2009: 136). Indeed, the construction of the nation is as much about the power to dominate as the ability to make nationality meaningful. The following section places the powerplay of centre–periphery relations within the narrower context of museums and their potential impact on citizenship.

II

The Economist newspaper has argued that states should use people's place of residence rather than their citizenship as a basis for allocating rights and responsibilities, 'because it stems from a conscious decision to live in a country and abide by its rules' (*The Economist* 2012). It reasons: 'live and pay your taxes in a country – and you should then be treated in the same way as any other resident, and better than a citizen who has lived overseas and not paid up'. This view chimes with some recent academic scholarship on citizenship (Kostakopoulou 2008). What it omits, however, is any explicit reference to a sense of national belonging or its ongoing role in legitimating the nation-state itself. Although *The Economist* acknowledged that 'citizenship is the glue keeping individual and state together', it did not address the key role nation-building plays in this relationship. Benedict Anderson long ago diagnosed what he called 'a crisis of the hyphen' between the concepts of nation and state (in McCrone 1998: 173). If the nation is indeed an 'imagined community' writ large, albeit a hierarchical one, then it is important

to understand how 'peripheral' or 'provincial' representations of the nation contribute to a wider sense of belonging. Museums offer an important forum for individuals to explore the link between abstract notions of citizenship, national belonging and their everyday impact on individuals. For example, the analysis of the UK Border Agency Museum in Section III suggests that there is a clear strand of negative Othering running through its exhibition, which applies not only to criminal smugglers but also to immigrant flows and foreign visitors as targets of suspicion. This highlights the potential for museums to shape visitor perceptions of who belongs to the nation and who should be excluded.

As Gerard Delanty put it, 'the power to name, create meaning, construct personal biographies and narratives by gaining control over the flow of information, goods and cultural processes is an important dimension of citizenship as an active process ... which mostly takes place in the informal context of everyday life' (2009: 128). Delanty's emphasis on citizenship as a learned process remains rather vague and difficult to grasp, much as the notion of national belonging itself. However, museums like that of the UK Border Agency address some of the practical consequences of belonging within nation-state borders, such as the impact of taxation and control. Newman, McLean and Urquhart offer a way of thinking about museums and social inclusion, understood in terms of active citizenship. Their findings suggest that: 'enabling the process of identity construction to be re-established and so giving people the capacity to become active citizens is possibly the most significant contribution museums can make to resolving social problems' (Newman, McLean and Urquhart 2005: 54). Specifically, involvement in local history projects was found to increase people's self-esteem, their sense of belonging to their current homes (in this case disadvantaged satellites of Glasgow and Newcastle) and even civic pride. By promoting self-confidence through museum initiatives, the local area was found to be 'an important context within which this sense of self was constructed' (Newman, McLean and Urquhart 2005: 53), once again emphasising the importance of local loyalties to a sense of community belonging. In fostering active citizenship and participation in the public sphere, museums latch on to individuals' identification with their local neighbourhood or community, which may or may not feed into a larger sense of national belonging (Wyn Jones et al. 2012).

Museums' contribution to constructing communities has been a key principle guiding their evolution from 'cabinets of curiosities' in nineteenth-century Europe, though until recently this largely remained an elite-driven, top-down process (Green 2001; Message 2006). As Gordon and Stack suggest in a different historical context, however, 'citizens of towns, by contrast [to national citizens], could aspire to being part of a public arena in which their views might just count for something' (2007: 118). This establishes a link between museums as identity-building arenas and a form of citizenship that 'suggests ways for people to take citizenship back from States, while still leaving a place for government' (Gordon and Stack 2007: 117–18). Tellingly, 'the cultural constitution of citizenship' (Janet Roitman in Gordon and Stack 2007: 119) through processions and parades, both

mediaeval and modern, has been identified as 'a key vehicle through which the city dweller could articulate and enact a sense of belonging within multiple, overlapping identities' (Gordon and Stack 2007: 119). It is submitted that museums can play a comparable role in negotiating urban and national citizenship today. As Aihwa Ong points out, 'in an information age driven by innovation and migration, ambitious cities are becoming spaces of mutating citizenship' (2007: 88). The iconic new museums often found in such cities are a privileged forum for representing and debating that mutating citizenship. The following section interprets the approach of the UK Border Agency Museum, located within the National Maritime Museum in Liverpool.

III

In 2012, the UK Border Agency Museum began an ongoing process of integrating the theme of migration into its exhibition. However, its permanent display already emphasised the protection of borders against a range of outside threats in ways that could influence coverage of migration. Since its inception in 1994, the museum has had to keep pace with several transformations in its funding ministry, including the merger of Her Majesty's Customs and Excise with Inland Revenue in 2005. For example, the permanent exhibition, called 'Seized! The Border and Customs Uncovered', opened in May 2008 but was renamed to reflect the formation of the UK Border Agency in 2009. As a result, the museum's remit has also been widened to include the theme of migration, and curators have embarked on a sustained period of research and reflection into how this might complement existing displays on a relatively small budget. The following analysis considers how existing displays already enable a rather negative interpretation of immigration by constructing a series of dichotomies between guilty and innocent, insider and outsider, suspicion and protection, us and them, thereby allowing visitors to draw parallels and make inferences between one dichotomy and another.

The exhibition aims to strike a balance between conveying the need to control smuggling and contraband and injecting a little excitement into the world of customs procedures. The exhibition title, 'Seized!' clearly nods towards the latter aspect, which sometimes sits uneasily with more sober interpretations. For example, the panel at the exhibition entrance states:

> UK Border Agency works on our behalf to protect us by controlling the movement of people and illegal goods, such as guns and drugs. Revenue and Customs officers also work to raise taxes to pay for services we all use. It is an unseen world of smuggling, intrigue and detection.

The last sentence is rather at odds with the first two, both thematically and grammatically, because it is not clear to what 'It is an unseen world' refers. The sentence seeks to create a sense of excitement to draw in the visitor, in marked

contrast to preceding references to the more mundane world of community service. The use of the first person plural includes the visitor in a shared community, namely the United Kingdom. Creating a sense of 'we-ness' is a key nationalist trope (Billig 1995). As such, this introductory panel already appeals to a sense of national belonging that implicitly justifies the policing of nation-state borders throughout the exhibition. It also echoes the museum's aim to 'communicate the role of the UK Border Agency in ensuring our way of life is fair, safe, civilised and protected' (UK Border Agency Museum 2012b). This sets up a dichotomy that is central to theories of nationalism, between 'our way of life' and an unnamed Other potentially threatening a 'fair, safe, civilised' society that has to be 'protected'. Casting the UK Border Agency in the role of protector also underlines the national arena implicit in the statement.

The UK Border Agency's name has evidently been chosen to emphasise the protection of UK borders and, by extension, the national community evoked by the phrase 'our way of life'. Parallel to this, the museum website identifies its key themes as 'anti-smuggling' and 'the importance of raising taxes' in order to 'explore issues of fairness and safety in society, affecting all of us today' (UK Border Agency Museum 2012a). Again, the references to smuggling and taxes, which are only meaningful in the context of the bordered nation-state, suggest that 'all of us today' is used here as a national rather than a local or global referent, and that the term 'society' connotes the UK and its citizens. Thus, the introductory texts in the museum and on its website clearly, though not explicitly, delimit the UK territorial space and paint it as a fair and civilised place in need of security and protection.

Far from being marginal, borders are central to the remit of the UK Border Agency and its museum. In turn, the protection of borders is constitutive of the nation-state as an 'imagined community' (Anderson 1991) and a mapped territory, because borders help give meaning and identity to all that is contained within. Therefore, the UK Border Agency museum is just as much about nation-building as it is about border controls, and this is explicit in its exhibition. For example, a panel about tax is titled 'The Nation's Money' and another panel entitled 'Our Island Nation' points out how Britain's coastline has been both a defensive asset and an added difficulty in controlling smuggling. Words like 'hidden', 'guarding', 'waiting', 'protecting', 'frontier', 'watching', 'suspicious' and 'concealed', printed in capitalised, bold type against a yellow background, run like ticker tape along the bottom of a large-scale frieze of a calm seascape and other surrounding panels, as if to underline the protective function of borders and heighten mistrust of the Other attempting to cross them. Apparently, the empty, untroubled seascape should not be taken at face value, just like smugglers who, to quote from panel texts, use the 'art of distraction' to look 'completely innocent'. The exhibition presents so-called 'profiling' as the customs officer's weapon against this. One panel specifies that officers 'look at where travellers have come from, who they are with and how they have paid for their tickets'. Although this seems to acknowledge that profiling constitutes little more than a random selection on the basis of an

individual's suspicious looks, provenance or company, it is defended elsewhere in the exhibition as pseudo-scientific. Indeed, the panel titled 'Observation Test' reads: 'It's not just about looking. It's about using research to predict what may happen or to spot something that is not quite as it should be.' This recalls the museum website's evocation of a 'safe, fair, civilised' society. A berthed ship or travellers streaming past an airport desk appear to represent a potential threat to this society, which is why borders are so crucial to the national narrative.

The exhibition most clearly defines the Other as criminal gang leaders, represented in one panel by a picture of a huge yacht subtitled 'Luxury'. It is easy to condemn this Other, but a game asking visitors to examine airport arrivals at customs perhaps unwittingly points to the dangers of categorising individuals as legal or illegal, with all the connotations of belonging this entails. Entitled 'Spot the Smuggler', the game asks visitors, under time pressure, to judge whether individuals photographed going through airport customs look like smugglers or not. Each time the game is played the figures are randomly labelled either 'innocent' or 'guilty', thereby highlighting how difficult it is to judge by appearances. However, this conclusion only emerges if the game is played at least twice, which visitors are unlikely to do. In effect, then, visitors are asked to judge by appearances and have no basis for justifying their chosen answer, which will be randomly 'right' or 'wrong' depending on which iteration they play. This raises questions as to the basis for customs officials' decisions. It is not clear on what these are founded or whether prejudice may have a part to play in them. All of the individuals pictured are white, presumably so as not to encourage racial stereotyping. The inclusion of black or Asian figures would have raised uncomfortable issues surrounding racial prejudice and whether it could play a part in judging likely guilt or innocence. One figure is female and another is in a wheelchair, but these nods to gender and disability do nothing to address the likely ethnic mix of people milling through UK airports. As it is, the 'Spot the Smuggler' game and the panels on profiling effectively highlight the random nature of border controls in practice. This undermines the image of competent customs officials dedicated to protecting UK security that is built up elsewhere in the exhibition by means of panels subtitled 'Chase, Arrest, Deterrent', 'Reliable, Searching' and 'Scrutiny', which describe different ways of detecting illegal activity, and one on the recent history of the customs service, subtitled 'Responsibility, On-line, Modern'.

In sum, the 'Seized!' exhibition asks visitors 'to enter a world in which things are not always as they seem' but does not interrogate the way in which dichotomies of 'us' and 'them', guilty and innocent are constructed. Instead, the first person plural is used to draw the visitor into an 'imagined community' of law-abiding, tax-paying citizens belonging to 'our island nation', which is guarded by well-trained officials ranked against the criminal Other. Customs staff are depicted as inherently watchful and suspicious of those seeking to cross into the 'fair, safe, civilised' UK, and this guardedness is connoted as positive throughout the exhibition. Visitors are encouraged to judge pictures of people entering the UK as innocent or guilty on sight, with only the questions 'What are they wearing?'

and 'What are they carrying?' to guide them. The overall message conveyed in the exhibition is that of an island fortress with a long history of vigilance against infiltration. This is best summed up in the panel portentously entitled 'Our Island Nation'. Part of it reads:

> Being an island has helped us repel invaders in the past, but having such a long coastline makes us especially vulnerable to smuggling. Uniformed officers at ports and airports control both people and goods entering the country. However, they are not alone. The staff behind the scenes, who monitor and investigate trading activity, play an equally vital role in protecting our borders.

The panel features an image of waves beating against a strong seawall ending in a lighthouse, as if to highlight the potentially destructive forces attacking fortress Britain, itself a beacon of fair, civilised and safe values.

Conclusion

This chapter has argued that the UK Border Agency Museum can be read as dangerously self-aggrandising in its defence of 'British values'. The exhibition is ambivalent, not about the importance of preserving a sense of bounded, Westphalian sovereignty against all odds, but rather about how customs officials profile the Other and judge who is guilty or innocent in 'our' name. In the age of globalisation, European integration, multiculturalism and mass migration, this exhibition does not provide a promising role model for museums as 'spaces of mutating citizenship' (Ong 2007: 88). An examination of what she calls 'the cartography of citizenship', leads Dora Kostakopoulou to argue that 'the conventional idea of citizenship as membership in an undifferentiated statal community [is] unsuited' to the contemporary world (2008: 12), characterised by globalisation, constant cross-border flows and supranational integration. Yet nation-building persists today as the primary means of legitimating states, and governments still seek to mobilise local loyalties for this purpose. In turn, border controls are one reflection of the UK immigration minister Damian Green's wish to ensure that the 'right people are coming here. People who will benefit Britain, not just those who benefit by Britain' (in Travis 2012).

Major European centres like London, Amsterdam, Paris, Frankfurt and Milan have become the focus of state efforts to attract economic investment and regeneration, at the expense of many peripheral, stagnating, marginalised or deindustrialising zones (Brenner 2004: 258). Yet port cities like Liverpool, Bremerhaven, Antwerp and Genoa have sought to buck that trend by regenerating run-down neighbourhoods through new, iconic museums highlighting their history of emigration. These cities' fortunes were shaped by their role as points of departure for the American continent in the nineteenth century and the subsequent decline of this industry. Focusing on them as 'borders of belonging' and on how

their museums depict migration is thus particularly revealing of how the nation is defined and delimited today. Liverpool Maritime Museum's emigration gallery and the UK Border Agency's exhibition find themselves side by side by accident, and there has been no attempt to connect the two thematically. However, closer attention to Liverpool's history of emigration, as well as Bremerhaven and Hamburg migration museums' attempt to link Europe's history of emigration to greater tolerance for immigration today, might help the UK Border Agency Museum to navigate the treacherous waters of migration representation and interpretation.

References

Anderson, B. 1991. *Imagined Communities*, 2nd edn. London: Verso.

BBC 2011a. 'Toxteth Riots: Howe Proposed "Managed Decline" for City', *BBC News* (30 Dec.). Available at <http://www.bbc.co.uk/news/uk-england-merseyside-16355281> (accessed 28 Jan. 2012).

——— 2011b. 'Romancing the Stone: The Golden Ages of British Sculpture', *BBC Four* (9 Feb.). Available at <http://www.bbc.co.uk/iplayer/episode/b00ydp2y/Romancing_the_Stone_The_Golden_Ages_of_British_Sculpture_Masons_of_God/> (accessed 28 Jan. 2012).

Billig, M. 1995. *Banal Nationalism*. London: Sage.

Brenner, N. 2004. *New State Spaces: Urban Governance and the Rescaling of Statehood*. Oxford: Oxford University Press.

Chatterjee, P. 2005. 'The Nation in Heterogeneous Time', *Futures* 37: 925–42.

Delanty, G. 2009. *The Cosmopolitan Imagination*. Cambridge: Cambridge University Press.

Dorling, D. 2012. 'Domesday Reloaded: How Britain Has Changed', *BBC Radio 4* (25 Jan.). Available at <http://www.bbc.co.uk/programmes/b01b1hzw> (accessed 28 Jan. 2012).

The Economist 2012. 'Citizenship: In Praise of a Second (or Third) Passport' (7 Jan.): 10.

Glancey, J. 2012. 'The Tower and the Glory: Terry Farrell's KK100', *The Guardian* (31 Jan.). Available at <http://www.guardian.co.uk/artanddesign/2012/jan/31/terry-farrell-kk100-shenzhen-skyscraper?INTCMP=SRCH> (accessed 3 Feb. 2012).

Gordon, A., and T. Stack 2007. 'Citizenship Beyond the State: Thinking with Early Modern Citizenship in the Contemporary World', *Citizenship Studies* 11(2): 117–33.

Green, A. 2001. *Fatherlands*. Cambridge: Cambridge University Press.

Hobsbawm, E., and T. Ranger (eds) 1983. *The Invention of Tradition*. Cambridge: Cambridge University Press.

Holston, J., and A. Appadurai 1999. 'Introduction', in J. Holston (ed.), *Cities and Citizenship*. Durham, NC: Duke University Press.

Hughes, C. 2009. *Dependent Communities*. Ithaca, NY: Cornell University.

Kelly, J. 1998. 'Time and the Global: Against the Homogeneous, Empty Communities in Contemporary Social Theory', *Development and Change* 29: 839–71.

Kostakopoulou, D. 2008. *The Future Governance of Citizenship*. Cambridge: Cambridge University Press.

McCrone, D. 1998. *The Sociology of Nationalism*. London: Routledge.

Marinetto, M. 2003. 'Who Wants to be an Active Citizen?', *Sociology* 37(1): 103–20.

Message, K. 2006. *New Museums and the Making of Culture*. Oxford and New York: Berg.

Moore, S. 2012. 'I'm not Alone in Feeling English, not British: But that has Nothing to do with Racism or Ukip', *The Guardian* (4 Jan.). Available at <http://www.guardian.co.uk/commentisfree/2012/jan/04/feeling-english-is-not-racism> (accessed 10 Jan. 2012).

Newman, A., F. McLean and G. Urquhart 2005. 'Museums and the Active Citizen: Tackling the Problems of Social Exclusion', *Citizenship Studies* 9(1): 41–57.

Ong, A. 2007. 'Please Stay: Pied-a-Terre Subjects in the Megacity', *Citizenship Studies* 11(1): 83–93.

Prime Minister's Office 2010a. 'Government Launches Big Society Programme' (18 May). Available at <http://www.number10.gov.uk/news/big-society/> (accessed 10 Jan. 2012).

—— 2010b. 'PM and Deputy PM's speeches at Big Society Launch' (18 May). Available at <http://www.number10.gov.uk/news/pm-and-deputy-pms-speeches-at-big-society-launch/> (accessed 10 Jan. 2012).

Sklair, L. 2006. 'Iconic Architecture and Capitalist Globalization', *City* 10(1): 21–47.

Souto, A. 2011. 'Archiving Berlin's Past and Renewing the Ruhr Valley', *Austausch* 1(2): 98–120. Available at <http://www.austauschjournal.net/Issue%202/Souto.pdf> (accessed: 18 July 2012).

Sutherland, C. 2005. 'Repression and Resistance? French Colonialism as seen through Vietnamese Museums', *Museum and Society* 3(3): 153–66.

—— 2010. *Soldered States: Nation-Building in Germany and Vietnam*. Manchester: Manchester University Press.

—— 2012. *Nationalism in the Twenty-First Century: Challenges and Responses*. London: Palgrave.

Travis, A. 2012. 'New Immigration Policy Favours the Wealthy, say Critics', *The Guardian* (2 Feb.). Available at <http://www.guardian.co.uk/uk/2012/feb/02/selective-immigration-policy-wealthy> (accessed 3 Feb. 2012).

UK Border Agency Museum 2012a. 'Seized! The Border and Customs Uncovered'. Available at <http://www.liverpoolmuseums.org.uk/maritime/collections/seized/> (accessed 30 Jan. 2012).

—— 2012b. 'Who We Are'. Available at <http://www.liverpoolmuseums.org.uk/maritime/visit/floor-plan/seized/partnership.aspx> (accessed 30 Jan. 2012).

Wind-Cowie, M., and T. Gregory 2011. *A Place for Pride*. London: Demos.

Winter, E. 2009. 'Die Dialektik multikultureller Identität: Kanada als Lehrstück', *Swiss Political Science Review* 15(1): 133–68.

Wyn Jones, R., et al. 2012. *The Dog that Finally Barked: England as an Emerging Political Community*. London: Institute for Public Policy Research.

Chapter 14

Perspectives on the Far East: Understanding War through Veterans' Eyes

Amy Ryall

This chapter deals with the utility and truth-value of eyewitness testimony as defined by Imperial War Museums (IWM). Using IWM's education project 'Their Past Your Future' (TPYF) as a case study, it will look at assumptions about eyewitnesses and historical truth. It will also assess the challenges and limitations of eyewitness testimony and its contribution to historical understanding, both for young people and those who work with them.

IWM uses eyewitness testimony because people are fascinated by the personal. Hearing what someone thinks and understands about a historical situation that they have witnessed provides a powerful connection with the past. Ordinary objects, which comprise much of the collections of IWM and other war museums, are brought to life by a good story. Personal testimony adds the nuances that a written history cannot and highlights common emotions, across generations, which support our understanding of the past. It can also raise many moral questions about an event that are not found elsewhere in the historical record and address ethical issues surrounding personal testimony and the retention and retelling of memory. For the young people that took part in the TPYF project, there was also value in meeting witnesses rather than just hearing them, asking the questions that they wanted to ask, not what an interviewer felt should be asked. TPYF aimed to further enhance understanding of the impact and legacy of conflict and to encourage young people to be motivated to learn about the past and its relevance to the present and future.[1] Meeting veterans and eyewitnesses fulfilled these aims in that it highlighted that 'history is not a dead subject' (MacMillan 2009: xii).

It was with this in mind that the TPYF project was set up in 2004. It stemmed from the UK government's 'Veterans Reunited'[2] programme, part of the

1 Learning outcomes for the second phase of the project (2007–10), based on *Inspiring Learning for All*'s Generic Learning Outcomes: 'Knowledge and Understanding' and 'Attitudes and Values' (see <http://www.inspiringlearningforall.gov.uk/>).

2 Veterans Reunited's other strands were Heroes Return and Home Front Recall. Heroes Return funded over 39,000 Second World War veterans, their spouses, carers, widows or widowers, to visit over 35 countries which were related to their wartime service, as part of the 2005 commemorations. It was so successful that it continues today (see <http://www.biglotteryfund.org.uk/prog_heroes_return>). Home Front Recall awarded 3,300

commemorations of the sixtieth anniversary of the end of the Second World War. TPYF was the learning strand and worked with young people, teachers, academics and museum educators to explore the legacy of the Second World War. In this first phase, it included a touring exhibition and an accompanying online exhibition.[3] The second phase of the project, from 2007 to 2010, expanded to include other, more recent conflicts and their legacies. It did this though online exhibitions[4] and a series of commemorative visits, all over the world, which will be key to the discussions in this chapter.[5] One of the main aims of the project was to enable participants to gain knowledge and understanding of the variety and diversity of people's experiences of war and its long-term impact on their lives. It aimed to use a variety of sources to achieve this – diaries, letters, books, museums, historic sites – but, most of all, it aimed to give participants the chance to hear from the people who had seen it for themselves: veterans and eyewitnesses.

The role of the eyewitness was crucial to TPYF's work in widening understanding of the legacy of war and in helping participants to understand the enormity of the effects of conflict. Intellectually, it helped participants to understand the difficulties of the discipline of history. In this context, one of the most profound experiences for the participants was learning how to assimilate eyewitness testimony into their historical understanding; to understand that each person has a different version of the truth but that this does not detract from the integrity of what they say. We addressed the notion that eyewitnesses can disagree, people embellish, misremember, they can under- or overemphasise and play to the

grants to fund celebrations such as reunions, street parties, tea dances and village fetes, visits to historic sites, museums and memorials, concerts, theatre and music productions and wartime gardening projects, the creation of archives of people's memories, community activities, local history projects and exhibitions and participation in national and local commemoration events, parades and services.

3 The online exhibition 'One in Five' accompanied an exhibition about the Second World War which toured to 69 venues across the UK. It included an outreach learning kit and tactile book for use with the exhibition, and venues augmented the exhibition with their own locally sourced material. See <http://archive.theirpast-yourfuture.org.uk/upload/package/52/Flash%20Site/index.html>.

4 Online exhibitions: 'Through My Eyes' <http://www.throughmyeyes.org.uk/>; 'What Lies Beneath' <http://whatliesbeneath.org.uk/>. Further details about the activity of both phases of TPYF can be found at <http://archive.theirpast-yourfuture.org.uk>.

5 Between 2004 and 2010, 33 visits took place, to Europe, North America, the Far East and Australia. In total they involved 726 young people, mainly aged between 16 and 18, though a significant proportion of trips to the First World War battlefields involved younger participants. They were accompanied by 122 of their teachers, educators and youth leaders. In a separate strand of professional development visits, 61 education professionals took part in the 'InSite' programme which looked specifically at post-1945 European history. Involvement was by application, either by the school or by the individual. All participants in the 'InSite' programme had to propose a work-based project, related to the content, as part of their application.

gallery. Participants learned that this in no way invalidates what an eyewitness says, and that it is crucial to interrogate their testimony, rather than listen passively to what they have to say. Testimony to the success of this approach comes from the young people themselves. One student, who visited Japan in 2010, as part of the second phase of the project, learned 'not to take things at face value, like you have to combine ... lots of different pieces together to get the full story on something' (Morris Hargreaves McIntyre 2010a: 62). Another, who visited France, 'learned to question things. I now ask myself when, where, how and why?' (Morris Hargreaves McIntyre 2010a: 52). This experience caused some deep and heated debates about the subjects they were studying which went beyond the immediate history.

From the very beginning of the project, Samantha Heywood, then Head of Corporate Education at IWM, who would become the Director of TPYF, recognised that immersing young people in the history of the Second World War would be a key feature of the project (2011). Unsure exactly how to do this at first, it took a conversation with a former prisoner-of-war to solidify her thinking. The war in the Far East perhaps gives some of the starkest contrasts in attitudes and experiences, and the experiences of this particular veteran, William Rose, sparked the notion that meeting veterans and eyewitnesses would be essential for the project. Bill, as we knew him, was an RAF veteran who was imprisoned by the Japanese after the fall of Singapore in 1942 and whose war diary and bed-sheet flag celebrating the end of the war are held in IWM's collections.[6]

During this conversation, Bill told Sam of his reconciliation with Japan, as a result of his second son marrying a Japanese woman. Bill's experiences had been harsh and had tested his resolve and leadership to their very limits. In a situation where almost 25 per cent of prisoners held by the Japanese did not return home after the war (Patrick and Heaf, 1981: 38), Bill had done well to survive his ordeal. On meeting Takako, his future daughter-in-law, Bill had confided that he had visited Japan. Takako, innocent of Japan's role in the war had asked him if he had enjoyed his visit. He responded by telling her of his experiences there. Takako researched and found the site of Mitsushima camp at Tenryu village where Bill had been from November 1942 to April 1944. The campsite was now the village school, and she persuaded Bill to return there, to meet people in the village. Bill's encounter with the children and their curiosity about all aspects of his time there enabled him to finally come to terms with what had happened to him.

Heywood described her first encounter with Bill:

> The phone call with Bill was probably the moment when I made an emotional connection with what the project could be. If we could succeed in putting young people in touch with this kind of story – where the legacy of war was as powerful, surprising and life changing as this – that surely would be worthwhile. (Heywood 2011: 24)

6 For more history about this period, see Bradder 2011; Daws 2007; Lomax 1998. Bill's own story is told in his memoir *You Shook My Hand* (Rose 2002).

It was worthwhile. Over the life of the project, this dignified man lent us his history and entrusted us to treat it with respect and to pass it onto others. Time and time again, the young people involved did this and felt compelled and honoured to do so. Bill's story encouraged empathy with Bill, but also with all the other men who were held under similar circumstances.

Bill's story was not challenging in itself. He spoke of his time in the POW camp with calmness and a total lack of anger or resentment about his treatment. The challenge was in understanding how he was able to go back to Japan and behave with such grace. How could he accept a Japanese woman as part of his family? The answer seemed as much of a mystery to Bill as to those listening to his story. In his wartime memoirs, he wrote of his first encounter with the children of the school at Mitsushima: 'These children, they knew nothing of the war. They, like everyone else I met, were offering friendship. They wanted to know everything. Where had I slept? What was in the Red Cross parcel? And I found I could answer without any feeling of hurt or hatred' (Rose 2002: 125). For the young people who met Bill, heard his story and then visited the Far East, it challenged them to think about how Bill had been able to reconcile himself to what had happened and what that had meant for the rest of his life.

Another veteran that TPYF groups met before they headed east was Eric Adie. Eric was in the Royal Norfolk Regiment and had also been captured after the fall of Singapore in 1942. He was held in Changi jail in Singapore and then moved to Thailand where he worked on the Thai–Burma or Death Railway. Eric's testimony was in many ways similar to Bill's, measured and calm with his manner concealing the true nature of his experiences.[7] However, he never reconciled himself to his experiences in the way that Bill had been able to. He freely admitted to having trouble accepting his experiences at the hands of the Japanese. Challenging for the students was the harshness of Eric's response towards Japan as a country. In a world where they had been brought up to be tolerant of other races and cultures, here was a man who was anything but towards a specific group of people. He became key to their understanding of the differences in the emotional responses of veterans. His attitude towards the atomic bomb also provoked some thoughtful debate about the nature of those kinds of weapons and the circumstances under which they are used. Before they met him, many had been very firmly against the dropping of the atomic bomb, but hearing Eric talk about the bomb as a positive thing for him, meaning that his ordeal was coming to an end and that he could go home, challenged their own thinking.

Both Bill and Eric helped the young people make an emotional connection with history. After the visits, the consultancy group Morris Hargreaves McIntyre[8] conducted focus groups as part of the evaluation of the project and reported:

7 For more on testimonies that conceal and enlighten, see Onciul, Chapter 2, this volume.

8 <http://www.lateralthinkers.com>.

> A sense of pride and respect for those who lived through conflict aroused deeply emotional and spiritual responses from some young people, which led to a greater awareness of the importance of commemoration and remembrance and more pro-active participation. (Morris Hargreaves McIntyre 2010a: 11)

One of the teachers that accompanied the second trip to Japan in 2008 reported that: 'on an emotional level it impacted. They actually met individuals that were involved in the stories that we were looking at [which] really enabled them to connect which no amount of textbook or DVD would have done' (Morris Hargreaves McIntyre 2010a: 17). At its most basic level it highlighted to them that a war is about real people and never a simple event that affects everyone in the same way. This, combined with visiting some of the places that these men served supported their understanding of events. It meant something more to them because of that personal connection. They started to care about what they were learning because it happened to someone that they knew and could connect it to their experience. This student met Eric Adie and then visited Hellfire Pass, where he had worked:

> You go to museums and you see these things and you take it as read. But then you go to Thailand and you think 'wow, you had about two rice cakes a day to survive in this climate and this is what you were working on' that is incredible. (Morris Hargreaves McIntyre 2010a: 21)

The young people who met these veterans were still mindful that they were getting a version of the tale, repeated and honed over time. They knew that they were able to gain an insight into the experiences of those men, whilst simultaneously acknowledging that 'we can never truly understand what soldiers went through' (Morris Hargreaves McIntyre 2010a: 52).

Although most of their conversations with veterans were based on wartime service, actually meeting veterans in person gave the students much more than this. It led them to realise that the sum of a veteran's life is more than his or her wartime service, as another student who took part in the same trip to France and Canada in 2007 commented, 'it doesn't just affect them at the time, it affects their whole life' (Morris Hargreaves McIntyre 2010a: 52). There was also a sense that 'the war' means different things to different people, that actually it was futile just talking about 'the war', because there were many different 'wars' that happened between 1939 and 1945: 'There are no generalisations. The same event is different for every person that experienced it' (Morris Hargreaves McIntyre 2010a: 8).

The group of young people involved in the evaluation of 'Their Past Your Future' were self-selecting and the quotes were obviously chosen to indicate the positive impact of the programme. Experiences both with meeting veterans and on commemorative visits suggest though that these were not against the grain and that dissenting voices were non-existent. Meeting Bill and Eric humbled the young people into thinking more deeply about these men as people and into

looking at other veterans through this lens. They cared about them, and considered their responses accordingly.

In striving to understand the Second World War (or any other historical event) it was important that the students looked at many different perspectives. In its work with the history of the war in the Far East, TPYF tried to do this by introducing Japanese veterans and eyewitnesses to the groups that went there. For the young people that we worked with, it seemed as important to expose them to the many different experiences of that war as was possible. In Tenryu village, where Bill Rose spent several years as a POW, a TPYF group met Nagase, a former member of the Kempeitai, the Japanese military police. Nagase had been an interrogator and interpreter and, until his death in 2011, spent the years since the war trying to atone for his actions, through acts of reconciliation between him and some of his former prisoners and in fundraising for the Asian victims of the Japanese occupation. In writing of this encounter, Heywood speaks of a certain amount of nervousness on the part of the TPYF and school staff accompanying the trip. Nagase had been present at the torture of three POWs, two of whom had died under interrogation. Here was a challenging veteran. In his testimony Nagase explained his involvement in the Kempeitai by saying he had little choice but to join. His manner, as witnessed by Heywood and the group, betrayed a craving for sympathy and forgiveness that was uncomfortable. It provoked varied reactions amongst those in the room. Heywood admits that she did not know what to do and left the room:

> When I returned to the room everything was in uproar. Nagase was shaking with rage, haranguing a Japanese boy who was standing up and shouting back at him. It was chaos for a few minutes, during which time it became clear they were arguing over whether it was right for the Japanese students to seek forgiveness from the British students for the cruel treatment of prisoners during the war. This was what Nagase had demanded that these young people do – seek atonement now for the sins of his generation in the past. (Heywood, 2011: 26–8)

And here is the risk we take when involving veterans and eyewitnesses in our work: the situations can be unpredictable and quickly become volatile particularly in countries with a very different culture. The decision not to intervene was a difficult and possibly not a conscious one, but the insight into the workings of Japanese society, of its involvement in the war and of the attitude since the war was invaluable to the students. Debates about their experience took place for the rest of the trip, opinions were emotional and, more crucially, divided about what they had witnessed. There is no doubt that they emerged with a greater and more subtle understanding of the conflict and its legacy from Japan's point of view. Nagase's attitude challenged everyone in the room, but, on reflection, that challenge added to the experience. When eyewitnesses behave in unexpected ways, it tells us this: we must take risks with our teaching and learning about history if our understanding of events is to retain its integrity. War is a serious

and messy business, and we do not do our young people any favours by trying to conceal this fact. Nagase's outburst illustrated this convincingly.

Working with veterans and eyewitnesses is not about encouraging young people to put themselves in another's shoes, but about breaking down events to a personal level. For educators, it is about taking risks with potentially volatile situations where young people might hear challenging viewpoints and being confident enough to allow young people to address these viewpoints in a safe environment. Increasingly it is also about deciding how to do this when events are no longer within living memory. The First World War's last surviving veteran died in 2009 and the youngest Second World War veterans are in their late 80s. How do we allow them to speak from beyond the grave and continue to influence the way in which young people see the world? One way is to use the many testimonies and interviews that have been recorded and collected by museums around the world. Diaries are also a powerful resource, which afford us an insight into the personal. All these solutions come with a problem though: you cannot ask diaries questions. One of the most valuable experiences of working with veterans is that they can answer those questions. We must seek to reimagine the role of serving soldiers in helping us to understand past conflicts as well as to help us understand those currently in progress.

The range of veterans and eyewitness that young people encountered during TPYF perfectly illustrates the importance and value of working with veterans and eyewitnesses. Combining the different viewpoints and experiences of events that were for some a life-changing blessing whilst for others a life-changing curse, starkly illustrates the complexity of the events of history. Through the contrasts of people's different experiences, we can help young people (and ourselves) to look at other events, both historical and in their own lives, in a similar way; to understand the world not in black and white, but in colour (see Morris Hargreaves McIntyre, 2010b: 19). A black and white, two-dimensional world where things are either right or wrong is straightforward and easy to understand, but it does not present a very accurate picture of events or experiences. By hearing about history from a variety of perspectives and from those who experienced it at an age similar to theirs, they, and we can start to see that things are not always that simple.

References

Bradder, R. 2011. *The Naked Island.* n.p.: Nabu Press.

Daws, G. 2007. *Prisoners of the Japanese.* London: Pocket Books.

Heywood, S. 2011. 'The Case for Teaching and Learning about War', in S. Heywood (ed.), *Making Their Past Your Future 2004–10.* London: Imperial War Museum.

Lomax, E. 1998. *The Railway Man.* London: Vintage.

Macmillan, M. 2009. *The Uses and Abuses of History.* London: Profile.

Morris Hargreaves McIntyre 2010a. *You Can't Ask a Textbook a Question: An Evaluation of the TPYF Immersive Learning Programme Their Past Your Future 2*. Available at <http://archive.theirpast-yourfuture.org.uk/upload/pdf/ Immersive_Learning_Prog_Evaluation_Report_Final.pdf> (accessed 15 Jan. 2013).

—— 2010b. *'Like Going from Black and White to Colour': An Evaluation of InSite Educator CPD Programme Their Past Your Future 2*. Available at <http://archive.theirpast-yourfuture.org.uk/upload/pdf/InSite_Evaluation_ FINAL_Report.pdf> (accessed 15 Jan. 2013).

Patrick, D.L., and P.J.D. Heaf 1981. *Long Term Effects of War Related Deprivation of Health: A Report on the Evidence*. London: British Members Council of the World Veterans Federation.

Rose, W. 2002. *You Shook My Hand*, Once Upon a Wartime 12. Grantham, Lincs.: Barny Books.

PART 4
'Teaching' Challenging History

Samantha Cairns

There has been evolution in the understanding of the role and purpose of museums for as long as they have existed. In the late nineteenth century, the educational role of museums was unquestioned but so was the perception that there was a received cannon of knowledge that museums could transfer to their visitors, as Hooper-Greenhill notes 'education was based on the mastery of bodies of knowledge, its purpose to fit individuals to their expected station in life' (2007: 13).

As our understanding of the subjectivity of knowledge and our role in mediating it has changed, so has our understanding of museum 'teaching', education and learning. There continues to be an ongoing negotiation in our understanding of what learning in the museum means. Part 4 explores the extent to which we can ever 'teach' in museums, given our visitors construction of knowledge is mediated by their own identities and past experience. Jones' chapter in particular explores our, sometimes unarticulated, assumptions about how children and young people learn history and whether the idea of development of self-identity through history is at odds with developing an understanding of the multiple narratives of the past.

Collectively the chapters explore what museum learning can be expected to do for audiences.[1] Much funding for museum learning in the UK is predicated on the idea that museums 'deliver' benefits for their audiences much wider than just understanding the past, that in a variety of ways by studying the past people will become better citizens. That they will be able to understand and negotiate the world they live in better as a result of engaging in active meaning making. This is a complicated argument to unpick, it is almost impossible to find evidence for it, and it places a heavy burden on museum learning to transform lives. Museums can deliver these transformational experiences, but museums in the UK continue to grapple with this expectation and what it means in practice when examining their role and remit.

While acknowledging and recognising the wider cultural and political tides and currents they find themselves and their organisations working within,

1 'Audience' rather than 'visitor' is used deliberately to denote that the groups museum-learning teams work with are wider than just the visitors to their institutions. Teams will often provide outreach services off-site and will also have a remit to consider how they can serve non-visitors.

contributors to this section are all concerned with navigating the best ways to interpret challenging histories for our audiences. This was a central concern of the 'Challenging History' network set up in 2009 in response to the needs of a group of 30 museum educators who had come together to discuss how to support audiences to engage with contested or sensitive histories. The network's aims were to enable museum educators to provide learning opportunities around these histories, which many educators felt unprepared to do and wanted, if possible, a guide to best practice. These histories were increasingly being pushed into the limelight by the inclusion of slavery and abolition in the English History National Curriculum and the demands of the citizenship curriculum.[2] Within our own practice we felt the tension of wanting to develop the social justice[3] aspect of museums with the ethical need to maintain the balance of interpretation and not advocate one viewpoint or narrative.

A mistaken assumption that many of us who formed the 'Challenging History' network had, myself included, was that there would be a 'right' way to deliver each challenging history. We hoped to draw together a lexicon of proven ways to provide learning opportunities around each of the difficult histories we were struggling with in our institutions. Our work in the intervening years has convinced us there are no set ways to interpret challenging histories. The work of providing museum learning around a contested history must be a constant negotiation between the subject, the resources and the audience.

The following chapters, in particular Jones' explore some of the assumptions we make about how visitors learn in our museums and also examines living history as an extensively used, and proven successful, method for engaging young people. The 'real' or perceived authentic history as provided by a first-person account has a strength and impact which cannot be denied, as explored by the following chapters and in Bryan's, Rosendahl and Ruhaven's and Ryall's chapters.[4] On reading these chapters we are invited to question to what extent the success of living history is built on our response to the perceived authenticity of a real person. What is clear is that face-to-face encounters with witnesses or living history re-enactors have an impact that is difficult to replicate in other forms of interpretation (Jackson and Kidd 2011). I am aware my juxtaposition of first-person witness with living history here will be contentious, but both suffer from weaknesses if used exclusively. Living history is our interpretation of how a historical figure might react and is, as such, highly subjective and reliant on our cultural context. First-person witness testimony needs to be contextualised, although we might say an eyewitness has the right to their own interpretation of events in a way living history practitioners do not.

2 <http://www.education.gov.uk/schools/teachingandlearning/curriculum/secondary>.

3 By 'social justice', we mean the role of the museum in promoting equality and justice at a community and societal level through the use of their collections and programmes.

4 Chapters 4, 5, and 14, this volume.

Bound up in questions of the best way to provide learning about challenging histories is our responsibility as educators to the audience in front of us, what we tell children and adults about some of the truly distressing and horrific histories, and our responsibility to the victims and their often clearly expressed need for people to know what happened. As museum educators we are aware of the cultural authority of museums and also the added responsibility, through our contact with schools, of being the part of the museum that reaches a large number of children from families who are not museum visitors and who may have no other contact with museums (RCMG 2006).

We know that the school history curriculum has an impact on what museums chose to direct resources towards and how histories are viewed by our wider society. Including a subject in the curriculum is seen as having a validating effect: that a history has become mainstream and accepted. As Smith and Fouseki argue 'museums as institutions of representation play a role, however unintended, in the politics of recognition' (2011: 98). The use of the school curriculum to try and impose a single national historical narrative is a recognised tool of some governments (Cannadine, Keating and Sheldon 2011), and at a more subtle level this is recognised in the chapters in this section. Shamoon in her case-study (Chapter 16) explores teaching a subject which general audiences do not show much interest in, but which is included in the school curriculum: the English Civil War and the execution of Charles I. In Chapter 15, Alberti explores some of the impacts of curriculum inclusion for Brazil where a requirement to study the history of Africa and Africans, the struggles of blacks and Indians and black- and Indian-Brazilian culture was added in 2008. We have also seen the impact of this recognition at work in England with the inclusion of slavery and abolition in the English secondary curriculum from 2008 and the increase in provision of resources available from museums for teaching this subject including the 'Understanding Slavery Initiative' hosted by the National Maritime Museum. In both cases there was an overarching requirement to teach a history that everyone agreed needed recognition but without a common understanding of what was to be studied or what was at stake.

In the UK, whilst working at the Museums Libraries and Archives Council London during the bicentenary of the abolition of the Slave Trade Act in 2007, I was ambushed by the complexity of the issues surrounding teaching about transatlantic slavery. Discussion with colleagues in museums and schools demonstrated that the complexity arose from our own unease with the subject – museum educators felt unprepared to teach slavery and abolition because they lacked detailed subject knowledge. Research also showed misconceptions among teachers around the history of transatlantic slavery abounded as well as a great deal of anxiety about exploring a subject that was extremely distressing to comprehend and which, teachers felt, would provoke strong emotions including anger from students of all backgrounds ('Understanding Slavery Initiative' 2007). Groups representing Black African and Black Caribbean communities in London came to meetings with museums, angry about the lack of representation of their histories in institutions

and felt further rejection by the museum processes: for example, when museums responded that they were unable to tell a particular story as they did not have the objects (Smith and Fouseki 2011).

Part of Alberti's solution in trying to define the narratives of Brazil's contested history to teach is to recognise memory as an object and examine how it is constructed. This approach of classifying memory as an object also allows for the presentation of challenging histories which by their very nature, as mentioned by Vandervelde in Chapter 18 on teaching about the Holocaust, have few objects left to represent them or only objects that tell the perpetrators' story and frame the victims as having no agency or identity beyond victimhood. In the UK, we learnt a great deal during 2007 and moved on in our understanding to reach a point where audiences became not just a group to be consulted but stakeholders who had a right to be intrinsically involved in how their museums are run, although there is still much work to be done (see Lynch, Chapter 6, this volume). Developing the mechanisms to ensure this becomes a core part of our practice is an ongoing project.

All the chapters in this section touch on the social-justice element of museum educators' practice asking how far it is appropriate to influence the results of any learning taking place in the museum. As institutions where impartiality and grounding in evidence are central to authority, to what extent can we teach with a particular outcome in mind? We agree that slavery and the Holocaust were crimes against humanity and would want any visitor to leave an exhibition knowing this unambiguously, but as museums to what extent should we state this as fact or provide a range of information that allow visitors to reach their own conclusion? Which of course then begs the question 'which information'?

Such an approach is very challenging when dealing with crimes against humanity and Vendervelde and Rosendahl and Ruhaven among others, explore how they have dealt with this issue in their museums. Of course some museums are very comfortable with a social justice role, as David Fleming explains (Chapter 1, this volume), but the framing of a challenging history needs to be debated and decided by each institution as explored in the *Challenging History: Report and Mapping Document* (Kidd 2009).

A further part of framing a challenging history is the element of memorialisation which can be at odds with our role of providing a historical overview of a topic. An exhibition offering its visitors an opportunity to examine and unpick and form their own opinions could be in conflict with a call to remember and honour. The Canadian War Museum's solution to this in their Canadian Experience Gallery is to recognise memorialisation as a topic in its own right, with a history of its own, and to place the Royal Canadian Legion Hall of Honour which 'explores Canada's long history of honouring individuals'[5] at the centre of the gallery with four chronological exhibitions covering Canadians experiences of conflict arranged around it. This allows visitors to move into a contemplative space from exhibitions

5 <http://www.warmuseum.ca/event/the-royal-canadian-legion-hall-of-honour>.

about conflict, but keeps memorialisation separate from the history galleries. The Canadian War Museum has also considered deeply their social justice role. In an interview with Lisa Leblanc, Manager of Programmes and Interpretation in 2009, she explained they wanted the 'museum message' to be that visitors have agency but without advocating for a particular view or position. An example of this is the panel that confronts visitors at the end of the Canadian Experience Gallery:

What will you do?

History is not just the story you read. It is the one your write. It is the one you remember or denounce or relate to others. It is not predetermined. Every action, every decision, however small, is relevant to its course. History is filled with horror and replete with hope. You shape the balance.

The following chapters explore some of the ways in which museum educators are negotiating the responsibility of shaping the balance of museum education services, to serve current audiences and the memories of people bound up in the many challenging histories our institutions house. They add to the tools museum educators can use to manage the constant negotiation needed between subject, resources and audience required by challenging histories.

References

Cannadine, D., J. Keating and N. Sheldon 2011. *The Right Kind of History: Teaching the Past in Twentieth-Century England.* Houndmills: Palgrave Macmillan.

Hooper-Greenhill, E. 2007. *Museums and Education: Purpose, Pedagogy, Performance.* Abingdon: Routledge.

Jackson, A., and J. Kidd (eds) 2011. *Performing Heritage Research: Practice and Innovation in Museum Theatre and Live Interpretation.* Manchester: Manchester University Press.

Kidd, J. 2009. *Challenging History: Summative Document.* Available at <http://www.city.ac.uk/__data/assets/pdf_file/0004/84082/Challenging-History-Summative-Document.pdf> (accessed 19 Mar. 2013).

RCMG (Research Centre for Museums and Galleries) 2006. *What Did You Learn at the Museum Today? Second Study,* report for Museums Libraries and Archives Council. Available at <http://www2.le.ac.uk/departments/museumstudies/rcmg/projects/what-did-you-learn-at-the-museum-today-second-study/What%20did%20you%20learn%202%20FINAL.pdf> (accessed 19 Mar. 2013).

Smith, L., and K. Fouseki 2011. 'The Role of Museums as "Places of Social Justice": Community Consultation and the 1807 Bicentenary', in L. Smith et al. (eds), *Representing Enslavement and Abolition in Museums: Ambiguous Engagements.* Abingdon: Routledge. Available at <http://www.academia.

edu/413619/The_role_of_museums_as_places_of_social_justice> (accessed 20 Mar. 2013).

'Understanding Slavery Initiative' 2007. *Unlocking Perceptions: Understanding Slavery's Approach to the Histories and Legacies of the Transatlantic Slave Trade*. Available at <http://www.understandingslavery.com/images/pdfs/USI-handbook.pdf> (accessed 19 Mar. 2013).

Chapter 15

Controversies around the Teaching of Brazilian 'Black History'

Verena Alberti

Since 2003, African-Brazilian history and culture has been a compulsory part of Brazil's curriculum for basic education. In 2008, government legislation added the requirement to teach the history and culture of the indigenous peoples. These have to be taught across the curriculum, but particularly the syllabus for arts, Brazilian literature and Brazilian history. The legislation was passed after campaigners denounced textbooks and classrooms for featuring so few blacks and Indians in positive political and social roles. However, certain groups, intellectuals included, have criticised the legislation and referred, as counterpart, to a sort of national grand narrative portraying Brazil as a mixed society in which 'whites', 'blacks' and 'Indians' are indistinguishable. It has to be said, however, that this professed 'mixture', far from levelling everybody in terms of social relations, underpins a complex hierarchy of skin colours ranging from 'darkest' to 'lightest'.

As part of the curriculum, the 2008 law lists 'the history of Africa and Africans, struggles of blacks and Indians in Brazil, black- and Indian-Brazilian culture, and the role of blacks and Indians in building the nation and society' (Brazilian Federal Government 2008). These words continue to raise definitional issues for government, teachers, and black and Indian communities in Brazil. Which Africa is to be taught? Is there such a thing as an 'African-Brazilian' or 'Indian' 'history and culture' in the singular? Whose history and culture is at stake here?

This is indeed a challenging history for Brazil, in the sense of being a history 'that is contested, or difficult and upsetting to know about'.[1] This chapter summarises and discusses points arising from that controversy and explores ways of teaching this content in future. In parallel, it focuses on parts of the permanent exhibition of the National Historical Museum located in Rio de Janeiro, as a way to throw light on the treatment of sensitive issues in museums and heritage institutions, in the Brazilian context.

1 To use a term from the Challenging History Conference's 'call for papers'.

Brazil's 'Mixed-Race' Ideology

On 2 October 2009, as part of Rio de Janeiro's bid to host the 2016 Olympics, former president Luiz Inacio Lula da Silva made a speech to the International Olympic Committee in Copenhagen. The following section is what particularly concerns us here:

> We as a people are passionate about sport, and passionate about life. When I look at the Olympic symbol's five rings, I see my country in them. A Brazil made up of men and women from every continent: Americans, Europeans, Africans, Asians, all proud of their origins and all proud of being Brazilian. We are not just a mixed people; we are a people that very much likes being mixed. This is what makes up our identity. (Lula da Silva 2009)

For some of those following the discussion on the race question in Brazil, Lula da Silva's speech clearly showed convergence with what we might call an 'ideology of mixture': we are a racial and cultural mixture; we are proud of this characteristic, and differences of race or colour do not matter to us (Pallares-Burke 2010). Moreover, as the president added: this is our identity.

Indeed, the vast majority of Brazilians have believed in this idea for a long time, as corroborated by official speeches, such as the president's, and by constant media messages. But although this is propagated as 'our identity' today, it has clearly not always been the case. In the late nineteenth and early twentieth centuries, many members of the political and intellectual elite advocated theories that saw Brazil as doomed to failure by the large numbers of blacks in its population, or because – even worse, for some of them – its people were predominantly mixed, which could not be a good thing, since mixing led to degeneration (see Schwarcz 1993; Skidmore 1974).

In terms of its history of building national identity, Brazil differed little from other Latin American countries. Following independence from Portugal and Spain (from 1810 to 1825 mostly), the question of the basis on which each country would constitute a new nation started to come up more frequently. In the mid-nineteenth century, the 'scientific' racial theories recognised in Europe, such as Francis Galton's, led Brazillian elites to the 'racial problem': how would these nations develop if they had to deal with a huge 'mass' of 'inferior' blacks and Indians? (Stepan 1991). One solution – advocated, for instance, by Domingo Sarmiento, the Argentinean intellectual, educator and president (1868–74) – was to exterminate the indigenous peoples (Trinchero 2006). In Brazil, 'whitening' the country by encouraging European immigration was seen as a good solution.

According to scientists who supported this measure, a massive influx of white immigrants would produce a white society within 100 years (Skidmore 1974). The plan failed: Brazil now has the world's largest black population after Nigeria, Africa's most populous country.[2]

The 'whitening' project was so blatant that an 1890 decree regulating immigration encouraged Europeans to come to Brazil while practically banning Africans or Asians unless authorised by Congress.[3] Brazil's population was around 17 million in 1900, with some 1.8 million immigrants, mainly Italians, Portuguese and Spanish, arriving from 1890 to 1909 (Brazilian Federal Government 2000). A classic image for this ideal of 'whitening' is a work by Modesto Brocos, a Spanish painter living in Brazil, called *Redenção de Cam* (1895), which shows a black grandmother thanking heaven for having had a white grandchild.

In the early twentieth century – as 'eugenics societies' sprang up in several cities, and São Paulo was home to Latin America's first, founded in 1918 – certain Latin American intellectuals began disputing the assumption that blacks and Indians would be a 'problem' and started to analyse racial mixing as a hallmark of nationality. Fernando Ortiz in Cuba wrote several essays on African-Cuban culture from 1906 onwards, coining the concept of 'transculturation' (Davies, 2000). In 1916, Manuel Gamio, who studied under Franz Boas and is considered the founding father of Mexican *indigenismo*, wrote *Forjando Patria* (Forging the Fatherland). In 1925, José Vasconcelos, also from Mexico, argued for mixing of all races in *La Raza Cósmica*. In 1928, José Carlos Mariátegui wrote *Seven Interpretive Essays on Peruvian Reality* in Peru. In 1933, Gilberto Freyre, another former student of Franz Boas, wrote *Masters and Slaves*, which is seen as something of a foundational text for what was later called 'racial democracy', on account of its description of 'harmonious' race relations in Brazil.[4] All these authors looked beyond the racial biological theories that condemned Latin American societies to permanent underdevelopment. By so doing, they succeeded – along different paths, of course – in connecting mixed races to national pride.

For a number of reasons, this proposal won support in many Latin American countries, and the vast majority of Brazilians today would agree with Lula da

2 The 2010 Brazilian census indicates the following distribution of the population, according to the criterion 'color or race' (of a total of 190,755,799 inhabitants): white – 91,051,646 (47.73%); black – 14,517,961 (7.61%); yellow – 2,084,288 (1.09%); brown (*parda*) – 82,277,333 (43.13%); Indian – 817,963 (0.43%); without declaration – 6608. These five terms are used by the census itself, which asks people to choose. 96,795,294 people, or 50.74% of the population, declared themselves to be 'black' or 'brown' (Brazilian Federal Government 2010). On the subjectivity involved in classifying people by race or colour, see e.g. Costa 2002; Paixão and Carvano 2008.

3 Decree 528 (28 June 1890). Two years later, on 5 Oct. 1892, Law 97 repealed the ban on Chinese and Japanese immigrants. Both laws are available at <http://www6.senado. gov.br/sicon/index.jsp?action=LegislacaoTextual>.

4 On the genealogy of this concept, see Guimarães n.d.

Silva. Brazil's national identity narrative, consolidated since the 1930s particularly, boasts of a mixed society, a mixture of 'the three races'.

However, since the seminal writings on nations and nationalism of Ernest Gellner (1983) and Eric Hobsbawm (1985), we have known that nations' grand narratives are also good inventions.

Racism in Brazil

Brazil's 'fable of the three races' (Da Matta 1981) was so successful that UNESCO sponsored research on race relations in Brazil in 1951 and 1952. Shortly before that, the UN had introduced the Universal Declaration of Human Rights (1948), and UNESCO decided to hold a programme of anti-racism activities in 1949, including the Declaration on Race published in 1950.[5] A world that had just gone through the horrors of the Holocaust was looking for ways of ensuring peaceful coexistence between nations and races, and Brazil, among other countries, was chosen for the project.

Findings showed that racism did exist in Brazil, even if there was no distinction between whites and blacks from a legal point of view, as there was in South Africa or the USA. Subsequent research, especially in the social sciences, revealed significant inequalities between blacks and whites that were often interpreted as a legacy of slavery, in other words, reflections of social inequality rather than consequences of racism as such.

Certain intellectuals, such as the sociologist Florestan Fernandes, took to denouncing 'racial democracy' as a myth, an idea that was taken up by the black movement that started mobilising in the late 1960s.[6] A study by sociologist Carlos Hasenbalg examined economic and social data and concluded that inequalities between whites and blacks were due to racism blocking non-whites' upward mobility rather than historical social inequality (1979).

Since then, several researchers have looked at race in Brazil and built a corpus of knowledge of racism and racial inequalities and examined the way these issues have been dealt with in the course of the history of social analysis in Brazil.[7] More recently, there has been a sort of polarisation, which has affected intellectual circles too, between those who advocate affirmative action and measures to offset racial inequality and those who believe these initiatives are wholly inappropriate and would pose the risk of dividing society on racial lines.[8] Inevitably, this polarisation has had repercussions in schools, museums and historical memory

5 See Maio 1997, 1999. It was in this context that Claude Levi-Strauss, among other intellectuals called upon to elucidate the subject, wrote *Race and History* (1952).

6 On the contemporary black movement, see Alberti and Pereira 2007.

7 See e.g. Costa 2002; Guimarães 2006; Paixão and Carvano 2008; Telles 2004.

8 Examples of this polarised debate may be found in manifestos for and against quotas for black students in university admission procedures.

institutions, and the racial question in Brazil has become a particularly sensitive and controversial issue.

In general, all involved in this debate agree that racism is pernicious and should be condemned – in this respect, there is no controversy. Disagreements occur when people start thinking about what can be done about it, and opinions vary as do feelings about the severity of the problem.

In Brazil, as in other countries in the twenty-first century, people are still killed due to racism. There are several examples, but let us take an incident that took place in São Paulo in February 2004. Flavio de Sant'Anna, a black dentist aged 28, was shot dead by five policemen after being falsely accused of stealing a wallet. A gun was placed in his hand to make it look as if he had resisted arrest. The press reported his father, Jonas Sant'Ana, a retired corporal in the state's militarised police, saying: 'I know how the system works. I'm sure he would not have died if he were white.'[9]

What is the point of being a mixed people, and one 'that very much likes being mixed', if people are killed in Brazil just because they are black, as they have been in other countries?[10]

The Context of the Debate and the Example of the National Historical Museum Exhibition

As already said, racism is not a controversial issue in Brazil – people are practically unanimous in its condemnation. The problem is recognising racism. On the one hand, many do not realise that racism is constantly involved in everyday uses and customs; on the other, to recognise it, you must agree that there are such groups as 'blacks' and 'indigenous peoples', which many would see as incompatible with the ideology of mixture. Moreover, this point was – and largely still is – the main obstacle facing the black movement in Brazil today: how can one fight something that 'does not exist'?

By making African, African-Brazilian and indigenous history and culture compulsory for all schools, the 2003 and 2008 laws brought these issues into classrooms, museums and heritage institutions. The initiative was part of a broader process taking place in different countries, which advocated the need to teach and learn more inclusive historical narratives encompassing migrations, postcolonial history and histories of different ethnic, linguistic and religious communities, for example. Authors dealing with this issue unanimously argue we need a

9 *O Globo* (10 Feb. 2004): 10. The trial of the policemen was postponed several times, but they were eventually sentenced to 17 years in prison in October 2005 (see also Câmara dos Deputados 2004; Paim 2004).

10 Among many others, there was the case of Stephen Lawrence, the 18-year-old Englishman murdered in April 1993, which eventually led to the Race Relation Act of 2002 (see Gillborn 2008).

thorough reconsideration of the way we treat the past, unlike the mid-twentieth century, when national grand narratives were relatively easy to produce (see e.g. Stuurman and Grever 2007). This line may have been reinforced by UNESCO's 2005 'Convention on the Protection and Promotion of the Diversity of Cultural Expressions', which deals with the threatened extinction of different cultural expressions worldwide.[11]

The issue is also related to recent discussions around the teaching of emotive and controversial history and the 'duty of memory' (*devoir de memoire*), a term coined in France in the 1990s, which reflects the idea that memories of suffering and oppression give rise to obligations on the part of state and society in relation to the communities that retain these memories (Heymann 2007: 18).[12] Emblematic instances are the cases against Nazi war criminals in France in the 1970s and 1980s, in which historians testified as experts; South Africa's Truth and Reconciliation Commission set up in 1995; recognition of the 1915 genocide of the Armenian population by countries including France and the USA; and slavery and slave trading, recognised as crimes against humanity during the Third World Conference against Racism in Durban in 2001. Each of these examples, like many others, was (and is) the subject of important controversies, showing that disputes around memories are huge drivers of mobilisation in societies today.

The controversy over teaching African history and African-Brazilian and indigenous history and culture should also be understood in this context. In Brazil, and perhaps in other Latin American countries, the movement advocating plurality in history teaching has been seen by many as a threat to 'mixing', which they presume to be already inclusive. To what extent does the discourse of mixture thwart the emergence of differences?

It is interesting to see how the permanent exhibition of the National Historical Museum deals with this tension between mixing, on one side, and difference, on the other. The exhibition is divided in four parts.[13] The first, called 'Oreretama' – meaning 'our land'/'our home' in Tupi, a language family to which a large group of Brazilian indigenous languages belong – is devoted to pre-Columbian archaeological remains, artefacts and explanations of past and contemporary indigenous societies. The idea is to show the diversity of people, languages and forms of organisation, and this becomes clear on the map that closes this part of the exhibition, showing the distribution of numerous indigenous groups in the country.

11 For the Portuguese version, see <http://unesdoc.unesco.org/images/0014/001497/149742por.pdf>; for the English version, see <http://portal.unesco.org/en/ev.php-URL_ID=31038&URL_DO=DO_TOPIC&URL_SECTION=201.html>.

12 See Kidd 2009; Historical Association 2007; and the articles published in the thematic issue *Vergangenheitspolitik* of *Aus Politik und Zeitgeschichte* (2006), which is part of the weekly *Das Parlament* (Frankfurt, Germany). I have addressed these issues in e.g. Alberti 2011.

13 See <http://www.museuhistoriconacional.com.br/>.

This approach, however, does not apply when it comes to blacks. In the second part of the exhibition, entitled 'Portuguese in the World', we can find a room clearly focused on the African influence in Brazilian nationality. Upon entering, the visitor hears a quotation from Gilberto Freyre's *The Masters and the Slaves*:

> In our tenderness, in our excessive mimicry, in the Catholicism in which our senses delight, in our music, in the way we walk and talk, in our lullabies for children, in everything that is a sincere expression of life, we almost all bear the mark of black influence. (Freyre 1933: ch. 4)

Gilberto Freyre's book is a good example of how, in the 1930s and 1940s, when the idea of racial mixing was first widely posed as one that accounted for Brazil's national identity, it became common to speak of the 'contribution' blacks and Indians made to national culture, as if the core of the nation consisted of whites. Despite the title of the book, Freyre's purpose was to understand some of the 'most significant aspects of the formation of the Brazilian family', so everything turned on the 'contribution' of blacks (Indians too, but less so) to the master's big house (the locus of that family). *Casa grande* (master's house) ... is often used by Freyre as a synonym for 'Brazil', and its landowner for 'the Brazilian' or 'Brazilians':

> The pleasing figure of the Black nurse ... was followed by those of other Blacks [the aged Black, the house girl, the Black cook] in the life of the *Brazilian* of yesterday (Freyre 1946: 349)[14]

We observe, therefore, that while the interpretation of indigenous communities sees difference acknowledged and celebrated, the African is absorbed or engulfed by a Brazilian nationality, whose 'contribution', would come to characterise a nation. This is evident in the following interpretation from the exhibition:

> The ambivalence between the religious and secular aspects and the relation with European and Amerindian culture make the Afro-Brazilian culture essential to Brazilian culture overall, since it is an inextricable part of the symbolic elements that identify us as a nation and make us feel Brazilian. (National Historical Museum 2010)

14 The understanding of 'white' as 'centre' and often as a synonym for 'Brazilian' is not an isolated phenomenon. Several authors who discuss the issue of race have pointed to the phenomenon of whites being taken as the normal or default model (see e.g. Bhavnani, Mirza and Meetoo 2005). While 'cultural' features are applied to non-whites – we are more at ease speaking of 'black culture' or 'Indian culture' rather than 'white culture', whites do not have 'ethnic' features and appear to be 'naturalised'. A most eloquent example of this association between white and normal is the adjective 'flesh-toned / flesh-coloured' commonly used to describe a piece of beige fabric, as if the only 'normal' skin colour were that of white people.

Getting beyond the Polarisation

Both the movement advocating plurality and the discourse of integration are thus present in official discourses in Brazil. While President Lula's speech reinforced national pride in relation to a mixed heritage, the aforementioned laws emphasise difference, as do certain Ministry of Education documents published in 1998, during the government of Lula's predecessor, the sociologist Fernando Henrique Cardoso:

> The idea conveyed in schools of a Brazil without differences, originally formed by the three races – Indian, white and black – that were dissolved to give rise to the Brazilian, has also been disseminated in textbooks that neutralize cultural differences and sometimes subordinate one culture to another. A conception of uniform culture was posed that belittled the diverse contributions that comprised, and still comprise, national identity. (Ministry of Education 1998: 126).

The historian Hebe Mattos concluded that documents of this nature ultimately suggest that there are only two possible models for national identity in Brazil: the old model of one mixed culture and identity or a new multicultural model with several sub-cultures and sub-identities: Afro-Brazilian, Italian-Brazilian, Polish-Brazilian and so on. Indeed, one might even ask if new essentialised histories such as 'women's history' or 'black histories' (for example) pose any real gains for knowledge of the past and reflection about history as a discipline (see also Stuurman and Grever 2007).

To avoid the dichotomy between canon (univocal narrative of national history) and counter-canon (different histories, also essentialised), we might think about a third way that focuses on the history of construction of identity or, for sociologist Michael Pollak, the work of framing and maintaining memory (Pollak 1992: 206).[15] Starting from Maurice Halbwachs' proposal for studying memory as 'social fact' – and therefore as 'object' in Durkheim's sense – Pollak suggests we go further and attempt to see how a certain memory (or identity, we might add) became a fact:

> It is no longer a question of treating social facts as objects, but of analyzing how social facts become objects, how and by whom they are consolidated and become enduring and stable. Applied to collective memory, this approach will therefore focus on processes and actors involved in the work of constituting and formalizing memories. (Pollak 1989: 4; see also Alberti 2004: ch. 2)

15 In fact, Pollak speaks of two works: one framing memory, the other he calls the 'remembering as such', which consists of maintaining consistency, unity and continuity of framed memory. Put simply, we may call them both 'works of framing and maintaining memory'.

Focusing on the history of the construction of identity is also posed as a solution by Hebe Mattos: 'Instead of reinforcing identities and cultures of origin, resistant to change, more or less "pure" or "authentic", I propose to educate to understand and respect the historical dynamics of actually constituted sociocultural identities' On the American context in particular, she adds: 'Positive black identity in the Americas was not built up as a direct counterpart of the existence or "survival" of African cultural practices on the continent, but as a response to racism and its dissemination in American societies' (Mattos 2003: 129).

Although the 2003 and 2008 laws have been instrumental in opening up teachers and learners to the study of histories previously ignored, we must be careful. If their application is not accompanied by reflection and research, these laws may well fail to have their intended consequences. Their wording reinforces the problem by presuming more or less 'pure' or 'authentic' identities in referring to 'Afro-Brazilian and indigenous history and culture' and 'black and indigenous culture', always in the singular and by using the term 'two ethnic groups' (Brazilian Federal Government 2008). Is it really a question of 'two ethnic groups'? What is meant by the 'history' and the 'culture' here? If the law is applied based on essentialised identities, are we not running the risk of actually strengthening prejudice? In the National Historical Museum exhibition, we saw how the African was subsumed within Brazilian identity, whereas indigenous cultures were recognised in their diversity.

Furthermore, we have to be aware not to create essentialised identities just because the laws would require those syllabuses to be taught. There are studies showing that the strategy of presenting black heroes and heroines as counter-stereotypes may not be the most appropriate, if not well handled, and may meet with audiences and students who are reluctant to change their values (Bhavnani, Mirza and Meetoo 2005). This and other programmes may have limited success if teachers and museum educators themselves bring their own prejudices to work and lack reasonable understanding of how people learn (US National Research Council 2005).

Teaching how to Detect Racism in History and Everyday Life

If we wish to avoid the paralysing dichotomy between 'canon' and 'counter-canon', the best approach is to get polarisation into the classroom and the museum, to be worked on and discussed there. This means ensuring a safe environment in which students feel at ease discussing the issue rather than being reluctant to express opinions. Controversial issues are never easy to approach, and time is undoubtedly one of the principal limitations (Kidd 2009; Historical Association 2007).

Taking up the idea of the third way proposed in the previous section, an important step may be to investigate how the grand narrative of national identity has been constituted (in this case, the mixed-race identity model), while looking at the nature of this mixture – far from presuming the equality of its component

parts, it always took the white man as 'normal'. Furthermore, instead of speaking about the 'contribution' of black people to Brazilian nationality, as suggested by Gilberto Freyre's interpretation, we might begin to tackle racism itself. What about bringing this theme to the exhibition, devoting a room in the museum to the history of race relations and racism? Classrooms and heritage institutions risk becoming irrelevant if they avoid sensitive and controversial issues that are important to the society. The emphasis on integration may serve only to blur our perception of the differences actually at stake here.

The concept of value developed by the anthropologist Louis Dumont may be of use to understand the illusion of equality involved in the ideology of mixture. Dumont writes that value is what makes the difference between two or more items in a hierarchical relationship. However, we tend to overlook this process because of the formal rationality germane to modernity: instead of hierarchy we assume equality; instead of value we assume 'nature', or 'fact' that would guarantee equality (Dumont 1983). We may assume that this same rationale is commonly transferred to the idea of mixture in Brazil, since for many people, mixing presupposes equality between component parts, whereas in fact there is a hierarchy of skin tones, from darkest to lightest.

How can you teach people to detect racism – in other words, the hierarchy of races/colours – in a place where they generally assume that racism does not exist? Some types of experiences, such as interaction with people of other races/colours or exposure to new information may introduce new knowledge.[16] It is important that strategies be developed without the prospect of denouncement or essentialisation.

An approach to teaching sensitive and controversial issues that has been identified as promising is the use of effective and compelling historical and sociological sources, in relation to which audience's and students' preconceived ideas will no longer work. In general, these learning sources are more effective than fictional films, for example, because they confer a sense of authenticity on the subject investigated and so instigate reflection (Historical Association 2007; Salmons 2003).

For instance, a document that strikes audience and students as extremely racist, produced in accordance with the eugenic theories of the nineteenth and twentieth centuries, might be effective in identifying racist values of the past and asking about changes and continuities in this respect. Again, a narrative experience of discrimination from the present day that shows how beliefs in the inferiority of black and indigenous peoples are rooted in different sectors of society may also be effective for perceiving racism in everyday relationships. As the sociologist Edward Taylor noted, narrative may 'redirect the dominant gaze, to make it see from a new point of view what has been there all along' (2009: 8).

16 Tatum reports the results of some experiments with his American college students (1992).

By focusing on the history of how different racial identities are constituted – in other words, by taking what I have called 'the third way' – we also ensure a better approach to the racial issue. We know that racial identities are situational: a person may be black in one place and white in another. Conceptions of race and racism are constantly changing in time and space, depending on historical, social and political conditions.[17] Therefore, it is not a question of operating in terms of essentialised identities.

Moreover, understanding similarities and differences in relation to the past is essential in order to realise that race relations have not always been the same, nor are they necessarily the same as those encountered in the present day – which implies that the current situation too may change.

Introducing the history of identities being constituted, as well as the history of polarisations between canon and counter-canon enables understanding of why 'black' and 'indigenous' were constituted as essentialised entities. This may be an important step for audience and students to ask why non-white people are not seen as normal too – in other words, they are not seen as diverse in the same way that whites are. Ivanir dos Santos, a member of Rio de Janeiro's black movement since the 1980s, gave a good example of the difficulty people have seeing a black man as normal in Brazil: 'When I'm on a plane, a guy will start talking to me in English, because he thinks I'm a foreigner. He cannot believe I could be Brazilian. I think that's disgraceful' (Alberti and Pereira 2007: 457). Detecting racism or finding it disgraceful may not do much to change the lives of blacks and indigenous people in Brazil, but it might be a starting point for aspiring to a society in which everyone, white and non-white alike, is recognised as normal. The black movement took up this notion in 1978 when one of its manifestos ended with the slogan: 'For a genuine racial democracy!'[18]

Acknowledgements

This text incorporates some post-doctoral research in history education carried out at the University of East Anglia and the University of London's Institute of Education (IoE) in 2009. I wish to acknowledge a post-doctoral grant from the Ministry of Education's body for supporting higher education research (CAPES) and a leave of absence from the Center for Research and Documentation in Contemporary History of Brazil (CPDOC) at Fundação Getulio Vargas, Rio de Janeiro.

17 See Bhavnani, Mirza and Meetoo 2005. The sociologist Carlos Alberto Medeiros calls this phenomenon 'arbitrariness of the racial sign': depending on the situation, the same individual may be identified as 'from Bahia', 'Egyptian', 'North-American', 'Indian', etc. (see Alberti and Pereira 2007: 412–13).

18 'Carta de Princípios do Movimento Negro Unificado' in Movimento Negro Unificado 1988; see Alberti and Pereira 2007: 131–64.

References

Alberti, V. 2004. *Ouvir contar*. Rio de Janeiro: FGV.

—— 2011. 'Oral History Interviews as Historical Sources in the Classroom', *Words and Silences* 6(1): 29–36. Available at <http://wordsandsilences.org/index.php/ws/issue/view/4/showToc> (accessed 8 Sept. 2012).

—— and A.A. Pereira 2007. *Histórias do movimento negro no Brasil*. Rio de Janeiro: Pallas, CPDOC-FGV.

Bhavnani, R., H.S. Mirza and V. Meetoo 2005. *Tackling the Roots of Racism*. Bristol: Policy Press.

Brazilian Federal Government 2000. 'Estatísticas do povoamento'. Available at <http://brasil500anos.ibge.gov.br/en/estatisticas-do-povoamento> (accessed 27 Aug. 2013).

—— 2008. Law 11.645 (Mar. 10). Available at <http://www.senado.gov.br/legislacao/> (accessed 17 Nov. 2008).

—— 2010. 'População residente, por cor ou raça, segundo o sexo e os grupos de idade: Brasil 2010'. Available at <http://www.ibge.gov.br/english/estatistica/populacao/censo2010/caracteristicas_da_populacao/tabelas_pdf/tab3.pdf> (accessed 27 Aug. 2013).

Câmara dos Deputados 2004. 'Audiência pública: Requerimento No. DE 2.004' (17 Feb.). Available at <http://www.camara.gov.br/sileg/integras/210271.pdf> (accessed 8 Sept. 2012).

Costa, S. 2002. 'A construção sociológica da raça no Brasil', *Estudos Afro-Asiáticos* 24(1): 35–61. Available at <http://www.scielo.br/pdf/eaa/v24n1/a03v24n1.pdf> (accessed 11 Feb. 2012).

Da Matta, R. 1981. 'Digressão: A fábula das três raças, ou o problema do racismo à brasileira', in R. da Matta, *Relativizando: Uma introdução à antropologia social*. Rio de Janeiro: Vozes.

Davies, C. 2000. 'Fernando Ortiz's Transculturation: The Postcolonial Intellectual and the Politics of Cultural Representation', in R. Fiddian (ed.), *Postcolonial Perspectives on the Cultures of Latin America and Lusophone Africa*. Liverpool: Liverpool University Press.

Dumont, L. 1983. *Essais sur l'individualisme*. Paris: Seuil.

Freyre, G. 1933. *Casa grande e senzala*. 28th edn. Rio de Janeiro: Record [1992].

—— 1946. *The Masters and the Slaves: A Study in the Development of Brazilian Civilization*, trans. Samuel Putnam. New York: Alfred A. Knopf.

Gellner, E. 1983. *Nations and Nationalism*. Oxford: Blackwell.

Gillborn, D. 2008. *Racism and Education: Coincidence or Conspiracy?* London: Routledge.

Guimarães, A.S.A. 2006. 'Depois da democracia racial', *Tempo Social: Revista de Sociologia da USP* 18: 269–90. Available at <http://www.scielo.br/pdf/ts/v18n2/a14v18n2.pdf> (accessed 11 Feb. 2012).

—— n.d. 'Democracia Racial'. Available at <http://www.fflch.usp.br/sociologia/asag/Democracia%20racial.pdf> (accessed 11 Feb. 2012).

Hasenbalg, C.A. 1979. *Discriminação e desigualdades raciais no Brasil*. Rio de Janeiro: Graal.

Heymann, L.Q. 2007. 'O *devoir de mémoire* na França contemporânea', in A.C. Gomes (ed.), *Direitos e cidadania: Memória, política e cultura*. Rio de Janeiro: FGV.

Historical Association 2007. *T.E.A.C.H.: Teaching Emotive and Controversial History 3–19*. Available at <http://www.history.org.uk/resources/resource_780.html> (accessed 1 June 2009).

Hobsbawm, E. 1985. *Nations and Nationalism since 1780: Programme, Myth, Reality*. Cambridge: Cambridge University Press.

Kidd, J. 2009. *Challenging History: Summative Document*. Available at: <http://www.city.ac.uk/__data/assets/pdf_file/0004/84082/Challenging-History-Summative-Document.pdf> (accessed 12 Feb. 2012).

Lévi-Strauss, C. 1952. *Race et histoire*. Paris: Unesco.

Lula da Silva, L.I. 2009. 'Speech to the International Olympic Committee (IOC)'. Available at <http://www.itamaraty.gov.br/sala-de-imprensa/discursos-artigos-entrevistas-e-outras-comunicacoes/presidente-da-republica-federativa-do-brasil/147730942008-discurso-do-presidente-da-republica-luiz-inacio> (accessed 10 Feb. 2012).

Maio, M.C. 1997. 'Uma polêmica esquecida: Costa Pinto, Guerreiro Ramos e o tema das relações raciais', *Dados* 40(1). Available at <http://www.scielo.br/scielo.php?script=sci_arttext&pid=S0011-52581997000100006> (accessed 11 Feb. 2012).

——— 1999. 'O projeto Unesco e a agenda das ciências sociais dos anos 40 e 50', *Revista Brasileira de Ciências Sociais* 14(41): 141–58. Available at <http://www.scielo.br/pdf/rbcsoc/v14n41/1756.pdf> (accessed 11 Feb. 2012).

Mattos, H.M. 2003. 'O ensino de história e a luta contra a discriminação racial no Brasil', in M. Abreu and R. Soihet (eds), *Ensino de história*. Rio de Janeiro: Casa da Palavra.

Ministry of Education 1998. *Parâmetros curriculares nacionais: Temas transversais*. Brasília: Secretaria de Educação Fundamental. Available at <http://portal.mec.gov.br/seb/arquivos/pdf/pluralidade.pdf> (accessed 12 Feb. 2012).

Movimento Negro Unificado 1988. *1978–1988: 10 anos de luta contra o racismo*. São Paulo: Confraria do Livro.

Paim, P. 2004. 'Imprensa: Pousada Sossego' (11 Feb.). Available at <http://www.senadorpaim.com.br/verImprensa.php?id=1622-pousada-sossego> (accessed 8 Sept. 2012).

Paixão, M., and L.M. Carvano 2008. *Relatório anual das desigualdades raciais no Brasil*. Rio de Janeiro: Garamont.

Pallares-Burke, M.L. 2010. 'A mistura é bela'. *Revista da Cultura* 36. Available at <http://www.revistadacultura.com.br:8090/revista/rc36/index2.asp?page=artigo> (accessed 10 Feb. 2012).

Pollak, M. 1989. 'Memória, esquecimento, silêncio', *Estudos Históricos* 2(3): 3–15. Available at <http://bibliotecadigital.fgv.br/ojs/index.php/reh/article/view/2278> (accessed 8 Sept. 2012); French version: 'Mémoire, oubli, silence', in M. Pollak, *Une identité blessée*. Paris: Metailié, 1993.

—— 1992. 'Memória e identidade social', *Estudos Históricos* 5(10): 200–215. Available at <http://bibliotecadigital.fgv.br/ojs/index.php/reh/article/view/1941/1080> (accessed 8 Sept. 2012).

Salmons, P. 2003. 'Teaching or Preaching? The Holocaust and Intercultural Education in the UK', *Intercultural Education* 14(2): 139–49. Available at <http://archive.iwm.org.uk/upload/pdf/TeachingorPreaching.pdf> (accessed 8 Sept. 2012).

Schwarcz, L.M. 1993. *O espetáculo das raças*. São Paulo: Companhia das Letras.

Skidmore, T.E. 1974. *Black into White: Race and Nationality in Brazilian Thought*. Oxford: Oxford University Press.

Stepan, N. 1991. *The Hour of Eugenics: Race, Gender and Nation in Latin America*. New York: Cornell University Press.

Stuurman, S., and M. Grever 2007. 'Introduction', in S. Stuurman and M. Grever (eds), *Beyond the Canon: History for the Twenty-First Century*. New York: Palgrave Macmillan.

Tatum, B.D. 1992. 'Talking about Race, Learning about Racism', *Harvard Educational Review* 62(1): 1–24.

Taylor, E. 2009. 'The Foundations of Critical Race Theory in Education', in E. Taylor, D. Gillborn and G. Ladson-Billings (eds), *Foundations of Critical Race Theory in Education*. New York and London: Routledge.

Telles, E.E. 2004. *Race in Another America: The Significance of Skin Color in Brazil*. Princeton: Princeton University Press.

Trinchero, H.H. 2006. 'The Genocide of Indigenous Peoples in the Formation of the Argentine Nation-State', *Journal of Genocide Research* 8(2): 121–35. Available at: <http://www.gertzresslerhigh.org/ourpages/auto/2009/1/28/37160780/Argentina.pdf> (accessed 9 Nov. 2012).

US National Research Council 2005. *How Students Learn*. Washington DC: National Academies Press. Available at <http://www.nap.edu/catalog.php?record_id=11100#toc> (accessed 8 Sept. 2012).

Chapter 16

'To Kill a King?'
Interpreting the Execution of a Monarch

Amanda Shamoon

Challenging Histories at Historic Royal Palaces, UK

At Historic Royal Palaces (HRP), our aim is 'to explore the story of how monarchs and people have shaped society in some of the greatest palaces ever built'.[1] HRP looks after five such sites: Hampton Court Palace, the Tower of London, Kensington Palace, Kew Palace and the Banqueting House at Whitehall. Almost 200,000 education visitors a year visit one of our sites, and the Tower of London, Hampton Court Palace and Kensington Palace all offer a range of education sessions designed to engage and inspire. An independent charity, Historic Royal Palaces receives no funding from the Crown or government, and our interpretation centres on the monarchs who lived in, and ruled from, our iconic buildings.

The stories the organisation chooses to tell reflect two key considerations. Firstly, an understanding of which stories are most relevant to the site and to the course of British history. For example, the Tower's history spans 1,000 years, and every key monarchical figure during that period has some connection to the site. Necessarily then, a significant amount of the Tower's history is only briefly touched upon or, in some cases, goes unrepresented. Secondly, HRP must consider which stories will have the broadest appeal for visitors, a large proportion of whom are from overseas and, more specifically, from countries that have no monarchy. For these and indeed most of our visitors, our palaces are best understood as places of royal splendour and intrigue. This inevitably has an impact upon our interpretation choices.

Perhaps unsurprisingly, then, the English Civil War and the period following the execution of King Charles I – known as the Interregnum – receives little attention across HRP. One exception is the Banqueting House at Whitehall. Originally part of Whitehall Palace, the Banqueting House is where Charles Stuart, king of England, was publicly executed following his trial at Westminster Hall. The interpretation of the Banqueting House centres on this key event and is primarily relayed by audio guide. There was little choice about which stories would be interpreted at this palace, because most of the palace's historic architecture was destroyed by a fire in 1698: only the Banqueting House remained. Although these

1 <http://www.hrp.org.uk/>.

events are mentioned in the audio guide and visitor leaflet, in 2010 the education team saw an opportunity to engage with the history of the site in a rather different way. This case study will explore the experimental interpretation of Charles I's trial and execution for education groups.

Current Interpretation at HRP

In the White Tower at the Tower of London, there is a display of monarchs' armour known as the 'Line of Kings'. It is presented in a timeline, and includes pieces from the Tudor and Stuart dynasties. Between Charles I and Charles II, there is a military sword that is thought to have belonged to Oliver Cromwell, Lord Protector from 1649 to 1658. Although not ignored, there are only a few sentences in this display that refer to the civil war, execution of Charles I, the Interregnum and the restoration of the monarchy: arguably one of the most turbulent and difficult periods in British history. As Purkiss notes, during the civil wars 'the nation was violently torn in pieces by the most costly armed conflict' it had ever witnessed (2006: 7).

For visitors interested in this period, further exploration of the Tower yields little reward. The Jewel House, housing the Crown Jewels, again only briefly mentions the upheaval of civil war and regicide. Just two sentences refer to the monarch's execution, the destruction of the original Crown Jewels in 1649 and the creation of new coronation regalia following the restoration of the monarchy.

It is important to note, however, that several of our palaces did play key roles in events of the period. Whitehall Palace, of which only the Banqueting House remains, was Charles I's main royal residence. It became a focal point for public anger and support, and crowds would gather there to express their views. As the relationship between king and Parliament deteriorated, Charles fortified his palace, adding a gun platform outside the Banqueting House and constructing a temporary barracks for 500 soldiers. During the king's trial, Whitehall palace was requisitioned for use by Parliament and later became the army's headquarters. It is best remembered as the scene of the king's execution, a platform having been erected outside the building so that the assembled crowds could witness the spectacle.

The second of our sites to play a key part during the period is the Tower of London. The Tower 'remained of contemporary strategic importance. ... It was England's principal military arsenal. ... As a last resort, its cannons could be trained on the city' (Adamson 2007: 218). As such, it became a pawn in the power battle between Charles I and Parliament. Key Tower roles, such as those of Constable and Lieutenant, were filled alternately by royalist and parliamentarian figures, reflecting the successes and defeats during the conflict. The Tower's role as a prison continued during this period and significant people on both sides were imprisoned there, most notably the Earl of Strafford, who was publicly executed on Tower Hill.

Hampton Court Palace also played a substantial role. Charles I withdrew to the palace several times, and, in June 1647, he was captured by Parliament and sent there as a prisoner. Although later managing to escape, he was recaptured and sentenced to death. With the exception of Charles's execution at the Banqueting House, few of these defining moments are interpreted at our sites, although some of the stories are referred to on the HRP website.

So why do our sites choose not to interpret these key events and stories? Is HRP's tendency to overlook this subject representative of a general lack of interest in it? Or, as a difficult part of our nation's history, is it simply easier not to represent it? Additionally, we might ask, who decides what stories and events are interpreted in a heritage site, and what are these decisions based on?

The five palaces looked after by HRP are visitor attractions that welcome around 3.2 million people every year. Internally we characterise each palace with a specific personality, and a style of interpretation to match. For example, Kensington palace is romantic, elegant and intriguing. As a 'feminine' palace, the focus is very much on queens and princesses, and large numbers of visitors arrive each year to see the former home of Diana, Princess of Wales. The Tower of London, on the other hand, is dark, strong and tyrannical. As such, its interpretation focuses heavily on the Tower's role as a prison and place of execution.

As certain periods loom larger in the public imagination, so our interpretation focuses on these periods. At Hampton Court, the Tudor palace is the biggest draw, and a whole programme of education sessions, events and live interpretation centres on the reign of Henry VIII. The Baroque palace has recently enjoyed a revival of interest, with a new exhibition on Charles II's mistresses, but it is the Tudor palace that most captures the public imagination. Consequently, it is this period that is most heavily interpreted.

At HRP, many of the interpretation decisions are thematic – for example, the Tower's past roles have provided the themes for recent exhibitions such as 'Fit for A King' (2010) and 'Royal Beasts' (2011), but even when stories fall within these broad interpretation themes, they are not necessarily represented. Given the vast histories of our palaces, it is inevitable that some stories will go untold. It could be argued that there is a correlation between 'difficult' or sensitive histories and a lack of representation. For example, there is no record of the German prisoners executed at the Tower during the two World Wars on the execution memorial. Is this history too recent and therefore too challenging to tackle? Or, like the civil war and Interregnum, does it conflict with our idea of England and the way we wish to present our nation's past to our visitors? As Huyssen observed, a nation's traditions are 'often invented or constructed, and always based on selections and exclusions' (2003: 1).

HRP's education programme reflects the way in which history is represented in the National Curriculum in England, Wales and Northern Ireland – as distinct blocks of time characterised by a monarch. As a result, our core includes a large number of Tudor sessions, some mediaeval sessions and a few Norman sessions. As palaces that have witnessed some of the most important events in England's

history, 'History where it happened' is at the heart of HRP's education strategy (HRP 2008). Enquiry-based learning, meeting and interrogating figures from the past, is used where possible to encourage meaningful engagement with our sites and their stories. Evaluation of our character-led sessions is consistently positive, with teachers praising this approach for bringing history to life.

Background to the Project

The opportunity to develop an education session based around the trial and execution of Charles I came about in 2010, following a meeting with Parliament's Education Service. Our aim was to work together to explore one of the most important events in British history, one which neither organisation had attempted to interpret through their education programmes before.

King Charles I was tried as a traitor by Parliament in Westminster Hall, located in the Houses of Parliament. Following the proclamation that the king, 'as a Tyrant, Traitor, Murderer and Public Enemy to the good people of this Nation, shall be put to death, by the severing of his head from his body' (Wedgwood 1964: 163), Charles's death sentence was carried out at the Banqueting House. Given the proximity of the two sites, and the thread of a story that begins in one and ends in another, we decided upon a joint study day aimed at Key Stage 3[2] pupils entitled 'To Kill a King?'

The main objectives of the study day were for students to understand the range of opinions about the monarchy that existed at that time, understand why the chain of events that occurred during the imprisonment, trial and execution of Charles I happened in that way, understand the impact and significance of the trial of Charles I and reflect critically on its outcome and critically assess a range of historic evidence.

These aims were linked to several of the Museums Libraries and Archives Council (MLA) Generic Learning Outcomes from the 'Inspiring Learning for All Framework' (MLA 2008a).

Using a Costumed Presenter

The decision to work with a costumed presenter was a natural one for HRP. A large number of our education sessions are led by costumed presenters, and many of these take place on the visitor route. Meeting a character from the past in a historic space is a powerful and immersive experience, particularly for young

2 The period of schooling for 11–14-year-olds in maintained schools in England and Wales.

people.[3] It places the learning of history in context, and enables audiences to question and interact with a multi-dimensional character (see also Bryan, Chapter 4; Jones, Chapter 17, this volume). It was agreed that, for the joint study day, we would follow the successful format of HRP's interrogative sessions, and use the historic spaces to maximum effect by working with a costumed presenter in the role of the king.

For Parliament's Education Service, costumed interpretation would be a new experience. As a working legislature and historic building, the Houses of Parliament presented its own challenges with regard to accessing and using the historic spaces. The unprecedented nature of the request – to host an actor in the role of Charles I in the location of the trial which led to regicide – resulted in much discussion and debate before permission was granted.

Once access had been permitted, it was agreed that the actor could be present in Westminster Hall for set times on each day of the pilot – three consecutive days during March 2010. As Westminster Hall is open to the public, the 'king' would be available to talk to interested visitors until he was required by the group – an opportunity that would need to be handled sensitively by the actor.

Parliament's education service aims to:

- inform young people about the role, work and history of Parliament;
- engage young people to understand the relevance of Parliament and democracy today through active learning;
- empower young people to get involved by equipping them with the knowledge and skills to take part (Parliament Education Service n.d.).

Whilst Parliament delivers a variety of sessions every year to around 40,000 education visitors, 'To Kill a King?' was to be their first history-based session. As Grade 1 listed buildings, both Westminster Hall and the Banqueting House offered unique opportunities for learning about life in the past.

'To Kill a King?'

The study day was split between the Houses of Parliament and the Banqueting House. The day began at Parliament, where students played the part of Parliamentarians and examined a range of sources that illustrated the king's alleged crimes. When each group had put a case together, they descended upon Westminster Hall to question the king. On entering the hall, the students caught their first glimpse of the king, standing on the steps and leaning on his staff. This powerful image of the monarch worked to visibly subdue the students, and they were initially tentative

3 Jackson and Kidd noted that it can encourage the learner to 'listen to other, till-now invisible and unheard narratives … performance can provide one powerful way of … giving voice and embodiment to those missing narratives' (2008: 73).

in their questioning. During the trial, the king refused to answer their questions, as he did not recognise the authority of the court. Following a mini-debate back in the classroom, the students decided that they had no option but to find the king guilty, as he had presented no defence. Any student that returned a not-guilty verdict was purged from the parliament, as the rest set about writing the king's death sentence. Students were then given excerpts from the real death sentence to read aloud, and listening to these was a moving experience. As students stepped forward to speak, the king listened silently. He spoke only to acknowledge their decision and left the hall to prepare himself for his execution.

After lunch, students made their way to the Banqueting House, a 10-minute walk up Whitehall from the Houses of Parliament. For the afternoon session, led by HRP, the students became Royalists. They were encouraged to understand that it was not only the king who had been put on trial but the entire concept of monarchy. The students began by examining sources that supported the king and his belief in the divine right of kings, the notion that a monarch is ordained by God and therefore is answerable only to him. After studying the sources, students worked in groups to come up with further questions. The final meeting with the king took place in the Great Hall, in which the stunning Rubens ceiling paintings can be seen. The paintings glorify the Stuart monarchy and depict Charles I's father, James I, as a peacemaker, uniting England and Scotland and ascending into Heaven – a perfect illustration of the divine right.

For this part of the day, 'Charles' was more forthcoming. He explained the reason for his responses in the morning, and talked openly about his beliefs. When the questioning was over, Charles I recited his scaffold speech – the speech that he gave when he stepped from a window in the Banqueting House onto the wooden platform outside, shortly before his execution. He then exited the room, leaving the students in silence, contemplating their part in his fate. A few nervous giggles reflected the unease that some of the students felt at their role in the proceedings.

In the morning, the students were asked whether the king was guilty or not guilty of the crimes he had been accused of committing. In the afternoon, they were given the option to choose which side they would like to be on, based on everything they had heard during the day. There was also the option of abstaining, if they could not choose whether to be a Parliamentarian or Royalist. For each study day, the results have followed a certain pattern. In the morning, all but a few students have been convinced of the king's guilt and have sentenced him to death. By the afternoon, the number of Parliamentarians has been small, with a greater number opting to be on the Royalist side. Most importantly, the largest group each time has been those who chose to abstain, reflecting the complex nature of the arguments on both sides.

Student Feedback and Lessons Learnt

The 'Inspiring Learning for All Framework' defines learning as 'a process of active engagement with experience lead(ing) to change, development and the desire to know more' (MLA 2008b). Through the use of unique historical environments and costumed interpretation, 'To Kill a King?' successfully engaged and challenged students. The change in opinion from the start of the day to the end of the day, once students had been encouraged to develop a broader understanding of the subject, was evident in the final vote results.

Despite the challenging nature of the subject, the feedback from all stakeholders has been overwhelmingly positive. Many of the student comments highlighted the impact of working with a costumed presenter in an historic space:

> We learned how to see both sides of the story before making the final decision.
> Really interesting day on a topic I don't find interesting.
> Asking our own questions and getting them answered in detail helped my individual learning.
> The speech of King Charles really moved me and made me think, which is why I had to abstain.
> Seeing the actual places the events took place made me understand things better.
> (HRP 2010)

One of the questions that arose during the pilot related to providing a context for the day's learning. To what extent should we, as museum educators, explain the build-up to Charles I's trial and execution and how far should it be the responsibility of teachers to prepare the students for their visit? Although the study day ran from 10 a.m. to 3 p.m., there was only a limited amount of time for exploring the causes (and consequences) of the civil war. In the marketing material promoting the session, we stated that prior knowledge of the subject was not necessary. With hindsight, due to the complex nature of the subject, it would be useful for the students to have had some knowledge about arguments on both sides, and of the key people and events of the period – although Ceri Jones' findings might indicate otherwise (Chapter 17, this volume). As a result of observations and teacher feedback, a pre-visit pack will be created for groups that book this session in the future.

The partnership between HRP and Parliament is now an annual event, with planning for the third year currently underway. Despite practical difficulties involved with accessing two historic spaces on the same day, both organisations are keen to continue this partnership and to explore new ways of working together. Although permission to use Westminster Hall must be re-sought each year, a precedent has been set at Parliament and the Banqueting House, both for teaching history-based sessions and for using costumed interpreters within the education programme. Although it can be a useful tool for engagement with difficult

subjects, it is crucial that costumed interpretation is carried out with sensitivity and historical accuracy.

Since the pilot of this study day in 2010, HRP has been making strides towards interpreting our more challenging histories. 'King Charles I' is now a frequent visitor to the Banqueting House, where he interacts with the public and has been interviewed as part of our adult-education programme. At the Tower of London, a new education session has been developed on the debates surrounding the Koh-i-noor diamond,[4] and a new partnership with the Fusilier Museum is based on a local soldier's experiences during the Second World War. At Hampton Court, 'All the King's Fools' won the Museums and Heritage 2012 Award for Education Initiative. This project was written and performed by a company of actors with learning difficulties, and its aim was to tell the story of the 'natural fools' of Henry VIII's court. How we can interpret challenging histories within HRP Education is a question that we continue to ask ourselves and one which is becoming central to the work we do.

References

Adamson, J. 2009. *The Noble Revolt: The Overthrow of Charles I*. London: Phoenix.

HRP (Historic Royal Palaces) 2008. 'Education Strategy, 2008–2013' [internal document].

—— 2010. 'Session Evaluation Forms for "To Kill a King?" ' [internal document].

Huyssen, A. 2003. *Present Pasts: Urban Palimpsests and the Politics of Memory*. Stanford, CA: Stanford University Press.

Jackson, A., and J. Kidd 2008. *Performance, Learning and Heritage*. Centre for Applied Theatre Research, University of Manchester. Available at <http://www.plh.manchester.ac.uk/documents/Performance,%20Learning%20&%20Heritage%20-%20Report.pdf> (accessed 1 Dec. 2013).

MLA (Museums Libraries and Archives Council) 2008a. 'Generic Learning Outcomes'. Available at <http://inspiringlearningforall.gov.uk/toolstemplates/genericlearning/index.html> (accessed 24 Apr. 2012).

—— 2008b. 'How We Define Learning'. Available at <http://www.inspiringlearningforall.gov.uk/learning/> (25 Apr. 2012).

Parliament Education Service n.d. 'About Parliament's Education Service'. Available at <http://www.parliament.uk/education/about-us/> (20 Aug. 2012).

Purkiss, D. 2006. *The English Civil War: A People's History*. London: HarperCollins.

Wedgwood, C.V. 1964. *The Trial of Charles I*. London, Collins.

4 The Koh-i-noor diamond was presented to Queen Victoria following the annexation of the Punjab in 1849. Its history is long and contentious, and some believe it should be returned to its country of origin. India and Pakistan both lay claim to the stone.

Chapter 17

Frames of Meaning: Young People, Historical Consciousness and Challenging History at Museums and Historic Sites

Ceri Jones

As sites of public history and heritage, museums and historic sites can play an important role in how children and young people learn about the past. Museums and historic sites are used by schools to bring the past to life as part of history lessons (Hooper-Greenhill 2007) and make a significant contribution to the views that members of the general public hold about history (Jordanova 2000). Whilst there are increasing numbers of researchers in education looking at the tensions between students' prior conceptions of the past and their subsequent history learning in school (Stearns, Seixas and Wineburg 2000), there is less evidence as to how students' ideas about the past may have implications for the effectiveness of history education at museums and historic sites.

This chapter explores the effectiveness of teaching challenging history at museums and historic sites, drawing on the results of research carried out at two sites, the Museum of London and Tower of London, with young people aged from 10 to 17 years old. Both sites offered an alternative perspective on the Middle Ages to the popular imaginings of the period as a 'dark ages' of war, violence and disease through a programme of living-history performances for schools.

Museums, Historic Sites and Challenging History

With museums and historic sites seeking to present alternative perspectives on history or confronting challenging events and themes, exploring the interaction between these sites and the young people that use them can illuminate the contribution that museums and historic sites can play in the development of historical understanding or 'historical consciousness'. Describing how we, as humans, are conscious of our place in time, existing in the present but with a sense of the past and future, theories of historical consciousness have emerged from northern Europe, most recently in the work of German historian Jörn Rüsen (2005). Researchers are turning to these theories to understand how they might address the challenges of learning about a difficult past (Lee 2004; Seixas 2005). Whilst challenging history or heritage is often related to the nature of the event or

topic studied, researchers in education have highlighted the potential challenges that young people face when learning the appropriate skills and ways of thinking which are central to the discipline of history. In particular, through research into how children and young people develop their historical consciousness, it is suggested that students' prior conceptions about the past, many of which are learnt in the 'everyday' or 'lifeworld' (Rüsen 2005), can make learning history in the classroom seem 'counter-intuitive' (Wineburg 2001).

At the same time, museums and historic sites are increasingly employing interpretive media which place an emphasis on performance, multi-sensory experiences, and affective and embodied ways of learning to convey ideas about the past to their audiences. Different terms are used to describe the practice of interpreting and representing the past through the body, including 'living history' and 'costumed interpretation'. 'Living history' has been used here, following de Groot (2009), because it offers the broadest category in which to include practices such as experimental archaeology, immersive research and virtual simulations of the past such as computer games. However, the relationship between these forms of interpretation is that they have the potential to offer an experience of the past whereby the individual 'does not simply apprehend a historical narrative but takes on a more personal, deeply felt memory of a past event through which he or she did not live' (Landsberg 2004: 2). Whilst living history has been used for education purposes in museums and historic sites since the 1920s (Samuel 1994), actual empirical evidence of its impact on young people's learning, however, has only began to emerge much more recently (see Jackson and Kidd 2008).

History: A Challenging Subject?

As described in the *Challenging History: Summative Document*, to date there is no standard definition of 'challenging history' (Kidd 2009). Since the 1970s, researchers such as Wineburg have come to realise that it is not only the content of history that can be challenging but children and young people may face many challenges when learning history (2001). Partly this is in response to the perceived decline of history education (Cannadine, Keating and Sheldon 2011) but also to the tension between the need for a 'useable' past that forms the basis of self-identity and the turn in education towards a critical engagement with history which recognises that there are multiple interpretations of what happened in the past (Stearns, Seixas and Wineburg 2000).

In response to such concerns, researchers in history education have increasingly turned to theories of historical consciousness to illuminate the processes by which children and young people frame their ideas about the past and give it meaning (Jensen 2009). Theories of historical consciousness seek to explain how humans orientate cognitively towards the past, whether naturally through memory or taught through history. Models of historical consciousness take into account that there is a substantial difference between historical thinking from the perspective of the

historian and so-called 'everyday' or 'commonsense' approaches (Collingwood 1946). Fundamental to this concept is that history is a construct of the human mind, 'a cognitive means of creating sense of the experience of the past' (Rüsen 2005: 4). Allied with theories of cognitive development, which suggest that children are active learners who make their own meanings about the world informed by their experiences and socio-cultural context, it is suggested that ideas about the past come to be stored in frameworks or schemas of meaning (Piaget 1967; Siegler 1998). These frameworks will be altered, modified or reinforced as children interact with the world in- and outside school (Cooper 2009) but essentially provide a template of ideas associated with the past which can be recalled by the child during their learning experiences. The implication is that ideas about the past absorbed from everyday encounters and interactions may conflict with the attitude and disposition required for learning history in the classroom.

The Tension Between Identity History and Critical History

There is much debate over how history should be taught, in terms of both content and skills (Cannadine, Keating and Sheldon 2011). Many historians would agree, however, that in order to understand the past 'as it really was' history necessitates detaching the past from the present, the differences understood as part of a specific social and cultural context (Ferguson 2004). Yet when children learn about the past in the everyday, it is often framed through the perspective of the present, as part of their heritage or self-identity. It is a subjective, as opposed to an objective, history which has a specific purpose in the present. Although a dichotomy is often presented between the practice of historians and everyday views of the past, historians such as R.J. Evans have problematised the possibility of an objective view on the past (1997). As Peter Lee explains the past can be used 'quite neutrally in a context where adults are explaining to children changes in everyday life, as one in which "we didn't have those" (whether the particular lack is of TV, or cars, or computers)' (2004: 35). However, when the past is introduced as a lack of things in the present to children who cannot imagine living without these material comforts or familiar social structures, the past comes to be (logically) perceived in a negative light. Lee goes on to argue that students' understanding of human behaviour and motivation is determined by their knowledge of these in the present and that this must be taken into account when designing history curricula. Otherwise, misconceptions of a deficit past or misunderstandings of historical terms such as monarchy and democracy, which have very different meanings in the present, can persist and potentially make history meaningless for children and young people (Lee 1978).

The challenges of learning history – of coming to terms with the different mindset of past people and societies – has become an increasingly significant area for research over the course of the twentieth century in relation to interest in theories of historical consciousness (Seixas 1996). The concerns expressed by

researchers such as Lee are exemplified when teaching the Middle Ages, a period in European history (which stretches from the fifth to the fifteenth century) that presents many challenges for teachers and students wanting to go beyond the 'familiar stories of Norman conquest and feudal barons, lords and peasants' (Shanks 1992: 150). Strategies used to make the mediaeval past more meaningful for contemporary audiences have, unintentionally, promoted reductive and simplified representations. By erasing the complexity of mediaeval society, Christopher Dyer argues that it has led to the patronising assumption that 'medieval people were primitive and ignorant' (2002: 6). This, conversely, can make mediaeval history more challenging for young people because, as Planel explains, this 'interpretive framework … does not help them understand medieval people, as the profound differences of life in another place and time … are not emphasized' (1994: 207). Planel suggests that profound differences can be seen in the material remains of the Middle Ages which provide museums and historic sites with the potential to present a more complex and authentic representation of the mediaeval past.

Having looked at some of the challenges presented by children and young peoples' prior conceptions of the past for learning history in school, I now turn to the evidence presented by research carried out at two case-study sites which sought to understand the relationship between young people's historical consciousness and their (potential) learning experience from a living-history performance.

Exploring Young People's Historical Consciousness at Museums and Historic Sites

The evidence presented in this chapter emerged from the findings of doctoral research which aimed to explore the impact that living-history performances at museums and historic sites might have on the historical consciousness of secondary school students (11–17 years). Two case-study sites, the Museum of London and Tower of London, were chosen for their education sessions which sought to challenge simplified and reductive perspectives on the Middle Ages and offer more complex, nuanced views of mediaeval society and culture. To capture the young peoples' experiences at the case-study sites, qualitative research methods were used, including observation, interviews from multiple perspectives (students, teachers, education staff and costumed interpreters) and concept mapping to capture students' ideas of the Middle Ages.

Fieldwork took place between December 2007 and September 2008. Schools were contacted through the two museum case-study sites by museum staff sending out letters to all schools booking a session. Interested schools were asked to reply to the researcher, and schools were therefore selected on the basis that they were willing to take part in the research. A total of six schools contacted the researcher and agreed to take part in the research project. Table 17.1 describes the key features of these schools, which included two voluntary-aided state schools, three private fee-paying schools and one grammar school. The students, chosen by their

teachers to take part in the research, were (generally) confident, conscientious and of high ability. Whilst the young people were not always personally interested in history, they were familiar with using museums and historic sites to learn about the past, and were keen to do well in school. During the fieldwork period, eight performances were observed with groups of students from the six schools, 25 students were interviewed and 10 students completed concept maps.

Table 17.1 Key features of the six schools taking part in the research

School	Type	Location	Age	Gender	Number of students	Site visited
1	Private	Outside London	16–17	Female	20 students observed; 4 students interviewed	Museum of London
2	Voluntary-aided, selective	London	11–12	Female	2 classes observed; concept mapping with 10 students; 7 students interviewed	Museum of London
3	Grammar	East of England	11–12	Male	2 classes observed; 6 students interviewed	Tower of London
4	Private	London	9–10	Mixed	2 classes observed; 5 students interviewed	Tower of London
5	Voluntary-aided, comprehensive	Outside London	11–14	Male	40 students observed (school did not want to participate in interviews)	Tower of London
6	Private	Channel Islands	15	Female	10 students observed; 3 students interviewed	Tower of London

At both case-study sites, living-history performances were used to illuminate mediaeval society and culture by focusing on the lives and experiences of its people. Performances at the Museum of London focused on an individual, Harry Baille, the actor taking on a different characterisation depending on the theme. For a study day focusing on *The Canterbury Tales* (School 1), he was the narrator

of Chaucer's tale, a gossip and social observer, who made cutting and humorous remarks about the people of his time. For School 2, the theme of the performance was the Black Death (1348–49, 1361–62) with Harry Baille as a survivor of the pestilence, afraid for his life in a society close to collapse. By contrast, the education programme at the Tower of London focused on broad themes of mediaeval society and kingship, which stressed the changing role of the Tower from commanding mediaeval fortress to the comfortable palace of an itinerant king. The position of the monarchy in society was emphasised from the personal viewpoint of the king, which provided opportunities to explore the life and culture of his court. Living-history sessions were led by a costumed interpreter who took students on an interactive tour of the former Mediaeval Palace, which has been restored to resemble its appearance during the reign of Edward I (1239–1307).

Making the Mediaeval Past Meaningful? Museums, Historic Sites and their Potential Impact on Historical Consciousness

This study revealed that the interaction between the living-history performers and their young audiences and the way in which the performances were structured as part of a wider learning experience were significant in terms of learning impact. Many of the students said that they enjoyed their visits, learnt new information about the past or reinforced information already known, and saw abstract ideas about the mediaeval past become more concrete. However, delving deeper many of these positive responses obscured subtle differences around how performances were structured, or, to follow Anthony Jackson, how the performances were framed (2010). The students did not want to be told what happened in the past, they wanted to find out for themselves, and these conditions were met more effectively where the performance was contained within a wider context of activities, such as a handling session with authentic mediaeval objects, whereby the young people's learning from the performance was reinforced and supported through themes which supported and developed the focused learning of the performance.

The study illuminated some of the different ways in which teachers and students considered that the visit to the museum or historic site could bring the mediaeval past to life. At both sites, students were encouraged to not only conceptualise the past as a series of events, but to consider the emotional and subjective elements of that past. In particular, they were encouraged to use material culture and historic remains to reconstruct how individuals from the mediaeval past experienced their world. For students, 'bringing the past to life' was predominately used in connection to the opportunity that living history could provide for the creation of visual images of the mediaeval past in their minds. Abby described how the performance literally 'made [the mediaeval past] more approachable, the Tale, you could see it in your mind'. It enabled her to create a tangible image of a mediaeval person: 'I actually see [Chaucer] as the actor because he was in the outfit and you have something to visualize talking' (Abby, 16, School 1, interview: 13 Feb.

2008). This use of the performer as a source of visual images for the mediaeval past – and perhaps additionally drawing on their experience of mediaeval artefacts in the museum gallery – was also significant for the young people from School 2. The Head of History explained how the students could 'sometimes [find it] hard … to visualize different aspects of life in that period' (Head of History, School 2, interview: 25 Feb. 2008). The museum experience therefore provided students with the means to develop their ideas of the mediaeval past: the more they could imagine it, the 'more believable' that past seemed to them. For teachers, the term 'real' was used in two distinct ways: firstly, to refer to living history's potential to make abstract notions of the past become tangible, to assist the 'imaginative leap' that is needed to create the past visually in one's mind, and, secondly, to refer to the creation of an authentic version of the past. It is important to make these distinctions rather than assume that real was used in relation to the performance itself. Students were very clear that they had watched a performance, but one which had caused their understanding of the past to develop.

In developing their ideas about the mediaeval past, students used various strategies to make it more meaningful to them. They proved discriminating about their learning and took what they needed from the sessions to suit their own purposes. Students assimilated language and ideas from sessions which were used to modify their frameworks of understanding associated with the mediaeval past, suggesting that the students regarded the information they learnt at the museum as authoritative. They seemed to prefer sessions that gave them the opportunity to become immersed in the past and engage their emotions. Hannah described how the use of first-person interpretation could make her feel much more involved in the experience: 'it was like you were part of the time … [They] treated us as though we were in that time era as well' (Hannah, 15, School 6, interview: 26 Sept. 2008). Students wanted an interactive relationship with history. They preferred it when they were given opportunities to ask questions, to investigate and resolve identified issues or problems, or to consider multiple perspectives. The students from School 3 talked favourably about a session at a historic site where they were exposed to multiple points of view and were asked to resolve a 'real-life' practical scenario using the evidence they collected. Alex explained: 'You want hands-on stuff to make history fun' (Alex, 11, School 3, interview: 11 July 2008). Many students valued the opportunities for emotional engagement that the living history performances presented, not simply enjoyment but also the uncertainty, anticipation and drama that some of the performances encouraged. This emotional response to the performance could also support development of ideas about the mediaeval past, for instance where performers emphasised the humour of the mediaeval people, students expressed their interest in seeing a more positive side to the Middle Ages. For School 1, the dramatic nature of Harry Baille's performance and the exaggerated humour of the performer supported a positive view of the Middle Ages, which was expressed in their desire to know more about everyday lives and culture, particularly from the realisation that mediaeval people had a sense of humour and told jokes (School 1, interviews: 4 Dec. 2007).

However, not all the students were able to make sense of the mediaeval past from the performances, and for some there remained some confusion about the difference between how the mediaeval past is understood from the perspective of the present and how mediaeval people made sense of their world. In particular, students from School 2 found it hard to understand why Harry Baille's understanding of the causes of the Black Death conflicted with what they had learnt in the classroom. In the classroom, they learnt that the Black Death was caused by fleas carried by rats, which transferred the disease to its victims. However, Harry Baille refused to entertain this idea, telling the students that people in the Middle Ages believed it was a plague caused by God's displeasure or by magicians conjuring in the Middle East or a result of 'bad air' (miasma) in the city of London. Students were concerned by this difference, and in response to this apparent conflict of ideas, they attempted to reason out the answer by coming to a compromise position. As one student wrote on her concept map, 'there were many different beliefs as to what the black death was and how it spread'. However, this was a difficult position for some students to adopt because, in their opinion, there could only be one right answer. For these students, their prior conceptions and ideas about the mediaeval past, which they had learnt in the classroom, modified the potential impact of the living-history performances.

There were other instances where prior conceptions of the mediaeval past continued to dominate students' thinking. When the information provided by the living-history performer could not be incorporated into existing frameworks quickly, or the students felt overwhelmed by the amount of information given to them, they tended to revert back to their prior ideas of the past. Furthermore, when students had an established and strong personal interest in the mediaeval past, this continued to dominate their thinking, even if the representation given by the museum or historic site contradicted their understanding. In particular, male students from Schools 3 and 4 highlighted their interest in what they called 'proper' history, which was predominantly concerned with conflict, warfare and political events, and their opinions on gender rigidly defined what, as boys, they should find interesting about history (School 3, interviews: 11 July 2008). They continued to express an interest in these ideas of the past despite their visit to the Tower of London contradicting these views of mediaeval history.

More significantly, despite the attempts of the two case-study sites to provide a more rounded, even positive perspective on the mediaeval past, the young people demonstrated enduring deficit views of the past which regarded the past as inferior to the present. Some of the older students from School 1 were able to demonstrate an emerging realisation that societies in the past had different cultures and ways of life to theirs and that this did not make them 'stupid' or 'weird' or otherwise lesser people. They were coming to terms with understanding the past as a different place to the present. However, for the younger students this distinction was less prevalent, and their conceptions of the mediaeval past continued to be negative. These conceptions appeared to be a combination of a view of progress which regarded change, not as a neutral force, but one which was for the better, and

a deficit view of the past grounded in the lack of material comforts, scientific and technological advances of the present. Ideas of progress regularly surfaced in the students' conversation concerning the Middle Ages being less advanced in terms of technology and ways of thinking. George explained that although there was not 'much improvement back then', the Middle Ages were an interesting period to study because 'it basically shows us progressing from ancient times' (George, 10, School 4, interview: 2 July 2008). Peter took a similarly bleak view, explaining that 'because like nowadays … you've got mobile phones and PSPs [Play Station Portables] and all that and in them days there was nothing. … Well they didn't even have electric' (Peter, 12, School 3, interview: 11 July 2008). This sense of progress was not only manifest in technological terms but also extended to intellectual ability: students tended towards a deficit view of mediaeval social behaviour, particularly when they did not understand why people behaved the way they did. The need to compare the past and to understand it through the eyes of the present is a strong inclination. As historian R.G. Collingwood wrote, 'what we perceive is always the this, the here, the now' (1946: 233). The tension between the two was never fully resolved in the minds of the students.

Discussion: Implications for the Teaching and Learning of Challenging History

The research carried out at the Museum of London and Tower of London suggested that it is not only everyday ideas about the past which can modify student responses to living history performances at museums and historic sites. Where museums are attempting to represent alternative views of the Middle Ages, or perspectives that were relevant to those who lived in the periods, ideas learnt in the classroom could also conflict with the ideas that were presented during the living history performances. In both cases, where their ideas were challenged, the young people reverted to their own, prior conceptions about the mediaeval past or modified these views to incorporate new understandings. Above all, it reinforces the strength of students' frameworks of meaning. What does this mean for the teaching and learning of challenging history?

The theory of historical consciousness, which highlights the need to understand the prior conceptions and ways of thinking about the past that students retain in their frameworks of meaning, is valuable in highlighting the ways in which ideas about the past can be shaped differently, depending on the context. An understanding of historical consciousness can help educators to be more aware of and better equipped to expose – even challenge – the preconceptions that young people have about the past and how these might shape the acquisition of new information and concepts. This is considered to be particularly important when teaching challenging history, which may require very specific ways of thinking about the past to be understood and internalised by students. History in the museum and historic site has to compete with other representations of the past, both in and outside the classroom and, as the evidence from the six schools showed, although

the students valued what they learnt at the museum, their prior conception of the past was sometimes given greater value. The research suggested that museums and historic sites may not always have a substantial impact on historical understanding, because the default perspective of the young people was to view the past through the distorted mirror of the present, compounded by their tacit understanding of progress as meaning 'to get better' rather than 'to change'. The students described here were active learners, and, whilst the experience at the museum could be used to modify their prior understandings of the mediaeval past, it could also be used to reinforce their prior ideas about the past in a way that might be contrary to the expectations of the museum staff and their teachers.

However, it is important not only to focus on students' ideas and assumptions about the past. To only focus on their response may result in a deficit view of their capacity to learn history. It is important to take into consideration how the past is framed by museums and historic sites, the pedagogy which underpins their learning sessions, and how their representations of the past are negotiated by students. There is a tension implicit within research into history teaching and learning that there is a right and a wrong way to teach, and to learn, about the past. The understanding of young people as active learners, who make their own sense out of the information they are given by teachers and educators, is difficult to reconcile with challenging history, where there may be a moral or ethical concern in ensuring that the information is taken in and used in a particular way.

Furthermore, is it right to expect children and young people to be able to understand the past outside the perspective of the present? Is it possible to understand history without the frame of modern-day perceptions and prejudices? This continues to be a contested point amongst historians. The views of Arthur Marwick, who supports the view that history can be written and studied objectively (2001), can be contrasted with those of Keith Jenkins, for example, who asserts that history cannot be objective because of the historian's underlying beliefs and ideological position (1991). Museums and historic sites should not ignore this issue but confront it head-on. The two case-study sites did have authority for the young people, and this is something which they could build upon. In particular, although students complained about the amount of information they had to learn or did not always feel comfortable taking part in a living-history performance, very few students questioned the content of what they had been told. Indeed, most students agreed that the living-history performer was the 'expert', and they did not question their authority, even if they questioned their delivery of the content. Performers were not agents of the museum or historic site, they were provided by external agencies. However, the young people did not know this, and it is likely that they regarded the performer as a representative of the site. There seemed to be a tacit respect from the young people for the museum's knowledge and expertise.

This study reinforces the need for museums and historic sites to be explicit about their purposes, if they want to challenge young peoples' ways of thinking about the past. It raises the question of whether there is the potential to develop equitable ways of teaching and learning which enable museums and historic sites

to fulfil their aims, to present an alternative view of the past to students, but which enable young people to learn about the past in ways which appeal to them. It points to the museum or historic site as a space where young people should be able to discuss and express their ideas about the past, to engage with the experts, to be immersed in the past and to have their ideas challenged in a way which they will respond to positively.

References

Cannadine, D., J. Keating and N. Sheldon 2011. *The Right Kind of History: Teaching the Past in Twentieth-Century England.* Houndmills: Palgrave Macmillan.

Collingwood, R.G. 1946. *The Idea of History: Revised Edition with Lectures 1926–1928.* Oxford: Oxford University Press [1993].

Cooper, H. 2009. 'Afterword', in H. Cooper and A. Chapman (eds), *Constructing History: 11–19.* Los Angeles: Sage.

De Groot, J. 2009. *Consuming History: Historians and Heritage in Contemporary Popular Culture.* London and New York: Routledge.

Dyer, C. 2002. *Making a Living in the Middle Ages: The People of Britain 850–1520.* New Haven and London: Yale University Press.

Evans, R.J. 1997. *In Defence of History.* London: Granta Books.

Ferguson, N. 2004. 'Introduction', in J.H. Plumb (ed.), *The Death of the Past.* Houndsmill: Palgrave Macmillan.

Hooper-Greenhill, E. 2007. *Museums and Education: Purpose, Pedagogy, Performance.* Abingdon: Routledge.

Jackson, A. 2010. 'Engaging the Audience: Negotiating Performance in the Museum', in A. Jackson and J. Kidd (eds), *Performing Heritage: Research Practice and Innovation in Museum Theatre and Live Interpretation.* Manchester: Manchester University Press.

—— and J. Kidd, 2008. *Performance, Learning and Heritage.* Centre for Applied Theatre Research, University of Manchester. Available at <http://www.plh.manchester.ac.uk/documents/Performance,%20Learning%20&%20Heritage%20-%20Report.pdf> (accessed 1 Dec. 2013).

Jenkins, K. 1991. *Re-Thinking History.* London and New York: Routledge.

Jensen, B.E. 2009. 'Useable Pasts: Comparing Approaches to Popular and Public History, in P. Ashton and H. Kean (eds), *People and Their Pasts: Public History Today.* Houndsmill: Palgrave Macmillan.

Jordanova, L. 2000. *History in Practice.* London: Arnold.

Kidd, J. 2009. *Challenging History: Summative Document.* Available at <http://www.city.ac.uk/__data/assets/pdf_file/0004/84082/Challenging-History-Summative-Document.pdf> (accessed 21 Apr. 2012).

Landsberg, A. 2004. *Prosthetic Memory: The Transformation of American Remembrance in the Age of Mass Culture*. New York and Chichester: Columbia University Press.

Lee, P.J. 1978. 'Explanation and Understanding in History', in A.K. Dickinson and P.J. Lee (eds), *History Teaching and Historical Understanding*. London: Heinemann.

—— 2004. 'Walking Backwards into Tomorrow: Historical Consciousness and Understanding History', *International Journal of Historical Learning, Teaching and Research* 4(1): 1–46.

Marwick, A. 2001. *The New Nature of History: Knowledge, Evidence, Language*. Houndsmill: Palgrave.

Piaget, J. 1967. *Six Psychological Studies*, trans. A. Tenzer. London: University of London Press.

Planel, P. 1994. 'Privacy and Community through Medieval Material Culture', in P.G. Stone and B.L. Molyneaux (eds), *The Presented Past: Heritage, Museums and Education*. London and New York: Routledge.

Rüsen, J. 2005. *History: Narration – Interpretation – Orientation*. New York and Oxford: Berghahn Books.

Samuel, R. 1994. *Theatres of Memory*, vol. 1: *Past and Present in Contemporary Culture*. London and New York: Verso.

Seixas, P. 1996. 'Conceptualising the Growth of Historical Consciousness', in D.R. Olsen and N. Torrance (eds), *The Handbook of Education and Human Development: New Models of Learning, Teaching and Schooling*. Malden and Oxford: Blackwell.

—— 2005. 'Historical Consciousness: The Progress of Knowledge in a Postprogressive Age', in J. Straub (ed.), *Narration, Identity and Historical Consciousness*. New York and Oxford: Berghahn Books.

Shanks, M. 1992. *Experiencing the Past: On the Character of Archaeology*. London and New York: Routledge.

Siegler, R.S. 1998. *Children's Thinking*, 3rd edn. Upper Saddle River, NJ: Prentice-Hall.

Stearns, P.N., P. Seixas and S. Wineburg 2000. 'Introduction', in P.N. Stearns, P. Seixas and S. Wineburg (eds), *Knowing, Teaching and Learning History: National and International Perspectives*. New York and London: New York University Press.

Wineburg, S. 2001. *Historical Thinking and Other Unnatural Acts: Charting the Future of Teaching the Past*. Philadelphia: Temple University Press.

Chapter 18
Challenging Histories – Challenging Memorialisation: The Holocaust

Judith Vandervelde

Like all museums, the Jewish Museum London is more than merely a holding bay for artefacts of interest and is typical of museums which 'provide a tolerant space where difficult contemporary issues can be explored in safety and in the spirit of debate' (DCMS 2005).

This approach of holding up the past as a way of interpreting the present is particularly challenging in the case of the Holocaust. In this chapter, I shall explore some of the complexities experienced by the Jewish Museum during the development of its Holocaust Gallery and accompanying learning programmes and the challenges that continue to this day.

In 2010, the Jewish Museum was extensively redeveloped. This provided the opportunity to rethink the existing museum. Previously, the museum had existed on two sites with complementary collections and activities. One focused on the 'Judaica' collection whilst the other site focused on the 'Social History' collection. The two are now merged on one site which has tripled in size. Consequently the Holocaust artefacts are now housed alongside items of Jewish ceremonial art, a mediaeval *mikvah* (ritual bath), household items from Victorian East End London and an interactive display which explores the contemporary British Jewish community.

The Holocaust Gallery is offset from the museum's permanent exhibition 'History: A British Story', yet at the same time intersects with the display, linking with the British Jewish experience during the Second World War. There was much discussion about the parameters of the display and the most appropriate ways to frame the narrative within a British perspective, as the Holocaust did not take place in Britain. A decision was made to highlight two key elements. The first element would be the rescue of 10,000 children on the Kindertransport to Britain between 1938 and 1939. The second would be the survival of one British-born Holocaust survivor, Leon Greenman, OBE. This chapter will focus on Leon's story (see also Greenman 2001).

There were a number of reasons for this decision. With limited gallery space and a multiplicity of potential narratives, it was decided that it would be more meaningful to relate events through a single narrative rather than to attempt to cover the many stories of the Jews in Europe. This decision ties in with the overall emphasis on personal narratives throughout the museum's display (Burman

2012). It was also informed by an understanding that Jewish individuality was intentionally discarded by the Nazis, in the anonymity of labels, tattooed numbers and a lack of respect for human life. The Jewish Museum wanted to redress this by giving visitors one complete story. By focusing on a single Jewish life before, during and after the Holocaust, rather than just during the period 1933–45, it is hoped the visitor receives a broader understanding of what the Holocaust means in human terms.

The Jewish Museum was also aware of the well-established and well-regarded permanent Holocaust exhibition at the Imperial War Museum (IWM). The IWM exhibition displays a comprehensive representation of the rise of Nazism and the wider narrative of the Holocaust and its impact on the Jewish community as well as the fate of gypsies, homosexuals and those with physical and mental disabilities. The Jewish Museum was keen to complement and not to replicate the IWM's exhibition and to provide the visitor with an alternative context and focus.

As Bardgett comments 'the thoughts of millions in mass, the human mind steps back, unable to take it all. But to focus on one person: this woman or that child hits you very hard' (Bardgett n.d.: 2). The deaths of Leon Greenman's wife (Else) and son (Barney) in Auschwitz and his survival against all odds illuminates on a number of levels. Leon exemplifies the fate of so many ordinary people who lived in extraordinary times. Only when visitors realise the impact of the loss of one child, can they extrapolate to the higher figure of 1.5 million children who shared a similar fate to that of 2-year-old Barney Greenman.

The museum chose to focus on Leon's life for three reasons. Firstly, Leon, who died in 2007, was a British-born Jew who, despite this, was deported to Auschwitz from Westerborg. This makes his story unique and instantly relevant to a museum which focuses on British Jewish history. Living in Holland at the time of Nazi occupation, he was unable to provide the correct paperwork to prove his British identity and was consequently treated as a Dutch Jew. Secondly, Leon's story is accompanied by a wealth of artefacts. Leon stored many of his young family's possessions and was able to claim these back after 1945. These include Barney's shoes, Else's wedding dress and numerous family photos, all of which poignantly display what was lost. The museum is fortunate to hold so many personal artefacts belonging to one person – many survivors emerged with no objects or images to connect them with those they had lost. The individual artefacts, like the individual story, also make the Holocaust tangible to today's learners:

> By using objects for learning, students often find it easier to access the history of ordinary people and they can, for example, begin to break down the enormity of the Holocaust into identifiable human stories. (Marcus 2007: 11)

Thirdly, Leon's personality and passion added immense power to the displays. After his liberation in 1945, Leon dedicated his life to speaking about the Holocaust. His story, as told to numerous groups, is captured in a short film in the permanent display called *Never Again Auschwitz* which is presented together with

his poignant personal items. Leon was a passionate activist and fought racism, anti-Semitism and fascism in all its guises. Consequently the museum is able to tackle both learning about the Holocaust as well as learning from the Holocaust. The final message of Leon's gallery is displayed in a large photograph of Leon in his late 60s at an anti-Fascist rally. Superimposed on this image is the question 'How will you make a difference?' and there is a large ledger in which visitors may write. The intention is to encourage all visitors to think about what Leon's story means to them and the ways in which they might take on his ideas about fighting prejudice.

Sandell states that museums have the power to act as social agents. The Jewish Museum is no exception, and this is evident throughout the building and is most explicit in the telling of Leon's story. There is clearly a dual purpose to tell the history of the Holocaust within a wider narrative of fighting prejudice both in the past and today.[1]

However, Sandell identifies a 'boomerang' effect whereby social agents can misfire and the outcome can be that prejudice is unintentionally enhanced (2007). This is a challenge for all museums and the Jewish Museum in London is no exception.

In response to the question posed by Leon's gallery, 'How will you make a difference?', most people comment in a way which might be considered 'on message'. A typical comment is 'What happened to the Jewish people should not be forgotten because people should know.' However, sometimes visitors bring their own ideas and agendas to the exhibition using the opportunity to write comments not necessarily envisaged by the museum, most often related to the heavily politicised situation in the Middle East. There is nothing in Leon's exhibition that explicitly links his story to this contemporary issue, but some visitors will make the connection. Pro-Palestinian comments such as 'Free Palestine' sit alongside 'Israel rules'. These 'off-message' comments are in the minority and are balanced in number on both 'sides' but demonstrate one of the challenges that open-ended questions pose. Museums can of course control the questions, but not the responses. The Jewish Museum actively encourages such open debate and does not pass judgement on the messages. This is part of what makes the museum a living entity.

It is also challenging, when focusing on one person in detail, not to become hagiographic. This is avoided by using Leon's own voice and keeping commentary to a minimum. He narrates his story with his own artefacts. The visitor, like the

1 The most explicit example of the Holocaust's place in the role to combat prejudice is the use of the *Diary of Anne Frank* as demonstrated by the work of the Anne Frank Trust in the UK. Using the diary as a springboard the narrative of the Holocaust is frequently placed within a contemporary context using Anne's voice as the messenger for fighting prejudice today. In the words of the Anne Frank Trust: 'We draw on the power of Anne Frank's life and diary to challenge prejudice and reduce hatred, encouraging people to embrace positive attitudes, responsibility and respect for others' (Anne Frank Trust n.d.).

museum and the thousands of people who heard him speak during his lifetime, is then left to interpret what Leon says. In addition to Leon's film and artefacts, four other camp survivors also tell their stories, complementing Leon's testimony, for example relating the experience of being hidden from the Nazis or fighting with the resistance. Nearby, in the 'Refugees from Nazism' display in the main History Gallery a further group of refugees tell their personal stories on camera.

Face-to-face encounters with Holocaust survivors are an incredibly powerful tool (for more on this theme, see Amy Ryall, Chapter 14, this volume). It is one the Jewish Museum uses frequently in learning programmes which support student visitors to the permanent displays. The museum is fortunate to have a body of 20 volunteer speakers who give their time to visiting school groups. This is a model used by other providers of Holocaust education, such as the London Jewish Cultural Centre, IWM, Beth Shalom / Aegis Trust, and is an incredibly powerful way of bringing lessons from the classroom to life. Like the Jewish Museum, these other organisations facilitate opportunities for groups (primarily schools) to hear camp survivors, hidden children and Kindertransport refugees tell their stories.

However, a new challenge confronts Holocaust educators, as the speakers who are now mostly in their 80s and 90s become increasingly frail and unable to speak as they have done in the past. The fact that this powerful resource is beginning to fade is a challenge to Holocaust education in Britain across the board, and one we are acutely aware of.

Whilst this development is anticipated, it is also difficult to discuss. The learning team, in particular, is indebted to its team of speakers and is committed to assuring that their stories continue to be told long after they stop speaking. Thus, even though Leon Greenman died in 2007, before the museum reopened with its new displays in 2010, his story lives on in the film in the Holocaust Gallery which is also available to show to larger groups of students in the museum's auditorium.

The films (of Leon and other survivors) are carefully edited and are intentionally intimate: full face to camera. The questions posed were drafted from years of experience of facilitating personal testimony for visiting groups. However, it is likely that a film makes less impact than a face-to-face encounter. All educators in the field need to develop skills and respond creatively to this inevitable outcome.

The Jewish Museum has begun to respond by creating a variety of object-based workshops. The intention is that, to some extent, the objects convey a narrative which, like the speakers, is personal. This is a well acknowledged facet of museum-based learning: 'Objects are always targets for feelings and actions; their interpretation is embedded in already existing experience and knowledge' (Hooper- Greenhill 2000: 104).

What might a workshop participant learn about a tarnished and damaged spice box (used during the *Havdalah* ceremony at the end of the Sabbath)? This object (the focus for a workshop entitled 'Every Object Tells a Story') introduces the visitor to the Weil family. There are no written accounts of this particular family, and no records in the museum's collection. Yet the spice box conveys a huge amount: the fear of living as a Jewish family in Nazi Europe resulted in the object

being hidden in a box in the garden; the desperation of a parent whose only option was to send her sons to Britain on the Kindertransport and then, many years later, the return of those boys as young adults to their native Germany where they were reunited with the spice box but sadly not with their family.

On one level, it is a simple narrative of suffering and fear in the context of the Second World War. On another it is the epitome of separation: the Weil boys separated from their family, their home and their country juxtaposed with the symbolism of the spice box, which is traditionally used in a ceremony called *Havdalah* ('separation' in Hebrew), which marks the separation of the Sabbath, the day of rest, from the working week. All this is conveyed by a single object.

A yellow star (much to the amazement of students and teachers 'a real one') similarly has deeper underlying meaning. At first glance, it is a historical artefact which was used to identify Jews. But it raises a host of questions. Why did Hitler choose the star – a Jewish symbol of pride and strength – rather than something more inherently offensive? What does the writing mean? Is it Hebrew? Why is the Star of David still used today by the Jewish community? Why did people simply not wear it? What happened if you were caught not wearing it? What makes someone a Jew? Just as with the spice box, it opens up a number of different lines of enquiry, and, like the spice box, this is not an artefact treasured for its uniqueness or its beauty but is an object telling of everyday life. Poignantly the inevitable question, 'Who did this star belong to?', has no known answer. Again this, in itself, is powerful: the star's role as a symbol of loss of identity functions on many levels.

> Artefacts can be powerful triggers that empower students and enable them to apply their knowledge and to search for deeper meanings. Most students, regardless of their level of ability, can 'read' the object or make some meaning from it. (Marcus 2007: 13)

Undeniably, in the right context and with a skilled practitioner, artefacts like the star and the spice box become objects of wonder. Greenblatt describes this 'wonder' as the power of an object 'to stop the viewer in his or her tracks, to convey an arresting sense of uniqueness' (1991: 42). Whilst acknowledging their uniqueness, the handlers are also able to put the artefact into a broader Jewish context: something not always achievable in other learning settings. The museum is acutely aware that all its learning programmes, regardless of whether they primarily focus on history or religion, should have a strong Jewish content.

This strong Jewish content is exemplified in the Holocaust Gallery. Leon was not a religious man. However, as detailed in his telling of his own story, he had a strong faith and, in his words, 'was born a Jew, suffered as a Jew and will die as a Jew'. All the people featured in the galleries identify themselves as Jewish, and, like the Jewish community today, they come from all sections of Jewish society from the strictly Orthodox to the secular.

For those participating in a learning workshop, 'Jewishness' is implicit in all aspects of their time spent in the museum. It is a fully immersive, Jewish experience. This is demonstrated clearly in the handling workshops described above. Another workshop entitled 'Faith and the Holocaust' for ages 12 and above (Key Stages 3, 4 and 5 in the UK), encourages students to evaluate a Jewish text (extracts from the book of Job) in *chevruta* style learning – close textual study in pairs – which is the essence of traditional Jewish learning and is replicated in religious schools and rabbinic colleges around the world. Consequently the participant (and 90 per cent of visiting students are not Jewish) is critically analysing a Jewish question in a traditionally Jewish way and will, hopefully, glean a Jewish response. Visitors are then enabled to re-visit the central question raised in the text (why do bad things happen?) in the context of Leon's story. The outcome is often an enriched understanding of the Holocaust from within a Jewish context while the experience is enhanced as the students are surrounded by evidence of a living and thriving community. Many students are surprised by this as their previous associations with Judaism often only relate to the Second World War, death and destruction, and they were hitherto unaware of the vibrancy and diversity of contemporary Jewish life.

For the younger visitor (under 12s), pre-booked school groups are directed towards workshops focusing on the Holocaust's more redemptive aspects and the narrative of 'rescue'. In Britain the story of the 10,000 children rescued from Nazi occupied Europe in 1938–39 on the Kindertransport is a fine example to convey this aspect to younger visitors. Popular workshops for this age group, 'Every Object tells a Story' and a 'Child's Journey' are in keeping with the adage 'up to the gates of Auschwitz but not beyond'. By concentrating on the lives of the *Kinder*, students are, to some extent, shielded from the horrors. Kindertransport members witnessed life in Nazi Europe but did not experience the camps at first hand: concentration camps and mass killings are alluded to but the details can be spared.

This 'gentler' approach works well. The team members at the Jewish Museum have become acknowledged leaders in this field (Kolirin 2011) and are often consulted by primary school teachers for advice on how best to achieve a meaningful and appropriate introduction to the Holocaust (for 5–11-year-olds). The advice given is, generally, to be student-led. If the student is not ready to hear the details, this can be deduced from their questions. A child who asks a Kindertransport refugee: 'Did you ever see your parents again?' might be satisfied with the response: 'No I did not'. If the child probes further, however, with such questions as: 'What happened to them?' this is an indication that the child might well be ready to learn more and all answers should be direct responses to the questions. When the Holocaust is revisited in school – usually three years later in the UK National Curriculum – more facts can be revealed as the student may, in the intervening years, have matured and now be better able to absorb the concept.

This methodology satisfies another challenge faced by the museum. Early on in the redevelopment, it was decided that the dignity of those who suffered needed to be maintained. There are no graphic images of emaciated, naked bodies; no

photos of anonymous mass graves; no depictions of gas chambers. The focus on the individual enabled the withholding of such images. Leon's story is all the more powerful without the presence of anonymous victims. Else and Barney are seen as vibrant and real. This makes their loss all the more untimely and unsolicited. The preclusion of graphic evidence also dovetailed with the requirement to be inclusive of all, regardless of age. It is not a matter of concern that young visitors may drift in to Leon's gallery. Nothing there will alarm them and experience has shown that those not ready find it 'uninteresting' (rather than frightening). Furthermore, in addition to large school groups, this suits family groups. Parents can take their children around the galleries. There is no arbitrary decision that Leon's gallery is not suitable for certain ages. The parent and child can decide for themselves. Parents can be seen taking very young children around Leon's gallery explaining it in its simplest terms, and children can then re-visit the subject (and the museum) if and when they are ready for further detail.

In the long narrative of the history of the Jews the Holocaust is only a small part of the story. The skill of the historian is to place the Holocaust within a broader context. It is also constantly evolving, and we are starting to see the emergence of different narratives such as those of the perpetrators. As each decade passes, and the war years start to fade from living memory, the Holocaust itself recedes into the past and it is perhaps with this distance that even more challenging and thought provoking lessons can be learned from its study.

References

Anne Frank Trust n.d. 'Our Mission'. Available at <http://www.annefrank.org.uk/> (accessed 1 Jan. 2013).

Bardgett, S. n.d. *Holocaust Survivors Tell their Story at the Imperial War Museum.* Available at <http://archive.iwm.org.uk/upload/pdf/Jewish_care_article.pdf> (accessed 1 Dec. 2012).

Burman, R. 2012. 'Transforming the Jewish Museum: The Power of Narrative', in T. Kushner and H. Ewence (eds), *'Whatever Happened to British Jewish Studies?* London: Valentine Mitchell.

DCMS (Department for Culture Media and Sport) 2005. 'Understanding the Future: Museums and 21st Century Life' [consultation document].

Greenblatt, S. 1991. 'Resonance and Wonder', in I. Karp and S. Lavine (eds), *Exhibiting Cultures.* Washington DC and London: Smithsonian Institute Press.

Greenman, L. 2001. *An Englishman in Auschwitz.* London: Valentine Mitchell.

Hooper-Greenhill, E. (ed.) 2000. *Museums and the Interpretation of Visual Culture.* Abingdon: Routledge.

Kolirin, L. 2011. 'Mummy, What was the Holocaust?' *Jewish Chronicle* (21 July). Available at <http://www.thejc.com/lifestyle/lifestyle-features/52035/mummy-what-was-holocaust> (accessed 1 Dec. 2012).

Marcus, C. 2007. 'No Child's Play: Can Children's Playthings Engage the Visitor in the Historical Narrative of the Holocaust and Stimulate them to Think about Complex and Challenging Questions?' MA thesis: Institute of Education, University of London.

Sandell, R. 2007. *Museums, Prejudice and the Reframing of Difference.* London: Routledge.

Index